EMBROIDERED STORIES

EMBROIDERED STORIES

Interpreting Women's
Domestic Needlework
from the Italian Diaspora

Edited by

Edvige Giunta and **Joseph Sciorra**

University Press of Mississippi / Jackson

www.upress.state.ms.us

The University Press of Mississippi is a member
of the Association of American University Presses.

Copyright © 2014 by University Press of Mississippi
All rights reserved
Manufactured in the United States of America

First printing 2014

∞

Library of Congress Cataloging-in-Publication Data

Embroidered stories : interpreting women's domestic needlework
from the Italian diaspora / edited by Edvige Giunta and Joseph
Sciorra.
 pages cm
 Includes index.
 ISBN 978-1-62846-013-1 (hardback) — ISBN 978-1-62846-014-8
(ebook) 1. Needlework—Italy. 2. Women and the decorative
arts—Italy. 3. Italians—Foreign countries—Ethnic identity. I.
Giunta, Edvige, editor of compilation. II. Sciorra, Joseph, editor of
compilation.
 NK8852.A1E43 2014
 746.4089'51—dc23 2013046793

British Library Cataloging-in-Publication Data available

To my children, Emily and Matteo, that they may
remember the stories of our culture and pass
them on; to my sister Claudia, fellow immigrant
and memory keeper; to my mother, Cettina
Minasola, knitter, teacher, and source of courage
and inspiration; and to the women who came
before us—Nunziatina Nuncibello Minasola,
Concetta De Caro, and Dorotea Favitta.
—Edvige Giunta

To my mother, Anna Sciorra (neé Anniballe);
to my paternal grandmother, Filomena Sciorra;
and to performance artist Pippa Bacca.
—Joseph Sciorra

CONTENTS

SKILLS AND ARTISTRY

LOST, DISCARDED, RECLAIMED

AFTERWORD

ACKNOWLEDGMENTS

This book is the culmination of work that began in 2001 with the planning of the symposium "Biancheria: Critical and Creative Perspectives on Italian-American Women's Domestic Needlework," sponsored by the John D. Calandra Italian American Institute in 2002. Working on this book over the last decade has been, for both of us, an enlivening and wonderful process—from writing the proposal to reviewing and editing submissions to conceptualizing the final manuscript to writing the introduction. Our collaboration as editors and coauthors of the introductory essay has been a rewarding and joyful experience.

We are grateful to all the authors—a truly global community of writers, visual artists, and scholars—for their commitment to the book, for their enormous patience during these years, and for their beautiful and insightful contributions. Our deepest appreciation goes to Donna Gabaccia for her thoughtful and evocative afterword—a perfect coda to the book—and for her generous response to the entire project. We thank Margaux Fragoso, Laura Ruberto, and Joan Saverino for their most helpful comments to early drafts of the introduction. We were fortunate to be able to count on Rosangela Briscese's precise comments to the introduction, her invaluable assistance with the index, and her support in many aspects of the work that this book required. We owe a special debt of gratitude to Sian Gibby at the Calandra Institute, whose careful copyediting in the final stages of our work has made *Embroidered Stories* a better book. We thank photographer Martha Cooper for her generosity in photographing objects featured both on the cover and in the introduction.

We are indebted to our editor at the University Press of Mississippi, Craig W. Gill, for having faith in our project and trusting our editorial choices. We also thank Katie Keene, Anne Stascavage, and Deborah J. Upton for their essential help in various stages of the book's production. The suggestions of our anonymous outside readers were invaluable in the final revision of our work.

Our deepest thanks go to the John D. Calandra Italian American Institute, Queens College (City University of New York), for serving as an ideal home

for this project in its various stages, and especially to Dean Anthony Julian Tamburri, for making the institute such a vibrant center of Italian American intellectual and creative life and for supporting this and all important Italian American cultural initiatives.

Edvige wishes to thank the SBR Fund at New Jersey City University for granting course release time vital to her work on this book. She also thanks the many Italian American women authors who have motivated two decades of writing and editing and her colleagues in the field. She is deeply appreciative of her mother, Cettina Minasola, for sharing Sicilian stories of needlework that fueled the passion sustaining this book, and of her sister Claudia, an inexhaustible source of Italian memories and a wonderful listener. Finally, for his support while writing this book—and virtually every word she has published over the last twenty years—she is deeply grateful to her husband, Joshua Fausty, whose patience, love, and much-needed humor continue to enrich her daily life.

Joseph wants to thank Anthony Tamburri for his unflagging encouragement and for creating a rigorous and constructive academic environment in which to conduct research and to write. He is grateful for the synergetic working camaraderie with Rosangela Briscese and Sîan Gibby at the Calandra Institute, who have made every project better, smoother, and more enjoyable. He is truly appreciative to be part of a community of artists and scholars whose work in the areas of folklore and Italian American studies inspires, challenges, and rewards him daily. And he is eternally indebted to Zulma Ortiz-Fuentes, whose support and affection have been vital to his life and work.

EMBROIDERED STORIES

Introduction

—Edvige Giunta and Joseph Sciorra

L'ago paziente intesse sulla tela
Motivi d'infinita leggiadria,
Come la spuma nella Bianca scia
Che s'allunga sul mar dietro una vela
[. . .]

The patient needle wove the cloth
with patterns of infinite loveliness,
like the foam on the white wake
stretching on the sea after a sail
[. . .]

—*"Merletti"* (Lace), Severina Magni

In 1933 Paulina Baldina Capozzi departed Naples on the steamship *The Rex* with a trunk filled with her trousseau, heading for her new home in Corning, New York.[1] Other women before her had taken this trip, carrying with them embroidered items that they, or other women, often in their family, had made. Italian women saw these items as beautiful objects, examples of their skill and resourcefulness; they also regarded their needle arts as a potential source of wealth and an epitome of womanhood.

In their new lives as immigrants, women like Capozzi developed a dynamically new relationship with their expertise as needleworkers. In new countries, many of these women utilized their old skills by working as seamstresses in factories and tenement workshops, often becoming their families' most reliable breadwinners. Some sold or pawned items from their dowry to cope with economic hardship. A number of immigrant women continued their domestic needlework for their family's use. A few still prepared trousseaux for their daughters, even though the anachronistic items from their own trousseaux (if they had them) remained unused in the oblivion of linen chests, unveiled only for rare use and then ritualistically washed, ironed, and stored. Some of these women taught their craft to their sometimes-reluctant daughters and granddaughters. The latter were often more interested in their Italian heritage than were their second-generation mothers, who had been so eager to reject their stigmatized immigrant origins.

Over the course of the twentieth century, this transmission of skills, too, became a thing of the past. Once valued and cherished, increasingly impractical and devalued embroidered items, such as doilies and capelets, were often dispersed, even discarded by their makers and descendants. And so the heartfelt yet unexamined history of needlework—with its artistry, its techniques, its practices—became embedded in the culture of the Italian diaspora as a symbolic and cultural trace and a token of the immigrant experience. In time, the very language of this art began to seep into the stories that told of the massive migratory movement that forever changed the country the immigrants left and the countries in which they made new lives.

For Italian immigrants and their descendants, needlework represents a marker of identity, a cultural touchstone as powerful as pasta and Neapolitan music.[2] Whenever we mention the subject of our book, Italian Americans of various stripes spontaneously begin to tell us stories—stories of women sewing, embroidering, knitting, crocheting. The pull of the mundane yet artistically rendered object—a tablecloth, a wedding sheet, a christening gown (collectively known as *biancheria*, or white wear)—drives accounts of needlework that has been given, received, or even lost and occasionally recovered. Needlework thus can function as an artifact of the imagination, a repository of dreams, hopes, disappointments, desires. It is the material for memory work.

For Edvige Giunta it is the story of a child's nightgowns made from the rose and blue linen sheets from her maternal grandmother's dowry; the story of the dowry embroidered by her paternal grandmother for her crippled daughter destined never to marry (this daughter, Edvige's namesake, would one day give it all away to a stranger, including a precious curtain on which her name had been embroidered); the story of her Sicilian mother showing her distracted adolescent daughter the dowry she had been preparing for her, a dowry this daughter would one day take to the United States in multiple trips, one sheet, one towel, one bedcover at a time; the story of that mother, almost eighty years old, visiting her immigrant daughter in New Jersey, opening an American-bought antique chest, and presenting her granddaughter with a finely embroidered tablecloth that seemed to come from another place, from another time—this, the first piece of *corredo* (trousseau) for Giunta's American-born daughter.

For Joseph Sciorra, it is the story of his seamstress mother, Anna, showing her seven-year-old son the expertise of the hidden, inside seam of a pants cuff to teach him about *lavoro ben fatto* (work done well); the story of a cross-stitch sampler with its varied lettering styles and line patterns that Anna, a schoolgirl at the time, had made in fascist-era Italy and considered important enough to bring with her to New York City when she emigrated

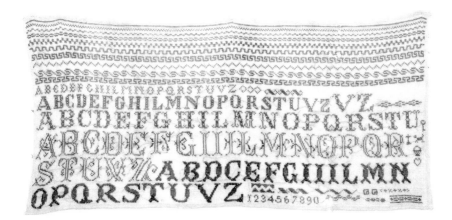

Sampler by Anna Anniballe. Maranolla, Formia (Latina province), Lazio, Italy, c. 1937. (Courtesy of Joseph Sciorra. Photograph by Martha Cooper.)

in 1950; the story of Sciorra framing this humble and frayed sampler as artwork and hanging it in his Brooklyn apartment; the story of his paternal grandmother, Filomena Sciorra, an emigrant who returned from New York City to the Abruzzo mountain town of Carunchio (Chieti province) in 1926 and, after the untimely death of her husband a decade later, took up his needle to custom tailor men's suits for local peasants and urban *signori*; the story of embroidered doilies Filomena gave to her American grandson, during his visits in the 1980s, as part of an untraditional gifting; the story of these very heirlooms carelessly mixed with similar pieces purchased in American flea markets, so that origins merge and the provenance of singular items is lost, as so often happens in immigrant histories.

Out of the artifacts of their memory and imagination, Italian immigrants and their descendants have created narratives around embroidery, sewing, knitting, and crochet that help define who they were and have become. Indeed, needlework is an integral part of the Italian migratory experience:[3] It is evident in oral histories and critical studies, but also in the works of writers and artists. Sometimes a piece of needlework is tied to the creative impetus behind an artistic work. Helen Barolini, for example, traces the origins of her cross-generational immigrant saga, *Umbertina* (1979), to a trip to Calabria in 1969 during which she came across a bedspread, which triggered a childhood memory of her grandmother.[4] Before leaving for the United States, Umbertina, Barolini's character, commissions and purchases a bedspread from the housekeeper of the village priest. For her, the bedspread represents something "beautiful and strong, to last forever," a symbol of her belief in the possibility for a better life.[5] After emigrating, Umbertina

makes the unavoidable choice of the poor who cannot afford luxuries such as the bedspread, as Anna Giordani, the social worker who sells it on her behalf, sharply reminds her. It is not until the end of the novel that we learn that Giordani herself had purchased the bedspread and donated it to the Museum of Immigration at Ellis Island, where Umbertina's own great-granddaughter, Tina, will one day see it, though she will remain unaware of its origins: "As she neared the glass of the case and read the card, it said: 'Origin: Calabria. Owner unknown. Acquired by Anna Giordani in 1886.'"[6] In a blatant case of cultural theft, Giordani's scheming relegates the immigrant to the silent condition of namelessness. While Umbertina's great-granddaughter never learns of her direct link to this immigrant bedspread, the story Barolini tells affirms the immigrant's right to ancestral connection and cultural reclamation.[7]

The very same Ellis Island Museum where Tina admires Umbertina's bedspread became, in 2001, the location for another cultural recovery through B. Amore's sprawling site-specific installation "Life line—*filo della vita.*"[8] The exhibit was an overwhelming ensemble of objects, images, texts, media, and exhibition styles culled from seven generations of the artist's family, artfully arranged in seven rooms for visitors to behold. A delicate red thread ran through the exhibition, making its way across time and space, connecting visitors to the past and propelling them into the future. This thread evoked the unraveling yarn immigrants used to temporarily remain connected to relatives left standing on the docks as they sailed away to an unknown world. Amore's installation, like Barolini's novel, illustrates how, by rewriting the stories of their ancestors, the descendants of immigrant women rewrite immigrant history.

Embroidered Stories: Interpreting Women's Domestic Needlework from the Italian Diaspora is an interdisciplinary collection of creative work—memoir, poetry, and visual art—by authors of Italian origin and academic essays by scholars from the social sciences and the humanities.[9] The collection explores a multitude of experiences about and approaches to needlework in immigration, spanning from the late nineteenth century to the late twentieth century.[10] The impetus for the anthology was the interdisciplinary symposium "*Biancheria*: Critical and Creative Perspectives on Italian American Women's Domestic Needlework," sponsored by Queens College's John D. Calandra Italian American Institute in 2002 and conceptualized by Giunta and Sciorra. The intense conversations between presenters and the audience made it evident that needlework was overlooked in Italian American studies. While a few of the scholarly and creative pieces originally presented at the symposium have been substantially revised and appear here, most of the book consists of new contributions. The majority of the work we present

here focuses on the Italian American experience not only because we, the editors, are operating within an American context but also because our work grows out of the extensive and diverse body of scholarship, as well as literature and visual art, produced by and about Italian Americans. Yet, building on recent scholarship that has brought to light the transnational and diasporic characteristics of the larger Italian migration, and in particular women's issues, the anthology also includes contributions concerning Argentina, Australia, and Canada.[11]

The private stories of *biancheria* by members of the Italian diaspora fueled our work. What inspired our search for representations of women's domestic needlework was the capacity of a simple object—or even the memory of that object—to become something else: literary, visual, performative, ethnographic, or critical reimagining. The process by which these transformations occur is the subject of this book. While we are primarily concerned with representations and interpretations of needlework rather than the needlework per se—its origins, design patterns, and techniques— we remain mindful of its history and its associated cultural values, which Italian immigrants brought with them and passed on to their descendants.

A Brief History of Italian Domestic Needlework

Embroidery and lacework were basic skills of Italian peasant and artisan women in the nineteenth century and well into the first half of the twentieth century.[12] These skills were essential in the creating and assembling of an Italian bride's *corredo*, which consisted of *biancheria*: the collection of bed coverings, tablecloths, towels, doilies, intimate apparel, and other textiles. Up until the 1960s, the items in this ensemble were hand-embroidered and trimmed with lace.[13] As Jane Schneider points out in her seminal work on Sicilian needlework and the dowry system, embroidered cloth among the poor was not "a timeless" component of "the marriage exchange system . . . with roots in an unchanging past," but "an interim arrangement."[14] During the nineteenth century a confluence of social changes—including the introduction of mass-produced cloth, immigration (as a new source of capital from remittances and returning immigrants), new class formations, and status emulation—generated opportunities for working women to create wealth from their own hands.

Embroidery among southern Italy's nonelite families took hold during the late nineteenth century with the emergence in rural towns of a new bourgeoisie class (*ceto civile*) who, in emulating the aristocracy, embraced embroidery, a luxury item and marker of leisure status, in their own lives.

During this period, the commercial distribution of factory-made textiles into the hinterland freed artisan and peasant women—whose families also experienced an increased standard of living—from spinning and weaving cloth, creating opportunities for them to shift their domestic work to the prestigious white-on-white embroidery. The working poor's adoption of embroidered cloth into their daily lives was "rapid and thorough."[15]

The significance of *biancheria* must be understood as integral to Italian gender and sexual roles: It is one of the means by which femininity was codified. Girls began their domestic training in embroidery and lacework often before the age of seven and learned to perfect various embroidery patterns during adolescence. This labor-intensive work "fatigued their eyes under the best of conditions [and] became burdensome when done by candlelight or oil lamp."[16] Needlework, often created in the public space of the *cortile* (courtyard), demonstrated that a family's female members had been properly educated in socially accepted practices and mores.[17] The preferred white-on-white embroidery ultimately served as a powerful "symbol of virgin girlhood."[18] Appropriately, Catholic nuns were a crucial source for training girls in needlework technique and design, as well as giving moral and religious lessons.[19]

Yet, because of the strict separation of the sexes among unmarried youth in southern Italian society, the worked cloth could also be a charged expression of Eros, albeit sometimes veiled, and of anticipated marriage. As Anna Chairetakis observes, a "girl's linens not only announce her capacities and wealth, but also draw to her the man she wants—weaving and needlework were implicated in the practice and beliefs of love magic."[20] The association of needlework and love is expressed in a male carter's song recorded by Alan Lomax and Diego Carpitella in Sicily in 1954, referencing a common practice among lovers:

Assira cci passavu ddi l'amuri,	Last evening I passed by my true love's house,
cc'èrinu ggenti e nun cci potti parrari.	But other people were there, and I couldn't speak to her.
Cci l'àvilu lassatui un fazzulettu,	I left a handkerchief for her
p'arraccamallu ri rrosi e ddi ciuri.	To embroider with roses and flowers.
Puntu pi ppuntu cc'ha lu nostru amuri	Our love will be in every stitch,
e nta lu menzu n'àcula riali.	And in the center, a royal eagle.[21]

In this song, the vocabulary of needlework is unobtrusively incorporated into the narrative of courtship. It is for the man to wield it, and to prescribe the form of the work—the handkerchief—through which the woman can express her affection.

By the time a girl reached marrying age (which has varied over time and according to location and class), she had assembled the trousseau that was an essential part of a dowry (which could also include land, a house, furniture, and money); she had also completed the decorative needlework on bed coverings, tablecloths, towels, doilies, intimate apparel, and other textiles that the family had accrued for her. A set of six bedsheets (plus supporting white wear) was usually considered a basic *corredo*. Depending on a family's wealth, bedsheets could be multiplied, from six to twelve, or even twenty-four.[22] The very poor, who lacked the free time—and the means—needed for their daughters to learn needle arts, struggled to piece together the bare minimum for a trousseau. "Having done no embroidery," Schneider notes, "was worse than a social stigma."[23] It made a woman less marriageable and marked the family as incapable of making the daughters suitable for the only socially respected choice for a woman besides becoming a nun.

The *corredo* was a source of a woman's wealth—as Joan Saverino's essay in this book documents—her property until she died and for her to dispose of or distribute as she saw fit. In times of financial disaster, women could and would resort to pawning or selling embroidered linens, but these were decisions dictated by "a desperate, almost immoral, economic necessity."[24] It was not uncommon for a married couple to sell parts of a dowry's embroidered linens to obtain the money to emigrate.[25] The depth of humiliation that the sale of the linen would cause the woman is evident in Sicilian author Maria Messina's short story "I Take You Out." Here, the woman, who is forced to sell in secret the "fine lingerie and linen" her mother left for her dowry, pleads to the character who is serving as an intermediary: "I'm warning you, *gna'* Filippa! Don't mention my name! I'd die of shame."[26]

The official enumeration of goods of a newly engaged couple, known as the *minuta*, followed by the *stima* (appraisal) on the eve of the wedding in Sicily, emphasized the importance of the economic value of a *corredo*.[27] The *stima* was a highly ritualized performative display involving the groom's parents, relatives, and other guests who, at the end of the ceremony, transported the *corredo* to the couple's future home.[28] The embroidered cloth was bound to critical stages of life and figured in key rites of passage. In addition to its prominence in courtship and the steps leading to marriage, the decorated textile played a dramatic role after the wedding night, when the mothers of the bride and the groom visited the newlyweds to examine the bedsheets for proof of the woman's virginity and then publicly displayed the sheets outside the house.[29] Swaddling clothes were adorned with the sayings "*Bello di Mamma*" (Mother's beauty), "*Cresci santo*" (Grow up holy), and "*Gioia, Gioia, Gioia*" (Joy, Joy, Joy).[30] The dead were buried in shrouds decorated with lace and embroidery.[31] In these and other critical ways, needlework became charged with potent emotional and symbolic value.

The ritualized function of women's needlework is manifested in the intertwining of religious beliefs and practices with aspects of the craft. The sacred connotations of cloth were made evident during the religious *festa* (public feast), when decorated bed coverings were hung over balcony railings as the saint statue was processed through the streets. In addition to apprenticing in nunneries where nuns taught girls how to perfect sewing and embroidery, girls and women embroidered clerical and ecclesiastic robes and garments as well as costumes for religious statues, often as part of religious vows to the Madonna and Catholic saints. Especially devout women known as *monache di casa* (house nuns) spent their days embroidering for the church.[32] Embroidered runners and table skirts became an essential feature on women's vernacular altars—and would be, too, in immigrant homes.[33]

In the early twentieth century, Italian ethnographers and other scholars began documenting peasant and artisan needlework, costumes, and other craft traditions as part of Italy's larger intellectual and political search for and creation of a national identity. Expositions brought national and international attention to local needlework practices, and women researchers such as Emma Calderini, Eleonora Gallo, and Elisa Ricci offered much insight into the needle arts through their published works.[34] The Italian manifestations of the Arts and Crafts Movement (known as Stile Liberty) that had spread throughout Europe and the United States (1880s–1910s) generated such revival initiatives as the Società Cooperativa delle Industrie Femminili (Cooperative Society for Italian Female Industries) in Rome in 1901, which sought to reintroduce Renaissance and northern Italian patterns to peasant women.[35] This "work of rescue," as Ricci describes it, occurred as Italian women were migrating toward urban centers and emigrating in larger and larger numbers to industrial areas in the United States.

Under fascism, as Ilaria Vanni notes in her essay in this volume, needlework classes were introduced in public-school education for girls in 1923. In *Such Is Life*, Italian immigrant Leonide Frieri Ruberto remembers learning the needle arts when she was in fourth grade (approximately in 1923): "They taught us how to pull the threads close to the fabric, in order to make a hem stitch (*punto a giorno*), they made us sew hems, and many other embroidery stitches that I liked a lot."[36] The newly created *liceo femminile* (women's high school), a finishing school "designed for daughters of good families," included needlework in its curriculum. During the fascist era learning needlework was considered an important component in the "pupil's spiritual formation" and not a skill to be used in the job market.[37] The fascist regime also took particular interest in domestic needlework, especially the embroidery and lace so essential to the fashion industry, and created the Ente Nazionale Artigianato e Piccole Industrie (National Organization for Crafts

and Small Industries) to promote such work as part of official policy. The regime's political and economic agenda concerning needlework, especially as it pertained to its support of folk art and regional costumes, stood in marked contrast to its policies directed at controlling local cultural expressions while exalting national culture.[38]

While women's needlework skills vitally contributed to the revival and global marketing of the Italian fashion industry after World War II, domestic needlework experienced a decline as more women sought higher education and entered the job market.[39] Starting in the 1960s, machine-printed and machine-embroidered linens and electrical appliances increasingly became staples of many Italian dowries.[40] The once-central place of handmade embroidered textiles in family life was forever changed in 1968, when the dowry was abolished by the Italian civil code.[41] Still, the dowry system survived, although in uneven ways, in smaller and larger towns of the Italian South, where the main streets are punctuated, to this day, by multiple linen stores in which items for the *corredo* remain a popular purchase for women from all social classes.

Italian Needlework in the Diaspora

Italian women who emigrated to northern Europe, Latin America, North America, and Australia throughout the late nineteenth and twentieth centuries brought needle arts with them. In these new social realities, these arts changed. In the United States, immigrant women were able to use their skills in factory jobs in the Northeast, especially in New York City, and thus became industrial proletarians and a significant force in the needlework trades. Jennifer Guglielmo notes that, in 1905, "close to 80 percent of all Italian women working in the United States were employed in the fashion industries," and, per a 1911 study, 91 percent of them had worked sewing, embroidering, or making lace before emigrating.[42] Like Italian immigrants in the United States in the earlier part of the twentieth century, women who left Italy for Australia after World War II and through the 1980s were sought after in the textile and fashion industries for their knowledge and skills. Ironically, this wage-earning work curtailed their ability to engage in domestic embroidery for their daughters' *corredo*, thus hindering the cross-generational transmission of needlework.[43]

In countless cases, women, with their highly prized needlework skills, were responsible for the immigrant family's survival in the United States. In an interview conducted in the 1970s, Elvira Adorno talked about her Sicilian immigrant parents who established a flag-and-banner company—ultimately

named the Adorno Flag Company—at the beginning of the twentieth century in Manhattan's Little Italy:

> My mother did fine work in embroidery and crocheting, being especially expert at designs and filigree. Father reasoned that he could exploit this talent by going into business supplying Italian organizations in need of regalia and banners. Having saved some money, he sent for my mother and two brothers. . . . After quitting his job father started a flag and banner business and we moved to 212 Grand Street, a tiny railroad apartment that did not have its own bathroom. Mother helped father in his business; she was his only embroideress. She would get up after he had fallen asleep to pick up where she had left off, thus finishing orders on the flags (standards) on time. Central heating was unheard of in these buildings; my mother caught pleurisy, and died leaving father with four children.[44]

Elvira's father sent for a new wife, also a skilled embroiderer, from his hometown and went on to expand the business to include four women needleworkers. Eventually, the new family moved from their cramped Little Italy apartment to a two-family house in Bensonhurst, Brooklyn.[45]

In 1905, middle- and upper-class Americans involved with settlement-house philanthropy and the Arts and Crafts Movement, in collaboration with their Italian counterparts, founded the Scuola d'Industrie Italiane in Manhattan, to uplift Italian proletarian women by training and employing them to produce high-end embroidery for sale to bourgeois women. George Pozzetta writes that, despite its altruistic motives, this twenty-year social and art "experiment" was characterized by romantic and paternalistic attitudes that led to regarding immigrant women "as pawns [to be] moved about" by reformers.[46] The names of the small number of young women employed or their thoughts about the Scuola are lost to history. It is telling that the label caption for an intricately crocheted "chalice veil" (c. 1915) in the New-York Historical Society exhibition on sewing in New York City attributed the religious item not to its individual creator but to the Scuola, in a real-life mirroring of the cultural theft of immigrant needlework recounted in *Umbertina*.[47]

In the United States, immigrants adapted aspects of needlework to their new settings, especially those involving powerfully charged ritual. In Roseto, Pennsylvania, Pugliese immigrants and their children continued the ceremonial transference of the trousseau to the new nuptial home, which they called, "to bring the *biancheria*—to make the bed."[48] In New York, Sicilian immigrants adapted the traditional *turnialettu* (valance), "a deep flounce of cloth that encircled the Sicilian bed, hiding the storage space beneath it," by draping cloth "around sinks and laundry tubs or under the shelves

BY MEANS OF OUR
EMBROIDERY CLASS WE
HOPE TO TEACH OUR
YOUTH SOME OF THE
HOUSEHOLD ARTS.
TEACHER
MRS. ANTONET CARUSO

Brochure (detail) for the Educational Center "Gioventù Italica" Brooklyn Branch, circa 1939. Courtesy of Stephanie Romeo. Given the organization's name—"Italic Youth"—it is not surprising that its director Arturo Egitto was a documented supporter of Italy's fascist regime.

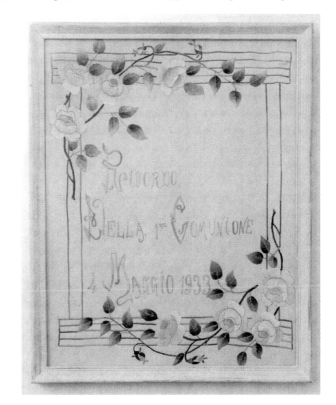

Commemorative embroidery, which reads in translation, "Souvenir of the 1st Communion, May 4, 1933." (Courtesy of Joseph Sciorra. Photograph by Martha Cooper.)

of kitchen dish cupboards."[49] Embroidered textiles were put on public display during the religious street *feste*, as evidenced in the 1935 procession in honor of Our Lady of Mount Carmel in East Harlem, New York: "Many windows of many apartments were hung with bedspreads—red, pink and blue silk, some brocaded in gold, some of bands of gold cloth and lace, some of white silk and lace."[50] At least in one undocumented case from 1933, a new religious practice emerged in which a child's First Holy Communion was commemorated with embroidered text and roses rendered with nuanced shading.[51]

During the first half of twentieth century, organizations such as the Carmela Testa Company of Boston catered to Italian immigrant women's desire for needlework designs. Pattern books like *Variety Italian Cutwork and Filet Lace* (1921) and *Italian Drawn Work and Antique Filet Lace* (1922) were written in English and thus their audience extended beyond the immigrant community. (Today these reproduced publications do a brisk business online.) Specialty niches were also established in Australia during the 1950s to meet new immigrants' desires, such as the Costanzo Emporium in Coburg, which sold imported Italian linens and the "glory boxes" for storing the *corredo*.[52] Thus immigrants became the consumers of their own now commodified traditions.

The intergenerational transmission of skills, which had been relatively uncomplicated in Italy, was affected by new influences and obstacles in countries where Italians migrated. Constance Sullivan-Blum found that in Corning, New York, old patterns were rechristened with American names (e.g., "wild strawberries" became "pineapples"); Irish lace techniques learned from neighbors were incorporated into Italian crochet; colored thread was increasingly used over the white or beige work favored in Italy; and the thicker American thread changed the look and feel of the finished product. As new economic and social opportunities became available, the daughters of immigrants refused to learn or practice the old skills: "They saw lace as an inconvenience that added work rather than an art that increased beauty of the home. They also rejected socializing in women-only crochet circles and acquired the social interests of other American youth."[53] In Australia, a shift in perspective occurred after World War II as immigrant parents rechanneled expenditures on the increasingly elaborate wedding celebration and/ or the purchase of property for the newlyweds, instead of investing in large quantities of expensive linens. These new ritualized experiences became the "modern" public markers of a young woman's worth and her family's standing among peers.[54]

Over time, *biancheria* acquired multilayered cultural meanings—literal and symbolic—that transcended its original use as dowry wealth and

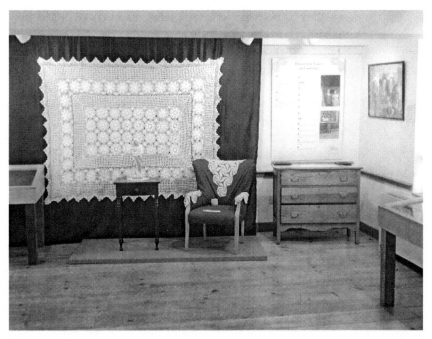

A display from the exhibition "Lace, the Spaces Between," at the Benjamin Patterson Inn Museum. Corning, New York, August 2008. (Photograph by Joseph Sciorra.)

utilitarian objects. As earlier practices faded over the course of the twentieth century, these heirlooms and the associated memories became fertile sources for renewed cultural and artistic production. The growing interest in needlework led to exhibits in Australia and the United States. In 2001, for example, "Stitches—*fare il punto*" brought together the works of eight artists—both traditionally and studio trained—to the Australian National Maritime Museum in Darling Harbour. As cocurator Ilaria Vanni (a contributor to this collection) observes, the displayed work "unravels the ways in which 'back there,' woven into our everyday lives, enriches, or curses, our present."[55] Another exhibit, "Lace, the Spaces Between" (2008), at the Benjamin Patterson Inn Museum in Corning, New York, focused on crochet—"the lace of the poor"—and community life to show, as its curator Constance Sullivan-Blum explains, how "handmade domestic lace can be seen as a metaphor for the Italian American experience in Corning [. . .] representing the social dynamics of the immigrant experience as people struggle with preserving their cultural identity while adopting new practices both by choice and by coercion in their new homes."[56]

Writers, painters, and sculptors began to use needlework—the techniques, the tools, and the embroideries themselves, as well as the related

social activities and relations that were the earlier contexts of production and use—as the subject matter for their creative work, recognizing and developing the function of *biancheria* as material embodiment of the culture of Italian communities abroad.[57] The 2002 Calandra Institute's "*Biancheria*" symposium brought together for the first time writers, artists, scholars, and the general public to discuss the lasting and multifaceted legacy of immigrant needlework in an Italian American context.

Approach and Structure

This is a book of stories about needlework. They are stories of seamstresses and factory workers, first-generation immigrants and the mothers and grandmothers they left behind in Italy, as well as the daughters and grand-daughters upon whom the task of remembering has fallen. They are private stories born out of the confluence of Italy and the diaspora, departing and arriving, remembering and forgetting, losing and recovering. And at the center of it all, there are always one or more objects, the humble and glorious fruits of needlework, and stories of a woman or a group of women at work.

The transformation of needlework into poetic and critical subject through memory work underscores our project and ties together the approaches and stories of scholars, writers, and visual artists. The methodologies of our respective disciplines—literature for Giunta and folklore and folklife for Sciorra—have coalesced here into an interdisciplinary editorial approach that has informed our choice of contributions as well as the overall contents, structure, and vision of this book. In choosing the contributions and organizing the book's structure, we have taken into account key issues that affect the representation of domestic needlework in the Italian diaspora: the gender and class elements that permeate the history of needlework and its relationship to cultural identity, specifically as it is shaped by migration; the place of needlework in the quotidian lives of women and their families and communities; the changing nature of the aesthetics and market value of needlework as a result of immigration; needlework in domestic and industrial settings and its role in the creation of an Italian female proletariat; the detailed attention to the actual object and its indigenous exegesis; needlework's symbolic power in the culture of the descendants of immigrants; the uses and transformation of material culture by writers and artists of working-class and immigrant backgrounds; the connection between the emergence and recognition of literary and artistic movements and the use of needlework as subject matter in creative works; and the disruption of

traditional practices, views, and interpretations of *biancheria* through creative representation of needlework.

We have organized the book into five sections: (1) Threads of Women; (2) Skills and Artistry; (3) Factory Girls; (4) Environmental Sites; (5) Lost, Discarded, Reclaimed. Each section juxtaposes scholarly essays and works of memoir and poetry, thus creating a conversation across genres. Visual works serve as links between and counterpoints to the sections: Each artist provides a reflection that is in dialogue with the work of art. Theme rather than genre is the organizing principle, although themes from one section inevitably spill over and reverberate into others, illustrating how needlework saturates Italian immigrant memory.

Many of the artists, writers, and scholars in this collection play with the delicate balance between intimate and public that underscores Italian diasporic needlework. They recount personal and family stories of needlework rooted in the experience of immigration, like the evocations of grandmothers by Elisa D'Arrigo, Louise DeSalvo, Maria Mazziotti Gillan, and Denise Calvetti Michaels, among others, or the choral female memory in Joanna Clapps Herman's piece. The legacy of needlework may surface through its remembered objects, like Giuliana Mammucari's bedspread, Anne Marie Macari's lost needle, Maria Terrone's tatted handkerchief, Lia Ottaviano's quilts, and Joseph Inguanti's Sicilian pillow sham. That legacy may also emerge in the distilled memories of figures like Gianna Patriarca's dressmaker and Sandra M. Gilbert's lace maker, who inhabit hidden, intimate spaces.

Other contributors push needlework, with its makers and objects, beyond these private realms. They do so through a global, international, and feminist awareness of the significance and implications of needle arts, like Karen Guancione's displays of Mexican *rebozos* and Tiziana Rinaldi Castro's linking of southern Italian, African, and Native American culture in a spirituality of thread work.[58] Paola Corso turns to the Triangle Shirtwaist Factory fire of 1911 that caused the deaths of 146 workers, mostly Italian and Jewish immigrant women and girls.[59] Corso's "girl talk" becomes the vehicle for transnational feminism, which also informs Phyllis Capello's poem about the 1993 Kader Industrial toy-factory fire in Bangkok that occurred in circumstances analogous to those of the Triangle fire. In a similar vein, Lisa Venditelli's installation, Backbone/*Colonna Vertebrale*, uses sewing thread spools to create a compelling visualization of the spine of immigrant women workers in textile mills.

Each of the texts included here fulfills multiple functions. Sometimes a poem will shed light on historical and social issues, as is the case in Rosette Capotorto's "*No 'So,*" in which the speaker writes of her mother's renunciation

of sewing as "a small act of rebellion": This woman, like so many daughters of Italian immigrants, "*learned* not to sew" in order to reject traditional, homebound Italian femininity. Critical essays may take on lyrical overtones and lean toward the genre of memoir, especially when a scholar examines the needlework produced by a family member or linked to her community of origins, as is evident in the essay by Christine Zinni, who writes of the women's needlework community in Batavia, New York. The fact that needlework provides a tangible record of the past—a piece of cloth inscribed with the presence of the needleworker—makes memoir an especially well-suited genre for both its representation and discussion. The practices associated with *corredo*—which are rooted in social and economic history, aesthetics, and family memory—are the subject of critical and poetic explorations, from the memoiristic narratives of Giovanna Miceli Jeffries and Annie Lanzillotto to the scholarly essays of Hwei-Fen Cheah and Joseph Inguanti to the contribution of folk artist Maria Grillo.

The first section, "Threads of Women," focuses on the intergenerational connections and disconnections at the heart of needlework. Mothers, aunts, grandmothers, great-grandmothers, even a mother-in-law, populate the pieces in this section. At times these women are depicted with ethnographic precision. At others, they are described as ghostly figures, conjured by the desire and necessity to reclaim and name a female past that has not made the historical record. The contributors document a rapidly changing and all-too-often lost world, with both its artistry and its drudgery. These writings and images counteract the rupture in the transmission of the skills of needlework that occurred as a result of "modernization" and "Americanization."

The section that follows, "Skills and Artistry," focuses on the creative component of *biancheria* through recovery and reexamination. Contributors write of the artistry inherent to the skills of needlework, whether produced by family members (B. Amore) or represented in Italian American literature (Mary Jo Bona). This section focuses on the tension between the needlework and indigenous ideas of beauty (Vanni and Herman). Authors pay attention to the technique, the gesture, the stitch, and the feel of cloth (Peter Covino and Barbara Crooker), rendering the richly layered quality and possibilities of needlework.

"Factory Girls" turns to the industrialized setting, which, as we noted earlier, is not per se a focus of this book. Women immigrants, however, carried the artistry of domestic needlework and the possibility of income that came along with it into the countries where they emigrated at a point of rampant industrialization, whether in early twentieth-century United States or post–World War II Argentina, as discussed by Jennifer Guglielmo and Bettina Favero, respectively. Frequently, their immigrant homes became extensions

of the factory, with the resulting blurring of the boundaries between private, domestic needlework and the national/international market of fashion. In addition, the histories and stories connected to the garment factory (for example, the Triangle Shirtwaist Factory) have long occupied an important place in the Italian American imaginary and may have contributed to, even as they sometimes overshadowed, the recent interest in domestic needlework.

"Environmental Sites" includes contributions that revolve around the notion of place. From the horticulture of the imagination (Inguanti) to site-specific installations in open, public spaces (Guancione) to urban and rural locales (Terrone), the geographies in this section position needlework as vital to the conceptualization of an Italian diasporic ethos of place, imagined or remembered. The nostalgically recollected Italian topography inscribed into immigrant and ethnic spaces—whether rural or urban—is a key element in the Italian diasporic imaginary, as evident both in needle art and in its creative reworking.

The last section, "Lost, Discarded, Reclaimed," centers around the memory work that needlework prompts and sometimes even demands. The displacement of objects (Jo Ann Cavallo and Angela Valeria) and the original context of their creation (Gillan) and use as well as their provocative transformation (Lanzillotto and Covino) are represented by the contributors to this section as immigrant loss but also hybrid reinvention (Saverino and Zarzyski). Contributors return again and again, with the obsession and devotion of an archeologist or a collector, to the embroidered object, to the needlework artist, to encounters and memories, and shape them into stories, poems, and visual art work in which the transmuted objects become manifest again.

In her evocative afterword, historian Donna Gabaccia reflects on the history and significance of needlework through the lens of personal narrative. It is appropriate that a memoiristic approach to scholarly analysis also shapes Gabaccia's contribution, for the form of the contemporary memoir, with its distinctive combination of narrative and reflection, suits well work like ours, a work of both devoted recovery and critical understanding.

Conclusion

Enough to last a lifetime: This was the promise inherent to the dowry a mother would give her daughter. This promise, made in towns and villages where families had lived for generations, was inevitably disrupted by the global migration (26 million people from 1870 to 1970) that threw those lives into confusion. The passing on of the objects themselves and the skills

of needlework took different routes. The journey was sometimes abruptly halted, and at other times radically changed, even as it was later resumed.

Sturdy and delicate, resilient and perishable, tedious and sublime, needlework takes on a new life in the words and images of *Embroidered Stories*. For the book's authors and artists, the ancestors engaged at their needlework become, through the discipline of their effort, as well as through their ingenuity and their creativity, an artistic ancestry to be acknowledged and remembered.

And yet, the work of the authors gathered here stands not merely as a tribute or testimonial to a world that no longer exists. This work also testifies to the vitality and resonance of the culture created by the women of the Italian diaspora. It also shows how women's labor and art serve as the inspiration for a new body of critical and creative work. It is the power of this legacy that engenders these embroidered stories.

Notes

Epigraph. Severina Magni (1897–1954) emigrated from Lucca to work as a textile worker in a banner and flag factory in Pittsburgh. This excerpted poem, which is the only known creative piece on needlework we found in Italian by an Italian American, was originally published in her *Luci Lontane* (Milan: Editoriale Moderna, 1936). See editor Francesco Durante's *Italoamericana: Storia e letteratura degli Italiani negli Stati Uniti 1880–1943* (Milan: Mondadori, 2005), 299–302. We thank Robert Viscusi, editor of the forthcoming English version of the book (Fordham University Press), for allowing us to use Maria Enrico's English translation. For more information on Magni, see editor Helen Barolini, *The Dream Book: An Anthology of Writings by Italian American Women* (New York: Schocken Books, 1985), 299–300.

1. "Lace, the Spaces Between: Domestic Lace Making and the Social Fabric of the Italian American Community in Corning" exhibition, Benjamin Patterson Inn Museum Complex, Corning-Painted Post Historical Society, February 22–December 20, 2008. See also Joey Skee (aka Joseph Sciorra), "Lace in Crystal City," blog post, accessed January 24, 2012, www.i-italy.org/bloggers/4034/lace-crystal-city.

2. Unlike the culinary and musical references, which have become favorite journalistic and cinematic tropes, needlework has not entered the media sphere.

3. Needlework figures prominently in the cultural production and memory of many migrant groups, from Puerto Rican seamstresses to Ukrainian weavers in New York City. It is not, however, the scope of this book to pursue a comparative analysis.

4. Helen Barolini's interview with Kay Bonetti. Audiocassette. American Audio Prose Library. 1982.

5. Helen Barolini, *Umbertina* (New York: Feminist Press/CUNY, 1996), 44.

6. Barolini, *Umbertina*, 407.

7. For a detailed discussion of the role of the bedspread in *Umbertina*, see Edvige Giunta, "Afterword," in Barolini, *Umbertina*, 433–42.

8. See B. Amore, *An Italian American Odyssey: Life line—filo della vita* (New York: Center for Migration Studies, 2006).

9. This book does not examine the rich history of Italian men in the garment industry, a topic that has inspired writers like Gay Talese (in *Unto the Sons*, 2006) and artists like Angelo Filomeno and is the subject of a documentary titled *Men of the Cloth* (2013) by Vicki Vasilopoulos on Italian and Italian American tailors (menoftheclothfilm.com/blog/).

10. Although we have not included works of fiction, other Italian American authors in addition to Barolini have incorporated needlework in their fictional narratives, for example, Adria Bernardi's *Openwork* (Dallas: Southern Methodist University Press, 2007), which Mary Jo Bona discusses.

11. Mark I. Choate, *Emigrant Nation: The Making of Italy Abroad* (Cambridge, MA: Harvard University Press, 2008); Donna R. Gabaccia, *Italy's Many Diasporas* (Seattle: University of Washington Press, 2000); Donna Gabaccia and Franca Iacovetta, eds., *Women, Gender, and Transnational Lives: Italian Workers of the World* (Toronto: University of Toronto Press, 2002); Donna Gabaccia and Fraser Ottanelli, eds., *Italian Workers of the World: Labor Migration and the Formation of Multiethnic States* (Champaign: University of Illinois Press, 2005); Jennifer Guglielmo, *Living the Revolution: Italian Women's Resistance and Radicalism in New York City, 1880–1945* (Chapel Hill: University of North Carolina Press, 2010), and Laura E. Ruberto, *Gramsci, Migration, and the Representation of Women's Work in Italy and the U.S.* (Lanham, MD: Lexington Books, 2007). In spite of a vigorous search for contributions from other countries with significant Italian populations such as Belgium, Brazil, and Germany, we were not successful in eliciting contributions.

12. On patterns and technique in Italy, see Vima deMarchi Micheli, *Pani & Fili: Bread and Threads of Italy* (n.p.: privately printed, 1996); Elisa Ricci, *Old Italian Lace* (Philadelphia: J. B. Lippincott Co., 1913); Elisa Ricci, "Women's Crafts" (17–32), in *Peasant Art in Italy*, ed. Charles Holme (New York: The Studio Ltd., 1913); and Jeanine Robertson's blog "Italian Needlework," italian-needlework.blogspot.com.

13. Donald S. Pitkin, "Marital Property Considerations Among Peasants: An Italian Example," *Anthropological Quarterly* 33, no. 11 (January 1960): 33–39.

14. Jane Schneider, "Trousseau as Treasure: Some Contradictions of Late Nineteenth-Century Change in Sicily," in *Beyond the Myths of Culture: Essays in Cultural Materialism*, ed. Eric B. Ross (New York: Academic Press, 1980), 324. We have relied extensively on Schneider's important study because of its rigor, precision, and thoroughness.

15. Schneider, "Trousseau as Treasure," 332–34.

16. Schneider, "Trousseau as Treasure," 325. The desired designs were not self-created but gleaned and copied from standardized pattern books, samples, and the finished work kept by Catholic nuns (Schneider, "Trousseau as Treasure," 341–42; Ricci, "Women's Crafts," 25; and Charlotte Gower Chapman, *Milocca: A Sicilian Village* [Cambridge, MA: Schenkman Publishing Co., 1971], 44).

17. Pitkin, "Marital Property Considerations Among Peasants," 36; Sydel Silverman, *Three Bells of Civilization: The Life of an Italian Hill Town* (New York: Columbia University Press, 1975), 195.

18. Schneider, "Trousseau as Treasure," 339.

19. Schneider, "Trousseau as Treasure," 338; Chapman, *Milocca,* 32.

20. Anna L. Chairetakis, "Tears of Blood: The Calabrian *Villanella* and Immigrant Epiphanies," in *Studies on Italian American Folklore,* ed. Luisa Del Giudice (Logan: Utah State University Press, 1993), 35.

21. "Carrittera (Carter's Song)" sung by Domenico Lanza, *The Italian Treasury: Sicily* (Rounder, #1808, 2000). See also Ricci's "Women's Crafts" (24) for references to embroidered sayings of affection.

22. Schneider, "Trousseau as Treasure," 325; Pitkin, "Marital Property Considerations Among Peasants," 36.

23. Schneider, "Trousseau as Treasure," 340.

24. Schneider, "Trousseau as Treasure," 343.

25. Linda Reeder, *Widows in White: Migration and the Transformation of Rural Italian Women, Sicily, 1880–1920* (Toronto: University of Toronto Press, 2003), 97.

26. Maria Messina, *Behind Closed Doors: Her Father's House and Other Stories of Sicily,* trans. Elise Magistro (New York: Feminist Press at the City University of New York, 2007), 82. "Gna" is the Sicilian abbreviation of "signura," a female appellation. We are indebted to Laura Ruberto for pointing out the opening scene of Vittorio De Sica's *The Bicycle Thief* (*Ladri di biciclette*, 1948) as a counterpoint to Messina's story. In this neorealist classic the husband feels emasculated by the pawning of the linen. Far from being ashamed, the wife comes up with the idea of resorting to her dowry for financial rescue.

27. Schneider, "Trousseau as Treasure," 327.

28. Salvatore Salamone-Marino, *Customs and Habits of the Sicilian Peasants,* ed. and trans. Rosalie N. Norris (Rutherford, NJ: Fairleigh Dickinson University Press, 1968), 186–91; William Foote Whyte, "Sicilian Peasant Society," *American Anthropologist* 46, no. 1 (1944): 65–74; Chapman, *Milocca,* 103–4; Pitkin, "Marital Property Considerations Among Peasants," 36.

29. Whyte, "Sicilian Peasant Society," 71.

30. Ricci, "Women's Crafts," 24–25.

31. Ricci, "Women's Crafts," 25.

32. Schneider, "Trousseau as Treasure," 338; Chapman, *Milocca,* 42.

33. See Chapman's photograph of a 1928 outdoor feast-day altar from the Sicilian town Milocca, featured in the unpaginated opening section of her book.

34. Michelangelo Sabatino, *Pride in Modesty: Modernist Architecture and the Vernacular Tradition in Italy* (Toronto: University of Toronto Press, 2010), 77.

35. Ricci, "Women's Crafts," 18; George E. Pozzetta, "Immigrants and Craft Arts: Scuola d'Industrie Italiane," in *The Italian Immigrant Woman in North America,* ed. Betty Boyd Caroli, Robert F. Harney, and Lydio F. Tomasi (Toronto: Multicultural History Society of Ontario, 1978), 138–53; Ivana Palomba, *L'arte ricamata. Uno strumento di emancipazione femminile nell'opera di Carolina Amari* (Maniago, Italy: Associazione Le Arti Tessili, 2011).

36. Leonide Frieri Ruberto, *Such Is Life / Ma la vita è fatta così,* trans. Laura E. Ruberto, intro. Ilaria Serra (New York: Bordighera Press, 2011), 6.

37. Victoria De Grazia, *How Fascism Ruled Women, Italy, 1922–1945* (Berkeley: University of California Press, 1992), 151–54.

38. Eugenia Paulicelli, *Fashion under Fascism: Beyond the Black Shirt* (New York: Berg, 2004), 21–24. See also William E. Simeone, "Fascists and Folklorists in Italy," *Journal of American Folklore* 91, no. 359 (January/March 1978): 543–57.

39. Schneider, "Trousseau as Treasure," 352; Nicola White, *Reconstructing Italian Fashion: America and the Development of the Italian Fashion Industry* (New York: Berg, 2000), 36, 38–40; Silverman, *Three Bells of Civilization*, 199.

40. V. A. Goddard, *Gender, Family and Work in Naples* (New York: Berg, 1996), 146.

41. Maria Tence and Elizabeth Triarico, "La Dote: Preparing for a Family," in *The Australian Family*, ed. Anna Epstein (Carlton North Vic, Australia: Scribe Publications, 1998), 76.

42. Guglielmo, *Living the Revolution*, 52, 69.

43. Tence and Triarico, "La Dote," 78.

44. Salvatore J. LaGumina, "Elvira Adorno," in *The Immigrants Speak: Italian Americans Tell Their Story* (New York: Center for Migration Studies, 1981), 189–98.

45. Women's needlework skills all too often saved families from the poorhouse. For example, see Dorothy Noyes, "Women's Networks and Ritual Trades: Yola Savastano's Beadwork," in *Uses of Tradition: Arts of Italian Americans in Philadelphia* (Philadelphia: Philadelphia Folklore Project, 1989), 40–43.

46. George E. Pozzetta, "Immigrants and Craft Arts: Scuola d'Industrie Italiane," in *The Italian Immigrant Woman in North America*, ed. Betty Boyd Caroli, Robert F. Harney, and Lydio F. Tomasi (Toronto: Multicultural History Society of Ontario, 1978), 150. See also Ivana Palomba, *L'arte ricamata: Uno strumento di emancipazione femminile nell'opera di Carolina Amari* (Maniago, Italy: Le Art Tessili, 2011). During this time period, a few Italian immigrant women succeeded in moving beyond the industrial sweatshop as did the sisters Anna and Laura Tirocchi, who established A&L Tirocchi Gowns (1915–1947) in Providence, Rhode Island, to offer handcrafted gowns based on Parisian couture to New England's elite women, employing a small coterie of Italian American seamstresses. See the exhibition catalogue *From Paris to Providence: Fashion, Art, and the Tirocchi Dressmakers' Shop, 1915–1947*, ed. Susan Hay (Providence: Museum of Art, Rhode Island School of Design, 2000). See also Adriana Trigiani's *Don't Sing at the Table: Life Lessons from My Grandmothers* (New York: HarperCollins, 2010), a memoir about her grandmother, Yolanda Perin Trigiani, co-owner of a blouse factory in Martins Creek, Pennsylvania.

47. "Home Sewn: Three Centuries of Stitching History," the New-York Historical Society (November 18, 2003–April 18, 2004). Thanks to Luis Rodriguez at the Society for locating details about this exhibited piece.

48. Carla Bianco, *The Two Rosetos* (Bloomington: Indiana University Press, 1974), 115.

49. Donna R. Gabaccia, *From Sicily to Elizabeth Street: Housing and Social Change among Italian Immigrants, 1880–1930* (Albany: State University of New York Press, 1984), 82.

50. "East Side Honors Saint of Healing," *New York Times*, July 15, 1935, 19. A significant yet underexplored religious needlework craft is that of religious banners created for immigrant mutual aid and lay religious volunteer associations. See *Sacred Emblems, Community Signs: Historic Flags and Religious Banners from Italian Williamsburg, Brooklyn* (exhibition catalogue), ed. Joseph Sciorra (New York: Casa Italiana Zerilli-Marimò, New York University, 2003).

51. Sciorra acquired this framed piece on eBay.com; a business sticker on the back locates the framer's shop in West Hempstead, New York. No additional information is available.

52. Tence and Triarico, "La Dote," 80–81; Susanna Iuliano, *Vite Italiane: Italian Lives in Western Australia* (Perth: University of Western Australia Press, 2010), n.p.

53. "Lace, the Spaces Between," 2008. We thank curator Sullivan-Blum for sharing the exhibition script with us. For a discussion of this shift in New York City, see Miriam Cohen, *Workshop to Office: Two Generations of Italian Women in New York City, 1900–1950* (Ithaca, NY: Cornell University Press, 1993).

54. Tence and Triarico, "La Dote," 81; Iuliano, *Vite Italiane*, n.p.

55. *Stitches—fare il punto* (exhibition catalogue) (Darling Harbour: Australian National Maritime Museum, 2001), 6.

56. "Lace, the Spaces Between," 2008. See also Skee (aka Sciorra), "Lace in the Crystal City."

57. Italian performance artists Pippa Bacca (aka Giuseppina Pasqualino di Marineo) and Silvia Moro undertook their 2008 "Brides on Tour" piece through Eastern Europe and the Middle East dressed in wedding gowns that would be embroidered along the way by local women they met until Bacca's murder in Istanbul abruptly ended the "peace project." See Elisabetta Povoledo, "Performance Artist Killed on Peace Trip Is Mourned," April 19, 2008, accessed August 13, 2012, www.nytimes.com/2008/04/19/theater/19peac. html?pagewanted=all; Joey Skee (aka Joseph Sciorra), "Pippa Bacca, performance artist, is murdered during 'Brides on Tour,'" April 18, 2008, blog post, accessed August 13, 2012, www.i-italy.org/bloggers/1682/pippa-bacca-performance-artist-murdered-during-brides-tour; "Pippa Baca," accessed August 13, 2012, www.pippabacca.it/.

58. Their work as well as this anthology is in keeping with a body of scholarship reexamining women's needlework from various disciplines, including but not limited to Rozsika Parker's *The Subversive Stitch: Embroidery and the Making of the Feminine* (London: BPC Books, 1996); Judy Chicago's *Embroidering Our Heritage: The Dinner Party Needlework* (Garden City, NY: Anchor Books, 1980); editors Annette B. Weiner and Jane Schneider's *Cloth and Human Experience* (Washington, DC: Smithsonian Institution Press, 1989); and Suzanne P. MacAulay's *Stitching Rites: Colcha Embroidery Along the Northern Rio Grande* (Tucson: University of Arizona Press, 2000).

59. On the 1911 fire, see David Von Drehle, *Triangle: The Fire That Changed America* (New York: Grove Press, 2004), and Leon Stein, *Triangle Fire* (Ithaca, NY: Cornell University Press, 2001).

Daguerreotype: Lace Maker

—Sandra M. Gilbert

From days spent bending over the pattern,
eyes and fingers caught in the tightening
mazes of the lace,
she has assumed the shape
of a hook, its deft ferocity,
thin glitter and abstraction.

She stares into the camera, very old,
no children now, no stewpots, never a berrying
afternoon with sun like pure hot iron
at her back, nothing but a shawl
on her shoulders now, black and thick:
and her eyes, passionate hooks,

say *only the lace, the lace is left*,
only the white paths, the stitches like steps
in a dance whose meaning is still unknown,
the walls of thread impossible to cross,
the tiny corners, the fields of webs and flowers,
the serious knotting and unknotting at the end.

THREADS
OF WOMEN

Donna Laura

—Maria Mazziotti Gillan

Donna Laura, they called my grandmother
when they saw her sitting in the doorway, sewing
delicate tablecloths and linens, hours of sewing
bent over the cloth, an occupation for a lady,

Donna Laura, with her big house falling
to ruins around her head,
Donna Laura, whose husband
left for Argentina when she was twenty-four,
left her with seven children and no money
and her life in that southern Italian village
where the old ladies watched her
from their windows. She could not have
taken a breath without everyone knowing.

Donna Laura who each day sucked
on the bitter seed
of her husband's failure
to send money and to remember
her long auburn hair,

Donna Laura who relied on the kindness
of the priest's "housekeeper"
to provide food for her family.
Everyone in the village knew

my grandmother's fine needlework
could not support seven children,
but everyone pretended not to see.

When she was ninety, Donna Laura
still lived in that mountain house.

Was her heart a bitter raisin,
her anger so deep it could have cut
a road through the mountain?
I touch the tablecloth she made,

the delicate scrollwork,
try to reach back to Donna Laura,
feel her life shaping itself into laced patterns
and scalloped edges from all those years between
her young womanhood and old age.

Only this cloth remains,
old and perfect still, turning her bitterness into art
to teach her granddaughters and great-granddaughters
how to spin sorrow into gold.

White on Black

—Louise DeSalvo

I was thirty-seven years old when I gave up knitting for a very long time. I had been knitting off and on for thirty years, since I was seven and learned how to knit from my grandmother. By the time I was thirty-seven, aside from my childhood projects of irregular scarves and unwearable mittens, I had knit a pair of argyle socks for my husband, too itchy to wear; a really ugly and poorly assembled maroon sweater for him too; a rose sweater for myself, but because I had forgotten to check the dye lot of the wool I'd bought, the front and the back were different shades; and about twenty items for my babies, all yellow and green and adorable and knitted before they were born.

But at thirty-seven, I gave up knitting for a very long time, because I thought I had better things to do, like write poems about knitting, like this one, called "Casting Off," which I wrote because I had stopped knitting, but also because thirty-seven was the unraveling time for me.

Yes, thirty-seven is the unraveling time, when sweaters carefully knit while children played must be undone, when what was made before must be unmade, because the wool is needed for another use, and because, what one knows at thirty-seven is that the making of those sweaters was unnecessary, or, if not unnecessary, then an occupation undertaken to prevent the hand from slapping, or to hold the anger in, or to turn the anger into sweaters or mufflers to help keep out the cold, to convince them that they were cared for, that the garment that caressed them came from hands that cared, and so, in caring, knit them mufflers that, pulled a bit too tight reminded them that the hands that knit, knit so as not to strangle.

Yes, thirty-seven is the unraveling time, the time to knit no more, the time to be perhaps indelicate, to be indecent, even, the time to be pariah, vamp, and whore, the time to throw away the knitting needles or to use the knitting needle to pry the unwanted fetus from the womb or to poke out an eye that has raised its eyebrow once too often, mockingly. Thirty-seven is the unraveling time, the time when variegated skeins are loosened, when the cords, tied end to end, are cast off.

Most days, as I was growing into womanhood, my old Italian grandmother used to sit, silently, all day long, very close to the radiator in a corner of the dining room of our house in Ridgefield, New Jersey, her old black shawl covering her shoulders, as she crocheted white tablecloths, or knitted sweaters or afghans from the wool that she had unraveled from the old sweaters we had outgrown, outworn, or despised. During the winter, the radiator hissed and clanked, creating more noise than heat. But sitting close to the radiator in the corner of the dining room meant that my grandmother never sat in the light and that my grandmother could barely see the work that she was doing, for that corner of the dining room was forever in shadow, and the economies of our household forbade the use of artificial light during the day. I knew that my grandmother was there, always there, for she had nowhere else to go, nothing else to do, but crochet and knit, for here in Ridgefield, she had no friends, no acquaintances, even—so far was she from Hoboken, where she had lived for so many years, so far from a meaningful life, earning her own living as the superintendent of the tenement where we all lived, complaining with her cronies on the stoop of our building. Still, as I went about my childish life, I often forgot that she was there, in the corner near the radiator, always there.

Her old Italian grandmother used to sit very close to the radiator to keep herself warm, she used to say, all through the long northern winters, the heat of the southern Italian sun having long since abandoned her.

Her old Italian grandmother used to sit in her straight backed chair, all in black, mourning her husband of ten years, as she crocheted the white lace tablecloths that she would give the girl, her granddaughter, when she became a bride, as she reused old wool for sweaters that no one in this house wanted, sweaters that no one would wear.

It was more than seven years since her husband had died, seven years since they had taken her to this place where she didn't want to be, and she wore black still, although the girl could remember the two of them, husband and wife, grandfather and grandmother, scowling at one another across the kitchen table, him swearing in the harsh accents of the village in Puglia where they had both come from. As the girl's mother had said so many, many times, there was no love lost between them.

She was his second wife. His first had been much more beautiful. And there are two photographs, now crumbling, of him as bridegroom, twice decked out in the black suit that he would be buried in, twice newly shod, twice with boutonniere (the first, a single rose; the second, a sprig of lily of the valley), twice holding the pose for the photographer begrudgingly, he, so unused to finery, who had laid the rails of the Delaware, Lackawanna, and Western Railroad

single-handedly if one were to believe his stories, who had been brought here all the way from Italy to do that, bringing with him his first wife, his girlish wife, who took in washing during pregnancy, who died, from influenza, like so many others, when their baby was but three months old.

Soon after, he worked out an arrangement with a woman from his village, looking for a situation. He needed her to care for his child; she needed him so that she could come to America. And on the boat, on the way over, she knit him a sweater from finely spun wool that she had secured by bartering a linen tablecloth her mother had embroidered for her trousseau, for she was inclined neither to finery nor extravagance, though her mother believed that this cloth, adorning her daughter's table on Sundays and feast days, would prove that she came from a respectable family. The local Italian priest had written her for him to say that it was sometimes very cold in this new land, even cold indoors, because they had only a coal stove in the kitchen to heat their living quarters, and it was inadequate to the task, and that it was colder, even, where he worked, outdoors on the railroad, for many months of the year, up north near a big lake, far bigger than the one near their small village, and that it was colder than she could ever imagine, and so she knit this sweater to please him, to show concern for him, although she did not yet know that she would not ever please him, that since his first wife had died, no one could please him but his tiny undernourished daughter that he needed this woman to attend. And she knit herself a shawl too, on the voyage over, for she was quick with her needles, and the wool was thick, and the work went fast, for she had nothing else to do, and she was unused to inactivity. The shawl was black, for though she would wear white for their wedding, he was in mourning, so black was what she used for her work, and black was what she would wear for some time to come, perhaps forever, though she had heard it said that the women in this new land, even older women, even women from the old country, sometimes wore colorful garments of reds or blues or greens, and there was something within her that would have liked to wear those colors too although she would not dare to wear them. Yes, the black shawl was something that she would wear around her shoulders to keep herself warm in this strange new place with this strange climate and she was happy at her knitting, and it satisfied her to knit this shawl that she knew she would make good use of. But she had decided that, no, she would not knit the child a thing, not now, perhaps not ever, because, although she would care for her, the child was his, not hers, not theirs, the child was not her blood.

Why my grandmother sat close to the radiator during the winter, I could well understand, for, though it threw off very little heat, this place was one of the warmest parts of our old, poorly heated, drafty house. Her body, born to

southern Italian sunshine, never got used to the cold, though she lived here longer than she lived there.

By the end of November each year, she would be wearing her long underwear, two or three dresses (one atop the other), two or three hand-knit wool sweaters (one atop the other) knit from fanciful lace patterns, out of keeping with her otherwise austere appearance, and her old black shawl. Everything except her long underwear—dresses, sweaters, shawl—was black, everything was frayed and worn, everything was poorly mended, for she was no seamstress like her mother; like my mother, she had no patience for the needle.

Often, my father would yell to my mother, so loud that my grandmother could hear him, and in Italian, so that she could understand him, although he rarely communicated with her directly, for he resented her presence in his household, hated her intrusion into their lives, though, what could he do, she had nowhere else to go: "Tell her to buy some new clothes, some warm clothes, goddamn it. Tell her that she's a disgrace. Tell her that people will think that we aren't taking care of her. Tell her to take a bath. Tell her that she stinks." My grandmother would manipulate another very complicated stitch on the white tablecloth that rested on her lap, or she would tug at another seam in the sweater that she was unraveling, and she would ignore his yelling, ignore what he was saying, and defeat him, as always, and for this, if for nothing else, I loved her, for to us both, he was the enemy, and I could not count the times that she had thrown her needlework to the ground, stitches slipping off needles, ball of wool or cotton unwinding across the floor, to put her body between his and mine, I could not count the times that she had taken the blow that was meant for me.

So, my grandmother would continue to buy nothing new, nothing American, nothing warm enough for winter, even though wearing more than one dress and all those sweaters and her black shawl and no coat on frigid winter mornings when she went to mass, marked her as a peasant, disgraced my parents, and embarrassed me—embarrassed me so much that I betrayed her, by laughing with my friends rather than silencing them when they called her *the old witch*, when they called her *the garlic eater* and held their noses and said *Puew, puew*, when they said she ate babies for breakfast.

On the rare occasions my mother would come home with a new dress—black, surely, but with a pattern of delicate little white flowers, or a store-bought sweater (solid black, of course), or an overcoat (black, again)—my grandmother, knowing that it was better to yield than to resist, and knowing that yielding was the best and most potent form of resistance, would take the item, thank my mother, hold the garment out in front of her at arms' length, and put it in her bureau drawer or closet, where it stayed, unused, until she died.

34

Why my grandmother sat inside the house close to the radiator in the summer, I could never really understand. Yes, the radiator felt cool to the touch, but that corner of the dining room was stifling. There was the front porch, with its breezes, or the back porch, with its shade, but my grandmother didn't ever sit outside except perhaps in evening, after supper, as the sun went down.

The radiator, I came to believe, must have grown to be something like my grandmother's companion. It, and her needlework, and the dim replicas of the food that she cooked that she had loved in the old country, became her only comforts. The radiator didn't yell at her, the way my parents did, nor mock her, as others outside the household did. The radiator didn't tell her what to do; it didn't tell her to be what she couldn't be: an American. It didn't condemn her for what she couldn't not be: a southern Italian peasant. The radiator didn't betray her the way I did. In summer, when it was chilly to the touch, it must have radiated the idea of coolness from its ugly gray mass so that, for a woman used to having so little, it might have seemed little enough. There, ignored and despised, she could carry on with the work that was the one thing, the only thing that sustained her, that and a love for me that defied explanation, for she detested my mother, and I did nothing to deserve her love, nothing to invite it, except, perhaps, bringing her a cool glass of water now and then so that she would not have to interrupt her work, and, once, sitting on the floor next to her for a few mornings so that she could teach me how to knit.

And so she sat, through the years in that darkened room, on the straight backed chair, close to the radiator, crocheting the tablecloths meant to grace our tables on important occasions, though she herself would not sit at those tables, but take her meager fare in the kitchen all by herself. Or knitting the sweaters that we never wore, knitting the afghans that, when finished, we would throw into the bottoms of our closets, so hideously garish and ugly in their colorations were they that no one with any self-respect—this is my mother talking—would ever use them, much less display them. There she would sit, this woman at her needlework, through the late 1940s, the '50s, the '60s, into the early '70s, until the year 1974, when she was taken to the nursing home run by the state.

There she died, in a nursing home that didn't cook pasta or anything Italian, which accounted, my mother believed, for the fact that my grandmother lost so much weight. And it didn't permit knitting needles, or crochet hooks, or wool, either, for fear that the patients might use the needles as weapons or the wool as a way to strangle themselves, a nursing home where the only outlet for a patient's creativity was cutting and pasting, on Fridays, but always under strict supervision, an activity geared to the

seasons—snowflakes in winter, flowers in spring and summer, and autumn leaves in the autumn that she died.

My grandmother—the Vermeer of needlework. Her handiwork, unappreciated in her time, now, family treasures after her death, after my mother's death. The sweaters are gone, and the afghans too. They were collected and thrown into giant plastic bags and dropped into a Goodwill box after her death, together with all that unused clothing my mother had bought her, and her old black shawl which, by now, was tattered and moth eaten.

But the tablecloths, I still have—heirlooms that adorn our family's festive tables, presents that I give my sons, and their wives, and that I will pass on to my grandchildren. I have many, many tablecloths to share. For you can crochet a lot of tablecloths, through all those years, when you have little else to do.

My grandmother must have known how little we valued, how little we desired what she made. Yes, we covered the dining room table with her tablecloths on Thanksgiving, Christmas, Easter. But that is all. The afghans, we never used. The sweaters, rarely. But still, she kept crocheting, still, she kept knitting, so that, at her death, there were thirty or so tablecloths, stuffed in bureau drawers all over the house, in boxes under her bed and in the bottom of her closet. As if to crochet and to knit was what was important. As if what she made was not. As if the admiration of others didn't matter.

Once, I saw her finish a tablecloth and begin a new one on the same day without stopping to admire what she had accomplished; without holding it up to the light of the window, admiringly. To crochet and to knit in the absence of anyone's desire but your own. To crochet and to knit because the very act of knitting, the very act of crocheting gives you what others do not, what others cannot give you, what this country that you came to does not give you: a sense of worth and some small scrap of human dignity.

No 'So

—Rosette Capotorto

My mother does not sew. My mother *learned* not to sew.
Her small act of rebellion, not to learn to sew.
Can I say she *refused* to learn? In the usual absence of
facts and history is it accurate to say
that my mother *refused* to learn to sew?
She learned to clean. Says she cleaned her mother's floors
on her knees with a scrub-brush every Saturday.
She learned to cook. She learned to care for babies.
But I've never seen my mother sew on a button. Or hem a skirt.
Perhaps she has done so. But the image is incongruous.

My mother did not teach us how to sew. Her children
three daughters and a son. School and girl scouts
and life in general demanded that a girl at least
sew on a button.
We learned to use a stapler to put up hems.
When buttons went missing we pinned blouses and skirts
with safety pins. We learned to do it so well that the
safety pins could not be seen through the fabric.

All the other women in my mother's family sewed.
Sewed for us. My grandmother made clothes for us
and for our dolls.
Our Barbies had hand-stitched evening dresses with satin capes.
There is a photo of me and my sister in homemade matching
short sets. White crop tops trimmed with lace and green flowery
shorts, a pattern I loved because it made me think of Brazil
where my grandmother had lived for a time when she was a girl.

Our white Communion and confirmation dresses
were made by the hands of my Sicilian aunts.

I say Sicilian though my aunts were born here in America.
My mother's elder and only sister Virginia sewed my
baptismal gown, long since lost to time and ritual.
The pale green dress I wore as flower girl
to Aunt Anne's—my father's sister's—wedding was made by
Aunt Helen, wife of my mother's brother Frank.
None of these dresses survive wrapped in white tissue.
None preserved in box or plastic.

My mother did not learn to sew. One less task to do.
The tiny hole in the tiny needle too small for
my mother's strong hands
better fit to wash chop fold
to carry half the world

on a day begun with tears I search.
I take out of drawers
and secret places the few things I have
made by my grandmother's hands

her handkerchiefs shy out of the drawer
one yellow, an Easter match.
I can remember the yellow suit they insisted on.
yellow for redheads the old wisdom said
though as a grown up
I wouldn't be caught dead
the other much older was her own
a handkerchief she kept tucked
into her sleeve
one in which she blew her nose and
shed her own tears

I take comfort in the very manner
the object the bit of tat
was meant to give

womanmade
womantouched
womanloved

bedspread

(to my mother-in-law)

—Giuliana Mammucari

I could never call you
mother
because the womb that sheltered me
was not yours

but you and I crocheted together
an entire bedspread
pieces and pieces piled up higher than snow
that winter
remember?

torrents of words relentless silences
got woven into the intricate pattern

your wisdom my exuberance
my fever your persistence
ripened as our thoughts raced faster than the thread

we never counted the pieces so many were needed
for a kingsize bed and the fancy border all around

we said we couldn't wait to finish
yet secretly wished it could go on forever

as longer days stretched into mild evenings
it was over

all those pieces proudly were sewn together
in a work of beauty and communion

true
I could never call you
mother

you understood

Precious Traditions: *Biancheria* in Italian Australian Women's Lives

—Hwei-Fen Cheah

As a key component of the Italian girl's trousseau, embroidered *biancheria*—underclothing, nightdresses, bedsheets, towels, bedspreads, blankets, handkerchiefs, tablecloths, and tea towels—revealed the bride's upbringing, skills, social standing, and wealth.[1] These embroideries were often a significant part of the belongings that Italian women emigrants took with them when they left Italy. The traditional roles of embroidery and *biancheria* as markers of status did not, however, necessarily apply in Italian migrant society. Angela Starita has noted the ambivalent attitude to embroidery among Italian American women since "many immigrant mothers . . . actively discouraged their daughters from sewing and lace-making and crocheting. They viewed it quite simply as work, work that generated neither money nor leverage."[2] For migrant women, *biancheria* thus carried multiple connotations.

Nevertheless, for young women migrants who made the long journey south—some of them as new brides and others getting married after they arrived in Australia—their embroidered *biancheria* represented a tangible link between the tradition of their homeland and the immediate needs of the present: settling and making a home. Brought into the everyday, these functional household items spoke of the woman's place as homemaker and keeper of tradition. These pieces of *biancheria* also served as sentimental and cultural reminders of the individuals who had made or gifted them and the milieu in which they were traditionally used. A woman's set of *biancheria* thus embodied precious traditions that were often woven into the constitution of migrant memories.

Art and cultural historian Ilaria Vanni explains the diasporic experience as giving rise to an imagined home, a mental construct that is implicated in the past through its dependence on the culture of origin but is simultaneously rooted in the present.[3] She notes that the practice and objects of

needlework and crochet provide arenas for women migrants not only to transmit culture;[4] the visual, symbolic, and material allusions to *biancheria* in the contemporary artwork of Italian Australian artists also present a means for the maintenance of cultural difference and negotiation of tradition.[5] Although domestic needlework has not been a significant focus of art historical and material culture studies of Italian Australians, compared to their contemporary textile art, historical pieces of *biancheria* exert an equally strong, and perhaps more widespread, connecting presence between locales and times.

To understand the changing inflections of *biancheria* for Italian Australian women, I spoke with women of Italian descent in Canberra, Sydney, and Melbourne. The women I interviewed included those who had migrated as adult women with young families and their daughters. These women thus offered perspectives across two generations. They mostly arrived in Australia in the 1950s and 1960s with their families, seeking better economic opportunities.[6] I had met a few of my informants on social occasions prior to commencing formal research on this topic. Sensing my interest in needlework, they would speak of how they learned to embroider, the *biancheria* they brought when they migrated, and their sense of connection with Italy through items and practices linked with their past. These early exchanges made me aware of the sentimental value of their *biancheria*.

While discussing the commonalities of women's experiences with *biancheria*, I also wish to present the individual voices of the informants as well as the diversity of their views. The conversations prompt a consideration of the ways in which the acts of making, using, and preserving *biancheria* open up spaces in which the diasporic notions of home, family, and its relationship with cultural memory are elicited, negotiated, and articulated for women of Italian descent in Australia.

In *Evocative Objects*, the anthropologist Sherry Turkle invites academics and researchers across different disciplines to reflect on an object of their choice that has been meaningful, highlighting the way in which objects become sites from which we construe our thoughts, memories, and creativity, thus making them part of our personal experience as well as a mirror of our feelings. The essays show how material things can sustain play, enforce discipline, encode exchanges, and animate relationships, mark changes in one's or a community's life, embody memories, invite meditation, and provoke new ideas. In this light, *biancheria* can productively be understood as "things we think with," invested with significance as textiles that "bring together thought and feeling."[7]

Italian Migration to Australia

The flow of Italian migrants attracted by the discovery of goldfields and agriculture into Australia in the nineteenth century was small, if expanding.[8] Gianfranco Cresciani estimates that there were about 7,000 Italians in Australia by the early twentieth century.[9] However, as a result of the devastation from World War I and the restrictions imposed in the United States on inflows of Italians in 1921, Australia became an alternative destination, and migration trebled within six years.[10] The ratio of women to men increased from about one in six in the 1880s to one in four in the 1920s. Yet the number of women migrants remained relatively low.[11] Push and pull factors spurred Italian migration to Australia in the two decades after World War II: Economic conditions at home, particularly in the *Mezzogiorno*, and demand for labor in Australian construction and industry, led to the influx of Italians to Australia between the 1950s and 1960s. Between 1947 and 1976, 360,000 Italians migrated to Australia.[12] As a result, the local history of many Italian Australian families stretches back only two or three generations.

Much of the Italian migration to Australia after World War II was economically motivated, and chain migration was a common phenomenon. Nevertheless, a common experience of the first generation of migrant women was the separation by geographical distance from their homeland and by language from their host country. Many women recall the difficulty with completing quotidian tasks such as shopping because of language barriers. In addition, tensions between northern and southern Italian migrants manifested within Italian Australian society, and migrants identified themselves by their Italian province rather than nation of origin. While pan–Italian Australian mutual help societies and clubs existed since the 1880s, the strength of regional affiliations is exemplified by the Italian social clubs such as the Isole Eolie Association in Sydney, established in 1903, and the Circolo Trieste, set up in the 1950s.[13]

If the first generation of migrant Italian women was doubly marginalized, second-generation Italian women developed double cultural competences, acting as intermediaries who could translate between native-born Australians and their Italian parents.[14] Italian parents were keen for their children to learn standard Italian so they could maintain their ties with their ancestral land and heritage. Rossana Bucciarelli was born in Casalbordino in Chieti, Abruzzo, and arrived in Australia in 1958 when she was three. Rossana's father would speak to his children in Italian rather than in dialect.[15] Growing up in Sydney, many Italian children like Rossana were sent to Italian classes on Saturday mornings. Rossana's mother, Aida Bucciarelli,

would ensure that her children spoke Italian to one another in the home, although she herself conversed with them in dialect. In this way, the second generation maintained a command of dialect, a "phenomenon" that surprised their Italian peers on return visits.[16]

Being Italian could be discomfiting for Italian children in postwar Australia, where the ideology of assimilation into an Anglo-Australian society prevailed. The following recollection by Pina Lombardo, a second-generation Italian Australian, poignantly shows this: "I tried to change myself in order to be accepted. The first thing I learnt was no salami sandwiches for lunch, and instead I wanted to order a meat pie or a vegemite [a typically Australian spread] sandwich. . . . In the classroom situation, when it came to tell the class 'news,' I'd find myself changing the stories so that mine wouldn't sound so different from the others. The day we spent making salami at Zio Rocco's turned into a family barbecue and watching a soccer game became an afternoon at the footy [an Australian form of football]."[17]

The home and the schoolroom thus represented two worlds and two cultures for the Italian growing up in Australia. Dona Di Giacomo and her family came from Rapone in Potenza, Basilicata, to Australia in 1955 to join her father, who had arrived three years earlier. Dona explains, "We had two lives. You had your life outside the house and you had your life when you were at home . . . you separated the two lives and that was it."[18] Reflecting on their youth, neither Dona nor Rossana felt embittered by their experience, and the latter notes, "It has taught us we have the best of both . . . [we were] pretty well adjusted."

Embroidering in Two Worlds

Carried out across the two worlds of the migrants, embroidery occupied a space across cultures. When they arrived in Australia, many post–World War II migrant women made use of their prior training in needlework and dressmaking to obtain jobs in garment factories or to take on piecework. Numerous accounts attest to the poor pay and the strenuous labor conditions, their sewing activities rendered more distasteful because of the low status of their jobs.[19] While the needlework undertaken by Italian women in Australia was regarded as good quality, the migrants themselves sometimes lamented their loss of traditional skills.[20] The experience of embroidery in the home was varied, however. Elderly Gina (a pseudonym) who arrived in Australia in 1962 from Scordia in Sicily, in the province of Catania, stopped stitching once her children were born, having no further need to make household linens or children's clothes.[21] She later

took up crocheting as a hobby. Other migrant women, however, continued to stitch. Filomena Costanzo learned to weave and embroider from her mother.[22] At the age of sixteen, Filomena had arrived in Melbourne with mother and siblings from Motticella in Bruzzano, Reggio Calabria, in 1956 to join her father and brother, who had arrived four years earlier. In the four years prior to her marriage, she sewed men's shirts for Henderson's, a shirt manufacturer in Melbourne. As Filomena had brought with her a complete set of items for her own *corredo* (trousseau), one of the first pieces she sewed after coming to Australia was a striking flared black woolen skirt with appliqués of green leaf patterns modeled after foliage picked from her garden. As of 2010, the septuagenarian Filomena continues to embroider items such as her hand towels with initials and pieces for her two-year-old granddaughter.

Younger migrants often conducted embroidery in spaces separated from the community with which they were encouraged to integrate. As Angela Signor states in a pre–World War II account, "As the only Italian girl at a country school in the early 1930s, I would go by myself to the most secluded spot in the school yard, behind a bushy tree, to eat my lunch and do some needlework my mother had given me to do in my spare time. Earlier, eating with the other children had brought some ridicule about my unusual lunch. Mother did not know how to make a sandwich like the other children had."[23] In a later period, Rossana's mother taught her to crochet, knit, and sew when she was six; mother and daughter crocheted borders for sheets and tablecloths together on Sunday afternoons at home. Rossana notes that, at school in the 1960s, Italian and Greek girls were generally acknowledged as being better at embroidery and her "[e]thnic friends . . . all did the same sorts of things . . . [we] talked about different sorts of stitches." My informants do not recall having discussed their domestic sewing sessions with their Anglo-Australian friends. Rossana recalls, "You just didn't talk to friends, especially to Australian friends [about needlework]."

Since the nineteenth century, the curriculum at Australian schools had been based on a British model of education, which included needlework lessons. Adele Bentley was born in Belluno in Veneto in 1926 and moved with her family to Australia in 1928. Here she had learned to sew and "made two frocks as part of the course in domestic science" at school. Both she and her sister were "passionately fond of embroidery," and she remembers "fancy working blue birds on the sleeves of an apricot coloured frock."[24] Needlework continued to be part of the girls' primary-school curriculum in Australia until the 1970s, contributing, according to the 1961 Needlework Syllabus, to the development of a girl's "emotional stability, powers of self-direction and social competence."[25] Dona learned to embroider with her

aunts in Sydney while sitting on their patio, and she also received needle-work lessons at school. Embroidery practice, legitimized across the dual worlds of the Italian-Australian girl, thus did not carry any social stigma. As Dona explained, she did needlework because she enjoyed it, not because it was part of a cultural equation. For Rossana, too, embroidery was enjoyable, although she also participated in other activities like sport as she grew older.

If cessation of production of domestic *biancheria* in Australia represents a loss of skill, Italian-Australian women do not necessarily regard it as a loss of culture or tradition. This is not only because it was acceptable to com-mission or purchase ready-made embroidered linens for a girl's trousseau. Dona explains, "I wouldn't put it down as tradition whether we do or we don't [do needlework] . . . [it] is a personal expression. My aunt's gone back to doing tapestry [here in Australia] but only because she loves it and it's time [when] she can relax." She draws a parallel with changes in Italy, where young women have moved away from the villages, living busier lives and facing more alternatives for leisure. The changes to needlework practice are implicated in a global, contemporary world, and embroidery has become an individual choice, an avenue for personal expression. Equally, migrants' change in lifestyle was explained by Filomena—she did not miss the weav-ing that she ceased to do after coming to Australia because "you see so many new things, you started to travel, have friends, you started to dance . . . listen to music. . . . Life changed."

Still, the forms of some needlework remain associated with Italian cul-ture. Filomena embroidered a sheet for her granddaughter's cot, a type of item that she feels is not common outside of Italy. She also juxtaposes the format of the crocheted bedspread, which she sees as being particularly European, with the doona (an Australian term for quilt) and its frills. Some motifs, styles, and stitches of post–World War II Italian-Australian needle-work may have been regarded as traditional. Certain motifs that appear to have been relatively popular among Italian migrants of the 1950s and 1960s hold symbolic meaning for Catholics. Both Serena (a pseudonym), origi-nally from Scordia, and Rossana own items of *biancheria* with motifs of cherubs or angels that signify innocence and playfulness.[26] These items were not seen as necessarily culturally specific. More generally, the widespread exchange of designs and the conventionality of many classic floral and geo-metric patterns current in the mid twentieth century rendered many motifs and embroidery styles far less regionally or ethnically inflected.

Books of transfer patterns were easily available, and the patterns many of the migrant women had become familiar with in the postwar years were also well established as a part of a pan-European (or Western) visual vocab-ulary. Filomena drew from patterns in magazines such as *Mani di Fata* that

Bedspread with a border
of cotton, border replaced
later, crocheted by Filomena
Costanzo and her mother.
Reggio Calabria, 1950s.
(Courtesy of Filomena
Costanzo. Photograph by
Hwei-Fen Cheah.)

Hair net, embroidered by Dona Di Giacomo. Sydney, 1960s. (Courtesy of Dona Di Giacomo.
Photograph by Hwei-Fen Cheah.)

Tablecloth with rose motifs in shadow appliqué made in India. Purchased in Sydney, c. 2000. (Courtesy of Teresa Restifa. Photograph by Hwei-Fen Cheah.)

were current for its time. When the crocheted fringe of a bedspread that she and her mother had made wore out, she made a new border. She decided to change from the original design of birds, which also adorned other bed-spreads, to one of roses for "more variety" while maintaining "traditional" patterns for bedspreads.

Rossana described the patterns her mother selected for their Sunday embroidery sessions as "classic" geometric and floral patterns—for her, the patterns carried no particular cultural connotations. Rossana applied the same stitches at school needlework lessons as those she learned from her mother. Dona embroidered floral sprigs and a scalloped border in satin stitch on a hair-net at school, averring that the "actual stitches [are] pretty much the same" as what are employed by other communities in Australia.[27]

Serena learned to embroider in her twenties, when she returned to Italy for a holiday; for her, embroidery is primarily a hobby that she finds relax-ing. While it is her "ambition to do something big," Serena feels it is unlikely she will ever have the time to devote to making elaborate *biancheria*. She explains that the designs she prefers have more to do with what she has seen in pattern books than the *biancheria* in her own *corredo* or in her family's collection. For these women, the largely decorative nature of embroidery motifs implied individual aesthetic choices rather than culturally inscribed representations.

Sixteen-year-old Teresa Restifa migrated to Australia from Poggioreale in Trapani, Sicily, with her family after a disastrous earthquake in 1968; as a consequence, they brought little of what they had with them.[28] Living in Australia, her mother acquired items for the *corredi* of Teresa and her sisters. Although the majority of Teresa's *biancheria* was from Italy, they also purchased from large department stores such as David Jones in Sydney. Teresa recalls a Chinese-made table-runner her father acquired for her *corredo*, noting that Chinese patterns could be very similar to Italian ones, although a small number of designs such as chrysanthemums (associated with death) might be considered unsuitable by Italians. The acceptability of embroideries was based on the quality of the fabric and needlework rather than its place of manufacture. Significantly, Teresa pointed to the embroidery on an organza tablecloth she purchased from a store in Double Bay, a fashionable suburb near Sydney; it was made in India but she remarks that the delicate shadow-quilted roses could as easily have been stitched in Italy and conforms equally to Italian taste. It is as much part of her *biancheria* as the other linens in her possession.

Evocative Embroideries, Personal Memories

If the designs, stitches, and practice of embroidery transcended locales and cultures, the specificity of items of *biancheria* manifest as threads that connect generations and mark transitions in life. The *corredo* and the associated *biancheria* have become key tropes in the construction of Italian Australian histories of their ancestral home. Rosa Melino wrote about her roots and ancestral culture in Anzano in Foggia, Apulia, opening her description of marriage customs and the role of women in the village with a discussion of the dowry and requisite embroideries for the *corredo*.[29] In 1999 the Immigration Museum in Melbourne hosted an exhibition on the importance of the *corredo* and *biancheria* for Italian Australian families, stating that "[w]e can look with wonder and nostalgia at the old Italian dowry tradition and the lifestyle it supported, but we can also enjoy the elements which have been retained and combined with the modern to complement the lifestyle today," emphasizing both its tradition and transformation.[30]

"Sempre con te," an exhibition that opened in Sydney in 2005, focused on the lives and recollections of nine Italian women who migrated to the Northern Beaches of Sydney to join their husbands between the 1920s and 1970s. The exhibition contrasted two rooms, recreated with furniture, mementos, photographs, and biographical information to convey a sense of the home "before" and "after" the arrival of the women. The artifacts and

photographs were organized so as to emphasize the warmth and the reunion of family as well as the centrality of the women to the formation of the diasporic Italian community in the area.[31] Textiles and *biancheria* included in the display showed life "after" the women had joined their husbands, reinforcing the gendered nature of the embroidered linens as well as their strong associations with domesticity and comfort.[32] The nine biographical booklets created especially for the exhibition were each designed with front covers embroidered by the women of the community, further alluding to a relationship between needlework and the inscription of women's personal histories.[33] A book, produced as a result of the exhibition, features lace-inspired corner frames for the pages and photographs of items such as an embroidery frame.[34]

Biancheria and its tools invoke memories and histories that the migrants left behind. The migration heritage website run by the New South Wales government features a number of articles of embroidery and the embroidery frame mentioned above. The frame, says its owner Silvana Toia from Gizzeria in Catanzaro, Calabria, was "made for me in 1956 when I was eight years old. It was hand crafted by a local carpenter. . . . My mother brought it to Australia because she thought that I would need it here. And I did. I still use it today and it has great sentimental value, it brings me back to the past."[35] Graziella Del Popolo, originally from Castiglione in Catania, says of the bedsheets she carried with her when she migrated to Australia in 1968 at the age of fifteen, "They are mine now and were very precious to my mother because they had been a wedding gift from her own mother. My mother hand embroidered them in a special '800' [1880s] design (a fashionable design of the time) for me in readiness for my *corredo* (glory box[36]). . . . They could never be replaced. They're an heirloom, irreplaceable today."[37]

Embroideries packed in migrant women's *corredo* speak of a journey across distance and time and embody the dichotomy of separation and connection. Maria Nero, from Serra d'Urso near Confluenti, in Cantanzaro province, Calabria, arrived in Sydney in 1955 as a proxy bride. When she found the contents of her trunk, including the linens for her matrimonial bed, soaked in olive oil, she recalled, "I cried and cried and felt sorry for my mother who had worked so hard to be able to make and buy all the things she had given me."[38] Originally from Burgos in Sassari, Sardinia, Rafaella Porcu arrived in Australia in 1959 to join her husband. She remembers a tablecloth with embroidered flower baskets that her godmother had made for her, and she reminisced, "I used [this tablecloth] many times and now keep it to remember my godmother."[39]

In their study of turn-of-the-century American quilts, textile historians Beverly Gordon and Laurel Horton note that quilt designs embody the

aesthetic preferences of the women who made them, through their fabric choices and patchwork styles; the sense that these quilts were "material extensions" of their makers was enhanced when the fabrics or production could be associated with particular family members.[40] They foreground the acquired associations of textiles with their specific histories and personal connections, becoming "not just a reminder of one's family or friends, but an embodied material representation of their relationships with the recipient."[41] Like American quilts, Italian Australian women's embroidered linens have come to enfold memories of individuals. As the following examples show, these material objects serve as distillations of personal qualities and carriers of emotions, becoming things through which individuals think, feel, and reconnect across time and space.[42]

Filomena Costanzo has found enjoyment both professionally and personally through embroideries for more than fifty years. Five months after Filomena married in 1960, she and her husband Attilio opened a store selling piece goods and items for the *corredo*. For her, traveling to the trade fairs in Italy to source embroidered linens, bathrobes, and towels took her back to her "roots," which she explains as doing what she knew best, dealing with "the things [she] understood . . . automatically [she] would like fancy embroidered things."[43] At a domestic level, Filomena has kept the embroideries that belonged to her mother and uses her own and her mother's *biancheria*. She remarks, "We remain attached to these small things [hand towels]. We try to keep them even if they are old. . . . They have a lot more value not because you can sell them for money but because you have done them yourself. You use your fantasy [in creating] the pattern, you use your hands to embroider or crochet, and you share amongst your family and your friends." The bedspread she made together with her mother, sized for a European bed, is no longer used in Filomena's own bedroom simply because it is too small for the larger Australian beds, but it is still placed in a guest room. Furthermore, the fresh, well-ironed embroidered bedsheets are symbolic for her of a sense of renewal of body and spirit that comes with rest and home. Her *biancheria* embodies personal effort and creativity as well as familial warmth and the home as a place of comfort, affection, and well-being.

Filomena feels it is important to dress her dinner table, especially when she has visitors, with an embroidered tablecloth, communicating hospitality, respect for guests, pride, and "because it is ourselves . . . it gives [us] joy, you notice more." Using embroideries is equally significant for Filomena's daughter Josephine Di Felice, an Australian-educated arts graduate and property lawyer.[44] Like her mother's, Josephine's dinner table is invariably covered with a crisp white linen cloth, establishing dinnertime as a regular

Pillow cover, crocheted by Aida Bucciarelli. Italy, c. 1940. (Courtesy of Rossana Bucciarelli. Photograph by Hwei-Fen Cheah.)

but significant moment in the day for familial and communal sharing, a moment of "happiness," "warmth," and "domesticity." While the tablecloths she uses are not always embroidered, she places needleworked sheets on her daughter's bed—they are her expression of the importance of nurturing a family through the provision of physical comfort. At the same time, Josephine reflects on the "preciousness" of her heirloom *biancheria*, the likes of which can no longer be purchased, articulating the tension she feels between using the embroidery that she has been given and maintaining it for the next generation. Josephine questions "at what point should they [heirloom embroideries] be used," evoking the ultimate contingency of material things and their agency in the constitution of personal memories.

Rossana Bucciarelli has kept pieces from her mother's *corredo*, which originally comprised thirty-six pieces of each type of item. Taking pride of place on her dining room wall is a framed panel of a lace pillow cover made by her mother, Aida Bucciarelli, when she was eleven.

Rossana has always preferred this cover to a similar but larger piece, sensing a strong connection with it through her childhood memories of the panel because it was "a special one for mum . . . she just loved it . . . she always just used to pick this [smaller] one to put on the bed." Rossana makes use of some *biancheria* that belong to her or her mother. Those that she does not use regularly have to be taken out for laundering and airing, a process that can take up to two weeks to complete. Some of the textiles cannot be hung on a clothesline but must be dried flat and turned, making the large pieces particularly unwieldy to manage. All the same, Rossana enjoys maintaining the *biancheria*, even as she becomes wistful that the pieces are "just in a trunk." Yet attending to and reviewing her embroideries gives her

"private time" for deep reflection, a moment when she can enjoy the pieces that she has, remembering "all [her] mother's hard work," connecting her to her much-loved family.

The validation of personal connections is performed through the use and maintenance of heirloom embroideries. Teresa is particular about the way her *biancheria* is laundered, preferring to iron the pieces herself to ensure that they are pressed smooth even though she has household help. She emphasizes that preserving and maintaining heirlooms signify a person's respect for the older generation, noting that her grandmother "would be happy" to know that her *biancheria* are still treasured and kept pristinely. The embroideries are awkward to wash and need special attention, and some women no longer use their embroideries on a daily basis. Although Serena's mother no longer brings out the embroidered sheets, Serena intends to use the *lenzuole delle feste* (sheets for special occasions) when she has her own home—"it's precious stuff, invaluable, and it's a shame to leave it in the glory box."

Maintaining and passing on her *biancheria* to the future generations is important for Filomena: It represents the sustenance of lineal ties. She remarks, "You keep this beautiful [piece] to show to your grandchildren because the rest of the family [does] the same thing. You want them to remember where you have come from and what you have done with your life." Filomena still uses her mother's *biancheria* and treasures an exquisite pillow cover embroidered with her mother's initials that Filomena was given "because when we married, parents were very likely to give one thing of their own—something they made." She has begun to embroider for her two-year-old granddaughter, which makes her "feel young . . . proud," expressing the wish that "the way that I remember . . . my mother, so she [her grand-daughter] will remember me one day, looking at this or using these things."

Carolina Buono was born in Ischia in Naples, Campania, and came to Sydney after she married in 1964. Her daughter Imma Buono's interest in her Italian background developed when she studied Italian by correspondence at high school and was further fueled on a subsequent trip alone to Italy. Visiting family, Imma recalled the stories her father told her that sparked her interest in her Italian heritage and in the individuals of her extended family. She regards embroidery as part of her Italian culture, but the pieces in her family *biancheria* hold value through the personal sentiments and past experiences they invoke rather than as receptacles of a more generic cultural identity.[45] Three of the most meaningful items for Imma are the linen hand towel with her grandmother's initials, a towel with white-on-white embroidery that her mother, Carolina, made when she was still in Italy, and a linen towel her mother made with her initials.

Hand towels, embroidered by Carolina Buono. Ischia, Italy (*left*) and Australia (*right*), second half of the twentieth century. (Courtesy of Imma and Carolina Buono. Photograph by Hwei-Fen Cheah.)

Imma particularly likes the white-on-white embroidery because of its simplicity and crisp design; she also associates it with the coolness of summer sheets and the cotton pillowcases she used as a child. The embroidery style reminds Imma of her grandmother who visited them in Sydney when Imma was eight, remembering how her grandmother's hands were always busy. In contrast to the white-worked linens, a black filet lace shawl in the family's possession does not appeal to Imma; yet she values the piece for the biographical trace of her grandmother who crocheted it at age fifteen.

Serena has very few pieces of *biancheria* in Canberra, where she works, because her mother, Gina, does not want to relocate the better-quality pieces of *biancheria* from their family home in Melbourne to a city she is not fond of. Speaking about one of the pieces, Serena said, "Questo è vecchissimo, ma per me è prezioso anche se un pò strappato" (This one is very old but for me it is precious even though it is in poor condition). Speaking of a tea cloth brings tears to her eyes; her mother quietly says it saddens her—it was made by Serena's elder sister who died tragically at age twenty-four, some six years after she migrated to Australia.

A consummate embroiderer, her sister had begun to prepare her *corredo* while in Italy and must have continued to embroider in her early days in

Detail of an embroidered tea cloth. Italy, c. 1950s. (Courtesy of an anonymous informant. Photograph by Hwei-Fen Cheah.)

Australia, for a photograph shows her doing needlework in an Australian backyard in the company of a few other girls. The tea cloth invokes the deep loss that has been a silent part of their lives.

Needlework does not have to be made by direct kin to be evocative. Serena keeps a plain cream handkerchief embroidered with initials in a simple satin stitch. Now serving as a cup cover, it originally wrapped the sugared-almond confetti that guests were given at her cousin's wedding in 2005. Made by the aunts of the groom, whom Serena had never met in person, the handkerchief nevertheless conjures up an image for Serena of women's labor and dedication: "It reminds me of the way the ladies were in the past . . . they never married so I can imagine them sitting all day long embroidering because, I mean, there is a bit of work here, and they would have had to do quite a few because there was one per guest. . . . I think I can imagine them." The handkerchief mediates the relationships between Serena, her cousin, and these needlewomen that connect Serena to a wider familial network in Italy. In contrast, Gina was impelled to consider the difference in the quality of the workmanship on the handkerchief with her own needlework.

Invariably, these women contemplate the effort embedded in handwork, whether they related it to themselves or to an imagined past. Although

Dona does not use her embroidered tablecloth and serviettes because she has "got into a bad habit," she still uses her crocheted bedspread occasionally in summer. She notes, "Whenever I feel like it, basically because I know that it is one of those things that will never wear out and I enjoy it . . . and mum paid a lot of money for it. I might as well enjoy it. . . . It's not that it has that sentimental value to it to the point where, if I don't have it, I will be upset about it, but at the same time, it does remind me . . . of the younger days when I went over there and I know the work that goes into something like this, and I appreciate it more than anything else."

The textiles further elicit memories of the networks of friends and relatives that needlework was implicated within. When Filomena makes use of her *biancheria*, they bring her back to her youth when she did "all this embroidery with [her] friends, and the nuns" in the afternoons. She thinks of her sisters and mother, explaining, "We didn't watch television but we . . . would sit all around and knit and do things, and one of my brothers was studying for a priest[hood] . . . and he was always reading poems, or history, or lovely stories to us, and we would work and listen to the older brother reading these special books."

Serena, who grew up in Australia, learned to embroider when she returned to Italy in 1974 for a holiday. Watching the women around her stitch inspired Serena to purchase some material and thread so she could experiment by "follow[ing] a pattern and, *voilà*, it was just a moment . . . and it was like bringing back childhood memories. . . . I enjoyed it very much, and I liked the compliments that I picked it up so quickly." Her mother energetically described her youth when she and her friends, each of whom preferred different types of stitches, would "swap" their needlework so that each would have pieces with a variety of embroidery styles. The friendships, camaraderie, and social exchange were distilled into these women's *biancherie*.

The sociability associated with the crafting of *biancheria* reconnects these women to a communal experience in Italian village life. Teresa remembers watching the women in her home town of Poggioreale embroidering outside their homes. Carolina learned to embroider from her mother, a talented needleworker who stitched liturgical vestments. As a child, Carolina used to embroider in the afternoons with her sisters and the girls who gathered at her mother's house in Ischia to sew. The recollections bring back "pleasant memories" for her, and there is little hint of nostalgia. Her embroideries mediate distance and the transformations that ground her in a present, one for which she feels "no regret."

Dona's mother, Caterina Moliterno, brought only very few items of *biancheria* with her from Rapone to Australia.[46] Coming from a relatively poor family, she left most of her embroidered linens with her sister, thinking that she would not need many of these items when she came to Australia.

A practical woman, Caterina is neither wistful nor sentimental. However, she has embroidered two napkins in chain stitch with single initials for her granddaughters as keepsakes, validating the material connections that evoke both change and continuity.

The *Corredo* and Family Values

If *biancheria* embodies personal relationships and individual memories, the *corredo* retains a place as a marker of Italian Australian cultural values. Apart from appreciating the creativity and artistry in needlework, aspects of *biancheria* and the *corredo* that Imma Buono associates with Italian identity relate to the customs of nuptial display and the cultural expectations to which women were expected to conform in the past. More relevant for understanding the resonance of *biancheria* in contemporary Italian Australian society, however, is what Imma refers to as Italian "lifestyle," which she explains is "the sense to provide for your family—historically, that would have been very important." Imma's mother, Carolina, adds that her mother used to do needlework partly because "she loved it" but also "to provide an income." Imma articulates this as "resourcefulness—you were taught to make the best of what you have," an attitude that is seen to also characterize Italian settlement in Australia. For Teresa, who began acquiring embroideries for her own daughter many years ago, presenting a daughter with the best possible *corredo* one could afford is a gesture that indicates the depth of family values. She sees the *corredo* as a presentation and representation of a parent's care and love for a child through the provision of material comforts for a new domestic life that continues today.

The mode in which parents accumulate items for the *corredo* has changed to reflect a practical "modernization" of tradition. Dona did not like some of the items her mother chose for her *corredo* and prefers to let her daughters select their own items. When decorating her daughter's matrimonial chamber, she recalls that her daughters "don't like it [a bedspread crocheted by a relative for Dona] . . . I wanted to use it for Sandra when she got married, but she wanted something plain . . . so I went out and bought her a very plain white bedspread." Ever pragmatic, the women's practices embrace change, articulating the *corredo* as a flexible but resilient thread of sentiment and values.

Conclusion

From migrants struggling with the unfamiliar, Italian Australians have, in many cases, become comfortable in thinking of Australia as their home.

Many have prospered economically. As Gianfranco Cresciani notes of the women featured in the exhibition "Sempre con te," "nearly all of them after living for a long time in Sydney declare that they are satisfied and happy to have been able to offer a better life, education, and independence to their children who would have found this difficult to achieve even today in their country of origin."[47] In creating a home in the diaspora, Italian Australian women have necessarily privileged aspects of their material culture and material practices, "thinking through" these things as they negotiate their place as Australian and Italian.

Biancheria stitches together the migrants' multiple worlds. Differential meanings are attached to the patterns, predicated on the fashion or tastes of their time; the repertoire of embroidery stitches, many of which were also practiced in Australia; the maintenance and use of *biancheria*; and the *corredo*. At once intimate and collective, *biancheria* transcends time and distance, offering Italian Australian women sites for evoking, feeling, contemplating, and performing their relationships to home, culture, and the individuals who enrich their worlds.

Acknowledgments

Foremost I would like to thank Dona Di Giacomo for generously helping me with contacts, interviews, and other sources. This article would not have been possible without her assistance and suggestions. I am also grateful for their time and openness to Linda Nellor at Co.As.It in Sydney, Rossana Bucciarelli, Teresa Restifa, Caterina Moliterno, Carolina Buono, Imma Buono, Filomena Costanzo, Josephine Di Felice, and two other informants who wish to remain anonymous. This article is dedicated to "Granny" Ida, who gave me my first glimpse of her neatly ironed stacks of *biancheria*.

Notes

1. The term "Italo-Australian" is a conventional term by which Italian Australians refer to themselves and is used in this paper to refer to Australian nationals with Italian descent. It should, however, be noted that migrants reflect on the semantic difference between "Italo-Australian" and "Australian Italian," which emphasizes Australian identity foremost. I have adopted the term Italian Australian to follow the conventions of this book.

2. Angela Starita, "Biancheria," *Iris* 48 (2004): 66.

3. Ilaria Vanni, *Stitches: Fare il Punto* (Darling Harbour: Australian National Maritime Museum, 2001), 8.

4. Ilaria Vanni, "Stitches: Domestic Crafts, Cultural Heritage and Contemporary Arts," in *In Search of the Italian Australian into the New Millennium* (conference proceedings, Melbourne, May 24–26, 2000), 451–52; Vanni, *Stitches: Fare il Punto*, 8.

5. Vanni, *Stitches: Fare il Punto*, 8.

6. This discussion does not suggest a comprehensive view of attitudes toward *biancheria* since all the women interviewed trace their family lineages to southern Italy. Expanding the sources to migrants from northern Italy may present a more diverse and multifaceted story.

7. Sherry Turkle, ed., *Evocative Objects: Things We Think With* (Cambridge, MA: MIT Press, 2007), 9.

8. Julia Church, *Per l'Australia: The Story of Italian Migration* (Melbourne: Miegunyah Press, 2005), 5.

9. Official statistics of just under 5,700 underestimate this number. Gianfranco Cresciani, *The Italians in Australia* (Cambridge: Cambridge University Press, 2003), 54.

10. Cresciani, *The Italians in Australia*, 24. Some of the migrants were also fleeing from political persecution after the fascists came to power in Italy in 1922 (Cresciani, *The Italians in Australia*, 78–79).

11. Ellie Vasta "Italian Migrant Women," in *Australia's Italians: Culture and Community in a Changing Society*, ed. Stephen Castles et al. (North Sydney: Allen & Unwin, 1992), 141–43.

12. In the same period, 90,000 Italians returned, bringing net migration to 270,000. Stephen Castles, "Italian Migration and Settlements since 1945," in *Australia's Italians: Culture and Community in a Changing Society*, ed. Stephen Castles et al. (North Sydney: Allen & Unwin, 1992), 41–42.

13. Church, *Per l'Australia*, 170; Ros Pesman and Catherine Kevin, "A History of Italian Settlement in New South Wales" (Sydney: NSW Heritage Office, n.d.), 7–9, accessed August 23, 2010, www.heritage.nsw.gov.au/docs/italianhistory.pdf.

14. See Ellie Vasta, "La Seconda Generazione," in *Italo-Australiani: La Popolazione di Origine Italiana in Australia*, ed. Stephen Castles et al. (Turin: Edizione della Fondazione Giovanni Agnelli, 1992), 277–95.

15. Rossana Bucciarelli, personal communication, August 6, 2010. This and all subsequent references to Rossana/Rossana Bucciarelli relate to this interview. Interviewees are mostly referred to by their first name to better reflect the informal and domestic atmosphere of the discussions.

16. Imma Buono, personal communication, August 9, 2010. This and all subsequent references to Imma/Imma Buono relate to this interview.

17. Ellie Vasta, "The Second Generation," in *Australia's Italians: Culture and Community in a Changing Society*, ed. Stephen Castles et al. (North Sydney: Allen & Unwin, 1992), 163.

18. Dona Di Giacomo, personal communication, August 6, 2010. This and all subsequent references to Dona/Dona Di Giacomo relate to this interview.

19. See, for example, Frank Panucci, Bernadette Kelly, and Stephen Castles, "Italians Help Build Australia," in *Australia's Italians: Culture and Community in a Changing Society*, ed. Stephen. Castles et al. (North Sydney: Allen & Unwin, 1992), 62–68; and Vasta, "Italian Migrant Women," 150.

20. Church, *Per l'Australia*, 132.

21. Gina (pseudonym), personal communication, June 27, 2010. This and all subsequent references to Gina relate to this interview. Her daughter is referred to as Serena.

22. Filomena Costanzo, personal communication, August 27, 2010. This and all subsequent references to Filomena/Filomena Costanzo relate to this interview.

23. Angela Signor, quoted in Anna Maria Kahan Guidi and Elizabeth Weiss, eds., *Forza e Corragio/Give Me Strength: Italian Australian Women Speak* (Broadway, N.S.W.: Women's Redress Press, 2007), 107.

24. Adele Bentley, *Between Two Cultures: Italian-Australian, an Autobiography* (Roylestone, W.A.: Adele Bentley), 49.

25. See Louise DuVernet, "The Factors that Shape the Valuing of Textile Education in Secondary Schools" (unpublished PhD thesis, RMIT University, 2007), adt.lib.rmit.edu.au/adt/uploads/approved/adt-VIT20080208.162750/public/02whole.pdf (accessed August 20, 2010), 22–27, 30.

26. Serena, personal communication, June 27, 2010. This and all subsequent references to Serena relate to this interview. Serena is Gina's daughter.

27. Worn like a cape over the shoulders, the net protects the wearer's dress as she combs her hair.

28. Teresa Restifa, personal communication, August 7, 2010. This and all subsequent references to Teresa/Teresa Restifa relate to this interview. See also Teresa Restifa, interview by Linda Nellor, in Migration Heritage Centre New South Wales, "Belongings," www.migrationheritage.nsw.gov.au/exhibition/belongings/restifa (accessed October 22, 2010).

29. Rosa Melino, *Anzano: The Home of My Ancestors* (Haymarket, NSW: Little Red Apple, 2000), 50. Its importance was further underscored by thirteen photographs of embroidery and lacework (Melino, *Anzano*, 55, 57, 59, 61–63).

30. Immigration Museum, "La Dote. Preparing for a Family. The Importance of the Dowry in the Australian Italian Family" (exhibition pamphlet, Immigration Museum, Melbourne, 1999).

31. "Sempre con Te" (exhibition website, n.d.), accessed August 13, 2010, www.sempreconte.com.

32. Images of the "con te" room are shown at the "Sempre con Te" exhibition website.

33. "Stories: Sempre con Te" (exhibition website, n.d.), accessed August 13, 2010, www.sempreconte.com/stories.htm.

34. Silvana Toia, *Sempre con Te* (Haymarket: New South Wales Migration Heritage Centre, 2009), 14.

35. Silvana Toia, interview by Linda Nellor in Migration Heritage Centre New South Wales, "Belongings," www.migrationheritage.nsw.gov.au/exhibition/belongings/toia/.

36. "Glory box" is a conventional translation of *corredo* used by present-day Italian Australians.

37. Graziella Del Popolo, interview by Linda Nellor in Migration Heritage Centre New South Wales, "Belongings: Post–WW2 Migration Memories and Journeys," October 2005, accessed August 20, 2010, www.migrationheritage.nsw.gov.au/exhibition/belongings/delpopolo.

38. Toia, *Sempre con Te*, 203. Proxy marriages, in which the wedding ceremony would be conducted in Italy between a bride and a groom's stand-in (usually a relative) before the

bride boarded the ship for the long journey to Australia to meet her new husband, were common between the 1920s and 1960s. Church, *Per l'Australia*, 26.

39. Rafaella Porcu, interview by Linda Nellor in Migration Heritage Centre New South Wales, "Belongings," accessed August 20, 2010, www.migrationheritage.nsw.gov.au/belonging s/?key=Cultural+background&s=Italian&cat=10.

40. Beverly Gordon and Laurel Horton, "Turn-of-the-Century Quilts: Embodied Objects in a Web of Relationships," in *Women and the Material Culture of Needlework and Textiles, 1750–1950*, ed. Maureen Daly Goggin and Beth Fowkes Tobin (Farnham, Surrey: Ashgate, 2009), 100–109.

41. Gordon and Horton, "Turn-of-the-Century Quilts," 95.

42. See also Nancy Rosenblum, "Chinese Scholars' Rocks," in *Evocative Things*, ed. Sherry Turkle (Cambridge, MA: MIT Press, 2007), 253–59.

43. The Costanzos celebrated the fiftieth anniversary of their eponymous business in June 2010. See Germano Spagnolo, "Costanzo: 50 Anni di Attività," *Il Globo*, June 21, 2010, 34. Their business initially concentrated on retailing piece goods and linens (known as "Manchester" in Australia) and gradually moved into women's and men's fashion, its main focus for the last ten years.

44. Josephine Di Felice, personal communications, August 27, 2010. This and subsequent references to Josephine /Josephine Di Felice relate to this interview.

45. Carolina Buono, personal communication, August 9, 2010. This and subsequent references to Carolina/Carolina Buono relate to this interview.

46. Caterina Moliterno, personal communication, August 6, 2010.

47. Gianfranco Cresciani, "Women of Strength and Courage," in Toia, *Sempre con Te*, 15–16.

The Tatted Handkerchief

—Maria Terrone

From Elena, Bill's mother,
this linen square edged with tatting—
a wedding present I'd forsaken
for decades in a cardboard box.

I hold it to my face now, trying
to inhale the history of women's lives,
to understand at last this gift
she'd sewn as a girl under the gaze
of her immigrant mother—"Dead
from a hemorrhage at forty-five,"
she whispered, light draining from the room.

Her mother looked out from her frame
in gentle reproach, a thin-lipped Cassandra
resigned to her own fate. We were alone
and I was just 20, perplexed
by this gift weighted with grief.
Exchanging vows with her son
soon after, I remember how white fluttered
before Elena's face like a small bird awakening.

I examine the handkerchief,
unfrayed and unfaded, admire
its intricate loops of lilac and lemon yellow.
Were they colors the mother chose for the girl,
recalling San Mauro Forte's hills in spring?
The tatted circles climb three tiers high,
each knot intact, thread joined to thread
like the fingers of a family of acrobats
stretched to hold one another,
defy expectation, achieve a tenuous balance.

Hand Towel

Circa 1963
Embroidered linen (detail), 43" x 28"
Photograph by Lucia Grillo

—Maria Grillo and Lucia Grillo

My mother Maria Grillo (née Caruso) is skilled in the needle arts. Born in Francavilla Angitola, Vibo Valentia province, Calabria, she earned her seamstress diploma from a convent. She completed an entire set of *biancheria* for her trousseau, which she brought to the United States when she emigrated in 1965 at age fifteen to marry Vincenzo, my father. She later shared her talents by crocheting my baby doll's bonnet and booties with a matching blanket, sewing my Barbie's unique wardrobe, working away on her magical

purring Singer as a seamstress for a boutique fashion designer, and later masterfully assembling gowns I had designed for myself as an adult. When playing "house" as children, my sisters and I used towels from her trousseau as our tablecloths, and when I became independent from the family, my mother's linen wedding bedsheets, carefully embroidered in a delicate white-on-white floral pattern, came with me.

I visited her in July 2011, at the house where I grew up in suburban New Rochelle, New York. She had laid out one of the few remaining pieces of her trousseau, a homemade linen hand towel with white embroidery, upon rose-colored tissue paper. "When you lay it on color, you can see the detail better," she told me.

> White on white is really beautiful. And it really goes with everything. And the girls—when you got married, you would love to hang these because everything had to be beautiful and white and bright.
>
> This was part of the dowry we gotta bring when we get married. We had to bring fifteen of these. Each one of them was supposed to be embroidered; different kind of stitches but each one had to be brought home already done when we got married. But you really don't use it; you use it for beauty in the bathroom—for show—because they're so beautiful. But a lot of us we use it for the face because it's really soft.

"How old were you when you made this piece?" I asked. Her cheerful expression changed to a mix of pride and pain, nostalgia and sympathy for the little girl she once was.

> Eleven and a half. I started at nine years old. We would do the simple things like punto ombra, punto erba on a centerpiece. They would teach you how to do it after school because you didn't have anything else to do so that would go towards your dowry. My second sister, Anna, used to embroider things for money. The older sisters had to watch the family and make the dinner, stuff like that. My sisters got me under their wing and taught me a lot of these stitches. Nina taught me the punto ombra, the punto rode.
>
> You know, once they showed you once, that was it. But this punto ombra was very hard at first. I would mess up. But before doing the real thing, they would teach you on an old cloth, so you would learn, because every mistake you make here, it would show and you could not show it to your mother-in-law and all the hundred people who came to see it, because you had to display it for the whole week [before the wedding], so the people who knew how to do these things, they would've known if there was a mistake here.

How did you decide on this particular design?

My father bought us a book and he used to help us with carbon paper. We would put it on the picture and it would come out beautifully. After we finished we would put ashes and hot water [on it] and the carbon would disappear when you washed it. My dad told me it would look beautiful. He also sometimes would help us design some things. Sometimes he would do the design himself. Let's say if I had this piece, my dad would add something to be pretty and he would help me to do the choosing because he would love to draw.

Her face lit up at mention of her beloved father, my Nonno Vincenzo, carpenter and clarinetist, who left memories of love and creativity after his untimely death in 1976. Pointing her pinkie finger, she stooped over her embroidery and explained in that gentle child-mother voice that made her the best person to play with as a child . . .

Punto rode *is inside the flower. It's actually [part of] the material but it has to be taken out, the stitches; every thread you take has to be counted. This is a very, very intricate piece of work. [For] all the holes you see [within the flower petals], thread had to be taken out, in squares; which that's what takes the longest because you have to make [them] into squares and you have to count every stitch you put in there, otherwise it won't come out nice with the rose. They teach you where to stop the thread so it doesn't run and they teach you how to start and finish, by counting: every little square you see here, they're all alike; they're all counted. See?*

Punto rode is a series of squares created by picking at the thread in such a manner that it creates holes, in this case square-shaped, by pulling out every fourth thread in both vertical and horizontal directions, then threading together every remaining fourth thread in a diamond shape.

All these things here [she points to open spaces along the trim], *they're called a* smarlatura. *It's done to all the outside so you can cut it from the material, so it won't run. This is going through the whole thing; this was all cut with little scissors after everything was done. You make the stitch and then you cut it. It takes a long time and patience.*

Then it was accompanied by punto pittore *(painting stitch). The reason they call it that is because when you finish, it's like somebody painted it. It doesn't look like an eleven-year-old daughter did it. It looked like somebody actually painted it.*

This [the stem-like design] is called punto erba *(stem stitch) because it was putting in all the filling, like when you have a bouquet of flowers that you*

wanna put something to be filled in. These little stitches here it's like a grass to fill in the design.

And if you noticed, in the little one [a hole in each of the four petal-shaped ovals near the edge of the towel] *is also* smarlatura, *so you go in here and you fill it up with a needle. Instead of going once or two times, you would go until this was filled. Look at this. See how we just left a little hole, to make it prettier? This is all filled in by hand.*

So you displayed this the first two weeks that you came here?

In Italy you had to display for two weeks. Over here, I only had to show it to my mother-in-law. It didn't matter who came to see it here. In Italy you put it two weeks prior to the wedding and all you—everybody, the family of the groom—has to approve, and your friends have to see it, and then everybody comes to see it. You leave it in a room and then—of course, then I put it in the suitcase to come here, but you have to. It's by rule you have to.

My mother-in-law, I asked her to come to my house when I came to this country, that I opened up my suitcases. And I guess she was impressed. I guess she didn't know how I did that at my age. And a lot of other kids, a lot of other people were there too. And they loved it. We had many beautiful things, and kids here didn't do that thing, so they were stunned when they saw it.

Why did you let us play with these beautiful, precious things when we were little?

I didn't know! How did I know they were worth anything? And you played with such joy: You liked to use them because they were mine. This one I'm going to keep!

With that, she folded the towel, laying it out flat on the table and creasing it back along the lines imprinted in the linen, and slid it into a thin plastic bag, which she smoothed to let out any air and finally secured it with scotch tape. Tenderly, she placed it with other "special" linens enveloped in a cotton tablecloth in her dresser drawer.

The Dressmaker's Dummy

—Sandra M. Gilbert

In my grandmother's room, treasures of old mahogany,
intricate and enigmatic as the 1890s;
the three-paned mirror, the great highboy
with knobs like cabbage roses and expensive brasses,

the bed of generations—brown and black, teak and rosewood, inlays
older than I could ever be—and a mattress
soft from half a century of sleepers,
and quilts and goose feathers,

and cast adrift on the crimson carpet
a dressmaker's dummy, headless, armless,
a barren stork on one steel leg . . .
The stork that brought me!—for as I grew it grew with me,

its plaster hips were padded to mimic mine,
and when I sprouted breasts so did the dummy,
and as I lengthened it slid up its pole, became lean, became bone,
became my own self, hardening, final,

and, at night, through the shadows, I watched it shine
in the mirror, the streetlamps casting white eyes
on its ludicrous height, white scorn on its hips,
its empty neck, its stiff stuck frame:

and still it's there in my grandmother's room,
curved like the prow of a ship, cleaving the air
dumb as a wooden whaler's wife, a hopeless
image of me, frozen and bare,

sailing forward into the triple mirror,
wading waist-deep, a dead lady, into the future.

Crocheting Time

—Lia Ottaviano

It is 1972, late at night. Anna, my grandmother, sits alone on her living-room sofa. Through the bay window in front of her, she can see only streetlamps. Her neighborhood, quiet during the day, is now a ghost town. The neighbors have long ago called their children inside, finished dinner, walked dogs, locked doors, turned off lights. Anna's daughters—sixteen, fourteen, and twelve—have been in bed for a time now. Hours. The television is silent. A lamp is lit. Beside her on the sofa, a book is cracked open.

Anna's hands are moving. Her fingers are slim, and she still wears her wedding band on the ring finger of her left hand. In her right hand, she holds an aluminum hook, its shiny stalk slender and its tip curved in. Looped around the hook is a length of yarn, the most affordable she could find at the craft store without having to compromise quality. Her lips move in silent count of stitches. On the clock mounted to the wall beside her, the second, then minute, then hour hands tick. She looks to the book when she's uncertain, then continues to wind and draw.

The evening pushes into next day's dawn. She can't seem to get herself tired. Friends and acquaintances have paid their respects; the gifts of food have been eaten or gone bad and been discarded. The casserole dishes have been washed and dried, forgotten or asked after and returned to their owners. The flowers have died and been thrown away, tossed in the wastebasket with the spoiled leftovers, taken to the dump to decompose. Anna has been awake a long while. Her husband has recently, suddenly, died.

She's teaching herself to crochet.

Anna's grandmother, Elisabetta, emigrated from Naples circa 1900. Anna's mother, Mary, nicknamed Mary Red for her rust-colored mane, was born in Providence, Rhode Island, in December 1911. Mary Red divorced her husband, Anna's father, while Anna was still a child, and while Mary worked in a jewelry factory at the peril of several of her fingers, Elisabetta, nicknamed Grandma Lizzie, looked after Anna. My mother tells me this story whenever we drive through Providence, past the abandoned buildings

that once housed the assembly lines on which her grandmother, my great-grandmother Mary, used to work. I look at my mother's ten fingers on the steering wheel and am glad she was spared that fate.

Neither Grandma Lizzie nor Mary Red taught Anna needlework. Grandma Lizzie lived in the apartment above the one where Anna and Mary Red lived. She was a strict disciplinarian who believed in corporal punishment. As a girl, to escape her home and to earn some extra pocket change, Anna stuck gum to the soles of her shoes, stomped across scores of busy city lots, and discreetly stole pennies from the men pitching them to the edges. She attended dances often and school less often, courted boys, and bellied up to malt shop counters, while Grandma Lizzie kept her own house plus Anna and Mary Red's. Mary Red worked late nights and arrived home exhausted. Grandma Lizzie and Mary Red didn't devote time to crafts or handiwork, and even if they had, and had attempted to teach her, I doubt Anna would have had the patience to learn.

Anna takes to needlework as an adult as a way to mourn. Amid funeral arrangements and increased church attendance, after burying her husband and wearing black and weeping, she does not consciously intend to initiate, in her own life, a ritual from her ancestors' homeland. The bed coverings she creates for her children following the death of her husband are not bequeathed to her, nor produced by a skill she inherits, but they are designs of her will.

When Anna's husband dies beside her of a heart attack in the middle of the night, she knows of no such practice. The last breath he takes is in the bed they share. She discovers him cold and unmoving when she awakens in the morning.

It is summer, and their bed is dressed in light linens. There's no need to sleep under anything thicker than a sheet. The bed is not fancy or elaborate but neat, the top sheet secured with the hospital corners whose crease my grandmother has mastered.

She is well under forty and a widow. Not given to lavish displays of emotion, she does most of her crying in private. She wears black only long enough to pay what she feels to be proper respect—two weeks, not a lifetime.

Though their bodies will forever be in separate places, though they will never again share a room or a bed, she makes no move to commemorate him, save for the bouquets she places on his headstone and the black-and-white photograph of him looking handsome she sets on her bedside table. She speaks of her husband, with whom she had spent nearly every day of her adult life, infrequently.

She makes no move to distinguish herself as a woman, a wife, suffering a loss. She does not put her social life on hold for any longer than necessary. She does not put an end to weekly card games with friends or her frequent trips to visit relatives. She does not move into a different house. She does not relocate to another town. She does not quit her job. She does not starve herself. She does not stop speaking.

Following the untimely death of her husband, she makes things for the beds. The quilts she crochets for her daughters do more than keep them warm in the winter, do more than serve as simple decoration. They supplement a void, seldom spoken but always felt. A quilt does not take the place of a father, but it's something. The quilts are a hangnail bandage on a surgery wound; they're itchy and garish; they're ugly and embarrassing; they're riddled with mistakes. And then, they're everything—Ralph DiMeglio's essence, spun again into being—and her daughters survive, and the quilts are enough.

My grandmother crochets a quilt for my twin brother. The colors she uses are blue, white, and red, requested from my brother not in patriotic spirit but to celebrate his favorite team, the Patriots. She follows a geometric pattern that looks like a series of slender letter V's woven successively into long, narrow rows and then cinched at each of their individual ends and stitched together to form a piece of fabric of considerable length. The majority of my grandmother's quilts she calls "quilts," but this one she refers to as an "afghan." She gives my brother his afghan for Christmas. We are still adolescents. I see his and want one for myself.

The quilt my grandmother crochets me for Christmas the year after she gives the afghan to my brother she calls a quilt. It is made of squares stitched together with the same colored yarn "so it all looks like one piece," she tells me. The squares are the approximate size of a dinner plate, and in the middle of each she has woven a flower the size of a fist. I'm not surprised when I unwrap the gift because I know what I'm getting. I picked out the pattern myself and the yarn—bright punch pink for the bulk of it; bold multicolor for the centers.

When my mother sees my quilt, she becomes jealous. "How come I never got one as nice as that?" she asks, and my grandmother answers, "Because you never asked." The next year, my grandmother crochets my mother a quilt that she refers to as a quilt. My mother has not had a say in the construction of her quilt because my grandmother has meant for it to be a surprise. I find the quilt's color and pattern unimpressive: green panels whose shade reminds me of the pea soup my mother often cooks in the winter; no flowers or V-shapes but blocks stitched together simply. My mother does

not put the quilt on her bed. She drapes it over the back of the couch and packs it away in the summer.

My grandmother crochets as a way to pass time. One day, when I'm no more than twelve years old and curious about the quilts I've seen her produce and the others I've been told have come from her, I ask her why she crochets so much, and she says, "Oh, I'm an old woman now, how else do you want me to pass my time?" I laugh and she laughs because we both know she's bluffing. My grandmother, an auburn-haired, slot-playing sixty-something, is hardly old—she's vital and overstuffs her days. She goes out to lunch, she goes to movies; she cares for her two elderly aunts; she plays bingo, Keeno, craps, poker, scratch tickets, quarter machines, dollar machines, rummy. But as years pass and I visit my grandmother on the weekends I don't have to work, or when I come home from college and observe her still crocheting, I think, maybe it's the momentum she likes, the getting caught up, like when she drives to the casino in Massachusetts for dinner and is still there for breakfast the following morning. Maybe the action of winding yarn around a needle is not dissimilar to the pulling of a coin slot lever. It's a motion that allows its operator to slip out, to fade from the body and be less attuned to both calendar and clock.

My grandmother crochets as a way to fill time. A hobby was not a luxury her ancestors could afford; time was not a thing they could call their own. For the majority of her life, my grandmother's mother, Mary Red, did not own her time. It belonged to her employer. The long hours she worked made recreation impossible; the time she was home, she slept. She was paid scant wages and could never vacation. Under poor supervision and with little training, she worked with heavy machinery in unsafe conditions and, for the sake of production, moved too fast to take care. When her fingers became caught in jewelry presses, she had to have them amputated. Crocheting for her would have been difficult at best; more than likely, it would have been impossible.

Nor did my grandmother's grandmother, Grandma Lizzy, have time. Restricted by her gender and her life as an immigrant in the United States, my grandmother's grandmother spent her days confined to the small space of her Providence apartment building, commanded by domestic duties. She raised a daughter and she raised a granddaughter. For decades, she made breakfast, lunch, and dinner; she mopped floors and scoured stove tops; she shopped for groceries; she swept the stairs; she recited the rosary; she maintained her marriage. She had little say in how she filled her time—time, in fact, seemed to belong to someone else.

When my grandfather dies, my grandmother is overcome with time. Without anticipation or warning, she finds an abundance of it on her hands, finds the time she and her husband shared is now solely her own. During the day, her time is filled mostly with obligations to her children and her family, to her job, her home. But after hours, when insomnia strikes her, when she's acutely aware that everyone is sleeping because she herself is so awake, time presents itself as a problem, as heavy as it is empty.

Too much time. Decades ago, two towns over and earlier in the day, her mother and her grandmother would have welcomed Anna's problem. But with her big bed made and her husband gone, with her children resting and the second hand ticking, too much time threatens to drive Anna mad. When I am twenty-five, she confides in me, and when I ask her again about her quilts, she tells me of these evenings. We're talking on the phone—she is in Rhode Island, I am in New York, where I've moved to attend graduate school. We are separated by two generations, 275 miles, big-city vs. smallest-state life, when she says off-handedly, the lilt of her voice familiar, "I was so nervous after your grandfather died. My brain just wouldn't turn off, and I couldn't sleep and my hands shook. I needed something to do with my hands." And refusing to let it get away from her, she adds, "I needed a way to fill the time."

Because my great-grandmother and great-great-grandmother grew up in worlds both different and separate from the one my grandmother knew, because such vast distance existed in the conditions of their upbringing, the importance of *home*—the place where these three women, divided in so many ways, could find common ground—compounded. For years, the three lived under the same roof, and my grandmother knew the word *home* to mean collection, knew *home* to mean a coming together, knew *home* to mean a feeling of family, the love and common bond shared among people who inhabit the same space, as much as it meant a physical place, walls and doors and a roof.

My grandmother grew up to be many things—a dedicated worker for the state of Rhode Island; a loyal friend; a terrible cook; a wife; a mother of three daughters; a grandmother of four grandchildren. For each of her daughters, beginning when they were teenagers, my grandmother crocheted quilts, bed coverings stitched from intricate patterns, each one singular, each one-of-a-kind, each a reflection of something ineffable she perceived in her daughters. With every quilt she spun for them, my grandmother was giving her daughters a piece of what she couldn't proffer through words—she was giving them *history*, she was giving them *home*.

My grandmother crocheted years' worth of quilts for her daughters—at least three apiece, probably more—and when her grandchildren were born, she began crocheting for them. My grandmother's daughters—my mother and my two aunts—and my grandmother's grandchildren—my brother, my two male cousins, and I—could never sit still long enough to master the practice that my grandmother taught to herself, the practice that her mother and grandmother didn't know, the practice that those who came before them might have, lifetimes ago, mastered. Or perhaps it was an art we somehow recognized as too far removed from its place of origin, too distant and separate for us to apprehend with any pretense of authenticity—perhaps the seven of us knew, in all of my grandmother's failed attempts to teach, that her crocheting was a practice to be revered, not imitated.

I still have the pink quilt my grandmother crocheted me. I live in Brooklyn now—several states and twenty years away from the Providence apartment in which I was raised, the same apartment where my grandmother lived with her mother, Mary Red, two generations and one floor below her grandmother, Grandma Lizzie. Every fall, before the weather turns cold enough to warrant an extra blanket, I unpack the quilt and fold it at the foot of my bed. The quilt is nearing fifteen years and unraveling at the corners, but I let the errant strands hang loose—they link me to my grandmother, whom I miss, and they link me to my grandfather, whom I never got to know—they link me to my history, they take me back to my home.

Stitches in Air: Needlework as Spiritual Practice and Service in Batavia, New York

—Christine F. Zinni

Like other Italian Americans who grew up on the south side of Batavia, New York, during the 1950s and 1960s, I recall the gossamer web spun by women who gathered in parlors, under backyard arbors, and at the community center to share stories, needlework patterns, and to pray. Real and imagined, dreamlike and dreamed into being, the matrix they fashioned linked us to ancestors in Italy just as gracefully as it tethered us to the here and now of life in western New York. Cutwork, hemstitch, chain stitch, double crochet, and picot joined family to family near the bend of the Tonawanda Creek in the gridlike network of streets bordered by cul de sacs and semicircular avenues. Like *punto in aria*, the spaces in between women's "stitches in air" also freed us to dream.[1]

The Tonawanda, the creek with the Indian name meaning "swift waters," set the physical and psychic boundaries of existence in our neighborhood while it opened vistas of our imagination. Encircling the eastern and southern perimeter of our communal enclave until it ribboned out to the Seneca Indian reservation to the northwest, the creek reminded us that, even after three generations, Italians were still newcomers to the region. We could learn the language of the 'mericani, recite a pledge of allegiance, and feel the consistency of the soil with our hands, but we were still strangers to the longer history of the land and its peoples.

The Haudenosaunee, commonly known as the Iroquois, conceived of their ancestral homelands in western and central New York State as a longhouse with the sky as its roof and the earth as its floor. The Seneca, called "The Keepers of the Western Door of the Longhouse," used the waters of the Tonawanda creek to traverse the hills and valleys of the Genesee Region and forge the bonds of a great confederacy governed by a constitution known as the *Kaianere'ko:wa*, or Great Law of Peace. Recalling their spiritual beliefs and practices, indigenous women of the region created beadwork designs

that marked native flowers, plants, and animals that could be found near the waterways. The images served as a reminder to continue their ceremonies and give thanks for the renewal and regeneration of the earth. Their prayers were meant to benefit all humans who became part of the first dream of celestial beings in what they called "The Skyworld."[2]

As wave upon wave of German, Irish, and Polish people came to the region, bridges and railroad tracks were built across the well-worn Indian trails that followed sections of the creek to the thundering waters of the Niagara Falls, or "The Outermost Door of the Longhouse." Migrating from diverse parts of central and southern Italy and Sicily during the great diaspora of the late nineteenth and early twentieth century, scores of Italians found work on farms, railroads, and in mines and factories. Numerous towns along the route of the Tonawanda became the site of extended networks of *paesani*. Interviews with the first generation of immigrants reveal they were impressed, not with height of buildings or technological progress, but the rich earth and verdant landscape by means of which they could nurture their families and find materials to build homes and communal places of worship.[3]

Starting out in boardinghouses, within a few years many immigrants were able to put down payments on homes and create gardens that provided sustenance for their families. From cultivating gardens to work as hired laborers in the "black gold" or mucklands of the region, Italian men and women brought from Italy their experiences with the soil and their appreciation for the bounty of the earth.[4] Although plants popular in their ancestral homeland like tomatoes, peppers, and grapes could grow in their gardens, native vegetables and fruits like the "Three Sisters"—corn, beans, and squash—and strawberries became staples in their diet and grown on a regular basis. Like their Haudenosaunee neighbors, the Italian immigrants marked their lives according to the rhythms of the earth and changes of the seasons. Ritual celebrations to honor the patron saints of their Italian towns reflected the links of the paesani to their ancestral landscape(s) and gratitude for the gifts of their adopted homeland. Serving to strengthen ancestral, communal, and spiritual bonds, feasts provided the occasion for regional gatherings of families and friends—and for women's work in thread.

I looked out on the weblike canopy of this network from various vantage points: my childhood home, the streets and gardens of our south-side neighborhood, and the rectory of Saint Anthony's Roman Catholic Church. The rectory was a communal touchstone for the diasporic movement of Italian immigrants that settled on Batavia's south side. Together with the school and community center, it was the nexus from which all our activities radiated. The rectory became a second home of sorts for me and my siblings

because my grandmother, Grazia/Grace, who emigrated from the town of Pollutri (Chieti province), Abruzzo, and her oldest daughter, Chiara/Aunt "Carrie," volunteered their services as housekeepers and general assistants there for close to twenty years. Like other immigrant women of her generation, Grazia had retired from work in the local shirt factory in the neighborhood. Along with cooking and cleaning the rectory after retirement, my relatives' "offerings" on behalf of the community were manifest in their needlework and care of ecclesiastical vestments and altar cloths. The beautiful brick church, school, community center, and rectory that comprised the communal ark of Saint Anthony had been constructed through the hard labor of men in the parish, but the communal spaces within these buildings were graced by the poetry of women's needlework.[5] Literally and figuratively, altar clothes and liturgical vestments undergird the celebration of the Eucharist in Saint Anthony's parish and helped set the tone of the daily lives of immigrant parishioners who often started and ended their days by attending mass or ritual devotions.

The diasporic movements of people that brought immigrants from Abruzzo, Molise, Apulia, Calabria, Campania, and Sicily to Saint Anthony's parish was evidenced in the existence of diverse societies dedicated to patron saints of their ancestral villages. A prominent sign of this unique microcosm of Italian peoples were the twenty or so statues of patron saints brought over by *paesani* from different parts of Italy and housed in niches along the inner walls of the church. At different times during the year, committees from the Saint Nicholas Society (Abruzzo), Saint Michael's Society (founded by immigrants from the town of Valva in Campania), or Our Lady of Loreto Society (formed by *paesani* from Vallelunga, Sicily) would hold meetings at the church rectory to plan activities for their particular saint's feast day.

The rectory was the common meeting place for committees from the men's Holy Name Society and women's Altar and Rosary Society, where cross-regional membership was more ecumenical and not restricted to peoples of a certain region. A coterie of people from the Altar and Rosary Society like grandmother, my Aunt Carrie, Antonia Di Martino, Lucia Gullo, Lena Luperino, Consuella Di Carlo Martino, Josephine Ognibene, and Lucia Ruffino were responsible for taking care of the sacristy and votive lights in the church and the long-term production and care of ritual/sacred textiles. Their delicate cutwork and needlework edgings graced the three main altars in the church as well as the priest's vestments.

While intricate needlework fashioned by women of Sicilian descent embellished Saint Joseph's altar to the left of the main altar, Grazia's lace-like crochet work adorned the altar dedicated to Mary to the right. Based

Women of the Saint Nicholas Society in front of the Saint Anthony's Community Center. Grace Niccolino Zinni in fur stole, *second row, seventh woman from left*. Batavia, New York, c. 1935. (Courtesy of Christine F. Zinni.)

on childhood memories of her mother's—Ciana (Spina) Nocciolino—pilgrimages to a shrine in the hill country of the Abruzzo region, Grazia had retained a special devotion to the Madonna, naming her second daughter after the Virgin. Following a tradition on my grandfather's side of the family, Grazia and her husband Franco/Frank chose to name my father Nicholas and their youngest daughter Nicolette after the patron saint of their ancestral village in Chieti, Saint Nicholas. They helped to form the Saint Nicholas Society when they first arrived in Batavia and were actively engaged in organizing annual events in his honor.

From year to year, time seemed to ebb and flow in relation to the production of the Saint Nicholas festival. As anticipation mounted for the ritual celebration in late May, which coincided with the first plantings, budding of spring flowers, and foraging for wild dandelions, the number of visits, meetings, and telephone calls to the rectory and our home would increase. The largest Italian celebration of its kind in the Genesee region, the event was emblematic of the communal spirit of not only the Abruzzese, but of the whole south side. The sound of a marching band playing the Italian national anthem signaled the beginning of the feast, which featured three days of activities. Followed by a procession of Saint Anthony's parishioners and a gaily decorated boat in which a statue of the saint had been placed, the band wended its way through the thicket of streets of the neighborhood for half a day or more, offering homemade bread, holy cards of Saint Nicholas, and music in exchange for donations to the church, and fortifying glasses of homemade wine. Although Grazia was busy preparing food in the community center along with other ladies of the society, a delicate slip of cloth she

Frank and Grace Zinni with author. 1950. (Courtesy of Christine F. Zinni.)

had embellished with lacelike crotchet work placed underneath the statue of the saint signaled that my grandmother was there with us.

Like other grammar-school children from Saint Anthony's parish, I was enlisted to join the procession and go from house to house distributing home-made bread and holy cards trimmed in shiny gold-leaf paper in exchange for donations. Public space was transformed during these processional events reaffirming *communitas* or our membership in a sacred community and revealing the porous boundaries between our homes and the streets.[6]

Dance was always a big part of the celebration, marking the culmination of each day's activities. One of the most memorable sights was watching friends and relatives from a sixty-mile radius of Batavia and the neighboring towns of Buffalo and Rochester perform the *tarantella* and *saltarello* along-side local south-siders. The experience of seeing the very same grandmoth-ers, godmothers, mothers, and aunts who had spent months organizing the event and devoutly praying to the saint now swaying in time to music in the archway of the communal kitchen, then slowly venturing out to the dance floor, always elicited cheers and shouts of "Bravo" from the crowd. Aprons slightly askew in one hand, swinging partners with the other, the women were urged on to greater involvement by the complicity of the band and the increased tempo and volume of music. For children and adults alike, this performance of culture elicited a joyful sense of participatory belong-ing, communicating the ways in which piety, spiritual devotion, and ecstasy could be entwined. Grievances might be brought to a head in this public arena but, just as often, grudges were forgiven and alliances formed in the name of the saint.[7] In the liminal time/space of the festival, women were valued as shapers of the event and applauded for their performance of *bella figura* as nurturing cooks and participatory dancers.

Without knowing the historical connotations of the Italian expression, children in the neighborhood understood the ethics and aesthetics behind the term and the ways in which it encompassed service—spiritual and/or social—on behalf of the communal body.[8]

One of our neighbors, Tommy Gullo, fondly recounts how the sound of my grandmother answering the rectory phone with "San Anton's!" instead of the more anglicized version, "Saint Anthony's" seemed to capture the Italian element of the parish.[9] At the time Tommy was born, in 1921, there were more than two thousand people from Abruzzo, Calabria, Campania, Molise, and Sicily living with Polish American neighbors in the twenty or so square blocks of our south-side neighborhood.

Growing up in the same house as my extended family, just around the corner from the Gullos, I recall life as being enmeshed in the everyday exchange of produce, recipes, and homemade wine. After tending to our garden and preparing meals, my grandmother and Aunt Carrie would do their needlework. Grazia's signature crotchet pattern for the *merletti*, white needlework she created for women in our family, was an intricately wrought one-inch and one-and-a-half-inch medallion motif composed of concentric circles of white thread, fashioned with a steel hook and delicate cotton and linen thread. The lacelike medallions unfolded like the petals of a flower, spokes of time, and/or spider's web. I would watch with admiration as she stitched the circular medallions into squares and joined them at the edges so that they formed perfectly symmetrical horizontal and vertical bands or columns repeating the motif.[10] My grandmother used this pattern on the table runners, tablecloths, and bedspreads she made for our household as well as on the pieces she made for her second-oldest daughter, Maria/Mary and her youngest daughter, Nicolette. Calculating the number of medallions to determine the length of the cloth, its shape, and final use, she employed precise mathematics and geometry with her forms and produced intricate lacelike mosaics, defined only by delicate borders with picots. My aunt Mary, who left home to enter a convent in the 1940s and became Sister Mary Agnes Zinni, recalls my grandmother teaching her and her sisters how to embroider. (My approach to [re]presentation and transcription of oral histories is based in part on Dennis Tedlock's work on oral narrative and ethnopoetics and the idea that the written word should register, as does a musical "score," paralinguistic aspects of the voice, inflections, pitch, and pauses through variations in type and spacing.)[11]

Carrie and Nicolette and myself all learned to do embroidery.
That was important during the summer months
when we were not in school.

And we learned to embroider scarves for the dressers in the living room
and pillowcases (that was one thing).
And my Mom would get together with a group of her friends
and they would do needlework together.
Sometimes it would be crocheting
and sometimes they would take flowers and make beautiful arrangements
Mom, somewhere in her youth
learned how to CROCHET
learned how to embroider.
She n e v e r cared for knitting
but the embroidery and crocheting especially the crocheting . . .
she just r e a l l y loved CROCHETING!

But most of all what I remember Mom crocheting was the WORK for the
church.
One thing she did for the church was to crochet

 really the lace
for the bottom of the priest's albs at Saint Anthony's church.
There was at least TWENTY-FOUR INCHES of lace at the bottom of the albs.
The other thing was to make altar cloths
for the altar at Saint Anthony's church.
It was always white linen
with that beautiful white edging she did.
The pattern was always rosette.
She just loved that pattern
that is what she did.
The other thing that stays with me so well is what she did for the family.
We had mom's embroidery all over the house.
We had it in the living room, in the form of scarves.
We had it in the dining room in the form of lace tablecloths.
and we had it in the b e d r o o m really as a scarf on the dresser.

But I think what touched me so deeply was after I left home

some years later.
Mom was already in her sixties or seventies
Mom, as a special g i f t, for each one of her children
she made a beautiful lace tablecloth
 with her signature ROSETTE pattern.
And she sent one to Nicolette

Grace Zinni with daughters Carrie, Nicolette, and Mary, and daughter-in-law, Regina on right. 1955. (Courtesy of Christine F. Zinni.)

> I know I had one ... and Nick and Reg (my mother) and Carrie
> And I remember Nicolette asked Mom for a special request
> for Mom to make a lace bedspread for her
> and that was the last thing that she would do.
> She made that bedspread and put her needle down.
> She retired from crochet,
> She was probably in her late seventies by that time.[12]

Unlike my aunts Mary and Nicolette, Grace's oldest daughter, Carrie, remained at home all her life. Deriving her sense of history predominately from oral culture, she assisted my grandmother with the cooking and devoted herself to helping raise me and my siblings while my mother worked as a legal secretary at my father, Nicholas's, law office. Carrie's embroidery was as colorfully wrought as her stories of the neighborhood. Stitching rainbow-hued flowers onto the edgings of pillowcases and handkerchiefs, she would inquire about the progress of our vegetable garden or gently quiz me on significant dates and events in our parish.

During the midafternoon hours, my grandmother and Aunt Carrie would put their needlework, prayerbooks, and rosaries aside for an hour or so and rest their eyes. The image of my Italian relatives sitting there in

the stillness of the parlor, amid the sound of crickets and the glow of colors refracting from our stained-glass windows, stayed with me over the years and reinforced my ideas about the connections between creativity and "dreaming." Through these quiet moments with my grandmother and aunt, I came to understand how the creative process could be tied to the sights, sounds, tastes, of the natural world. In my mind's eye, this peace was intricately connected to the protective gaze of the patron saints, present not only in our home and at church, but in the altars and backyard gardens that comprised the extensive network of kin, *compari* (literally godparents but also extended family members), and friends in the neighborhood. Evoking the deeper spiritual mystery at work that made our ark move together in time,[13] I attribute these lessons to my grandmother whose faith and devotion to the saints were rooted in quiet mysticism and a sense of belonging to a spiritual community.

When Monsignor Acquavia, the pastor of Saint Anthony's for over thirty years, was first assigned to Saint Anthony's in 1965 he began to notice how Grazia would mysteriously "disappear" for fifteen minutes to a half hour at a time. Responding to his inquiry into her whereabouts, her answer was always the same: "I go to talk with my son-in-law." The priest soon discovered that my grandmother went to pray in her favorite pew in church during these breaks and realized the "son-in-law" to whom she referred was Christ—"wedded" to Grazia's daughter, Maria, through her sacred vows as a nun. Grazia's response to the pastor was not only an allusion to her daughter's mystical "union" with "Christ the Divine Bridegroom" but a reference to the mystical body of the Church and our south-side parish as "The Bride."[14] Like other women of her generation, Grazia was not literate in the conventional sense, but she was familiar with the ancient lexicon of iconic signs and nuptial imagery of church liturgy. Daily acts of devotion in the form of sacristy and needlework were a material expression of this deeply felt spiritual compact with God.

Like the circular medallions Grazia shaped from "stitches in the air," the votive women's textiles materialized "in between" ordinary clock time, in interstices attuned to the rhythms of the natural world and liturgical cycles. Fellow parishioners appreciated this investment of time and the behind-the-scenes work of the *consorelle* (sisterhood) polishing the communal ark and maintaining it on a daily basis, just as they valued men's volunteer labor to construct the church, rectory, and school. As the longtime president of the men's Holy Name Society, Louis Del Plato, always exhorted: "It is easy to drop a few dollars in the offering basket each week. Giving up one's time demands more of a sacrifice." Fabricated by means of the ancient technology (from the Greek word *techne* meaning skill) of the needle and thread to fashion their offerings, the ritual textiles of the *consorelle* were the sacred

Monsignor Pasquale Acquavia awarding Grazia Zinni the Bishop's Medal for Community Service. 1972. (Courtesy of Christine F. Zinni.)

counterpart to the *biancheria* or whiteworks fashioned for the *corredo* or trousseau of individual family members. Constituting, in effect, a visual "text," the patterns inscribed in the votive women's white needlework served as an alternative form of writing culture.

Text and Textiles

Over the years, I came to understand how the production of lace needlework by the *consorelle* of the Altar and Rosary Society of Saint Anthony's parish follows in a long tradition that can be traced back to the medieval practices of nuns and female devotees. Studies of consororities of nuns and laywomen in sixteenth-century Florence revealed there were hundreds of sodalities dedicated to the Eucharist and to the Rosary in late medieval Europe, especially in urban centers.[15] Ephemeral bits of altar cloth and devotional coverings suggest that the earliest uses of needle lace (or *merletti*) produced by Italian nuns and laywomen were meant to beautify Eucharistic altars. Along similar lines, some studies place the practice of creating *merletti* even earlier, in the fourteenth century. Underscoring how readily antique Italian needle lace was associated with "nuns' work" and/or "the work of noble women," in 1875 lace researcher Bury Falliser writes: "If you show an Italian a piece of old lace, he will exclaim: *Opera di monache: roba di chiesa* [nuns' work: church stuff]."[16]

Ricamo or embroidery, another popular form of needlework that was created by the votive women in our south-side parish, enjoyed a similar

provenance. A skillful way of inscribing iconic images, symbols, and signs onto banners of the Altar and Rosary and Holy Name societies as well as those dedicated to various patron saints, *ricami* were also used by the *consorelle* to embellish the clothes in which the statutes of patron saints were dressed. A visual means of transmitting knowledge carried over from the immigrant women's ancestral homelands, it reflected something of the important role embroidery played in conveying spiritual beliefs over the millennia. Fourteenth-century cloister hangings displayed at the Metropolitan Museum of Art demonstrate how needlework by nuns served as a teaching tool in medieval communities of the faithful. Containing allegorical images and signs based on biblical commentaries and popular medieval picture books like *Biblia Pauperum*, these ancient embroidered works stand as sacred "texts" rooted in women's vernacular religious practices. Created at a time when women were rarely credited as historians or writers, in the words of a seventeenth-century church historian: "nuns with their needles wrote histories, also, that of Christ his passion for their altar cloths . . . as other Scripture Stories to adorn their houses."[17]

The import of "writings in thread" came into even sharper focus for me during the process of doing ethnographic research on the iconic, indexical, and symbolic aspects of textiles for what would become my dissertation project. Textiles, as I came to understand through dialogues with my thesis adviser, Dennis Tedlock, carry *utterances* or traces of voices from other times and places. Functioning as intertexts, they can contain elements of syncopation and symmetry akin to music and poetry. As such they serve as *ethnopoetic* forms that reflect knowledge of not only the tactile and visual arts but also of musical arts.[18] Exploring how the women of ancient Greece and Rome employed the needle arts and the ancient technology of the loom to convey historical events, beliefs, and cultural narratives, I learned it was no coincidence that the word "text" (from Latin *textus*) originally meant "to weave."

The idea that textiles contain echoes from the past and ethnopoetical qualities was evident in the needlework of the votive women of the Altar and Rosary Society. Comprised of geometric patterns and figural forms passed down from woman to woman in their ancestral Italian towns, dependent on their familiarity with liturgical signs as well as of the customs and values of their Italian ancestors, the lacework and embroideries of the *consorelle*, could be "read" by parishioners of Saint Anthony's on several different levels: as poetic forms marking the identity, memories, and knowledge of the maker; as symbols that bespoke the renewal of ritual and devotional practices learned from ancestors in a different time and place; and as material offerings that linked individuals and families through the communal body of the church.

Conveying knowledge, belief, memory, and the identity of their makers, on yet another level, the religious textiles of the *consorelle* were a material expression of *fare (bella) figura*. Indicative of the reverence and respect afforded rituals and ritual space, adornment of sacred vestments and altars was in keeping with the cultural aesthetics of Italian ancestors from medieval sororities: to "beautify something/someone," or "make a beautiful figure." Closely tied to concepts of honor and shame in Italian life and the values of Mediterranean society, the public presentation of ritual textiles and adornment of interior altars by the "sisters" of the Altar and Rosary Society was an enactment of this aesthetic, conveying ideas of piety and spiritual purity associated with the Eucharistic host. When the textiles of the women are viewed through this lens, it is easier to understand how they lent a personal touch to the transformation of communal space into sacred space. As folklore scholar Joseph Sciorra reminds us in his study of yard shrines and sidewalk altars of New York's Italian Americans, women's "beautification" of altars served "to link the home and hence family life into the public sphere." As such, "the outdoor altar publicly attests to the successful fulfillment of the mother's role as the heart of the Italian family. She is responsible for the family's spiritual well-being." Functioning in much the same way, the adornment of interior altars of Saint Anthony's church by women devotees not only linked the supernatural with the everyday and individual families with the larger community, but also reflected women's role in the maintenance of the spiritual life of the community.[19]

Rocking Rhythm(s)

The fact that textiles are produced through the actions of one's bodies—specifically the hands—begged further questions about the relationship of women's bodies and "muscle memory." As chronotypes of time and space, bodily rhythms encoded *in* and *through* the creation of textiles give individual pieces their protective qualities. Informed by prayers of thanksgiving in the making, *merletti* and *ricami* produced by religious devotees on the south side of Batavia became *both* the embodiment and means of honoring sky/earth connections through the very process of their production and connection to the body.[20] The ways in which touch and rhythm are imprinted in early childhood and thus become intricately involved in the creation of textiles has been underscored in the writings of Mesoamerican scholars like Marcia and Robert Ascher, who have maintained that "tactile sensitivity begins in the rhythmic pulsating environments of the un-born child far in advance of development of other senses." Considered from the standpoint

of memory and the opposite pole—of old age—this sensitivity only deepens over time. As Joan Saverino argues, needlework can serve as a mnemonic device and the means of life review. For the elderly Italian-American woman in Saverino's memoir, the process of creating *ricami* helped to recontextualize "a material past for her present circumstances, instilling it with new meaning."[21]

In different ways, these studies hold larger import as they not only challenge common meanings of "text" and the idea that writing is always, already based on alphabetic writing, they also debunk misguided notions that hark back to social Darwinism and the belief that only "advanced" alphabetic-based civilizations—not oral cultures—made use of technologies to write culture.

Writing with Color

The practical applications of these issues were evident in our south-side community. From designing and embellishing baptismal gowns of children and godchildren to sewing First Holy Communion dresses and suits to fashioning pieces of women's *corredo* and wedding gowns to making death shrouds that covered their husband's or relative's and friend's caskets, textiles marked different phases and liminal moments in the spiritual and social life of Saint Anthony's parishioners. Based on their familiarity with the spoken and written word of the liturgy from early childhood, parishioners at Saint Anthony's associated white textiles with rebirth and regeneration into a new life of spirit—as manifest in Christ's resurrection and transfiguration to divine status. On an individual plane, this rebirth to a new life of the spirit was symbolized by the ritual of baptism or christening into the Church and confirmation services. Kay Martino Ognibene, whose mother and mother-in-law were dressmakers and members of the Altar and Rosary Society, relates the role of whitewear fashioned by women back in the 1930s:

> My mother (Consuella Martino) made my sister's wedding dress
> and that was my CONFIRMATION dress
> My MOTHER-IN-LAW (Josefina Ognibene) made the Baptism gown
> for my three children
> All of my children were baptized in that dress.[22]

Kay's testimony resonates with that of another south-sider, Carol Lombardo Mruczek, underscoring how the custom of passing down textiles graced by

Grazia's crochet work (*merletti*) medallions. (Courtesy of Sister Mary Agnes Zinni.)

Grazia's work. (Courtesy of Sister Mary Agnes Zinni.)

women's needlework from generation to generation was prevalent in the community up until the end of the last century:

Mrs. Ognibene made our clothes.
We were COMARI.
My mother had a baptism gown made for my SISTER

 who is 90 years old

I was baptized in it,
and my nieces
Mary Rose and Janet
were baptized in it.
My children were baptized in it
and their CHILDREN were baptized in it.

So my generation, my kids and their children all WORE it.
A pink ribbon went around the neck and sleeves
 and hanging down in front
when it was a girl.
And when it was a BOY
we changed the ribbons to blue.[23]

Symbolizing purity and the newness of life, the white lace needlework that adorned the altar cloths and vestments in church was part of the ancient iconography and language of the church. The spiritual connotations of the color white were imprinted in the memory of parishioners through attendance at mass and readings from the Bible as well as visual texts, like the church's stained-glass windows and holy cards. Lest any of these associations with the color white be missed by the laity, there was the undeniable connection of white with Christ's body through the Eucharist Mysteries, hence the reason for pure white altar cloths and coverings.[24]

Path(s) to Production

Suffused with wishes for the well-being and protection of their families and the community during the very process of their construction, ritual textiles derived their power not only from their intricate connection to bodily movements and the visual effect created by the whiteness and the delicately wrought designs, but first and foremost from the ineffable fact that they were often produced in between the decades of saying the rosary as well as

Grazia's linen cutwork. (Courtesy of Sister Mary Agnes Zinni.)

other acts of prayer. Fastidious attention to the care and handling of sacred textiles also spoke volumes about the high regard afforded the women of Saint Anthony's whiteworks and the ways in which they were "implanted" with prayers.[25] For these reasons, the finely wrought white needlework used in the church textiles was carefully created, maintained, and treated with reverence. Through my experience accompanying Grazia as she tended to sacred textiles, I realized how the church linens required constant attention and time. She would wash the crocheted lacework in Ivory soap and then pat it dry between two towels to absorb excess water before laying it out to dry on another towel. My aunt Carrie was responsible for starching and ironing the linens. This process contributed to the aesthetic look of the textiles and the folds of the cloth when it was draped over the altar.

Ideas about the formation of new textiles for the church were conceived and executed by the votive women of Saint Anthony's parish at Mrs. Lucy Gullo's house. Her son Tommy vividly recalls the process and how much care and attention were devoted to every detail: from having the finest linen to adorning the edgings of the cloth with delicate needlework. As Tommy notes, duties were shared: Men helped with the construction of some of the church altars and furnishings, and women decorated and maintained the altars with linens, needlework, and candles.[26]

My mother being a dressmaker . . .
 she started to fix all the altar cloths
The ladies would do the embroidery
and crochet work
 to sew on the edges of the cloth.
And I can remember six or seven women doing that
and they were all GOOD AT IT
 they were all good at it.
Matter of fact if Father Kirby wanted anything
he would just come over
and say
"I want this"
and it was ready for him.

I think I mentioned my father was a cabinetmaker,
he done a lot of the furniture work in the church
and on the altar
It wasn't just our family,
It was other people who chipped in
and did a lot of work for Father.

My dad used to take my mother to Rochester.
There was a Mr. Nusbaum, a Jewish fellow
that had all kinds of cloth.
and my mother saw the linen
IRISH LINEN . . .
She said she wanted to buy all that he had
and he said,
"I've got about TWENTY-FIVE DOLLARS' worth."
That was A LOT of linen in those days.
She BOUGHT it all![27]

Since the 1930s and 1940s when my aunts were growing up, Saint Antho-ny's parishioners had established well-worn paths from their homes to the church, rectory, and community center—and the four corners that housed a grocery store, a drugstore, and the Surprise Store. Situated near the shirt factory and the arbitrary boundary that divided the north side of Batavia from our south-side neighborhood, the variety store catered to immigrant families with a plethora of needlework supplies as well as locally made shirts and a selection of children's toys and household goods. Various shapes and kinds of needles for crochet work or embroidery and racks of threads of

different hues and gauges constituted a large part of the store's merchandise, evidencing the popularity of the textile arts in the community and the amount of needlework being produced at one time. Women would get together to work on their textiles, share stories, and pray, not only at Mrs. Gullo's but at many other women's houses. Depending on the season and the liturgical calendar, different houses were distinguished by the scent of wildflowers, garden herbs or sprigs of evergreen placed on altars dedicated to a patron saint. Holding prayer meetings before a liturgical feast, women would take turns leading the group in prayer while others worked on their textiles and recited the words alongside them. Time was not measured by the clock at these gatherings: rather, it advanced, like the medallions on my grandmother's needlework, with decades of the rosary and spoken prayers. In this way, elements of the natural world, stitches, prayers, and stories were woven together, informing the spaces in between our lives on the south side.

Prayers, stories, and needlework went hand in hand on trips outside the community as well. At least once or twice a year, my grandmother and women from the Altar and Rosary Society would make group pilgrimages to the shrine of the Blessed Virgin in Lewiston, near Niagara Falls, or to Saint Anne's in Pennsylvania. Peek inside the recesses of Grazia's black purse or that of any of the other women and one would find a rosary, holy cards, needles, and small medallions of thread taking shape. The recitation of the rosary and prayers to the Madonna seemed to collapse distances from one town to another along the route of the pilgrimages, connecting us to the lay of the land and the ever-widening circle beyond our south-side neighborhood. In this way, through my grandmother's eyes, I experienced women's work in thread and some of the links between the natural and spiritual landscapes of our community. This is how I came to know the world until the time I was twelve when, like my childhood friends and classmates from Saint Anthony parish, I ventured beyond the parish buildings, the backyard gardens, neighborhood stores, and banks of the Tonawanda Creek to attend high school on the other side of town. Like other children from the neighborhood, I felt the protective and nurturing network fashioned by our immigrant ancestors bolstering our confidence—providing the courage to explore worlds beyond western New York in the years to come even as it compelled us to remain closer to home.

It was the gossamer web tying me to relatives and friends on the south side of Batavia that also brought me back to the region many decades later in the 1990s with the illness of my mother. Although diminished in numbers, mutual aid societies like the Altar and Rosary Society, Saint Nicholas, Saint Michael, and Our Lady of Loreto Societies were still actively sponsoring spiritual devotions and events. Struck by the impending loss of cultural

knowledge with the passing of our elders and changing demographics of the neighborhood, I was overcome by a sense of urgency and began to record people with a video camera and create shoestring stories.[28]

Infused with the time and space of the ritual feasts and celebrations I attended, I saw the pieces as forms of prayer interwoven with good intentions and wishes for the well-being of the community. Combining sound and images like the story-singers or *cantastorie* of old, the simple act of bringing the camera to the public or "town square," to gatherings at the community center and rectory as well as masses and devotions seemed to create a participatory space for making meaning.[29] Informed by dialogue and diverse perspectives, different versions of the pieces were played back at the community center for the audience's feedback. As memories begat more memories, many people experienced the distinct feeling that ancestors were present in the telling of stories and remembrance of events. Creating a type of "parallax effect" in their mosaic of voices[30] on yet another level, the shoestring documentaries served as a form of healing from the trauma of loss for members of the community at large.

For me, a good part of this healing occurred in work on one of the very first productions, *Backyard Angels.* It captured the stories of a ninety-five-year-old woman named Maria Michela, who had been an active participant in the Altar and Rosary and Saint Michael Society since she first arrived in Batavia in 1921. Reminiscent, in so many ways, of our grandmother's generation in her intense devotion, spiritual practices, way of speaking English, knowledge of plants, food, and needlework, Maria Michela never failed to remind us of our Italian roots, early south-side beginnings, and our debt to the protective power of the patron saints. Hailing from Valva, in Campania, like many of the Italian immigrants from our grandparents' generation, Maria Michela attributed her good fortune and longevity to faith, the protection of Saint Michael (the patron of her ancestral village in Italy), and the communal spirit and generosity of south-siders. An enduring vestige of the devotion to the saint by the large number of Campanians who had emigrated to our south-side community from Valva during the diaspora, a large statue of Saint Michael the Archangel was one of the few surviving artifacts from the burned wreckage of the first basement church in our community. Day or night, through all the four seasons, the light shone inside the wooden chapel that male parishioners had made for the saint in Maria Michela's backyard. Known to people in the neighborhood, the yard shrine was a focal point for neighbors and relatives from surrounding towns. Asked what the shrine meant to her, the matriarch invariably responded, "I lika to see Saint Mike in my backyard. It makes me feel good. You gotta be good, honey, you can't fool around with the SAINTS!"[31]

Over the course of 1996, while my mother was confined to the house with a terminal illness, I would go out to record Maria Michela's and her families' various comings and goings. Since everyone I filmed in the community knew that my mother was at home, the tapes always contained greetings and wishes for her recovery. When I played it back later in the day by my mother's side, the footage served as healing balm—allowing her to participate, albeit in a virtual way, in the life of the community, ritual celebrations, and prayers.

These experiences helped me to see more and more connections between the process of recording memories through the medium of film and encoding of memories through the production of textiles.[32] A material offering replete with symbolic meanings that could be read and understood by the community, the video *Backyard Angel* came to represent something more than itself. If the documentation of communal memories, actual events, and peoples was similar in any way to plying, collecting, and gathering threads in virtual form, the selection and combination of those images into a forty-minute piece was closer to the process of interweaving.[33]

The editing process demanded not only familiarity with the "loom" of editing technology, but also intertextual awareness and attention to the nuances of the voice, music, and ambient sounds of the neighborhood. One of the most memorable screenings was at the Saint Nicholas club in Batavia's south side to celebrate Maria Michela's ninety-seventh birthday. As progeny, godchildren, friends, and relatives came up to kiss her hand and extend to and receive blessings from the aging matriarch seated in the front of the room, *Backyard Angel* was projected behind her. Time seemed to fold into itself, as the colors and glow of the real and virtual woman and images of her patron Saint Michael overlapped, providing visual evidence of what so many of us in the neighborhood felt in our hearts. While the tactile qualities of real needlework might have been missing in the shoestring production, in some small way the memories recorded in its electronic matrix of sights and sounds had served to capture some of the spirit of my grandmother's generation and the network they had fashioned.

Notes

1. Bury Falliser, *A History of Lace* (London: Samson, Low, Marston, Low and Searle, 1875), 7–8. Needle lace, in the form of the delicate *punto in aria* or "stitch in air" technique, is thought to have come into existence in Italy around the fifteenth century and "was made mostly by nuns, and expressly for the service of the church." Also, as Clara M. Blum explains in *Old World Lace: A Guide for the Lace Lover* (New York: E. P. Dutton, 1920), 13–17, "*punto in aria* broke from techniques like *punto in tagliato* "where a piece is directly cut out of the

material and filled in with a needle stitch [and] *punto in reticello*, the continuous drawing away of the linen to create geometrical borders." Blum goes on to say, "*Punto in aria*'s first use was in the trimming of various altar cloths, albs, etc. of cut and drawn work. It was made in the form of edges and insertions."

2. John Mohawk, *Iroquois Creation Story* (Buffalo, NY: Mohawk Publications, 2005). According to the cosmology of the Haudenosaunee, Skywoman fell through the hole in the sky that formed after a Celestial Tree was uprooted in the Skyworld. This action, based on the fulfillment of a dream, set in motion life on the back of Turtle Island as it is known today. As an everyday practice, beadwork served to reinforce cultural identity and communal bonds by recalling original instructions for the Haudenosaunee to give thanks for the gifts of Creation. As noted by Tuscarora scholar and artist Jolene Rickard in *Across Borders: Beadwork in Iroquois Life*, ed. Kate Koperski (Niagara Falls, NY: Castellani Art Museum of Niagara University, 2005), "beadwork is an artistic medium that crosses the boundaries between Iroquois cosmological space and the physical world."

3. These sentiments are recorded in oral histories of stonecutters published in my essay "The Maintenance of a Commons" in *Uncertainty and Insecurity in the New Age*, ed. Vincent Parrillo (New York: Calandra Italian American Institute, 2009), 199–216.

4. Known as *mucklands*, the marshlands directly north of Batavia bordering the Tonawanda Reservation and Lake Ontario were drained centuries ago for use in farming. The mucklands provided income for first- and second-generation Italian Americans living in the region, and during certain seasons truckloads of Italian immigrants were driven to pick beans and other vegetables on the "mucks." For this hard labor, they would receive a dollar or so a day. In 1996 and 1997 I conducted interviews with local Italian Americans about some of their experiences. See "*Cantastorie*: Ethnography as Storysinging," in *Oral History, Oral Culture and Italians*, ed. Luisa Del Giudice (New York: Palgrave, 2009), 95–98, and the video documentary, *Backyard Angels* (Video) (Passatempo Productions, 1997). Also, *The Legacy of Italian Americans in Genesee County*, ed. Paolo Busti Society (Interlaken, NY: Heart of the Lakes Publishing, 1992).

5. Joseph Sciorra, "Yard Shrines and Sidewalk Altars of New York Italian Americans" in *Perspectives in Vernacular Architecture*, Vol. 3, ed. T. Carter et al. (Columbia: University of Missouri Press, 1989), 193–94. Sciorra observes "shrines can embody both female and male roles." He goes on to explain, "while the permanent structures exhibit traditional male skills, the altars display the feminine arts of needlework, such as crocheting and embroidery [. . .] the elaborate artistic and decorative work 'charges' the construction with power and imbues it with supernatural qualities [. . .] outdoor altars are an extension of one's home into the public sphere [. . .] conceived as sacred space, through which communication with the divine is possible."

6. Sciorra, "Yard Shrines and Sidewalk Altars of New York Italian Americans," 185–98. For further discussion of *communitas* and the "porosity" between heaven and earth, streets and the homes, achieved through communion with the saints in Italian American culture, see *Robert Orsi, The Madonna of 115th Street* (New Haven, CT: Yale University Press, 1985). For a comparative view of everyday links to the supernatural in the celebration of La Madonna del Carmine in Polla, Italy, see Elisabetta Silvestrini, "Corredi e dotazioni delle Madonne da vestire," in *La Ricerca Folklorica* 52 (2005): 17–28.

7. In his study "We Go Where the Italians Live: Religious Processions as Ethnic and Territorial Markers in a Multi-Ethnic Brooklyn Neighborhood," Sciorra argues that these public events were a performance of "intra and extra ethnic difference" and ultimately political (350). *Gods of the City*, ed. Robert Orsi (Bloomington: Indiana University Press, 1999), 310–50.

8. Gloria Nardini, *Che Bella Figura: The Power of Performance in an Italian Ladies Club* (Albany: State University of New York Press, 1999). While I heartily agree with Nardini's explanation that *bella figura* is both a cultural code and central metaphor of Italian life intricately involved with "grace" (5–32), I find the idea that civility as always already linked to city ways limited in regards to immigrant life (45). As I hope to prove through this essay, among first-generation Italian Americans, *rispetto* or respect could be gained by one's service to the communal body—regardless of one's association with the city.

9. Thomas Gullo. Interview by author. Batavia, New York. July 20, 2010.

10. I find similarities between my grandmother's use of rosette/spider web pattern and *reticello* motifs from the sixteenth and seventeenth centuries. See especially plates 82–85 in Alfred Freiherr Von Henneberg, *The Art & Craft of Old Lace* (New York: E. Weyhe, 1931). As Von Henneberg explains, geometric patterns and circular spider web designs of the sixteenth century preceded the use of figural motifs and continuous branchlike sprays in needle lace. In the afterword to Helen Barolini's novel *Umbertina*, Edvige Giunta draws attention to ways that a bedspread or *coperta* embroidered with "the design of grapes, fig leaves, twining ivy, flowers and stylized hearts evoke[s] the longing for the abundance of the homeland." She observes that the *coperta* "symbolizes the protagonist's desire for connection to the traditions of Italy, the continuity of life among different generations and, just as importantly, to a sense of cultural and familial belonging." Afterword to *Umbertina*, by Helena Barolini (New York: Feminist Press, 1999), 436–37.

11. See *The Spoken Word and the Work of Interpretation* (Philadelphia: University of Pennsylvania Press, 1983). Further discussion of "voice as locus of consciousness" and examples can be found in Zinni, "*Cantastorie*: Ethnography as Storysinging," 92–98.

12. Sister Mary Agnes Zinni. Interview by author. Video recording. Batavia, New York. September 4, 2010.

13. In *Meandering Through the Mystery* (Austin, TX: Diocese of Austin, 2009), Msgr. Victor M. Goertz J.C.D. notes how prayer is both an appreciation for and acknowledgment of the deeper mystery of life. He writes, "[F]or the most part, the journey of daily life is not experienced as a boundless exploration of mystery. In the ordinary, day-to-day living, the reality of mystery is shielded from view by the usual, the familiar and the routine" (23). A personal friend of the family who was with my grandmother during her last days notes that Msgr. Goertz often remarked on my grandmother's quiet mysticism.

14. The spiritual covenant and metaphorical relationship between the Church or community of faithful believers and Christ the divine bridegroom is underscored in numerous biblical passages and liturgical services: from the New Testament and writings of Saint Paul about the Church (cf. 2 Cor. 11:2–3; Eph. 5:22–27); to the gospels (cf. Matt. 9:15; Mark 2:19–20; Luke 5:34–35, John 3:29) to parables about marriage (Matt. 22:2–14, 25:1–13); to passages in Revelation that allude to Christ in his mystical incarnation as "The Lamb of God": "Hallelujah! For the Lord our God the Almighty reigns. Let us rejoice and exult and give him the

glory, for the Marriage of the Lamb has come, and his Bride has made herself ready; it was granted her to clothe herself with fine linen, bright and pure—for the fine linen is the righteous deeds of the saints" (Revelation 19:6–9).

15. Sharon T. Strocchia's study of a consorority of nuns and laywomen known as *La Compagna dei Miracoli* or Company of the Holy Miracle in "Sisters in Spirit: The Nuns of Saint' Ambrogio and Their Consorority in Early Sixteenth-Century Florence," in the *Sixteenth-Century Journal* 33, no. 3 (2002): 735–57. Strocchia discovered that the upkeep of a eucharistic altar and holy relic by *La Compagna* provided a unique space not only for organized religious expression but for social integration. She writes, "[A] thicket of networks" linked "the nuns to secular kin, friends and enabled cross-cultural relations in a structured environment" while prayer meetings, monthly masses, and other feast days "offered the occasion for sociability and the demonstration of individual largess in almsgiving, and/or remembrance after death" (762).

16. See Falliser, *A History of Lace*, 1875. Various semiotic studies are just coming to light on the significance of some of the geometric patterns in women's needle lace. If there is any clear evidence of the extent to which needle lace was used to pass on cross-generational knowledge, it is contained in the oral histories and ethnographies of immigrant women.

17. Bonnie Young, "Needlework by Nuns: Medieval Religious Embroidery," *Metropolitan Museum of Art Bulletin* 28, no. 6 (1970): 262–77. On the use of color as a visual code in medieval memory books, see Mary Carruthers, *The Book of Memory: A Study of Memory in Medieval Culture* (New York: Cambridge University Press, 1990), and Ivan Illich, *In the Vineyard of the Text: A Commentary to Hugh's Diadacalicon* (Chicago: University of Chicago Press, 1993).

18. Drawn in part from linguist Roman Jakobson's view that poetics is not confined to the verbal arts and Michel Bakhtin's insights into *heteroglossia* (the idea that every text carries with it *utterances* or traces of voices from other times and places), as early as 1985, Barbara and Dennis Tedlock's groundbreaking study, "Text and Textiles: Language and Technology in the Arts of the Quiche Maya," in the *Journal of Anthropological Research* 41, no. 2 (1985), revealed how geometric, indexical, and iconic designs in Mayan textiles contain elements of syncopation and symmetry.

19. Sciorra, "Yard Shrines and Sidewalk Altars," 1989. See also, Sciorra's "Multivocality and Vernacular Architecture" in *Studies in Italian American Folklore*, ed. Luisa Del Giudice (Logan: Utah State University Press, 1993), 201–43.

20. In an interview conducted by this author with needleworker Elaine Greiner (August 2010), Greiner used the term "muscle memory" to explain how movements and rhythms of the hands take on the speed of automatic reflexes. My views on this subject are drawn from the insights of Barbara and Dennis Tedlock on textiles as chronotypes of time and space in "Text and Textiles" (1985) and Barbara Tedlock, *The Woman in the Shaman's Body: Reclaiming the Feminine in Religion and Medicine* (New York: Bantam Books, 2005).

21. As Marcia and Robert Ascher remind us in *Code of the Quipu*, 1981, "the manner of recording and the recording itself are decidedly rhythmic; the first in the activity; the second in the effect" (61–62). Joan Saverino asserts, "[N]o full exploration of women's role in the (re) production of culture exists. The result is a forgetting, an erasure of part of the lived experience of a people" in "Embroidery as Inscription: Memory, Meaning and Life Integration"

(paper presented at annual meeting for the International Oral History Association in Rome, Italy, June 23–26, 2004); see also Saverino's chapter.

22. Kay Martino Ognibene. Interview by author. Batavia, New York. August 20, 2010.

23. Carol Lombardo Mruczek. Interview by author. Batavia, New York. August 20, 2010.

24. Along with its profound association with rebirth and regeneration in the Catholic faith, the color white retained its ancient "pagan" provenance through associations with water as the cleansing, purifying, and healing aspect of transitional phases in a person's life. Hence children are dressed in white gowns when they are baptized with holy water into the Christian faith just as, at the end of life, holy water is sprinkled on the white shroud covering the casket of the deceased. Fashioned after the example of Moses's garment, the undergarments of a Catholic priest's vestments, such as albs and surplices, were always constructed out of white cotton or linen. From the writings of Gulielmus Durandus (1237–1296), *Sacred Vestments: Rationale Divinorum Officiorum*, trans. Thomas Passamore (London: Sampson Low & Marston, 1895), 120–39. The color white was associated with hope, the brightness of the morning star and angel heralds, and the host of angels in the heavens. As such, white albs and chasubles were specifically used for rituals associated with Christ's birth and rebirth into new life like the Feast of the Annunciation, Nativity, Epiphany, Resurrection, and Ascension. White vestments are also used on the dedication of a church, underscoring the mystical relationship with the communal body of faithful as the "Bride of Christ" (1–22; 24–28; 48–54).

25. Barbara and Dennis Tedlock, "Text and Textile," 1985. See also my dissertation, "Interweaving: Memory Through Machines" (Ph.D. diss., University of New York at Buffalo, 2007). I am indebted to Dennis Tedlock for his feedback, trenchant insights, and generosity as a scholar.

26. Sciorra observes, "[S]idewalk altars and shrines are a public proclamation of faith and belief in the saint's power to protect. As such they demonstrate a system of reciprocity linking heaven and earth," in "Yard Shrines and Sidewalk Altars," 187.

27. Thomas Gullo. Interview by author. Batavia, New York. July 20, 2010.

28. I am indebted to a number of people—most especially Ester Rossi, Tom Rosica, and the input of media artists from Rochester, New York, who taught me how to edit on (then state-of-the-art) three-quarter-inch analogue tape decks and helped me produce my first piece: *La Vita Nuova* (Video) (Passatempo Productions, 1995).

29. Zinni (papers presented at annual meeting for annual Oral History Association [OHA] Buffalo, New York, October 15–18, 1998 and the International Oral History Association [IOHA] in Rome, Italy, June 23–26, 2004); *Interweaving: Memory Through Machines*, 2007, and "*Cantastorie*: Ethnography as Storysinging," 2009. Also, Luisa Del Giudice's "Ethnography and Spiritual Direction: Varieties of Listening," in *Rethinking the Sacred*, Proceedings of the Ninth SIEF Conference in Derry 2008, ed. Ulrika Wolf-Knuts, Department of Comparative Religion, Åbo Akademi University, Religionsvetenskapliga skrifter, 2009: 9–23.

30. The term "parallax effect" is drawn from an influential article by filmmaker and anthropologist Faye Ginsburg, "The Parallax Effect: The Impact of Aboriginal Media on Ethnographic Film," in *Visual Anthropology Review* 11 (1995): 64–76. Ginsburg uses the term to explain the numerous ways culture can be represented, quoting from the dictionary,

"the apparent displacement or the difference of an object as seen from two different points" (*Webster's Third International Unabridged Dictionary*, 1976) (64).

31. Maria Michela Tenebruso. Interview by author. Video recording. Batavia, New York. May 13, 1995. In "Yard Shrines and Sidewalk Altars," Sciorra observes that "by displaying religious states and erecting yard shrines and sidewalk altars, Italian Americans make a public proclamation of faith, announcing from their homes and neighborhoods that they are protected by the powerful saints they venerate" (186) and "placed outdoors, the saint statue is testimony of the special relationship a family enjoys with the supernatural" (197).

32. Aiding in what Saverino astutely pointed out is the "life integration" process in her essay in this book. As Edvige Giunta observes in "Teaching Memoir at New Jersey City University," "memoir is a powerful tool, especially for women and minorities to record traditionally unspeakable and unspoken stories," in *Transformations* 11 (2000).

33. Zinni, *Interweaving*.

Canto for a Quilter

—Marisa Frasca

earliest surviving quilted coverlet

I want to name you Cantacutra, say your offering is not lost.
Your Tristan quilt hangs on a museum wall. We marvel
at the faces, the cotton corded knights in battle, how tight
the *trapuntato* stitch, eight to ten per inch.

How abandoned your lovers in relief medallion of rolling hills
& fields of fleur des lis. Who kissed you, Cantacutra?
Did the brave knight lift your heart as you knotted, twisted
threads into Sicilian verse? *Tristaiunu dai lu guantu*

Tristaiunu a tradimantu sings your needle upward,
downward, as Iacopo da Lentini sang with ink and feather.
I seem to be forever watching you pour life
into a coat of arms, eyes transfixed on Tristan folded on your lap

as you stitch and backstitch into the passing centuries—linen
threads of cream & white—for someone else's wedding night.

SKILLS AND ARTISTRY

Great-Grandmother's Ocean

2004
Linen thread, iron artifacts, fabric, Plexiglas, wood, 2' x 8' x 8'
Photograph by Christopher Burke

—B. Amore

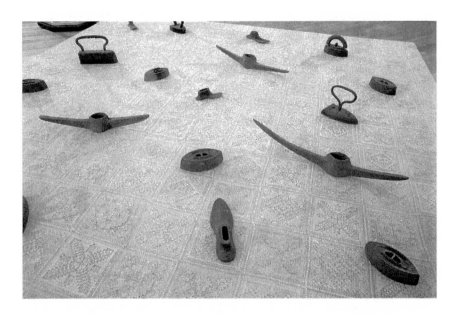

It was my grandmother, Concetta De Iorio, who taught me the Italian word for thread, *filo*. It was she who stitched the past, present, and future of our family together. Her stories of Giovannina Forte, her own mother, inspired the sculptural installation pictured here. Giovannina's dowry bedspread, which she brought with her when she crossed the ocean in 1901, represents an entire way of life, a time when young women spent years sewing their *corredo* or trousseau in preparation for their betrothal and marriage. The bedspread was woven in the latter part of the nineteenth century (Giovannina was married in 1881) in Lapio (Avellino province), in Campania.

The "filet" technique is executed in the same way as a fishing net, only smaller in scale. In this example, each individual square was stretched on a frame and then embroidered using the weaving techniques *punto tela* (linen stitch), *punto rammendo* (darning stitch), and *punto spirito*, a delicate and decorative stitch in which the threads are wound around the corners of the net, making the filled-in areas more decorative. The squares are joined by the use of a cross-stitch, belying the skill of the *ricamatrice* (embroiderer) who hid the knots of the net, employing precise, even stitches throughout, which resulted in perfect squares. These are just a few of the techniques used in this exquisite example of a way of weaving that is centuries old and largely lost to the modern world.[1]

In this installation, the entire weaving is spread over a plane of frosted blue-green Plexiglas, which symbolizes the ocean of immigration. Antique irons and pick-axes float like boats, traversing the vast space, stretching from Giovannina's Irpinian hill town to *L'America*. The installation evokes the labor of both men and women. Often men's labor was back-breaking: Their picks and shovels dug the deepest subway tunnels and miles of railway beds. Their masonry skills constructed the brick buildings we still inhabit. The women usually labored in sweatshops or doing "homework," the term commonly used for sewing that was brought into the home, making the immigrant kitchen a de facto extension of the factory floor.

In the early twentieth century, approximately one-fifth of the workforce in the men's garment industry that manufactured male clothing were female home finishers, almost all of them Italian women and their children.[2] My great-grandmother, Giovannina, a skilled needlewoman, worked in the Aieta Tailor Shop in Boston's North End. After moving to America, she never created a work comparable to her dowry bedspread. Instead, she became a wage earner, using her skills in the hidden stitchery that underlies the collars, lapels, and buttonholes of finely tailored men's suitcoats.

For me, the stories of Italian immigrants are sewn into the stitches of the women and preserved in the constructions of the men. From the mundane to the extraordinary, the objects themselves tell the story of immigration. The traces of people mark the remains of their handwork. The past does not feel so far away when I touch the fine linen thread of the bedspread that my great-grandmother wove one hundred and fifty years ago. Her fingers touch mine and my grandmother's voice whispers in my ear—"*filo*"—the thread that sews history into one delicate, open piece.

Notes

1. Special thanks to Giovanna Bellia LaMarca, who provided this information gleaned from *Nuova enciclopedia dei lavori femminili*, 7th ed. (Milan: Edizioni Mani di Fata, 1971).

2. U.S. Congress, Senate, Report on Condition of Woman and Child Wage Earners, vol. 2: Men's Ready-Made Clothing, S. Doc. 645, 61st Congress, 2nd sess. (Washington, DC: Government Printing Office, 1911).

Filatrici: Stitching Our Voices Together

—Joanna Clapps Herman

Italian cousins are a special kind of intense friend-siblings. Gilda, Diane, Lucia, Joanna, Clorinda, Beatrice: We were the six older girl cousins in my large Italian family in Waterbury, Connecticut. There were two older boys, then the six of us girls, then six younger boys, and finally two younger girls. So, symmetry and alternation: boys, girls, boys, girls. The six girls were planets in our own universe, orbiting the sun of our mothers and aunts—playing house, dolls, school, secretary, doing acrobatics, swimming, riding our bikes, hiking, running, running to the store, climbing out of windows, climbing trees, doing housework, lollygagging in order not to help our mothers, fighting, skipping, cooking, sewing. We slipped in and out of one another's yards, houses, chairs, beds, swings, and cellars. We used our hands to hold and twist everything within reach to make what was at hand into what we wanted. Working with needles and threads for the women and girls was one of the intense centers of this making. All the grandmothers, all my aunts, and all my very first friends in the world, my girl cousins, were involved in this.

We lived in one another's hair then. We live in one another's heads still: These women are my sisters. Our lives and voices were bound together by needle and thread: Jill, Didi, Lulu, Jojo, Linda, Bede. I have spun our voices in one.

I

The needle is held precisely between thumb and forefinger, the thread is licked between the lips and the tongue, the end of the thread is bitten sharply off with the front teeth so that the tip is clean and wet and will slip easily through the tiny eye of the needle.

"You roll the end of thread around your finger, like this, and pull it tight, down to the end to make a knot. Now you try it. No, just one knot is enough."

The needle penetrates the fabric, the long gentle pull through, then the final satisfying tug, to join, to hold, to finish. The soothing repetition of these

motions, a kind of breathing—each stitch an inhalation, exhalation, each stitch bringing a deep immersion, disappearance into this other, like reading, meditation, swimming, or prayer.

II

We watched as the fingers of the elders flew and fluttered, fastened and fixed with needles and thread and yarn in the air around us as commonly as brushes and combs, forks and spoons. Needlework was a major idiom, the language of thread spoken between our women. The older the woman, the more elaborate her skills. In Italy, they grew up spinning and weaving, making their linens for their future homes, putting them in *le casse*, the chests for keeping their *biancheria*. They learned to make lace to trim those *lenzuola* and their *fazzoletti*. All this came on the boat with them, carefully packed in *le casse*.

They sewed, crocheted, knitted, embroidered, tatted: made clothes, blankets, spreads, shawls, embroidered pillowcases, all of this flowing out of their dexterous fingers and needles. We'd stand near them, watching the art of something from nothing come from threads and yarns and needles, using patterns they had learned as children and given to us in turn. Needles and threads were at one with sitting.

They made most of their family's clothes, and although our grandmother had her own treadle-foot sewing machine in the sun parlor, she might just as often sew a garment by hand.

"A peddler would come around selling bolts of fabric and we'd all look. Then Mama would choose one or two bolts, and that would be our fabric to sew for that year. She would cut out the patterns for dresses, shirts, and pants for everyone, for her own dress suits—from memory." Only the patterns they had learned at their elders' knees. Pleating was embedded in the shoulders and under the arms of these clothes to allow for many growth spurts.

"After Mama made all of our clothes, we were allowed to have the rest of the fabric to sew with for ourselves. That was a big treat."

III

Sewing provided my mother the first aesthetic control she had over the chaotic life of the farm. She told us with pride, "Once, when my mother went to Saratoga for her rheumatoid arthritis, I decided to paint the downstairs and sew all new curtains for the dining room and living room."

She made her own clothes, elaborate outfits, as soon as she was able: dresses and suits with inset panels and complicated pockets. She tailored each garment to sit close and easy on her lovely young body, to be elegant and stylish, like the women in the movies she and her sisters went to see. Her sewing machine always sat prominently in our kitchen. It was her passion, her joy.

"After I bathed you girls and put you to bed—Dad would be down the street—I'd put on the radio and take out whatever I was working on at the time. I always had something going, something for you girls, maybe matching dresses—remember the plaid taffeta ones?—or Easter suits for all of us or a dress for me. If the weather was warm, I'd open the windows and lay out the cloth and the pattern, say, and I'd pin the pattern and cut the cloth. That might be all I'd do one night, but it made me so happy. I looked forward to it all day. That I would have that time to myself. Oh, how I loved it."

My sister Lucia reminds me on the telephone, "Mom always said, even if I only sew one seam, I'm satisfied. Always have to have something going. Promotion dresses stand out! Turquoise taffeta. And all those matching dresses we had. I remember waking late at night to the sound of mom's machine tearing along. She really worked that thing! It was not a contemplative activity for her!"

If stitching was meditation, sewing on the machine often started as a hum, then a revving up, zip, zip, then into a tearing roar—the machine speeded up into an explosion of stitching. It was less a machine than an animal of stitching, its needle moving up and down so fast it was a small terror of mouth eating up fabric and thread. The sewer fed the creature as fast and straight as possible.

She made our sundresses, our pinafores, our ruffled skirts, our halter tops, First Holy Communion dresses, our confirmation dresses, our first-day-of-school dresses, our promotion-day dresses. While we watched, we got fitted and later wore her work proudly. And later than that the pleasure of these skills was passed to us.

IV

"Button, button, who's got the button?" we sang to one another as we sat lined up on the bed in the kitchen. Each of us had hands folded prayer-like in front of our chests. The one who had the button hidden between her prayer hands went down the row, chanting, "Button, button, who's got the button?" while she put her hands between all of ours and dropped the button into a set of waiting hands. The giving over of the button was partly to

hide it and partly to confer honor on her cousin. Each girl pretended ostentatiously that none of us had the button while one of us guessed who actually had it. If you guessed right, you got to be the one standing up to become the next button giver. Otherwise, the person who had the button secreted in her hands got to continue. Oh, the importance of that position! It seemed to me we played that game for uncounted hours. The pleasure of whiling away hours playing button, button!

"Grandma Becce taught me to embroider flowers and leaves. We embroidered on dish towels for practice first, and then we moved on to pillowcases. We'd cross-stitch—little samplers—but I think Aunt Antoinette showed me that. I have these amorphous memories of being surrounded by women who taught me things, and each picked up where the last one left off. There were so many visitors to our house on the farm that I don't have clear memories about who taught me what. And of course all of you older cousins taught me what you knew as well."

"How do you do that, Aunt Dora?" She's sitting in our kitchen by the pantry, crocheting. There I watch her nimble fingers fly fast, rhythmically, evenly, the stitches quickly accumulating row upon row.

"Oh, you want to learn how to do that?" a big laugh, she lays her work down in her lap. "OK, I teach you," she picks it up again. "Here. You take this crochet hook. First wrap the yarn around this finger here like this. Hold it tight in your hand. Now hold the hook like this, see, now bring it under the yarn in the other hand, see . . ." It wasn't so much language as it was all in the way the hands showed and guided. The needle is looped through the yarn, not the quick bird plucks now, but the exaggeratedly slow ones so that we can watch its loop, return, loop back in, pull up, finish. Her large belly sits back in the chair, she holds up the work, then we both bend over it to inspect. "Hmm, you see." Nod, nod.

V

Someone showed us a new thingamajig. I can't remember where the first one came from or who showed us how to do this. We'd beg for the largest empty wooden spools of thread. Then tiny nails were hammered into the top, and voilà, we had made small knitting machines. Thin cotton yarn was wound in a very particular way around those nails; then, using a crochet hook in a series of loopings and hookings, you released a tail of knitting that emerged row by row from the bottom of the empty wooden spool. Each of us would try to outdo the other girl cousins in making the longest one. I remember that eventually we all reached the length of the sun parlor,

which was about twenty-five feet. That was the goal. At some point we'd tie them off and sew them into circles, which we made into trivets for our tables. But that was an afterthought. The point was to do one longer and faster than anyone else.

VI

We'd be strewn around the room—a couple of us lying on couches, two or three of us stretched out on our bellies on the floor, or sitting on the arm of one of the solid old maple chairs the older cousins sat in, standing and sitting, all talking at once—each trying to get their say in, but there was no question that Gilda was the oldest of the girls and special for it. She was also taller and had already finished first and second and third grades. Gilda had two older brothers and a newspaper route and knew about everything first, long before we did. So, she was our queen, what we all aspired to be like, a dancer, full of what I would later know was called savvy. So, Lucia and Diane, the next two cousins in age, her handmaidens, could get her attention easily. Linda, Bede, and I had to push our way into the talk trying to have our say, too. But Gilda and her handmaidens would loftily tell us, it wasn't like that for third-graders. We'd have to wait until we were older. Then we'd see. Still, it was all girls and talk and connection. "Look at how long mine is. How do you tie on some new yarn?"

It was just us, the girls, wrapped around one another in play, in hierarchy, in competition: Gilda, Diane, Lucia, Linda, me, and Bede. Yes, we'd see.

VII

"Remember the packages to Italy? The boxes would go on the table up the farm. They'd take whatever they were sending, put it in a box, but then they'd wrap it in fabric. Was it heavy muslin? And we'd hand stitch all the seams. After that they'd seal the package with wax, melting it all along the seams with an orange wax. I wonder why we did that. Was it to make sure that no one opened it before it got there?

"We were taught early to darn socks, to sew buttons back on our own clothes. 'Do it in a pattern, either from hole to hole or in an X. But don't do it every which a way. It looks funny that way. Take it out and do it over again.'

"All the baby bibs we made. Then we'd embroider them. I made one for Rocky. I was sitting with Aunt Bea up [on] the farm while I was embroidering and shyly saying I know a song that is just right for him. 'What's that?'

she says (I can still see her sweet and amused smile). I sing, 'Baby face, you've got the cutest little baby face, and there is no one who can take your place.' She laughed that lovely gentle way she had. We had so much time. We simply inhabited our days then. I don't know what we do now."

VIII

Every summer Grandma Crawford and Aunt Antoinette came to visit the farm and helped with the mending—some of it having accumulated from their last visits. There would be baskets of clothes with holes and missing buttons and torn sleeves, socks with holes, piled high in the sun parlor. They did this with pleasure and ease. They wanted to help my overworked Aunt Bea. Aunt Bea had five children. She did all the cooking, always had food and drink for all the endless company coming and going on the farm, for all the extra harvest help, did all the canning and cleaning of the vegetables, did all the cheese making, and all the making of sausages, and, with Grandma, all the putting up of the prosciutto.

After they'd sewn back three buttons, a deep draught of the icy lemonade was made for and carried to them by my cousin Bede. A deep breath, a careful wipe of the bottom of the glass on their aprons, the glass set back down on the table at their side. They sat for hours looking up from their work over the high grassy fields and the wide blue lake, and back down to their work, slowly reducing those piles into submission.

"I'd thread a bunch of needles at once so that they wouldn't have to stop when they were in the middle of their mending and they could just keep going. They'd tell me how many to do with white thread if that's what they were working on right then. Later my brothers Rocky and Vito would thread the needles for them, too. But you know that was usually our work. The girls inside, the boys outside."

IX

All day our fingers moved: quickly, deftly, delicately, twisting, turning, tying, binding, joining; we pinched, pinned, picked, prodded, poked; our hands lifted, threw, sorted, stirred, smoothed, soothed; these, our most essential tools, fingers and hands—the co-joined extensions ready for our endlessly capacious manual life—cooking, gardening, laundering, ironing, cleaning, painting, bathing, picking, preparing, *but* needlework was also our artisanal satisfaction.

"I was about eleven, I think. My mom was expecting Danny, and I wanted to make something for the baby. Grandma wasn't happy that I was allowed to know my mother was expecting. I don't know how we got past that to the sweater.

"But that was the first time I made something that was actually useful. I can remember learning all the hooks and loops. Grandma taught me a stitch that was called a triple loop. You crocheted three loops before hooking into the next loop. I made a hat to match, a little layette; I felt competent to be able to do that. I wonder what happened to that sweater set. My mother had him wear it. So, I guess it must have come out all right. I'll have to ask her.

"As we got older, we made our own Easter outfits. I remember staying up into the middle of the night to finish an outfit to wear that next day."

As hard as the men and women in our world worked, still there was time enough for coffee, coffee and sitting on the porch talking, platters of watermelon eaten with huge slurps on a hot summer day. We were all of one place, all of this family, all of being together.

X

"In my mother's kitchen there was a small yellow cupboard. One drawer was filled with buttons that had been cut from clothes that had been made into dust rags. Another drawer held jars of hooks and eyes, snaps, black or silver, each jar color-sorted for when you needed them. The next drawer was filled with neatly sorted and color-coded rickrack, bias tape, binding tape. Another drawer held zippers that had been ripped out of old clothing.

"On shelves at the back of my mother's closet there were shoe boxes filled with more zippers, sorted for color and length. There was one box just for beige, another with just white, then a box of black, and finally a multicolored box. You never bought a new zipper unless, strangely, there wasn't one that matched the cloth you were working with."

Our eyes fell naturally into the laps of our grandmothers, our great-aunts, our mothers, our aunts as they sat and worked. It wasn't even always a passing on to us of these skills, this capacity; it was the natural order of things. Needlework was a major idiom, our language in thread.

Running stitch, basting stitch, backstitch, blanket stitch, buttonhole, hem stitch, slip basting, the whip stitch. Each one carefully demonstrated—the older woman looking over the girl's shoulder, "Make small, even stitches; the smaller the stitches, the better the work." The girl bent over the fabric, the needle in her hand, the fabric passed back for another careful and slow demonstration, "Now watch, see how I put the needle just under the fabric here."

The girl's chin is lifted in concentration. Initiate, novice, apprentice—there is only mutual concentration between them, the fabric, the needle, the stitch, and the passing on of this dexterity. "You should almost not be able to see the stitches if you've done them right."

"The buttonhole stitch is the same as the blanket stitch only very tiny and very close together. You cut the slit later. First you do the two rows of each side, leaving enough to cut open the middle." A revelation: big made little creates another skill.

XI

"When I was about twelve or thirteen I bought ten yards of an orange calico for ten cents a yard with my allowance money. I was so thrilled with my bargain, and I started to make my first dress. It was going to have a fitted bodice, with a very full gathered skirt and puffed sleeves, a zipper in the side. I worked on that dress for probably a week. When the dress was finished it was all there, but I knew I would never wear it. The sleeves weren't set right. The zipper was set in lumpy. First I took off the puffed sleeves. I was going to make it into a sleeveless dress. Still not right. I decided to take the bodice and the skirt apart and make a blouse and a skirt. It would be easier to do separate zippers. It still didn't work. I decided to just make a full gathered skirt. With a cummerbund waistband. I can't remember why that didn't work. In the end the ten yards was reduced to a not so great orange calico cummerbund, and I was deflated but after that I knew how to sew. I learned everything on those ten yards and the endlessly revised dress and that final cummerbund. I think I may have worn the cummerbund twice. I can see it hanging on a hook in my closet, the banner of my apprenticeship."

XII

All the aunts and mothers used the tiniest stitches for hand finishing, careful buttonholes, invisible hems. We were taught to do the same. A hem should barely show, if the stitches were small enough and even enough. We had contempt for hems that were doubled over. You could see the bulk at the bottom of the shirt or leg. Terrible. Bad sewing. Their mothers didn't teach them right.

"Whenever I wanted my mother to sew something special for me, she'd say, 'Well then, you have to cook!' There were four kids, and I was the oldest.

I'd desperately want something special, a fancy sleeve or a pocket so I always agreed to cook!

"She'd be sitting at the sewing machine by the window looking out over the yard and my father's garden. I'd be at the other end of the kitchen by the stove. From where my mom would sit, she would give me my instructions. She'd never look up from the sewing, to see if I was doing it right or come to the stove to check on things. She'd sew. I'd make the meatballs—'Now put breadcrumbs in,' she'd say as she bent over the Singer. 'How much?' 'Just shake some in.' Of course, we had made the breadcrumbs by rolling dried bread between two sheets of wax paper. Every ingredient gained me a seam or two.

"'Now chop the garlic, and add it to the heated olive oil. When the garlic's brownish, add the tomatoes.' 'How brown, how much tomato?' 'Brown, not too brown. Golden brown,' as she concentrated on the sewing. 'You know, one of the jars of tomato we canned this summer.' As long as I heard the sewing machine humming along, I kept cooking.

"You know the sewing-machine stool was always my seat at the dinner table. No one ever sat on the sewing-machine stool at dinner except me. Every night, I'd carry it from under the sewing machine and bring it to the kitchen table. I guess that stool brought the cooking and sewing together. She did teach me later, but it ended up that I liked to cook better."

XIII

Auntie Ag would carefully pull out the hemming stitches if something had to be re-hemmed so that she could reuse the thread. She'd wrap the old thread around an empty spool she had saved just for this purpose to be used again. If she didn't have an empty spool she'd use a piece of folded paper. The crimped threads from the commercial hems unwrapped as she threaded the next needle. The lick, the point, the aim, and the slipping of the thread in. She'd pull the thread through, then flatten each crimp with the wet tips of her fingers. A head tilt, a leaning toward the window's light. Yes, it looks good.

"Even though I never liked sewing, after I took sewing classes in grammar school my mother would make me take the old sheets when they were worn out in the middle and cut them up into squares and rectangles. Then I had to hem those pieces to make handkerchiefs and *mappines*. Nothing went to waste in my mother's house. Nothing. We reused everything.

"My grandfather Louis always wore a white dress shirt, and when his collars got frayed my mother would take them off and turn them the other way around and sew them back on. My god, how hard she worked.

"And she used to make all my dance costumes for the recitals. Then the other mothers asked her to make them for their children, too. She made a little extra money on the side that way every year. She'd be sewing until the middle of the night in the room off the kitchen.

"But I was never interested in sewing. I was always at the dance studio working with Barbara Hyland."

XIV

Over stitch, over casting, over basting, interfacing, linings.

"My grandmother Padula made gigantic bedspreads of fine lace for everyone in her family from thin, thin thread. So delicate, so intricate—she crocheted them. Then she made me a gold crochet dress from brown satin ribbon. So beautiful. I still have it.

"Did you go to the Girls' Club, too? I was so excited. I asked my mother to sign me up for art classes, but instead she signed me up for sewing and cooking. 'What good are art classes going to do you?' I was so disappointed. But it was a nice place; it had a lovely feeling to it. The women were so lovely, made it a warm welcoming kind of a place. I loved learning to sew, but I had been so excited that I was going to take art classes."

XV

In seventh and eighth grades we took sewing and cooking classes at school, but by then our mothers had taught us more than the teachers could pass on. We used those classes to make new clothes for ourselves. Half the time we were teaching the other kids how to do it.

"Iron the fabric first. The pattern will sit better on the fabric. Lay it out on a hard surface. Take the time to clear everything out of your way. Use the floor or the table. Pin it slowly. Basting can save you a lot of mistakes. Don't skip that step."

Iron, layout, pin, cut out, pin, baste, sew, press the seam open. Seams, darts, gathers.

"Remember the circle skirts in grammar-school sewing classes?"

We didn't use thimbles; the tips of our fingers were filled with tiny perforations, sometimes tiny drops of blood, especially if it was a big project—over the years the hems of our skirts got wider and wider, and then came the years of crinolines.

XVI

"We loved going down to Bedford's and Fishman's fabric stores. We'd spend hours there looking through long rows of pattern books, Butterick, McCall's, Vogue, each of us roaming around, feeling fabrics for long contemplative hours.

"Silk organza, taffeta, satin, peau de soie, bouclé chiffon, silk crepe de Chine, the luxurious sounds wrap around my tongue, the feel of their lusciousness in my hands; muslin, lawn, tulle, georgette, white eyelet, madras for summer; the lightness in the hand, the heft and substance of gabardine, corduroy, a good Scotch wool plaid, herringbone, and mohair for winter. We'd run the names over our tongues with the pleasure of touch and competence as we discussed which to use for which garment.

"The first prom dress I made was out of gorgeous white satiny fabric. The top was strapless, and it was very fitted and came down just over my hips. Then I made a skirt that sat under the top. I think I used two different patterns for that gown.

"We went on to suits and prom dresses, kind of fearless. Well, because everybody did it and nobody acted like it was hard. Remember having to stand on the kitchen table and turn slowly, slowly while someone else 'pinned you up'? Mom bought that weird contraption with the movable ruler to measure how high from the table you were to mark the hem. Then we'd squeeze that rubber bulb from which a white chalky powder puffed out of this thing to mark the place. It was all marked for you to pin it up. We thought this was the height of fancy. We did sew like crazy, didn't we?"

"What do you think of this pattern? Does this color work on me?"

We'd savor the touch and weigh the fabric gently in our hands. We'd consult each other. Enjoy each speculation. Satisfied with our decisions, we'd take our fabric and patterns home on the bus to the North End. There was the sheer joy of entering those tiny *bijou* notions stores with their shelves running to the ceiling, their cabinets full of sewing supplies: pins, needles, chalk, buttons, snaps, zippers, ribbons, tapes, rules, scissors. I can see the spools of ribbons. Grosgrain and satin ribbon spools, lined up by color and width so that you could look, touch, unspool them, imagining that someday you might be able to buy as many yards as you liked in every color and width—buy the widest one in blue for a sash on the next dress you're going to make. But for today you had enough to buy a half of a yard of one-inch red grosgrain ribbon to tie up our pony tails. Row upon row of what we might need, all calling to us for what we might make. "I'm going to have to take this in. Would you pin it for me?"

"For my junior prom I was still sewing my prom dress, my hair up in curlers when my date arrived, with his corsage. My mother tsk-tsked, 'I'll finish it for you. Go get ready.'

"'It's OK, Mom. I'm almost finished.' I couldn't have her take that powerful I-made-it-myself feeling away from me at the last minute.

"'I'll be ready in a few minutes.'"

As much our world as the world of the women now.

"When I was in high school I worked at Eli Moore's, and I told them I'd do all their alterations for customers. How nervy. I'd never do that now. But I did it then.

"Later I worked for Mr. Marshall, who had an upholstery store. I learned so much from him. I learned how to make draperies; how to put fabric on the walls, how to make piping, cutting the fabric on a bias, how to make slip covers. He was from Scotland. I helped him make huge fantastic drapes for some theater in Waterville. That was amazing. Whenever a customer was coming in the store he'd say, 'Hide these other bolts of fabric and get her fabric out so she'll think we're only working on her job.'"

XVII

"After college, my sister began to spin and weave, and she brought her work up the farm to show our grandmother.

"She went quietly off into the dining room and pulled this spindle out and pulled out a beautiful piece of heavy linen, a dish cloth, and she described the whole process to me. How they raised the flax and then they would cut it, then lay it in a brook with stones on top so that the water running over it would break down the fibers, softening it, getting it from a piece of plant life to something you could spin.

"'That's an old thing. I use it when I was a little gal in *mia madre*'s house. I bring it in *le cass son venute con me. Tre cass'. Biancheria e roba da mangiare, tutt le bianchiari* (in my chest, three chests came with me *ala'Merica*, my linens and stuff to eat).' Grandma said to Lucia, laughing, showing us her old spindle. 'Grandma gave me that spindle.'"

XVIII

By the last part of her life, when she wasn't working, my grandmother's hands, twisted and broken with rheumatoid arthritis, lay mute and stupid,

two drugged *bestie,* still in her lap like the merely momentarily abandoned tools that they were. As twisted and as full of pain as they were, she'd always pick them back up and set them going again.

We were a world unto ourselves, the Girls Club, the Home Economics classes—these, these were all just small extensions of the important center—us, our fabric, our family, the girls, all of us on the couch playing button, button, on the sun porch making our long, long tails on the thread spools, at our machines making our clothes, measuring and pinning one another's hems. The outside world just wasn't that important. It was just there for us to live in. We were almost too busy with work and play and ourselves to pay it much attention. It was 'Merican and bland. Our world was rich and complicated, full of us and making. One generation to the next, the grandmothers, mothers, aunts, and the girls.

We didn't know what we did was highly skilled or astonishing. We were having fun. We made things. From baby bibs to prom dresses. We lived in a land where what isn't—then is. The reach toward the fatal human aspiration—trying to touch the divine—making—the making—ex nihilo—from that which has never been to that which now *is!*

The lady in the hat

for patricia landrum

—Rosette Capotorto

The lady in the hat said to me
darling you don't know
what good is
til you've
 heard me read

 my poems
 like jewels
are high priced
not just for any ole

my poems
go where certainly
no man can go
 and where few enough
 women meet me
for a cup of tea
 at day's end

I write with a dainty hand
 but don't let dainty fool you
 where I
come from dainty means
 something
 other
than what you're thinking

dainty is
 a finely made thing
that does not come apart
 in two/three
 washings. No this dainty
this piece of work
 stays fresh and beautiful
 forever

From Domestic Craft to Contemporary Arts: Needlework and Belonging in Two Generations of Italian Australian Artists

—Ilaria Vanni

Familiar objects—things used every day—lose and acquire meanings in the process of migration. The semiotic of objects related to needlework is particularly relevant. Graziella del Popolo, who migrated from Italy to Australia in 1968, illustrates the importance of needlework in the experience of Italian migrants in a memoir collected as part of "Belongings," the New South Wales Migration Heritage Centre's online exhibition on post–World War II migration memories and journeys:

> We had brought two large trunks and lots of suitcases with us. Dad had told mum to only pack winter and summer clothes, shoes, sheets and towels but nothing else, so mum sold everything else before we left Italy. Dad also said, "just bring yourself and make sure that you cut off all that hair and wear lipstick." He said, "don't come to a big city with your hair in a bun." So Mum reluctantly had a perm. I thought that she looked gorgeous but she felt so ashamed that she wore a scarf.
>
> These sheets were in one of the trunks. They are mine now and were very precious to my mother because they had been a wedding gift from her own mother. My mother hand embroidered them in a special "800" design (a fashionable design of the time) for me in readiness for my *corredo* (glory box or dowry chest). In the village in those days, all the girls learned to sew and embroider. She had made some gorgeous pieces for me over the years, such as linen hand towels, bath towels and washcloths.
>
> These special bed sheets get used only very occasionally now. They could never be replaced. They're an heirloom, irreplaceable today. They are stored safely in my cupboard.[1]

Similar ideas on needlework were apparent in an exhibition, "Stitches, *fare il punto*," I curated at the National Maritime Museum in Sydney in 2001.

"Stitches" explored the role of domestic crafts in the lives of Italian Australian women. The exhibition brought together two generations of women and mixed domestic objects and contemporary arts, showing the continuity of needlework across generations, diversity of practices, and the chasm between art and craft promoted in accepted artistic hierarchies. Doilies, cross-stitched tablecloths, embroideries, crocheted bedspreads hang together with paintings, installations, and photomedia engaging with needlework either in their execution or in their subject matter.

"Stitches" built upon a body of critical theory, influenced by feminism and postcolonialism, that critiques notions of the canon intended as an instrument to legitimize as proper the artifacts, objects, and texts of those with cultural power. The canon is therefore considered as a tool of exclusion of cultural practices and artifacts of those who do not have cultural power.[2] Concentrating on the canon of art history, feminist art historians, theorists, and artists since the 1980s have addressed the exclusion of women's works, including needlework, providing critical analysis of the ideological and patriarchal dynamics at play in such exclusions and writing alternative art histories.[3]

Rozsika Parker's book *The Subversive Stitch: Embroidery and the Making of the Feminine* (1984) was particularly illuminating in thinking about the exhibition for the depth of its historical scholarship and as a method of inquiry. Parker considers embroidery as a cultural practice and as a tool to historically explore femininity as a social and psychoanalytical construction, but also femininity as a lived experience, as an ideal, and as a stereotype. The book shows how the changing meanings attributed to needlework from submission to self-containment are entangled with ideologies of class and gender. This theoretical framework is useful to reflect on the absence of needlework from official representations of the cultural production of Italian diasporas. The exhibition "Stitches" redressed this void, blurring the boundaries between "proper" art practices (painting, installation, photomedia recognized as contemporary arts) and amateur, domestic crafts, and showing that all the objects on display were part of a continuum of cultural practices.

Largely based on the primary research I carried out for the exhibition, this essay considers the role of objects, and in particular domestic crafts, in the Italian diaspora through the notion of *crisi della presenza* (crisis of presence), developed by the Italian anthropologist Ernesto De Martino (1908–1965) to describe contemporary experiences of the "end of the world." De Martino developed the idea in the 1960s studying the theme of apocalypse in different religions. He also collected material from psychoanalysis, the arts, and literature to explore contemporary occurrences of crisis in modern societies. De Martino termed these crises "cultural apocalypses."[4] To explain these apocalypses and the consequent "crisis of presence," De Martino

introduced the concept of the "end of the world," described as the separation of objects from the web of familiar relations that give these objects meaning. Migration, I argue, can be inscribed in the category of *crisi della presenza*, as it marks the end of a known world. The objects of needlework and their inscription into a new set of relations can be used to read migration as detachment, loss, and separation, but also as its opposite—that is, settlement and the beginning of a new life. Needlework marks the continuum of experiences from one place to another, one person to another.

A common cultural practice in Italy, needlework was taught in familial settings and by nuns and was introduced in the school curriculum (for young women) by the fascist school reform in 1923 and taught in secondary schools to girls until 1979.[5] Needlework itself, sometimes quite literally, migrated from Italy to Australia in the post–World War II years, becoming a material connection between the two countries. As Anedina De Luca and Anna Ilacqua Ianni, two of the artists in the exhibition "Stitches," recount, needlework was for instance the continuation of "home" during the long boat journey from Italy to Australia:

> I thought that to while time away during the twenty-eight days it took on the ship, I had to carry with me something to do. As I had started a tablecloth made of embroidered daisies that eventually were stitched together, I decided to continue to embroider it on the ship. I finished it three years after I arrived in Australia.[6]

> I first learnt to embroider and crochet when I was a little girl in Sicily. At first, my mother taught me. Then a local woman, who would teach the little girls to embroider and cross-stitch in preparation for working on their glory boxes, taught me. My mother began a bedspread for my glory box when she was still in Lipari. When we migrated, this bedspread came with us on the boat to Australia and later I finished it.[7]

These two quotations illuminate the role of needlework in the transition from home to migration. In the book *Uprootings/Regroundings: Questions of Home and Migration*, writing about the relationship between mobility and senses of home, Sara Ahmed, Claudia Castañeda, Anne-Marie Fortier, and Mimi Sheller describe the process of migration as "uprooting and regrounding."[8] Uprooting and regrounding help one to rethink ideas of home and migration not as being in opposition, but as affective, embodied, cultural, and political processes. These processes allow us "not to categorize 'home' as a condition distinct from 'migration,' or to order them in terms of relative value or cultural salience, but to ask how uprooting and regrounding are

enacted—affectively, materially, symbolically—in relation to one another."[9] In *Uprootings/Regroundings* "making home" is described as a reclaiming process that brings together the affective qualities of home, the memory associated with them, and the concreteness of rituals, objects, borders, and habits.[10]

How did Italian women domesticate the antipodean space, literally making it "home?" What did objects do, once they traveled from Italy to Australia, and once their web of familiar things was at first broken by the journey and then stitched back together? What kind of objects made it to Australia? In which form did they travel, as material objects or as objects reproducible through a set of skills? Is there a relation between these objects and the stories told by migrants?

Addressing these questions can provide insights on how to read migration through material culture. Writers like Grant McCracken have focused on consumption, stressing how objects substantiate cultural categories or how they "are created according to the blueprint of culture and to this extent they make the categories of this blueprint material."[11] This position has been taken a step further by David Howes, who has concentrated on cross-cultural aspects of consumption, raising questions directed at how objects produced in one culture are received in another and, in such cases, asking whose cultural blueprint is substantiated by these objects.[12] I want to bring these questions into the area of migration to explore how objects produced according to a cultural blueprint acquire new meanings once they move into a different culture.

Domestic Crafts as Narratives of Migration

During my fieldwork I met many Italian Australian women, sat in many sitting rooms drinking coffee, and listened to many tales taking place in ports and ships and involving descriptions of bleak Australian suburbs. A sense of dismay at the emptiness of Australian cities permeated many accounts. This emptiness was not only a reflection of the material differences between the thick and crowded Italian village and urban space and the broadness of the typical Australian suburban home. It was also a conceptual and sensorial emptiness caused by the lack of signs of homemaking as shaped by an Italian aesthetics. Many of these stories, as told by Italian women who migrated, or whose parents migrated to Australia, referenced everyday domestic objects and in particular needlework, which was invariably talked about with pride, affection, joy.

The focus on domestic craft also marked a shift in my own thinking about migration and hybridity, migration and identity, transnational lives, and

the Italian diaspora. Sitting in Italian living rooms in suburban Australia, often admiring the virtuosity of a piece of embroidery taken out of a linen press for the occasion, made me zoom in to details. Needlework is subtle. Its appreciation requires the ability to understand the craft, skills, time, and patience that went into its making. Silvia Saccaro, for instance, describes the making of Burano lace:

> I was eleven when I started to do embroidery in my village in Italy. We learnt with a nun from the village who specialized in this work which is called Burano lace. There is a museum in Burano near Venice showing old Burano lace. They are still making it there though very few people are doing it. The nun told us [Burano] lace was once more expensive than gold. It is done with very, very thin cotton and because it is so thin, it takes very long to embroider. I made this tablecloth embroidery but also placemats and doilies. My eldest sister was doing the same thing too. Just one of these patterns on this cloth would take about 20 days. The bigger ones would take about one month.[13]

These skills and objects migrated with people. Considering needlework in the context of migration calls for a shift in perspective, from a conceptual analysis of diaspora as a movement of people to a much more intimate encounter with stories of the migration of persons. Needlework bears the mark of its maker, and as such it is both an embodied and a sensual practice. Unlike other creative practices, such as painting and sculpture, needlework reduces the distance between the person who displays it and the person who observes it: It requires poring over, touching, looking, even sniffing.

The appreciation of needlework creates its own sensorium calling for the understanding of the visual aspects of needlework, the intricacies of design, the difficulty of stitches, the virtuosity of the color schemes, the references to particular patterns fashionable at different times. In brief, it is part of a precise cultural grammar, and it requires a specific knowledge, or "eye." For instance to understand at a glance that a piece of lace is a Burano lace, made with thin cotton over a long time, as Silvia Saccaro recounts in her memories of convent school above, one needs to be familiar with lace in general and with the patterns, techniques, and materials of Burano lace in particular. Appreciation of needlework involves other senses: smell, of course, as invariably needlework carries the scent of linen presses, the scent of "home." Needlework invites the observer to follow patterns by touching, tracing the stitches with a finger, handling, and hefting objects such as towels or bedsheets—objects that are used on the body. This tactile encounter with the object opens an intimate space for understanding stories of migration.

The online exhibition of the New South Wales Migration Heritage Centre, which collected stories about migrant belongings, lists, among other items, a saucepan, a potato masher, cups and saucepans, a cutlery set, a tomato sieve, sheets, a bedcover, an embroidery loom.[14] As Graziella Del Popolo recounts, the experience of migration combines diverse occurrences: the removal and separation from that which is familiar; the imagination of the unfamiliar and the planning to domesticate the latter; the journey; and the making of a new home. Often, migration involves multiple trips back to the place of departure. Del Popolo's short account illustrates the centrality of domestic crafts in narratives of migration. After all, it is only logical that, to make a new home, women carried not only the objects that would furnish their new houses, but also the habits, the skills, the cultural practices belonging to the sphere of home. This baggage made regrounding, to use Ahmed's term, possible.

Il baule e la valigia, the trunk and the suitcase, which accompanied migrants in their journeys, are rhetorical devices to narrativize migration and to socialize it as shared experience.[15] They function as metonyms to describe migration as journey away from, loss of, and sudden rip in one's cultural fabric. Italian philosopher Luisa Muraro, in her book *Maglia o Uncinetto* (Knitting or Crochet, 1981, reprinted 1998), describes the link between figures of speech, language, and lived experience:

> The relationship between the figurative and literal meaning coincides with a material link, either spatial, or a temporal or causal link.... The specificity of metonym ... consists in its taking shape through discovered rather than invented links. These links can be of any kind, provided that they are established not through pure thought, but that they come to us as already given (formed). While metaphor springs from an original idea, metonym makes its own way through lived experience. Thanks to metaphor, existence is molded into an ideal representation, while with metonym it is articulated in its various parts.[16]

With metonyms we "combine, associate, link, move from context to context, allude, narrate: things and words make sense through references and associations accompanying them."[17] In the migration stories I heard, the relationship between the figurative and the literal finds its embodiment in the figuration of the trunk or the suitcase and their contents. As metonyms, these tales are part of lived experiences; they also function as prompts to tell stories that combined form the experience of migration. Silvia Saccaro's description of the needlework she carried to Australia captures the metonymic value of domestic craft. Objects stand for family, for relations, for affects:

It is important for me to keep these objects for sentimental reasons; when you are away from your family every little thing counts. You remember your mother and your sisters and the things that they have made or done for your children. When you see these things there is something there about the heart and you appreciate everything. I get attached to everything for sentimental reasons. It is very important.[18]

This narrative records the ability of objects to embody affect, "something about the heart" of its maker. The trunk and the suitcase become the containers of domestic objects, of dowries, things connected to everyday use but also rich with affective and sentimental meanings. Trunks are filled with objects one used in the old country and objects one could imagine using in the new country: These objects may be thought of as useful to orient oneself in an unknown and unhomely space.

Essere Spaesato e Sentirsi a Casa: Feelings of Disconnection and Belonging

It would be easy to classify these objects as embodiments of nostalgia or simply as heirlooms. This, however, would mean to read them without considering their own place in the making of migrant histories. Domestic crafts have a double value: They enable the narrative and performance of uprooting from one place and the regrounding in another. The way everyday objects become meaningful in the context of migration is not simply a matter of recontextualization from one country to another. By crossing country lines and cultural geographies domestic objects become embedded in the loss and recreation of entire life-worlds, relational universes, senses of place, "homes." Needlework does not sit outside the flux of history, as an ossified relic of a past life. The way it operates in the everyday is discussed in the next two sections: As material objects it makes possible the domestication of the unhomely space that often awaited migrants at the end of their journey; and as a cultural practice it creates a continuum of belonging between generations.

Ian Chambers remarks that the modern sense of place is invariably inscribed in the nomenclature of nationhood.[19] In the case of Italian migration earlier senses of belonging inflect the understanding of being Italian. Looking at an imaginary map, "Italians" in Australia would tell me: I am from Veneto, or perhaps: I am from Sicily; then they would name cities— from Treviso, from Messina—and finally villages: I am from Arsiè; I am from Lingua, in Salina. The village is at the core of the geographical imagination

of homeland. The village is also the fundamental unit that defines identity and belonging, predating the idea of nation.[20]

The village is central to Italian Australian anthropologist Loretta Baldassar's writing about the idea of "home" and "the trip back" in Italians' imaginary. Baldassar explores the interplay of multiple senses of home and belonging when writing about her own trip "back" to Italy, or as she puts it to "many Italies":

> It had been clear for me from an early age that I was a northerner—that explained why I was never easily identified as Italian. . . . I also knew from an early age that I was Veneta and Trevisana. These are respectively the region and province of my father's birth. My mother's ancestry in the Valtellina, a beautiful valley in the Lombard region's province of Sondrio, represents another important identity marker for me. These various levels of identification pale into insignificance, however, when compared with the most important of all—the ancestral village or town. After all this is the place people travel back to.[21]

Baldassar's description of multiple geographies of belonging from nation to village reminds us that in Italian the word for village and the word for country are the same: *il paese*. The nouns *appaesamento* and *spaesamento* are significant words in the context of migration. They are linked to *paese* and indicate either a feeling of connectedness and belonging or disconnectedness and loss of one's bearings in the world. To express the sense of dismay and foreboding upon being in an unhomely place the Italian phrase would be *essere spaesato*, literally to be without a village, to be disconnected and dislocated. The opposite of *essere spaesato* is *sentirsi a casa*, to feel at home. In the context of needlework what is the role of objects in the negotiation from *essere spaesato* to *sentirsi a casa*? Teresa Restifa, a businesswoman and Italian Australian politician, in "Belongings" recalls hers and her family's *spaesamento* upon arriving in Sydney, where relatives had furnished a flat for the newcomers:

> It all looked pleasant but strangely quiet. We were used to Palermo [Sicily], a bustling city. We really didn't like it at first. At the end of our first day we went to see our unit that our uncles had organized for us. The flat was owned by a cousin and he let us have it for as long as we needed it. They filled it with furniture, linen, everything for the kitchen. We brought everything that we could salvage from the earthquake including an Egyptian cotton bedcover. My grandmother's sewing machine was rescued; I've still got it now, it is about 90 years old. It still works really well. The apartment was fine but it had laminex furniture and we had had very beautiful stuff [in Italy], we had had a beautiful house

full of antiques. Now we had laminex. We appreciated what had been done for us but it was a shock.[22]

The experience described by Restifa could be compared to what the anthropologist Ernesto De Martino calls *crisi della presenza*. This crisis is characterized by objects that have lost their relation with their web of domestic uses and cultural memories, with words and language (as happens when moving from one culture and language to another). These objects become "weird, bizarre, weak, uncertain, indecisive, artificial, arbitrary . . . in the moment when they become separated from their name and their meaning and when they fall in the opaque thickness of a 'bare' existence, without memory of human domestication."[23] These objects become like a flat on the other side of the world furnished with laminex, a new, synthetic material with no history, memories, or cultural value for a young Italian woman.

De Martino identifies the beginning of *la crisi della presenza* in a mutation of that domestic background that makes it possible to function in everyday circumstances, according to a shared and culturally meaningful blueprint. To function in the everyday involves a background made of implicit relations between objects, usage, words, and memories that are so habitual as to become obvious and unconscious. These relations do not require an interpretation or a translation. According to De Martino, everyone develops such relations and memories depending on their social and cultural biography, what he terms *latente storicità dell'esserci* (the latent historical authenticity of being). This set of obvious and often unconscious relations between objects, cultural memories, and agency (which he calls later *la patria culturale dell'agire*, the cultural homeland of agency) enables people to function in the everyday.[24]

Once this set of habitual relations is interrupted, as it is in the case of migration, and objects become separated from their web of domestic relations, "things escape their frame."[25] The relation between people and objects becomes fuzzy, and objects lose their *appaesamento*—their connectedness with habits, gestures, and meanings. In this shift, which can be thought of as the journey from one country to another, two things are possible according to De Martino: Either objects lose their ability to be meaningful and become mute—which he terms a semantic deficit—or they acquire extra layers of meaning—which he terms a semantic excess.

The psychoanalyst Claudio Neri has read *la crisi della presenza* in relation to migration as the loss of one's place in the historical moment.[26] Neri connects this crisis with cultural apocalypses, intended as "cultural manifestations involving, within one specific culture and historical moment, the theme of the end of the present-day world, regardless of the way this end

is actually lived or represented."[27] Neri identifies the possibility of renewal of recuperation from this apocalypse through the reenactment of everyday rituals and the domestication of space. Objects play a central role in this, as Silvia Saccaro and Silvana Toia describe in their migration memories in "Belongings":

> There were things in the house I would have liked to have brought with me. My mother and father were happy to give it to me but with the long trip, it was impossible. I brought my sewing machine though! It is a Singer machine and it was bought in Italy in the beginning of the 1960s, so it is about 49 years old.[28]
>
> My mother packed as many of our belongings as she could and included special things that she had been keeping for our corredo (glory box, dowry), such as a new cutlery set, hand embroidered sheets, towels and tablecloths. She also brought my embroidery loom that she had had made for me in 1956 when I was eight years old. It was hand crafted by a local carpenter called Tariggi from Gizzeria. . . . My loom has a little drawer for all the cottons. Tariggi must have made it around Christmas time because he had decorated it on the top with Christmas decorations, a bell and a star as well as my initials "A.S." for Ambrozio Silvana. My mother brought it to Australia because she thought that I would need it here. And I did. I still use it today and it has great sentimental value, it brings me back to the past.[29]

For some migrants, needlework, and the tools used to produce it, can domesticate space and reestablish the habitual relations between objects, usage, and memories. As a metonym enabling the narrative of migration, needlework also brings together again words and objects. Making their way through lived experiences, they assist the passage from *essere spaesato* to *sentirsi a casa*.

Cultural Heritage / Contemporary Arts

Needlework is at once object and practice, utilitarian and virtuosic, unique and reproducible. Bedspreads, sheets, doilies recreate a sense of place and an aesthetic, intended as the way to frame and represent the domestic sphere through a set of gestures, spatial relations, habits. Needlework was part of the first generation of Italian Australians' domestic aesthetics.

Even if needlework and the skills for its production could be, and are, passed down from first-generation women to second and third generations, what caught my attention as a curator was not the contemporary production of cross-stitching or crochet or lace. Rather, I found contemporary Italian

Australian artists had translated needlework in multiple and ambiguous references to domestic crafts in their works.

Maria Pallotta-Chiarolli, author of the book *Tapestry*, which chronicles the life stories of five generations between Italy and Australia, explains how tapestry—the particular form of needlework in her family—became for her the cultural background to become a writer, academic, and activist. Tapestry in her writing is a symbol of the understanding of diverse experiences and of writing itself:

> I do not know how to embroider, I do not know how to weave. My mother
> and grandmother encouraged me to pursue my education instead. But I cre-
> ate tapestries too. Perhaps they knew that education would one day lead me to
> pattern my own kind of tapestries and embroideries. Just as they used weaving
> and stitching as metaphors for the patterning and planning of their lives, I use
> tapestry as a metaphor to describe the interweaving of questions and emotions
> that I have inherited from them or experience as a woman today.[30]

The artists in the exhibition "Stitches" shared similar preoccupations to those of Pallotta-Chiarolli. While needlework in itself was not the medium of choice, the exhibition explored a persistence and continuity from domestic crafts to contemporary arts. To illustrate this continuity of needlework in contemporary arts I will use here a daughter/mother pair of artists: Rox and Anedina De Luca.[31]

Rox De Luca references her mother's needlework in her own artistic practice as a comment on the importance of domestic crafts as sites of cultural memories and connections to Italy. In this dialogue with her mother, Rox uses aluminum panels, sometimes painted in oil and embossed (embossing in itself is of course a form of needlework) to tell the histories of her family. In *L'Arrivo* (Arrival 1998), a small boat makes its way toward the empty map of Australia; *Bloody Dings / Achille Lauro* (2001) reminds us of the 1950s discrimination, as *dings* was derogatory Australian slang for an Italian or Greek immigrant.

Other works focus on single objects, which, in their semantic excess (to use De Martino's term), allude to personal and family histories. The image of a dress for instance conjures up metonymically the experience of growing up Italian in Melbourne (*Il Grande Vestito di Wog* [The Big Wog Dress 1998], *wog* being another derogatory term used for Southern European migrants). A letter dispensing advice and written in Italian to preserve the language is embossed in another panel, *Cara Rosicella* (Dear Rosicella 1998). Food is present, as pasta shapes are superimposed onto the outline of the map of Australia, *L'Invasione dei maccheroni* (The Maccheroni Invasion

1997), and *Le farfalle volanti* (Flying Butterflies 1997). A whole series is dedicated to embroidery patterns from the Italian magazine *Mani di Fata* (Fairy's Hands), which was imported to Australia from Italy and which Rox's mother used to buy:

> I am using *Mani di Fata* issues from the 1950s that belonged to my mother during her early post-migration years as well as 1999 issues. I have also incorporated fragments of letters my mother writes to me. The use of these patterns and textual elements seeks to create a dialogue about migration, craft practice, memory and identity.[32]

The lace patterns chosen by Rox are translated from paper into aluminum in a particular form of needlework: metal embossing. The result tricks the viewer: The designs look familiar—a rabbit, floral patterns, a swan. The technique has all the delicacy and attention to detail of lace, but the material does not speak of domestic environments, and it is not immediately thought of as feminine. Aluminum carries industrial connotations: It is shiny, it is hard, it is metal. The contrast between the expected softness of the design and the rigidity of the material scrambles normal perception mechanisms and expectations. Similarly these works allude to the artist's ambivalence between separating oneself from the domestic expectations of "the good Italian girl" and recovering family memories and cultural practices.

Rox's mother, Anedina De Luca, took up painting in her late forties, after a "trip back" in 1975 to Italy, which she had left to emigrate to Australia in 1951. Oil painting gave her the opportunity to record in narrative form the memories and recollections of Italy that until then had been embodied in her needlework. These images are snapshots of everyday events: Flowers are gathered (*La Raccolta delle Margherite* [The Gathering of Daisies 1998]), a family sits together (*La Mamma e le Figlie* [Mother and Daughters 2001]), a ship sails from Italy to Australia (*Roma* [2001]). There is no apparent chronological order, and events are painted in the same way they are remembered, by way of associations, stories, serendipity. In a 2001 oil on cardboard (*Il Chiacchierino* [Tatting]) Anedina painted her "other" crafts: embroidery, knitting, weaving, and tatting. She had learned these particular needlework techniques in Italy: "I attended school up to my second year in high school; I had to leave because of World War II. When I left school, I started going to a nuns convent to learn to sew and embroider."[33] After arriving in Australia in 1951 needlework became for Anedina a way to maintain memories and a link with contemporary Italy, in the form of the pattern magazine *Mani di Fata*, which she used to buy to follow the latest Italian designs.

Conclusion

I wanted to explore the journey of needlework, both as objects and as practices, in the context of migration from Italy to Australia. The abundance of doilies, embroidered tablecloths, and lace curtains in the Italian Australian houses I visited after I had migrated to Sydney had impressed me and made me curious. I could understand it was a particular domestic aesthetic belonging to a particular historical moment and transported as it was to Sydney. But I could sense, talking with Italian Australian women, a feeling of pride in the narratives about these objects that went well above aesthetic appreciation.

I played here with ideas of home and belonging and their Italian equivalents of *sentirsi a casa* and its opposite *essere spaesato* to look at how domestic crafts were used in relation to space. By concentrating on the capacity of needlework to recreate the web of gestures, usage, habits, and aesthetics that make belonging possible, I have suggested, domestic crafts take on multiple roles. As carriers of habits and memories they assisted in the transition between countries and cultures, keeping both habits and memories alive. As objects, they helped to domesticate the unhomely space of postwar Australia. As practice they ensured a cultural continuity often translated into different, yet similar, creative forms.

Notes

1. Graziella del Popolo, "Graziella del Popolo's Memories of Migration," in "Belongings: Post WW2 migration memories & journeys," ed. Andrea Fernandes (Sydney: Migration Heritage Centre New South Wales, 2007), accessed August 16, 2010, www.migrationheritage .nsw.gov.au/exhibition/belongings/delpopolo/.

"Belongings" is an ongoing online exhibition, curated by Andrea Fernandes, NSW Migration Heritage Centre (MHC), Powerhouse Museum, supported by the Community Relations Commission for a Multicultural NSW. The exhibition content is produced in partnership with community groups, local government museums, galleries, and libraries across the state of New South Wales. The original concept for the online exhibition was developed by MHC manager John Petersen. See also www. Belongings.com.au and www.migrationher itage.nsw.gov.au/belongings-home/acknowledgements/.

2. Patricia Waugh, "Canon," in *A Companion to Aesthetics,* ed. David Cooper (Oxford: Blackwell, 1995), 59–61.

3. For a brief overview, see Linda Neal, "Feminism, Art History and Cultural Politics," in *The New Art History,* ed. A. I. Rees and Frances Borzello (Atlantic Highlands, NJ: Humanities Press International, 1988). See also Rozsika Parker and Griselda Pollock, *Old Mistresses: Women, Art and Ideology* (London: Pandora, 1987), and The Guerrilla Girls, *The Guerrilla*

Girls Bedside Companion to the History of Western Art (Harmondsworth: Penguin, 1998). More specifically for craft history and theory, see Sue Rowley, ed., *Craft and Contemporary Theory* (St. Leonards, NSW: Allen & Unwin, 1997) and Rozsika Parker, *The Subversive Stitch: Embroidery and the Making of the Feminine* (London: Women's Press, 1984).

4. See the following texts by Ernesto de Martino, "Apocalissi Culturali e Apocalissi Psico-patologiche," in *Nuovi Argomenti* 69–71 (Luglio–Dicembre 1964): 105–41; *La fine del mondo. Contributo all'analisi delle apocalissi culturali* (Torino: Einaudi, 1977); *The Land of Remorse: A Study of Southern Italian Tarantism*, trans. D. L. Zinn with an introduction by V. Crapanzano (London: Free Association Books, 2005).

5. The role of needlework had class diversifications, from the utilitarian in the case of *massaie rurali* (rural homemakers), to connotations of proper femininity in the case of the urban middle class. However, thanks to its inclusion in the activities of the fascist Saturday school, the Opera Nazionale Balilla (1926), and in the school curriculum with the Riforma Gentile (1923), needlework was a common women's practice. See "La riforma Gentile" in ControStoria, il sito di riferimento sulla storia della Seconda Guerra Mondiale, accessed August 20, 2010, www.controstoria.it/documenti/riforma-gentile.html; and Victoria De Grazia, *How Fascism Ruled Women: Italy 1922–1945* (Berkeley: University of California Press, 1983). See also "Legge 16 giugno 1977," n. 348, accessed September 2, 2010, www.edscuola.it/archivio/norme/leggi/l348_77.html. This bill ended the division in male and female education in matters relating to technical education, including needlework.

6. Anedina De Luca, Artist Statement in "Stiches: fare il punto," ed. Helen Trepa and Ilaria Vanni (Sydney: National Maritime Museum, 2001), 26.

7. Anna Ilacqua Ianni, Artist Statement, in "Stitches," 32.

8. Sara Ahmed et al., eds., *Uprootings and Regroundings: Questions of Home and Migration* (Oxford: Berg, 2003).

9. Ahmed et al., *Uprootings and Regroundings*, 2.

10. Ahmed et al., *Uprootings and Regroundings*, 9.

11. Grant McCracken, *Culture and Consumption: New Approaches to the Symbolic Character of Consumer Goods and Activities* (Bloomington: Indiana University Press, 1988), 74.

12. David Howes, "Introduction: Commodities and Cultural Borders," in *Cross-Cultural Consumption: Global Market, Local Realities,* ed. David Howes (London: Routledge, 1996), 2.

13. Silvia Saccaro, "Silvia Saccaro's Memories of Migration," in "Belongings," accessed August 16, 2010, www.migrationheritage.nsw.gov.au/exhibition/belongings/saccaro/. Silvia Saccaro was interviewed by Sandy Minter, Lake Macquarie City Art Gallery.

14. Andrea Fernandes, "Belongings: Post WW2 migration memories & journeys," accessed August 16, 2010, www.migrationheritage.nsw.gov.au/belongings/?key=Cultural+background&s=Italian&cat=10.

15. See, for instance, Anna Maria Dell'Oso, *Songs of the Suitcase* (Pymble, NSW: Flamingo, 1999), and the Australian multicultural television station SBS program *Tales from a Suitcase: Stories from the Migrant Experience 1949–1959* (Sydney, NSW: SBS Independent, 1996).

16. Luisa Muraro, *Maglia o Uncinetto* (Roma: Manifestolibri, 1998), 54.

17. Ida Dominijanni, "La parola del contatto" (The word of contact), in Muraro, *Maglia o Uncinetto,* 12.

18. Silvia Saccaro, "Silvia Saccaro's Memories of Migration," in *Belongings.*

19. Ian Chambers, "A Stranger in the House," in *Communal/Plural* 6, no. 1 (1998): 38.

20. Donna Gabaccia, *Italy's Many Diasporas* (London: UCL Press, 2000), 15.

21. Loretta Baldassar, *Visits Home: Migration Experiences Between Italy and Australia* (Melbourne: Melbourne University Press, 2001), 75.

22. Teresa Restifa, "Teresa Restifa's Memories of Migration," in *Belongings,* accessed August 16, 2010, www.migrationheritage.nsw.gov.au/exhibition/belongings/restifa/. Teresa Restifa was interviewed by Linda Nellor, Co.As.It. Italian Heritage.

23. Ernesto De Martino, "Apocalissi Culturali," 122.

24. Ernesto De Martino, "Apocalissi Culturali," 126–28.

25. Ernesto De Martino, "Apocalissi Culturali," 130.

26. Claudio Neri, "Il calore segreto degli oggetti: a proposito di un saggio di Ernesto de Martino," in Quaderni di Psicoterapia Infantile 40, 1998, accessed August 28, 2010, www .claudioneri.it/anni.asp?anno=1998.

27. Ernesto De Martino, "Apocalissi Culturali," 105.

28. Silvia Saccaro, "Silvia Saccaro's Memories of Migration," in *Belongings.*

29. Silvana Toia, "Silvana Toia's Memories of Migration," in *Belongings,* accessed August 16, 2010, www.migrationheritage.nsw.gov.au/exhibition/belongings/toia/. Silvana Toia passed away in September 2012. She was interviewed by Linda Nellor, Co.As.It Italian Heritage.

30. Maria Pallotta-Chiarolli, "Writing About Tapestry, Weaving Tapestries Through Writing/Scrivere sugli arazzi, intessere arazzi di scrittura," in "Stitches," 16.

31. The following paragraphs describing artworks are an adaptation of what I wrote in the exhibition catalogue essay, "Cross-stitching objects, memory and cultural difference/ Intessendo oggetti, ricordi e differenza culturale," in "Stitches," 6–14.

32. Rox De Luca, "Artist Statement," in "Stitches," 28.

33. Anedina De Luca, "Artist Statement," in "Stitches," 26.

The Dressmaker

for Maria

—Gianna Patriarca

she has been shaping material
around my body
for decades
cottons and silks
wool knits and polyesters
that refuse ironing
my preferred Italian linens
light, cool
she has chalked and pinned
my mutable shape like a map
standing on a stool
to reach my shoulders

this sixty-inch woman
with thinning hair and dusky eyes
this woman from the stony hills
of the *Maiella*
from a town where the almonds
taste sweet
stained with sunlight and a
coating of honey

this ordinary woman
has landed in the basement
of a suburban house
in a country of maple and snow
with a Singer sewing machine

a table and mismatched chairs
tape measure, scissors
necessary small things

it is 1973 and she will be here
in the year 2000

among her spools and threads
boxes of used patterns
a devoted cassette player
serenades her long nights
only the music assists her
triumphs, her mistakes

the skin of her fingers shines
it is thin, buffed
polished like wood
but the digits of her hands
are liquid
they are a violin
the sly footwork of a tango
precise

each stitch
each blouse is
a rose tattoo

the dressmaker
serves espresso along with
the fantasy
and the women return
again and again
for the gowns that create the
illusion
for the skirts that hide the
indulgences
they return for the white dress
with the brilliant pearls
each sewn individually
such pride

in another place
another time

her hands might have carved
angels in stone

here
she patches wings
to help them fly.

Junior High, Home Economics

—Barbara Crooker

My best friend and I were in love with sewing,
our old Singers, black as licorice, gold scrolls
and flowers, the name, lettered in Old English.
The hum, the glide, as miles and miles of seams
ran through the presser foot, straight
as train tracks. The fine mercerized cotton thread,
that wound from spool to bobbin, an intricate dance,
through the tension, around the dial, the take-up
lever, then entered the needle's eye.
The possibilities of an uncut bolt of fabric,
what it might become. Butterick, McCall's, Simplicity,
the rustle of patterns. We dreamed about cloth:
puckery seersuckers, watered silks, crushed velvets,
pinwale and widewale corduroys, dotted Swiss.
Laying out the pattern, a flimsy jigsaw puzzle,
the thin tissue. Finding the straight of the grain,
parallel to the selvage edge. The fat tomato pincushion,
the strawberry needle sharpener. Cut on the bias last.
The slick, the slide of oiled shears. Some seams
have to be eased. Stay stitching, basting, top-
stitching, gathering. Press all seams open, wrong
side of fabric. Cut on curves, clip on notches.
The endless variety of closures: hooks & eyes,
buttons & holes, snaps. I set in her zippers,
she put up my hems; every other day,
we traded clothes in the girls' room
before the last bell. Box pleats, knife pleats,
pin tucks. All those notions: rickrack, twill tape,
corded piping. Plaids, both even and uneven.
My first project, a heather blue and charcoal gray

circle skirt, the fabric wasn't wide enough;
I had to piece an inset to match the plaids.
Even her grandmother looked hard to find the seam.
We didn't know what was coming: the broken marriages,
the sweet babies who turned into teenagers;
couldn't imagine a future that didn't fit
the pattern, thought there was nothing
we couldn't alter, darn, or patch,
somehow make right.

Knitting

—Barbara Crooker

I

My grandmother's needles
force the soft gray yarn
into patterns old as Europe.
She came from a family of tailors,
and gave each grandchild an afghan
of her own design;
the colors glow like January fire,
the stitches are perfect,
cabled with love.

II

My mother also knits
from patterns and pictures:
mittens with snowflakes
and Fair Isle socks.
Does she weave in June days
of yellow light, the babies
quietly piling blocks, the clean smell
of steam from dampened laundry?

III

My older daughter tries to knit, too,
but her hands can't master the needles,
so she pretends and spends hours

in a tangle of wool and steel.
She is already a maker
of emperor's cloth.

See the fine patterns?
 the royal colors?
 the designs more beautiful than stars?

IV

And here I sit, like a bear in February,
huddled in yards of wool; skeined up in love,
clicking my pen across the page.
I take words and knit them back in poems.
Something could be made of this.

Spalancare (Wide Open)

—Peter Covino

a lullaby
lost to me now

the soft acrylic
of the blanket's

touch as in
porta

spalancata
riscoperta

door opened
past

the uncovered
& discovered

participle, root
blood memory

thorned
mother word(s)

uncombing sound
promesse

guiding flesh
mind

through the forever
opened door

of the page

"A Needle Better Fits?": The Role of Defensive Sewing in Italian American Literature

—Mary Jo Bona

> I am obnoxious to each carping tongue
> Who says my hand a needle better fits.
> —Anne Bradstreet, "The Prologue"

In their suggestion that Emily Dickinson's sewing was more than metaphorical, Sandra M. Gilbert and Susan Gubar also note that, like most nineteenth-century women in England and America, "she must have been as proficient with needle and thread as she was with spoon and pot." That Dickinson literally bound her poems into fascicles made her a "highly conscious literary seamstress," "exploiting a traditional metaphor for the female artist. Like Ariadne, Penelope, and Philomela, women have used their looms, thread, and needles both to defend themselves and silently to speak of themselves." For many women, then, the literal and figurative activity of stitching "both conceals and reveals a vision of a world in which such defensive sewing would not be necessary."[1]

Defensive sewing is both an economic necessity and an instrument of power for women in literary works spanning decades of writing by Italian Americans. From Garibaldi Lapolla's 1935 *The Grand Gennaro* to Adria Bernardi's 2007 *Openwork*, writers of Italian America represent the activity of sewing as a radical act with both centripetal and centrifugal impulses. The needle both returns the sewer to her *paese* (hometown) and connects her to an increasingly transnational identity that situates her to some degree beyond the "regime of nationalism," while also reinforcing her status as a laborer in a capitalistic market.[2] The literary works emerging from the Italian diaspora persuasively demonstrate the relationship between the Italian female immigrant, industrial work, and a complex transformation of domestic codes during the twentieth century—in Italy and the United States. The Italian immigrant who migrated to America

during the Great Wave of immigration was deeply rooted to her *paese*, which denotatively translates as country or *nazione* (nation), but refers to those small villages and towns to which Italians were emotionally tied. When writers of Italian America return to those villages in their narratives, they often use storytelling traditions that serve emancipative purposes for teller and reader alike.

This essay explores several works that focus on Italian female migrants who travel to the United States during the late nineteenth and early twentieth centuries, markedly altering their roles in the family economy. From stories adapted from oral traditions to postmodern narratives, writers of Italian America have consistently represented the role of sewing as a bulwark that both protects women from changes effected by an increasingly global economy and also provides them with portable skills, enabling their success in the new world. Similar to their nineteenth-century sisters in England and America, the sewers (including weavers, quilters, and embroiderers) represented in literary Italian America gain self-possession through their activity; they use sewing as a "strategy for mending fragmentation," often a result of the life-altering experience of migration.[3]

In addition, the sewer represented in Italian American writing reveals a vision of the world that is fundamentally unjust; she struggles to free herself from powerlessness; and she, or the author as her mouthpiece, links the dual activities of sewing and storytelling, melding two forms of expression used by the traditionally powerless. The connection writers make between sewing and storytelling radicalizes the narrative itself, serving libratory purposes for the woman who sews and with whom she shares her skills. The word *radical* comes from the Latin word *radix*, meaning root, and the literary works discussed in this essay all examine how immigrants remain rooted to their homeland despite the experience of migration. Adria Bernardi's Imola, in *Openwork*, sews bridal linens by trade, but she also teaches sewing to her two daughters and neighborhood girl children, who then transfer usable skills to another country and on to the next generation. Italian women who migrated in the early decades of the twentieth century in Bernardi's novel simultaneously increased their autonomy and ensured financial solvency.

With migration (including seasonal migration within Italy and other European countries), relations between the genders became slowly but increasingly equalized.[4] During the early decades of the twentieth century, Italian immigrant women went to work in cities throughout the United States with "the promises of wages for work—wages agreed upon in advance—mak[ing] the individual possible for the first time in history: the individual *woman*, one might say."[5] Writers of Italian America regularly portray mothers and daughters in the labor force, often working together in

the same factories in order to make ends meet during their first decades in the new country.

In Her Hands: Italian American Women and (Needle)work

Italian American writers generally describe immigrant workers as suffering from the effects of indecent wages, rhetorically applying the Christian story of martyrdom to immigrant workers as Pietro di Donato does in *Christ in Concrete* (1939), effectually overturning the stereotypes of Italian immigrants as stiletto-wielding criminals whose racial inferiority made them unassimilable. Early in their literary history, writers of Italian America represented immigrants and their children as assimilating Americans, despite their love of homeland cultural mores. Dominating the Italian American oeuvre are narratives about work—getting it, maintaining it, and recognizing the evolving role of women in the labor market. As Donna Gabaccia points out, Italian migration was a search for "*pane e lavoro*'—for work and bread. Work and bread, not a secure sense of belonging to a nation, were uppermost in the minds of most labor immigrants."[6]

On both sides of the ocean, however, women factory workers agreed that, as Elizabeth Ewen argues, "if work was an educational experience, it was an education in exploitation."[7] Alice Kessler-Harris points out that the domestic code sharpened not only class differences, but also gender differences: "[B]ecause employers assumed that a woman belonged at home, they relied on her family to make up the difference between what she earned and what she could live on." The cultural belief that women belonged in the home "permitted employers to exploit working women by treating them as though their earnings were merely supplemental."[8] Intransigent Italian immigrant men ensured the continued powerlessness of their spouses in America by subscribing to a family code that not only supported their position of superiority but also blinded them to the existence and necessity of women's work. When asked if his wife ever worked, a Sicilian immigrant interviewed in the 1970s exclaimed that his wife did not work after they were married, dramatically ignoring the fact that his wife ran a boardinghouse and bore him eleven children.[9] Mass migrations altered the domestic code[10] for Italian women who chose migration as an alternative to delayed marriage due to poverty and the dowry system.

Rules governing female deportment steadily changed for Italian women who left their villages to escape the pressures of poverty, rendering them unfit for marriage without a respectable dowry. Ensuring financial solvency, a respectable dowry for nubile girls increased the odds of upward mobility

through marriage.[11] The tyranny of the dowry system propelled more than one Italian woman to emigrate from Italy. Mario Puzo's fictional representation of Lucia Santa Angeluzzi-Corbo in *The Fortunate Pilgrim* (1964) remains the most memorable depiction of migration as a form of resistance for a young girl without a dowry. Reminiscing on her reason for sailing with two other girls, "brides by proxy," to marry men who had migrated to America from Naples, Lucia Santa recalls her seventeen-year-old "madness" that triggered her departure: "[S]he could not hope for bridal linen. The farm was too poor. . . . In that moment she had lost all respect for her father, for her home, for her country. A bride without linen was shameful[.] . . . what man would take a woman with the stigma of hopeless poverty?"[12] Lucia Santa's rationale is no exaggeration. That Lucia Santa's daughter, Octavia, becomes the expert seamstress in America symbolizes not only the redemption of the mother, but also the creation of the "layers," traditionally represented by embroidered trousseaux, between the Angeluzzi-Corbo family and poverty.

In the literature of Italian America, Italian girls without a dowry suffer but manage to survive and transcend social stigma. When the alcoholic behavior of one of Jerre Mangione's relatives in *Mount Allegro* (1943) makes providing a dowry impossible for his brood of daughters, most of these girls choose migration to America as an alternative to marrying below their social status. While the focus of Mangione's humorous memoir is not on the status of the marriageable daughters, the author suggests that paternal irresponsibility trumped poverty in the daughters' choice to migrate to the United States. In both examples above, young women migrated to America in order to achieve independence from impoverished fathers. In doing so, they managed to save themselves from moral and economic disaster in the homeland.

Such autonomy is achieved with equal parts pragmatism and willfulness for Umbertina in Helen Barolini's 1979 novel of that name. Fortuitously, she manages to wend her way to America by marrying a man who accepts her *without a dowry*. Instead, Umbertina's betrothed provides her the linens, and, unlike the husbands of Lucia Santa, she is not disrespected for it. Working as a goat girl in the hills above Castagna, Umbertina is portrayed as utterly self-possessed at sixteen, walking as erect as the goats she tends. On the first page of *Umbertina*, Barolini describes this Calabrian girl as strong, mature, and thoughtful, shepherding goats, gathering chestnuts, mushrooms, and wild greens, *and* knitting. The activity of knitting in the quiet hills of Castagna stimulates thinking and ultimately incites the quiet rebellion against her foreordained destiny that will take Umbertina to America. Her later suffering, however, is intimately woven into the *coperta matrimoniale* (matrimonial bedspread) that Umbertina takes with her to the new world. Suffice it to

say, Italian women without a dowry are portrayed in the literature as attaining a kind of self-sufficiency that benefits them when they are presented with equally daunting challenges in the American labor market. As Jennifer Guglielmo notes, the relationship between the trousseau and migration emerged from already-established "local patterns of labor migration" and enabled women "to develop a craft that could assist the transnational family economy without undermining the family's reputation."[13]

Mangione's Mensch: The Story of Annichia

Jerre Mangione's *Mount Allegro* features the paradigmatic tale of defensive sewing. This memoir was composed after Mangione's first trip to Sicily, during Mussolini's regime. As Fred Gardaphé explains, during the early stages of his writing career "Mangione begins the task of interpreting Italian culture and life under Mussolini," revealing his own fears while in Sicily of being arrested by fascist authorities and pressed into military service as punishment for his father's migration to America.[14] Mangione utilizes several features of defensive sewing, which other writers of Italian America employ and extend innovatively.

Not surprisingly, Mangione plucked his tale from the field of folklore. A cursory comparison between an Italian folktale collected by Italo Calvino (called "Catherine, Sly Country Lass") and Mangione's story of Annichia reveals a theme shared by both: In the struggle to free oneself, Calvino writes, "we can liberate ourselves only if we liberate other people, for this is the sine qua non of one's own liberation."[15] Another thread uniting the two tales is the activity of defensive sewing, enacted by both peasant women in order ultimately to achieve justice. An expert weaver, Catherine of Calvino's tale passes the outlandish tests of a capricious king first by agreeing to make shirts for a "whole regiment of soldiers," for which she requests from him a loom to weave the cloth. Her expertise wins the king's heart, but he soon realizes that "Catherine was smarter than he was" and banishes her after their marriage for meddling in his court of justice. Through a verbal sleight of hand as cunning as her weaving, Catherine eventually wins back the king's heart, managing simultaneously to institute a fairer form of justice in his court.[16]

As if imbibing the words of the Tuscan proverb "The tale is not beautiful if nothing is added to it," Mangione rewrites the old folktale by weaving into it a feminist sensibility influenced by American culture.[17] The narrator's perspective calls attention to the ingenuity of the peasant classes and the triumph of personal justice for peasants in a world that dictates against their receiving fair treatment, features occasionally found in folktales. But

this tale is also Mangione's commentary about unequal gender relations between men and women he had observed during his travels to Sicily as a young man.

When the rich and handsome Baron Albertini lays his eyes on the fifteen-year-old Annichia spinning in the sunlight, he falls instantly in love. Mangione reverses the tests of faith and love narrative by requiring the baron to pass the test of his future mother-in-law, who insists that Annichia be educated and trained for the role that she will assume as the wife of a gentleman. He agrees, and "within five years [Annichia] had lost all traces of her peasant upbringing and could read and write as well as anyone who had been born of a rich family." They marry. Before they can live happily ever after, however, their marriage is tested by the baron's three lecherous friends, who cannot abide the fact that a woman of peasant origin might remain faithful to her husband when he is out of sight, that is, a woman without a man. The baron's friends believe that Annichia's "inferior blood naturally gives her base instincts which she cannot possibly escape."[18] So the fun begins. Through his amiable use of humor, Mangione spins a story about the efficacy of folk wisdom in resisting oppressions of prejudice and disrespect. And success is achieved through defensive sewing.

A parodic cross between Edgar Allan Poe's "The Cask of Amontillado" and folktales featuring the motif of the "Three Wishes," Mangione's story of Annichia portrays one of the formerly most powerless members of society using the materials of her sewing life against her randy suitors. Without Annichia's knowledge, Baron Albertini makes a wager that his wife would always remain faithful to him. Thus begins the test, the three cronies betting against Annichia's fidelity for lands, which the baron will receive in the end. More important is Annichia's means of survival, when each of the men comes at separate times to visit her when her husband is away, betting on an easy seduction. All three men think they are being led a secret route to Annichia's boudoir, but she locks them in an empty vault, requesting that they spin for their food and water, allowing her servant to assess the quality of their (poor) workmanship. The food earned by the would-be seducers, a crust of bread and some water, parallels the land-poor peasants of the *Risorgimento*, denied access to baronial lands for hunting and fishing.

As a young man in Sicily, Mangione was shocked by the separation between the sexes, the enforced silence and self-censorship during the fascist regime, and the inability of Sicilians to recognize their ongoing condition of servitude under Mussolini's power. His story was written as much for his Sicilian relatives in Agrigento as it was as a tribute to those migrants who changed in America with the times, belying the assumption that immigrants were constitutionally unable to assimilate new ways.

Mangione has radicalized his retelling of a country lass who outsmarts the gentry and retains her self-possession, the control of her desires, and her talents. Virulently antifascist, Mangione understood the connection between abuse of authority in the government and within family and community. While he does not overtly connect women's subjugation and governmental oppression, Mangione's *Mount Allegro* voices the aspirations of Sicilian immigrants in America whose storytelling denounces class and gender inequality.

Pane e Lavoro: Italian American Women Have Always Worked

When women are unable to work, they do not survive. Four characters in novels of sewing women—Annunziata of Pietro di Donato's *Christ in Concrete* (1939), Carmela of *The Grand Gennaro* (1935), Lucia of *Like Lesser Gods* (1949), and Octavia of *The Fortunate Pilgrim* (1964)—shed light on the ways in which sewing women do not merely contribute pin money (a spurious term) to their family's income. Rather, women sewers sustain and enlarge the family's economy, ensuring security for the next generation.

Pietro di Donato represents Italian workers being killed by the work they do. Italian male immigrants overwhelmingly worked in precarious jobs such as construction, "[b]y far the most important occupational niche worldwide."[19] When Annunziata loses her husband in an avoidable construction accident, she falls into a deep depression from which she never emerges. Mother of eight children, living in tenement poverty, unprotected and exploited by institutions of government and church, Annunziata accepts her fate with a resignation bordering on catatonia. That she lives before the Great Depression on the Lower East Side, the most "industrialized neighborhood in the city," offers Annunziata the means to work, albeit in the most exploitative industry: homework. Homeworkers were used as "cheap labor" by garment contractors and manufacturers, who "exploited ethnic family patterns," doubling the mother's workload as she raised and cared for her children and "worked in the home to ensure their survival." A "breeding ground for child labor," the homework industry both increased a woman's work and made it feasible for her to earn money.[20] In contrast to the presumption that married women took this work to supplement the irregular earnings of husbands, many such women were black-clad widows, as di Donato portrays in his novel.

Annunziata's kitchen becomes a workshop for the garment industry. Like other immigrant women, she finds work through the kinship network of her Italian community. The section in which di Donato portrays working women

elides Annunziata's presence, even though it is her kitchen that became "a small gathering place where the widows sat in a circle busily cutting through rolls of embroidery." Rather, the focus is on Annunziata's brother, Luigi, who has undergone an amputation from a construction accident. Luigi humbly takes sewing lessons from the widow Cola, who becomes his teacher and later his wife, and it is from his perspective that di Donato paints a picture of the women's homeworking industry, Italian style. Luigi observes in Cola a warm generosity that kept him in a "continual condition of faint";[21] she is an excellent worker, singing old songs of Abruzzi and engaging in storytelling, recalling the stables of rural Italians, where "women sat on tiny seats in a circle around an oil lamp. They brought chests filled with material and would sew, knit, and teach the girls how to embroider linens for their trousseaux."[22] Maintaining close ties with their homeland villages, the widows of the Lower East Side replicate *paese*-based practices through their activities of sewing and storytelling. As cloth itself evokes "ideas of connectedness or tying,"[23] the women's work together illuminates their cultural unity. They tell stories while they embroider, for stories, too, are spun and woven: "[T]he trope is not a conceit, for it is the traditional way in which storytelling is described in most of the world in which weaving is done."[24]

Familiar with the story told around the table in Annunziata's kitchen, the women listen reverently to the tale of a pregnant woman who gives birth to the devil as a result of her scorning of God and sending away a hawker of holy relics. Refusing even to accept a relic of the Virgin as a gift from the peddler, the woman in the story refuses a basic tenet of a gift economy in which civility must be upheld. In response to a story they know, the widowed women make the sign of the cross "against the Evil One, and then repeated it upon their bellies."[25] Despite their hardships, these women live within "the confines of the gift economy. As Serge Latouche writes, 'The obligation to give, receive, and reciprocate weaves ties between men and gods, the living and the dead, parents and their children.'"[26] Despite her donning widow's weeds, Annunziata has earlier and forcefully rejected the visitors and their stories at her bedside following her husband's death and the birth of her eighth child; she protests, "Let me escape! This role I do not wish to play!"[27] She comes to embody the Indo-European meaning of widow: "'to be empty, to be separated,' to be 'divided' 'destitute,' or 'lacking' [;] Death has entered the widow ... she is filled with vacancy and has dissolved into a void, a state of lack or nonbeing that is akin to, if not part of, the state into which the dead person has journeyed, fallen, or been drawn.'"[28] Refusing kinship with the other widows, Annunziata remains an almost ghostly presence in the homework scene where women embroider. Her death at novel's end leaves her children orphaned.

No such dramatic ending occurs for the women sewers in Mari Tomasi's *Like Lesser Gods*, Garibaldi Lapolla's *The Grand Gennaro*, and Mario Puzo's *The Fortunate Pilgrim*. There is no shortage of widowed women in these novels—and they all know how to sew. The widowed Lucia Tosti in Tomasi's novel parallels Annunziata in several ways: She becomes widowed early due to her husband's illness contracted by insalubrious work conditions in the Vermont quarries; and her love for her husband exceeds her need to marry another man. Lucia's work options are limited due to three factors: her position as a mother of three children, her first-generational status, and limited work opportunities in small-town Vermont. Like Annunziata, however, Lucia is supported and protected by the Italian American community in her neighborhood. When she resorts to selling bootlegged liquor in her kitchen (the year is 1924), the town's moral conscience, Mister Tiff, encourages her otherwise, offering a practical solution that employs her skills as a seamstress on behalf of the workers who wear aprons in the carving sheds. While Mister Tiff's intercession might strike a critical chord in the reader for reinforcing Lucia's gendered status as a seamstress rather than as a bootlegger, her sewing grows into a business. Lucia's goal is to protect and educate her children; she manages to achieve this through her needle and a supportive community.

Daughters of immigrant parents are empowered by their ability to sew, and they function to sustain in primary ways the family's economy and to become financially independent individuals. As Elizabeth Ewen explains, "the factory . . . separated the experience of daughters from the homebound history of their mothers."[29] Such is the case for Carmela of Lapolla's *The Grand Gennaro* and Octavia of Puzo's *The Fortunate Pilgrim*. In the first decades of the twentieth century, twelve-year-old Carmela Dauri migrates to Harlem's Little Italy with her parents and brothers. By age twenty, Carmela has become a "leading business woman of Little Italy" and a skilled milliner. The greatest compliment her future husband, and business supporter, Gennaro, can give Carmela is to compare her to a man: "'You ought to've been a man. No question. You got the stuff.'" But the stuff of ingenuity and skill that Carmela possesses is distinctively related to her gender. Because she has been socialized to be a woman of *serietà* (seriousness, reliability), Carmela functions to unite the community through cooperation rather than unbridled competition and savagery, as Gennaro does. Carmela's acquaintance with sewing eventually prepares her to take over the millinery business from her neighbor and protector, Donna Maria Monterano. Lapolla's description of Donna Maria's expertise with the needle could also be said of Carmela: Both are trained "like all Italian girls of whatever station in life to a skillful acquaintance with the needle and cloth.

Intelligent, eager to learn, she had soon mastered the millinery art and had even reached the point where she made successful suggestions and had been promoted to forelady."[30]

Donna Maria's intercession on Carmela's behalf (when, after being raped, she is hastily forced into a marriage by her parents) enables Carmela to escape cultural codes about family honor and shame.[31] For all her forward-thinking qualities, Donna Sofia, Carmela's mother, reverts to ruinous old-world mentality when she insists that her daughter marry her rapist: "'You will marry him. We shall have no open shame in our family.'"[32] In good American style, Donna Maria challenges Carmela's mother's insistence that her daughter be immediately married, which she considers immoral, turning for help to a Protestant social worker, who manages to wrest Carmela and her brothers away from their family. The Juvenile Protective Asylum, part of the Americanization effort of social reformers, becomes a boon for Carmela, despite its "prison-like shelter from all the natural ways of life."[33] For it is here that Carmela masters English, improves her needlework skills, and teaches other girls how to become able seamstresses.

When she returns to the brownstone owned by Gennaro Accuci and where her family lives, Carmela comes to embody the meaning of the brownstone's name, "Parterre." From the old French for ornamental garden, the word *parterre* describes a flower garden with beds and paths arranged to form a pattern. Organized, creative, and communicative, Carmela thickens the threads of relationships among the three Italian families living in the brownstone, creating a unified pattern that is as successful as her millinery business. She recreates a feeling of *campanilismo* (village-mindedness), but she encourages the younger children to become educated and seek other landscapes. She keeps vigil while Gennaro's first wife dies; she guides and mentors the younger children of the Parterre, and she mothers (and eventually adopts with Gennaro) the children of the Monterano family, after their parents die. She redefines the idea of extended family within an Italian town or village, embracing immigrant families from different diasporas, from the *contadini* of Capomonte to the landed gentry of Castello-a-Mare. A widow at narrative's end, Carmela, entirely independent, moves away from East Harlem and lives downtown near her hat store. Despite Gennaro's grandiosity and larger-than-life personality, Lapolla ends the narrative with Carmela's story. Not only will she survive her husband's death, she will live fully and gracefully as an independent woman.

Lapolla's portrayal of Carmela is Puzo's blueprint for his creation of the spectacular Octavia Angeluzzi of *The Fortunate Pilgrim*. Second-generational daughter of Lucia Santa, Octavia plays a role in the family that ensures her mother's financial and emotional stability. Sacrificing for her mother

and siblings her dreams of becoming a teacher, Octavia uses her skills as a seamstress to keep the family afloat even during the Depression of the 1930s. Twice widowed, Lucia Santa depends on her oldest daughter to function as a second parent to her four younger children. As such, Octavia's support far exceeds in scope and intensity the help Lucia Santa ever received from either of her husbands.

Being a dutiful daughter does not prevent Octavia from planning an escape from the life of motherhood and "dreamless slavery by children" in her married adulthood. Practical and book-smart, Octavia juggles her work and home life as deftly as she does her needle and her words. Their quarrels fierce and brief, Lucia Santa and Octavia illuminate their generational differences early in the narrative, clarifying opposing ideological positions based on lived experience. Objecting to her mother's insistence that she remain a dressmaker rather than attending college to become a teacher, Octavia exclaims, "'I want to be happy.'" Her mother, unable to speak English and unlettered in Italian, responds in scornful imitation "'*You want to be happy.*'" But the mother then utters her proclamation in Italian and her rule is law in the Angeluzzi-Corbo family: "And then in Italian, with deadly seriousness [Lucia Santa said] 'Thank God you are alive'" [*Grazie a Dio sei a posto*].[34] Octavia continues working in the needle trades.

Winning the next battle with her mother, Octavia switches jobs to become a sewing teacher for a company promoting the sale of sewing machines. Lucia Santa relents only because Octavia's new position allows her to sew dresses for her mother and her younger sister while on the job. Octavia is enormously successful with the Italian ladies to whom she gives lessons and sells machines, and her fundamental decency is demonstrated when she is forced to sell more expensive machines to women who cannot afford them. As with many stories of sewing women, Octavia's experience at the Melody Corporation reveals to her a vision of the world that is inherently unjust; refusing to cheat poor women in order to increase her power, Octavia risks losing the job rather than wrongfully deprive people like her mother. "She had for the first time in her life to make a moral and intellectual decision that had nothing to do with her own personal relationships, her body, her sex, her family. She learned that to get ahead in the world meant despoiling her fellow human beings. . . . Sometimes she tried, but she was not capable of the final bullying that was needed to clinch a sale."[35] She is summarily fired, but due to her sewing expertise, Octavia finds work immediately in the garment shops.

It is in those dressmaking shops that Octavia achieves further independence as a worker and a woman. When she returns to her family after a protracted hospital visit (due to pleurisy), Octavia, like Carmela before her,

seems utterly transformed, "an American girl, full blown."[36] Octavia's dual talents as a worker in the garment shops and a reader of literature afford her the moxie to defend her family against a welfare agent, who has been cheating the Angeluzzi-Corbos during her absence. When she bustles into the apartment after work, Octavia meets the relief investigator, whom Puzo ironically nicknames La Fortezza (the fortress, the strength), whose condescending sexism and class prejudice reignite her ferocity, which had been quelled during sickness. For it is second-generation Octavia, not her mother, who has the linguistic virtuosity in English that topples the flimsy fortress of the relief investigator. Through language, Octavia sews his mouth shut once and for all and sends him voiceless out of the Angeluzzi-Corbo apartment. Puzo clarifies the centrality of Octavia's position in the family through the strength of her voice, which bears full citation:

> "You take eight dollars a month from my poor mother, who has four little kids to feed and a sick daughter. You bleed a family with all our trouble and you have the nerve to ask me out? . . . My kid brothers and sister do without candy and movies so my mother can pay you off, and I'm supposed to go out with you?" Her voice was shrill and incredulous. "You're old-fashioned, all right. Only a real guinea bastard from Italy with that respectful Signora horseshit would pull something like that. But I finished high school, I read Zola, and I have gone to the theater, so find some greenhorn girl off the boat you can impress and try to screw her. Because I know you for what you are: a four-flusher full of shit."[37]

Octavia's voice serves equally as a weapon of self-empowerment as her needle does. Publishing *The Fortunate Pilgrim* in 1964 afforded Puzo the luxury of having read his literary Italian American predecessors and living during a time of tremendous change in social relations. As powerless as all these women could feel, none of them accepted the role of the distressed seamstress; all of them, except for Annunziata of *Christ in Concrete*, increased the earning power of their families through the work of their needles. Like the *sarta* of her Italian village, each of the female sewers holds a distinguished position in her family and communities; *la sartina* becomes a working-class symbol of entrepreneurial expertise in the literature of Italian America.

Bernardi's *Openwork* and Italy's Diasporas

In her oral history of immigrants (many of whom came from the province of Modena in the north-central region of Emilia-Romagna), Adria Bernardi interviewed nearly fifty men and women from the working-class community

of Highwood, Illinois, a suburb thirty miles north of Chicago, flanked by affluent suburbs such as Lake Forest and Highland Park. Bernardi's 1990 *Houses with Names* is the historical precursor to her 2007 novel, *Openwork*, though the author continued her research in the intervening years. In the earlier work, Bernardi transcribes the stories told by immigrants who left their homeland and partook in the larger movement Gabaccia describes as "village-based proletarian diasporas."[38] The scattering of northern Italians from the mountains of the Modenese Apennines began as seasonal work and extended throughout *tutto il mondo* (the whole world).

The migrants from Italy—north and south—despite their limited resources and land hunger, voluntarily left their homes,[39] but their suffering has been equated by writers of Italian America with a trauma that damages beyond repair. A paradigmatic case in point in *Openwork* is Bernardi's description of a first-generation immigrant, Desolina, and her enormous suffering's causal relation to her migration experience, from which she never recovers. Impatient with her grief, Desolina's husband thinks she takes a "calendar page and turn[s] every day into a day of mourning," but Desolina's pain is written on her body as trauma: "[I]t was a piece of metal wire, a piece of thread. . . . It seared from underneath, upward into her skin: she will never see those people again. With inadequate language, her body became words. Her body is like the bodies of other women, her friends and neighbors."[40] Like textiles woven with gold and silver thread, the bodies of migrating women suffer physical pain as though fine wires are threaded through them. Desolina's *desolazione*— desolation—is paradoxically shared by the Italian American women in her community, and each woman suffers from physical and mental pain that is then passed down to their children, who replicate their suffering. Sewing assumes further significance for migrating women as it repairs the damages of disconnection by reminding the women of the village *sarta*, from whom they learned the skill.

Bernardi's *Openwork* represents the activity of sewing as a radical act, literally re-threading transplanted immigrants to their *paese*, the town they came from. Structurally, Bernardi's novel simulates the diasporic experiences of Italians, connecting them also to a transnational identity that crosses borders, enabling more permeable boundaries and thereby keeping open the connections between families, generations, and places. *Openwork* depicts the lives of several generations of closely related northern Italian families. Seven intersecting voices speak, the author reinforcing through repetition and layering the threads that connect them.

The novel's first voice is that of *la sarta*, Imola Bartolai, who begins and ends the narration. Her story is as varied as the linen she embroiders with

all the creatures she can think of, creating a large tablecloth that will come to symbolize the enormity of the migration experience. Imola, a seamstress and wet-nurse from a mountain village on the border of Tuscany, has a story that will cross into and intersect with the other voices throughout the novel, most presciently, that of Adele, who will strengthen the bond through writing. Imola's losses extend beyond her miscarriages and into New Mexico, where her beloved brother, Egidio, is killed in a coal mining accident. Imola's and Egidio's childhood companion from the mountain village, Antenore, the voice of radicalism in the novel, struggles to find justice through unionizing efforts on behalf of his fellow workers. A stonemason by trade, Antenore Gimmori raises three sons in the Highwood area of Chicago, where Rina, daughter-in-law of Antenore and Desolina, struggles with depression as debilitating as Imola's. Rina's daughter, Adele, will attempt to find a strategy for mending her mother's and her family's ruptures, recognizing them as part of a long-term response to migration.

The term *openwork* describes the method of needlework to which Imola is dedicated, but also the word choice references the structure and style of the novel itself. Openwork refers to ornamental or structural work as of embroidery or metal, containing numerous openings, usually set in patterns. The word *open* suggests both fragility and opportunity. Bernardi examines what anthropologist Annette B. Weiner describes as the tense exchange and universal paradox of "keeping-while-giving." Imola refuses to sell her embroidered openwork to a buyer, but rather sends this "inalienable possession" in memoriam to her brother's widow in the desert. In this way Imola engages in the gift economy of her culture, and in doing so, she engages in the universal paradox of securing "permanence in a serial world that is always subject to loss and decay."[41] To defeat loss, Imola sends her tablecloth to a weeping widow, keeping her brother's memory alive through this gesture of generosity. Cloth production remains a source of power for many of the women in this novel.

Openwork also exists outside the story's pages and is suggested when Bernardi begins her book with a page of writing that might be called a prologue: The word *prologue* comes from the Greek word *prologos*, literally meaning "before speech." Adele, the wordsmith in the novel and a mouthpiece for Bernardi, tries to understand the layers of meanings in words and actions, including her mother's stupefying depression, which recalls Imola's earlier episodes of catatonia. In keeping with the structure of openwork embroidery, Bernardi includes three separate paragraphs of about the same length, serving didactic and semiotic purposes. The first is a quotation from page 5 of the book, the second is an autobiographical paragraph signed by the author, and the third is a descriptive summary of the novel. Serving both

hermeneutically and heuristically, Bernardi's three-paragraph "before story" tells a story three different ways, a thrice-told tale, as it were.

In the first paragraph, Bernardi separates needlework activity from the contexts of her character's remunerative life. It reads: "For this trousseau, it's variations on a cobbler stitch. One stitch over four threads. Imola is at work on the ground cloth. . . . She's teaching her girls and they're coming along. . . . They want to have a thick sample book, just like hers, pages with every kind of stitch. . . . Imola can teach any kind of needlework, but what she's most proud of, what she's vain about, is pulled-thread needlework."[42] Before the story begins, Bernardi offers a bird's-eye view of women's work and the association of needlework with domesticity rather than with solely the apprenticeship of daughters who will find acceptable employment in their futures. Bernardi's governing metaphor of sewing is introduced here, and the activity of needlework is valued aesthetically. Its utilitarian value, further contextualized in part 1, will provide information on Imola's trade as a seamstress who sews bridal linens for other families.

Bernardi's autobiographical paragraph mimics the activity of threading by connecting itself to the fictional paragraph above it, both pieces united by a sense of the sacred in cloth. The author heightens the magic of transmitting the past through a literalization of the transatlantic voyage itself—the trunk: "The trunks were rarely opened, and when they were, the white linens were unfolded and displayed as if they were precious and fragile, barely to be looked at. When you touched the rough linen, you could hear water running in a river in mountains. And sometimes when my grandmother picked it up, you could see a kind of electric current surge through her to her own mother." To secure a sense of permanence, the author, who is a third-generation inheritor of cloth, comes to recognize this linen as an inalienable possession and interprets the language of openwork: "[It] speaks to me most because you can see through it and it's made from the ground cloth itself."[43] As Weiner explains, even if the inalienable possessions inside the trunk are not being exchanged, "the possession exists in another person's mind as a possible future claim, and potential source of power."[44] For Adria Bernardi, trousseau is treasure.

Bernardi claims the power in order to keep alive the memories of northern Italian immigrants, creating a conversation "across a century" as she writes in her third explanatory paragraph, linking Imola Bartolai Martinelli to Adele Gimorri, "four generations that connect U.S. coal mines, the first World War, the Great Depression, and the era of the Vietnam War." As a witness to both her grandmothers' "traumatic break with their home," Adele will imaginatively and literally wend her way back in time to the memory of her grandmothers' friend Imola. In refrain, Bernardi returns to the metaphor

that governs the structure and style of her novel: openwork. In homage to Imola, Bernardi writes, "It is from Imola [that Adele's grandmothers] learned openwork—a kind of needlework in which the threads of ground cloth are pulled together in endless variation and tension—and which patterns are formed with holes."[45]

It is in those spaces that Bernardi stitches a story of trauma and shame, illness and pain, but also a story of beauty and generosity, of work and gain. *Openwork* is Bernardi's imaginative attempt to mend fragmentation and yet leave space for overlapping fibers to be sewn. Of the many threads woven throughout the novel, two resonate in particular and refer to defensive sewing and to the experiences of migration for Italians who left their homes for work. Such resonances frequently recur in Imola's sections of the book, where the activity of sewing also becomes her bulwark against the destabilization that occurs with migration. Part 1 of *Openwork* is called "Child Carrier" and refers to Imola's work as a wet-nurse, which both her grandmother and mother performed before her. For a fee, Imola takes away a baby from a neighbor who cannot afford to keep him due to both poverty and shame, since the baby was likely conceived with someone other than her husband.

Imola's job as a wet-nurse is but one of many ways she keeps starvation at bay while her husband is away working. Exhausting and never-ending work compels Imola to think that when she lies down "she counts one less night of sleep in her life."[46] Imola's work situation parallels that of white widows, "large numbers of married women with absent husbands" who "worried about heavy burdens of work."[47] Having gained independence from her spouse's absence, when Imola's husband returns, she refuses to allow him to control her. She thinks, "In winter she and the children went weeks with nothing but dried-out-tree-bread and polenta, waiting for money to arrive, while he was out seeing the world. She managed without him for six months; he can manage without her for three days. She said this. He looked at her in disbelief. He liked the sweet wife better. How could he expect her to manage the children, the animals, the land, the house, the needlework, half the year, then, the second he stepped through the door, expect her to become a meek lamb?"[48]

Despite her pending three-day trip down the mountain with two infants in tow (her own and the neighbor's), Imola awakens to a morning of needlework. Bernardi's introductory paragraph before the onset of the novel has prepared the reader to value this focus. Before she leaves, Imola sews with the rising of the dawn light. Bernardi's depiction of Imola sewing innovates on the well-known iconology of the poor seamstress. In this *tableau vivant*, Bernardi introduces a pervasive visual type of seamstress iconography during the Victorian period: the lone needlewoman. Established in

nineteenth-century England during the proliferation of dressmaking and needlework trades, "the motif of the isolated seamstress . . . became an enduring symbol for the Victorian populace generally and for reformers, painters, and illustrators specifically."[49] Like her needlewomen sisters in Victorian England, Imola worked under harsh conditions, and, like the majority of women working, she was neither alone nor single. Imola's needlework expertise affords her a living as she prepares trousseaux for young brides. During this morning scene, Imola reinforces her connections with her daughters, Lidia and Licia, who eagerly learn the stitches from their mother, sewing "samples into a little cloth book."[50] Because of their mother's guidance, the girls learn how to sew and to write, preparing them further to support themselves after their mother becomes ill and, eventually, to migrate to America, where their lives will intersect with the other voices in the novel.

Closely woven into the scene of Imola's sewing and transporting an infant away from its mother are Bernardi's recurring references to migration. Imola's voice is infused with grief over the departures of her brothers, whom she never sees again. Her musings about them become recitative and prayerful and are repeated decades later in America by Adele's maternal grandmother, Adalgisa, who learned the art of needlework not from her mother, but from Imola, alongside Lidia and Licia. Adalgisa's primal wound is never healed or forgiven. The loss of her unnamed brother (the infant Imola carries to a new mother) is assuaged by a guilt-ridden family through alcohol, to which Adalgisa remains addicted in adulthood.

These are some of the stories that tie neighbors from the same village together in Bernardi's novel, and they are passed down to the next generation for good and bad. Lest she show ingratitude when both sets of grandparents buy her a no-name brand bicycle for her birthday, Adele recalls a litany of loss drummed into her about the migratory lives of her family: "They never had bikes. They never had anything. Their brothers and sisters went far away when they were eleven and twelve and thirteen, and they never lived together again." Later, when her own mother, Rina, is taken for a period of time to a mental institution, Adele is told the story of Imola's daughters, who at ages thirteen and eleven were sent to different houses in Florence to work as maids when they took their mother away.[51] One of these sisters minds Adele when her mother is institutionalized for a brief time for depression.

Bernardi creates textual openwork throughout her novel, which offers spaces of possibility. The intricate webs of connection woven into *Openwork* do not hermetically seal the characters into unspoken reveries, but rather open up space for Adele to stitch a sentence of her own. Indeed, Bernardi's potent metaphor of openwork affords this space as illustrated when

her grandmother, Adalgisa, hands Adele a "threaded needle," and instructs her to "pull the threads of the cloth together[.] These three. Not too tight."[52] These instructions occur concurrently with the hospitalization of Adele's mother and with Imola's daughter, Licia, giving Adele information about her own childhood labor and subsequent migration.

Adele's lesson with needle and thread prepares her to connect with Imola in part 3, "Shore Line." A mother now of two adopted girls from China, Adele hears the call of her old-world neighbor, Imola, and finally heeds her imperative: "*Sriva pura.* Go ahead. Just keep writing. You who know how to write. . . . We will never know all the details. All we know are bits and pieces. . . . Do you think I know how we are all connected to one another? how I am connected to you? No. What are you waiting for? Between here and there are all the connections. Do you think someone else is going to put those babies back in my arms?" Despite fissures and gaps, Adele accepts Imola's admonition to write. Just as Imola will never feel "done working the cloth. Get it. Bring her a needle," so Adele will never tell the whole story, leaving holes in the narrative for rumination and future creation. Archival research, family stories, and imagined conversation are embroidered into *Openwork*, a textual parallel to Imola's "putting all the creatures . . . into that wide piece of linen."[53] Needle and pen merge as Adria Bernardi becomes another highly conscious literary seamstress and the hard-cover publication and binding of *Openwork*, her literary fascicle.

Conclusion

Used both literally and metaphorically, the needle serves as an instrument of self-possession for women workers represented in the writings of Italian America. A defensive tool, the needle reveals a vision of the world that is very likely unjust, but women's defensive sewing offers them the means to speak for themselves in a world that would deny their very existence. And the needlework they produce—often for others' consumption—is beautiful and precious.

Perhaps one of the most poignant examples of the costs of migration in the literature of Italian America occurs when Umbertina is forced to sell her matrimonial *coperta* to a local *padrona* to garner enough money to move her family out of the New York City tenements. As Jane Schneider explains, "selling or pawning" embroidered linens of trousseaux "was the last resort—a desperate, almost immoral economic necessity," but such items, as Umbertina ruefully learns, "may be multifunctional," and used for "potential exchange."[54] Umbertina realizes the cost of this transaction, and when she

tries to buy back the spread, realizing its significance to her life, Umbertina learns that the loss of her treasure symbolizes the sacrificial entry to a better life for her family in upstate New York. While forever lost to Umbertina, this icon of permanence, which is hand-stitched on hand-loomed fabric, achieves iconic status when later enshrined in America's Ellis Island museum and, as Josephine Gattuso Hendin explains, symbolizes "Barolini's faith in women as the weavers and custodians of an Italian future in America."[55]

The writers who take up the pen to honor the seamstress do so recognizing their custodial role in creating an Italian future in America and the necessary intersection between utilitarian and aesthetic value represented by the sewing of so many Italian American women. Of the past, it might be said that Italian and Italian American women have always worked, always sewed. Of the present, it might now be said that writers of Italian America have continued convincingly to represent those activities through hands a pen equally fits.

Notes

1. Sandra M. Gilbert and Susan Gubar, *Madwoman in the Attic: The Woman Writer and the Nineteenth-Century Literary Imagination* (New Haven, CT: Yale University Press, 1979), 639, 641–42, 642.

2. R. Radhakrishnan, "Ethnic Studies in the Age of Transnationalism," *PMLA* 122, no. 3 (May 2007): 809.

3. Gilbert and Gubar, *Madwoman in the Attic*, 638.

4. See Donna Gabaccia's *Italy's Many Diasporas* (Seattle: University of Washington Press, 2000), especially chapter 2, for a description of Italian migration streams—including labor migrants—to European capitals such as London and Paris, but also to North and South America, particularly the United States and Argentina, respectively.

5. Joyce Carol Oates, "Imaginary Cities: America," in *Literature & the Urban Experience*, ed. Michael C. Jaye and Ann Chalmers Watts (New Brunswick, NJ: Rutgers University Press, 1981), 18. The needle-trade industry clearly had a large presence in Manhattan during the migrations of immigrants from Southern and Eastern Europe, yet other factors also contributed to Italian women entering that trade. Louise Odencrantz studied 544 Italian families living on the lower end of Manhattan (below 14th Street) where the needle industries led in employing Italian women, many of whom "had learned fine hand sewing in the public or convent schools in Italy; others had worked as apprentices and finishers with the village dressmaker, or had themselves been the dressmaker for the village. Over four-fifths of the group of 65 who had worked at some form of sewing in Italy were in needle trades in New York City." In *Italian Women in Industry, 1919* (New York: Arno Press, 1977), 40.

6. Gabaccia, *Italy's Many Diasporas*, 60.

7. Elizabeth Ewen, *Immigrant Women in the Land of Dollars: Life and Culture on the Lower East Side, 1890–1925* (New York: Monthly Review, 1985), 243.

8. Alice Kessler-Harris, *Women Have Always Worked: A Historical Overview* (Old Westbury, NY: Feminist, 1981), 67, 63.

9. See Mariolina Salvatori's "Women's Work in Novels of Immigrant Life," *MELUS* 9, no. 4 (Winter 1982): 56–57.

10. "The domestic code, or 'the cult of true womanhood,' glorified the family structure and contributed to a stability that encouraged, even coerced, the male to work harder in order to support his family.... The moral imperative that confined women to their homes served many purposes.... It kept most married women and many unmarried women out of the labor force, restricting them to supportive roles in relation to the male work force. It offered industry the services of an unpaid labor force at home whose primary task was to stretch male wages." Kessler-Harris, *Women Have Always Worked*, 67.

11. Jane Schneider, "Trousseau as Treasure: Some Contributions of Late Nineteenth-Century Change in Sicily," in *Beyond the Myths of Culture: Essays in Cultural Materialism*, ed. Eric B. Ross (New York: Academic Press, 1980), 335.

12. Mario Puzo, *The Fortunate Pilgrim* (New York: Ballantine, 1997), 8–9.

13. Jennifer Guglielmo, *Living the Revolution: Italian Women's Resistance and Radicalism in New York City, 1880–1945* (Chapel Hill: University of North Carolina Press, 2010), 55, 53.

14. Fred Gardaphé, *Leaving Little Italy: Essaying Italian American Culture* (Albany: State University of New York Press, 2004), 63, 64, 165.

15. Italo Calvino, "Introduction: A Journey Through Folklore," trans. Catherine Hill, in *Italian Folktales* 1956. Selected and retold by Italo Calvino, trans. George Martin (San Diego: Harcourt Brace, 1985), xix.

16. Calvino, *Italian Folktales*, 263. As Jane Schneider explains, "a good wife was a good weaver, so much so that it was customary for prospective mothers-in-law to find pretexts for discovering the weaving skills of their son's betrothed before the wedding day was fixed." "Trousseau as Treasure," 334.

17. Calvino, "Introduction," *Italian Folktales*, xxi.

18. Jerre Mangione, *Mount Allegro* (New York: Syracuse University Press, 1998), 143.

19. Gabaccia, *Italy's Many Diasporas*, 74.

20. Ewen, *Immigrant Women in the Land of Dollars*, 123, 125, 243.

21. Pietro Di Donato, *Christ in Concrete* (New York: Signet, 1993), 152.

22. Roger D. Abrahams, foreword to *Italian Folktales in America: The Verbal Art of an Immigrant Woman*, by Elizabeth Mathias and Richard Raspa (Detroit, MI: Wayne State University Press, 1988), xi.

23. Annette B. Weiner and Jane Schneider, "Introduction," in *Cloth and Human Experience*, ed. Annette B. Weiner and Jane Schneider (Washington, DC: Smithsonian Institution Press, 1989), 2.

24. Abrahams, foreword to *Italian Folktales in America*, xi.

25. Di Donato, *Christ in Concrete*, 154.

26. As quoted in William Boelhower, "'Pago, Pago!': The Gift Principle in Contemporary Italian/American Narratives," in *From the Margin: Writings in Italian Americana*, ed. Anthony J. Tamburri, Paolo A. Giordano, and Fred L. Gardaphé (West Lafayette, IN: Purdue University Press, 2000), 385.

27. Di Donato, *Christ in Concrete*, 40.

28. Sandra M. Gilbert, *Death's Door: Modern Dying and the Ways We Grieve* (New York: Norton, 2006), 24–25.

29. Ewen, *Immigrant Women in the Land of Dollars*, 242.

30. Garibaldi M. Lapolla, *The Grand Gennaro,* ed. with an introduction by Steven J. Belluscio (New Brunswick, NJ: Rutgers University Press, 2009), 257, 111.

31. Carmela's rape deserves further commentary. None of the critics of Lapolla's work thus far has adequately examined the implications of the vicious attack on Carmela by Gennaro's son Domenico. That Carmela eventually marries Gennaro might be Lapolla's suggestion of his eponymous character's moral reform, but that Carmela has a stillborn child, and is thereafter widowed, might also be the author's deliberate choice to spare Carmela a long, married life to the grand Gennaro.

32. Lapolla, *The Grand Gennaro*, 136. For an examination of the interdependent concepts of honor and shame around Mediterranean family practices governing the virginity of their girl children, see Jane Schneider's "Of Vigilance and Virgins: Honor, Shame, and Access to Resources in Mediterranean Societies," *Ethnology* 10, no. 1 (1971): 1–24.

33. Lapolla, *The Grand Gennaro*, 190.

34. Puzo, *The Fortunate Pilgrim*, 12, 13.

35. Puzo, *The Fortunate Pilgrim*, 85.

36. Puzo, *The Fortunate Pilgrim*, 175.

37. Puzo, *The Fortunate Pilgrim*, 180.

38. Gabaccia, *Italy's Many Diasporas*, 12.

39. In *Global Diasporas: An Introduction* (Seattle: University of Washington Press, 1997), Robin Cohen constructs a taxonomy to describe different types of diasporas, evoking horticultural imagery to explain dispersal.

40. Adria Bernardi, *Openwork: A Novel* (Dallas, TX: Southern Methodist University Press, 2007), 170, 206–7.

41. Annette B. Weiner, *Inalienable Possessions: The Paradox of Keeping-While-Giving* (Berkeley: University of California Press, 1992), ix, 7.

42. Bernardi, *Openwork*, n.p.

43. Bernardi, *Openwork*, n.p.

44. Weiner, *Inalienable Possessions*, 10.

45. Bernardi, *Openwork*, n.p.

46. Bernardi, *Openwork*, 7.

47. Gabaccia, *Italy's Many Diasporas*, 88.

48. Bernardi, *Openwork*, 6.

49. T. J. Edelstein, "They Sang 'The Song of the Shirt': Visual Iconology of the Seamstress," *Victorian Studies* 23 (Winter 1980): 184.

50. Bernardi, *Openwork*, 5.

51. Bernardi, *Openwork*, 155, 272.

52. Bernardi, *Openwork*, 172.

53. Bernardi, *Openwork*, 300–301, 297, 323.

54. Schneider, "Trousseau as Treasure," 343, 351.

55. Josephine Gattuso Hendin, "Why Helen Barolini's *Umbertina* Is Still New," in *Italian Americans Before Mass Migration: We've Always Been Here*, ed. Jerome Krase, Frank B. Pesci Sr., and Frank Alduino (New York: American Italian Historical Association, 2007), 154.

FACTORY
GIRLS

Backbone/*Colonna Vertebrale*

2004
Antique wooden mill and sewing thread spools, velveteen,
aluminum rods, wood base, 5.5' h x 10' w x 6' d
Photograph by Lisa Venditelli

—Lisa Venditelli

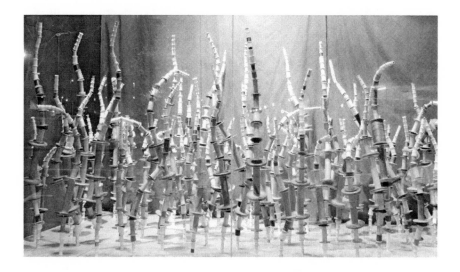

My art represents feminism, domesticity, body image, and female experiences, usually presented with more humor than angst, and from the viewpoint of my Italian American history. In my work liquid soap bottles become angels, clothespins become musical notes, and lasagna becomes wallpaper and a bikini.

Imagine the plight of early twentieth-century immigrant textile workers; tireless, detailed work, long hours and rugged, unsafe conditions. Using materials from the period, including antique wooden mill and sewing thread spools, Backbone/*Colonna Vertebrale* mimics backbones; some standing tall and others completely bent. Columns of spools that are placed over rods of

varying heights appear skeletal, crowded together, and casting long shadows to add to the dramatic effect.

In the United States Italian women immigrants worked in mills or sewed in their houses to supplement the income of their families. But it was not only Italian women who worked in the mills:

> Thousands of immigrant women of all ethnicities worked in New England textile mills. So dependent were these mills on immigrant labor that it was not unusual for several dozen languages to be spoken by their employees. Skilled women who had done this work in Europe said that in America, they often were assigned more looms than they could tend without exhaustion.[1]

Pennsylvania, New Jersey, and New York were major centers for the textile and garment industry. Textile mills were notorious exploiters of children.

Immigrant women and children boosted U.S. textile, garment, and lace-making industries. They worked to make money but brought their craft and their strong work ethic to the mills. The women were skilled embroiderers, weavers, silk and lace makers in their native countries. There the emphasis was on a quality product. They took pride in their work. But immigrant women were frustrated with the U.S. mills. The emphasis was on fast, cheap, and high-volume product. The women endured the hazards of unsafe working conditions. Some would lose their hearing from the drone of the machines while others would lose their lives as a result of poor working conditions.

Backbone/*Colonna Vertebrale* embodies the lives and spirit of these immigrant workers. It is dedicated to the thousands of women and children, in the past and around the world today, who endured harsh conditions with little reward and no recognition.

Note

1. Doris Weatherford, *Foreign and Female* (New York: Facts on File, 1995), 205.

How *la Sartina* Became a Labor Migrant

—Jennifer Guglielmo

Tina Gaeta learned to sew, like most girls, from the women in her family. Both her grandmother and mother were seamstresses, though her mother, Lucia, was particularly skilled. Word traveled fast in their southern Italian coastal city of Salerno in the region of Campania, and those who could afford it paid Lucia to make their clothes, giving her the status of *la sartina*—the seamstress. In an oral history, Lucia's daughter Tina recalled, "In Italy in those days women who sewed wore their scissors attached to a special ribbon over their long skirts. When they went home, they wouldn't take it off. The other women who didn't work or who worked as peasants on the farm, used to say, 'Oh, she's the seamstress, *la sartina!*' In those days, being a seamstress was a very, very good thing. It was very distinguished."[1]

Sewing would also become Lucia's most important resource. Early in her marriage, her husband left for long periods of time to lay tracks for the Long Island Railroad, joining the masses of southern Italian men who crossed the Atlantic. While this work was dangerous and exhausting, it was plentiful. Railroad companies in particular were hungry for cheap labor and recruited men from across southern Italy by the thousands. Those who didn't work on the railroad filled jobs in construction, as brick masons, coal heavers, stone crushers, concrete laborers, sewer construction workers, tunnel or building excavators, street graders, and ditch diggers—essentially building the infrastructure of modern industrial capitalism.[2] Lucia's husband sent whatever he could back home to his family, but his wages were meager and sporadic, so Lucia supported the family in his absence by working as a seamstress. When she saved enough, she purchased tickets for steerage—the cheapest class on the lowest decks of the ship—packed up her three children, and together they crossed the Atlantic in 1904.

Lucia's decision to migrate was strongly influenced by the fact that she could find work immediately in New York City, the very center of the international garment economy. Upon arrival, however, she found that the skilled sectors of the garment industry were closed to her, and like the majority

of Italian immigrant women in the city, she became a pieceworker, finishing ready-made clothing in her own home. Sewing clothing in her kitchen for mass production was monotonous and low paying, but it was necessary given her husband's meager wages. It also enabled her to care for the children at home, especially since their family continued to grow. When Lucia's husband died suddenly, leaving her alone with their six children, industrial sewing kept the family alive. "At the time," Tina remembered, "the only means of getting work from the neighborhood was from the men's clothing, boy's jackets, and men's jackets. So, she used to send my brother and my sister to pick up the work and take it home. Then, as my sisters grew up, she started them on making dresses." Working together, Lucia taught her children how to sew the invisible seams by hand, while she did the more complex sewing. As they grew older, she taught them to sew the entire garment on their own; and once they became experienced, they went to work in the factories.

Lucia and Tina's story is not just their own, but the story of most Italian women who migrated to New York City. Like men, women became labor migrants. While men worked as "veritable human steam shovels," women became sweatshop workers.[3] The movement of women from southern Italy into U.S. clothing and textile manufacturing marked an important moment in the developing global economy—a stage in the feminization of manufacturing that required that women (and children) move across national boundaries in order to secure their own and their families' survival. This was an early twentieth-century example of the "localization" of globalization, of "cross-border circuits in which the role of women, and especially the condition of being a foreign woman, is crucial."[4] This essay maps this history, to identify Italian women's position within and experience of the emerging transnational political economy of the early twentieth century. My goal in following the women is to make them more visible. But it is also to humanize and historicize the seemingly abstract economic systems that shape migration and to understand the world that these women experienced and gave shape to as they moved through space.

Lucia and Tina's story teaches us that sewing was many things: grueling, tedious, low-wage labor; an admired craft; an expression of creativity; a tool for survival; a skill developed for a changing marketplace; a source of connection between women; and a means of passing on wisdom from one generation to the next. Tina recalled that when her family did industrial piecework at home, Lucia sometimes "would give us a treat and put the potatoes in the oven, or toast bread with oil and chopped garlic," and "tell us so many stories and proverbs while we were sewing." Her favorite story was of a ninety-nine-year-old washerwoman in the old country who

fell ill. The woman's sister called the doctor, who came, but upon examining her exclaimed, "What can I do; she is very old." The washerwoman was so weak that all she could do was raise her finger. "What is it that you want to tell me?" the doctor asked. "*Oh Dio*, one more year," she replied. Surprised, the doctor asked, "You have had a good life. Time comes for all of us to leave each other. What is one year more or less? What are you searching for that you want to live one more year?" The old woman replied, "*Ho tanto ancora da imparare!*" I still have so much to learn.[5]

This story within a story captures the essence of women's resistance to industrial capitalism. The belief systems and narratives generated to support industrializing capitalism and patriarchal nation-states valued southern Italian women's lives only to the degree that they served as low-wage menial workers and caretakers of men (as wives, mothers, etc.). Such a worldview developed to justify their subordination and dehumanization and served to hide employers' and consumers' reliance on and complicity in immigrant women's cheapened work. But this arrangement was never complete. By following the women, we can see the many creative ways they developed a sense of dignity and refused the master narrative of their instrumental worth. In this story, after all, the humble washerwoman is wise, and it is *she* who teaches the doctor. Lucia made sure to pass this story on to her children. Tina did the same with her daughter and valued the story enough to share it with us. As a tale of the old woman's learning for her own sake alone, the story contains the profound truth of women's intrinsic value: The washerwoman's love of life stemmed not from her ability to provide for others, but from her desire to nourish herself.

Women and the Feminization of Manufacturing Labor in Italy

Italian women's labor migrations were set in motion by global processes of economic change that women first experienced in their homelands. Globalizing capitalism, including political centralization, nation-building, urbanization, the rise of the factory system, and mass emigration, were acutely felt even in the most remote southern Italian villages:

> As cities grew, the countryside fed and populated them, and as urban factories produced new and cheap products, the countryside often became an important marketplace for them. Change in the countryside might mean a new crop grown, an old trade abandoned, the search for a cash income, migration, or the loss of kin and neighbors to "better opportunities" elsewhere.[6]

It also meant that women entered the local and global marketplace in larger numbers and with more frequency, as consumers, merchants, workers, and rebels.

To cope with these changes, southern Italian women turned to weaving, sewing, and other "female industries" as a gendered strategy for family subsistence in primarily agricultural settings. These trades also offered the possibility of acquiring the respected status of the artisan. Many learned the craft at home from the women in their families and as apprentices in the workshops of skilled dressmakers and tailors, many of whom were women. With the rise in mass-produced textiles and garments in the late nineteenth century, however, and the shift from custom- to ready-made clothing, sewing changed dramatically. Instead of social status or a creative outlet, these industries offered women tedious, repetitive, physically debilitating work.

Migration to the centers of industrial production involved a process of de-skilling in which women found themselves not only poorly paid, but in workshops and factories that were increasingly controlled and defined by men.[7] Industrialization in Italy developed slowly and centered in the north, in the triangle formed by the cities of Turin, Genoa, and Milan. The southern cities, such as Naples, Salerno, Messina, Palermo, Trapani, Catania, Potenza, and Bari, offered women light industrial and artisan labor, especially in the clothing and textile trades. Since manufacturers could use the rationale that women's labor was supplemental in order to pay them as little as half the wages they offered men, most turned to female labor to save costs and drive up profits. Using the classic rationale that women and children were desirable workers for their "*dita delicate ed agili*" (delicate and agile fingers), manufacturers relied on biological determinist arguments to justify exploitation. By the late nineteenth century, women and children outnumbered male workers in most manufacturing in Italy, including silk, wool, cotton, cigars, matches, gloves, glass, pottery, leather, paper, printing, coral, pasta, and straw hats. In 1894, for example, among 382,131 industrial workers overall, women comprised 49 percent of the total, not including girls under the age of fourteen who also made up a large group and were concentrated in the "light" industries of textile and garment work.[8]

Textiles consistently drew the largest numbers of women. Between 1900 and 1910, textiles were among Italy's chief exports, and while such work varied from region to region, women dominated the industry, in domestic production, cottage industry, and factory manufacture.[9] The census records, however, document a large drop in the number of women working in textiles between 1882 and 1901, from 1,213,978 to 661,774. This was a result of mechanization, which shifted textile manufacture from homes to factories, causing a sharp decline in the number of independent artisans. In addition,

the liberal trade policies of the Italian state "allowed outside producers to challenge artisans' monopoly on local markets," and women were forced to abandon the domestic production of cloth.[10] By and large they turned to sewing. The growth of factory-made textiles in particular led to this rise in *sartine* or *sarte* (more specialized seamstresses, dressmakers, and tailors) and *cucitrice* (less-skilled seamstresses). As "spinning and weaving declined, women applied highly elaborate needlework to this factory produced and commercially distributed cloth," and the needle trades proliferated.[11] The rise of labor-intensive clothing industries at home and abroad further compelled women to take up this craft. When asked why she had learned to sew before coming to New York City, one young Italian immigrant woman noted: "We have to think of the future and not always of the present."[12]

Oral histories abound with evidence of the journey women made from apprenticing in Italy to becoming industrial workers in New York City. Women learned the techniques of hand sewing, lace making, and embroidery from the women in their communities—relatives, the local seamstress, and in convent and public schools.[13] Carmela Lizza's training was typical. Her parents sent her to the neighborhood *sarta* in Palermo when she was a child, to learn how to design, cut, and sew dresses, blouses, and coats. Since most of her neighbors were artisans and small-shopkeepers, becoming an apprentice to the local dressmaker was a valued part of a girl's education. By the age of fourteen, Carmela was training other girls and working as a dressmaker out of her home. Once she became an adult she and her brother, a cabinet-maker, migrated to New York City. There she found immediate work in a shop that specialized in custom-made bridal dresses, where she remained for thirty years.[14] Custom-made specialty shops that catered to a middle-class and wealthy clientele were becoming increasingly rare by the early twentieth century, however, and only the very skilled seamstresses had a small chance of entering these better-paying jobs.[15]

Most women entered the garment industry at the very bottom of the ladder. Maria De Luca and her sister were both sent by their parents to apprentice with the village dressmaker in their town of Spinoza in the region of Basilicata. When Maria turned eighteen, she migrated to New York City, having heard returning emigrants' "stories of the great wealth they had accumulated while in the United States." She joined relatives in Greenwich Village, and friends of the family helped to find her first job making corset covers and shirtwaists in a factory. Though she stopped working once she married, her husband soon became ill and so she returned to sewing blouses in a neighborhood factory, where she remained for sixteen years.[16] Maria Santoro learned to sew from her mother, who worked as a seamstress for the tailor in their Sicilian village. Her mother's job kept the family of

seven children alive during her husband's long absences, since he migrated five times for work in the United States. The family eventually reunited in Brooklyn, where Maria and the children found immediate work as home-workers on men's pants, when her husband's bricklaying wages could not solely support the family.[17]

Those women who did not apprentice with the local seamstress learned to sew by assembling a trousseau, which consisted mostly of linens for their future household, such as sheets, pillowcases, bedspreads, intimate apparel, napkins, tablecloths, towels, and so forth, that a young woman completed with the help of women in her family. Because of this, most women learned simple stitching before they were seven years old, and then the arts of embroidery and lacework in their adolescent years. Some even recalled that many of the games they played as children involved working with needle and thread.[18]

For the daughters of peasant and artisan families, the trousseau was deeply significant. First, it enabled women to develop a craft that could assist the transnational family economy without undermining the family's reputa-tion, since sewing was associated with the virtues of female industriousness and restrained sexuality. This connection between sewing and virginity was also affirmed by the large numbers of religious orders who trained girls in needlework. Second, the trousseau was quite often the only form of prop-erty that women brought into adulthood. It was also a resource that was mobile—it could come with a migrant and be easily sold or pawned if nec-essary.[19] In fact, government officials from Apulia reported a growing phe-nomenon: peasant men marrying in order to acquire the trousseau, which they pawned for passage to America. Men did this, they noted, in order to enlist a "safe manager" to whom they could entrust their remittances, as they saved to purchase property in the homeland.[20] How many women were will-ing to take this risk is unknown. But it is clear that, by the turn of the cen-tury, women valued sewing because it enabled them to produce goods that they could both use and potentially exchange. Sewing was not only honor-able; it could generate property and wages.

Italy's Seamstresses Become Transnational Labor Migrants

As transnational labor migration became a way of life, women joined the exodus. The garment trades, along with textile factories, cigar manufactur-ers, canneries, and many other industries, relied on low-wage female labor, and they were eager to import this largely illiterate and impoverished popu-lation. They were also able to provide "wages high enough to draw women

out of transnational family economies initially based on somewhat different, but solid, financial expectation of men earning where the wages were high (abroad) in order to spend where prices were low (in Italy)."[21]

In their own words, women gave many reasons for migrating: "to live with relatives," "to get married," "to see America," "to make a dowry," "to get away from family," and "to forget my sorrows." But the vast majority came "to get a job" because the "family needed help," "father is unable to support family," or they had fallen on "hard times."[22] But migration did not occur simply out of individual desire. As with men, it grew out of economic necessity and from a highly organized strategy to provide the industrializing sectors of the world economy with cheap female labor. News of work opportunities came through transnational relationships with family, friends, and neighbors, but also from manufacturing firms who advertised extensively in Italian newspapers and with postings on village walls, promising "good pay, long season, union shop."[23]

In the 1880s, women accounted for only 17 percent of all emigrants from Italy. But after 1888, they rose to 38 percent. By World War I, the stream of women and children began to equal and even surpass that of men, and in the years leading up to 1921, women totaled 46 percent of Italian emigration, sometimes accounting for over 60 percent.[24] The gender ratios of emigration varied considerably by region and were shaped by both work opportunities and local economies in Italy and beyond. As with men, the majority came from southern Italy—primarily Sicily, Campania, Calabria, and Basilicata.[25] The movement of women across the ocean often signaled the decision of a family to settle abroad more permanently. Still, in the years between 1909 and 1928, 20 percent of female emigrants returned to Italy, and male repatriation rates remained over 60 percent.[26]

Rather than migrating merely at the direction of the men in their families, women who made the decision to migrate often took several things into consideration: their own needs; their ability to find work; and the needs of their families. The Bambace family illustrates this complexity. Involving multiple generations and migrations, their story also dramatizes the significance of women, and seamstresses in particular, to the transnational family economy. It begins in the town of Leonforte, in the central Sicilian province of Enna, where life centered on the growing of wheat, olives, fava beans, almonds, peaches, and oranges. Here Maria Gattuso was born and raised. Widowed at a young age, she took her only daughter, Giuseppina, and migrated to São Paulo, Brazil, after a falling out with her family and others in her village. As she packed her bags, she vowed that no daughter of hers would "marry any of these bastards."[27]

In São Paulo, Giuseppina met and married Antonio Bambace, a Calabrese fisherman and sea captain. In the coming years she gave birth to three

children: Angela, Maria, and a third who died in infancy. While Antonio had a successful business in the nearby seaport of Santos with a fleet of three ships, he was often overcome with a deep sense of despair. It clung to him so tenaciously that he urged Giuseppina to return with him to Italy, to his town of Cannitello in the province of Reggio Calabria, in the hopes that it might improve his outlook and overall health. The small coastal fishing community did not ease his suffering, however, and the family soon migrated again, this time to New York in 1904. Angela recalled, "My mother did not want to come to America, and they had a lot of talks about this. But my father still had the idea or the fixation he would get well if he came to America. But when he got to America it was no different than in Santos, Brazil, or Cannitello, Italy."[28]

While the family did not migrate to New York with the explicit intention to find work in the garment industry, it informed their decision. Still consumed by depression, Antonio was unable to find stable employment and soon returned to Cannitello, sending small amounts of money to his family. Giuseppina joined the majority of other Italian women in her East Harlem neighborhood and supported her children by taking in piecework from the local garment shops.[29] Even later, when Antonio returned from Italy to live with them again, and after another child was born, Giuseppina remained the breadwinner, taking in sewing while also working all day in a factory trimming plumes for ladies hats and, later, sewing shirtwaists. Angela recalled that her father was "too sick to work. So my mother thought she had better take over managing the care and welfare of the family."[30] Giuseppina made sure her daughters completed school, but once they graduated they too entered the garment industry, as seamstresses in a neighborhood blouse shop, like so many of their generation. From Sicily to Brazil to Calabria to New York, back to Calabria and then once again to New York, the history of the Bambace family illustrates the contours of the Italian diasporic experience, but also how women's labor was far from supplemental.

Social scientific and government records from this period also confirm that women's wages were absolutely critical to a family's ability to survive. In one study of forty-eight Italian families in Manhattan, 90 percent of all family members were working for wages.[31] Women's labor migration enabled men to carve out more permanent and stable jobs as boot- and shoemakers, grocers, barbers, and tailors, occupations that required some investment and commitment to settle in order to develop a clientele and learn the trade. Even so, in 1925, men born in Italy were still primarily working in "unskilled," low-paying jobs, and their representation in the higher-paying skilled, semiskilled, and white-collar trades had not changed since 1905.[32] Even as Italian men made the transition from seasonal labor migrations to

settlement abroad, their jobs remained quite marginal, and their wages were rarely sufficient to support an entire family, especially in winter months when seasonal work in subway or building construction went idle.[33] As a result, women's wages typically contributed more to the family economy than men's. In one 1919 study of 544 family economies among Italians in New York City, researchers found that an average of 1.5 men and 2.1 women contributed to the family income. They noted that "the share of women in maintaining the household is large for the entire group."[34] In 279 of these families, mothers were the primary wage earners: 94 earned their wages as pieceworkers in the garment industry, 89 in factory work, 61 by keeping lodgers and boarders, 23 as janitors, and the remainder worked in other occupations, often as midwives and shopkeepers. Women migrated, then, in large part because their families needed their labor to survive.

Like men, women chose a particular destination for its wage-earning possibilities. Because of this, women headed to the Americas in greater proportions than men, while men migrated within Europe, to Africa, and Australia more than women. For southern Italian women, the preferred destinations were, in descending order, the United States, Argentina, and Brazil. In each nation, women made up close to one-third of the Italian immigrant community.[35] As with men, their migrations to the Americas took place in three waves: 1876–1890 primarily to Argentina; 1891–1897 primarily to Brazil and Argentina; and 1898–1930 primarily to the United States. Migration to Latin America continued to be significant in the later period, and from 1890 to 1915, when over 4 million Italians went to the United States, almost 2 million migrated to Argentina and 1 million to Brazil.[36] By 1914, the cities of New York, Buenos Aires, and São Paulo each had the largest concentrations of Italian immigrants in the world—370,000, 312,000, and 111,000, respectively.[37]

Becoming Low-Wage Workers in the Fashion Capital

New York City was the preferred destination for Italian women by the early twentieth century. The production of garments was the city's largest industry, making it the fashion capital of the country and a center of the international garment economy. By 1899, the city was home to 65 percent of the women's clothing market and 27 percent of the men's clothing market.[38] The garment industry recruited Italian women heavily, and in the 1900 census the top three occupations listed for Italian immigrant women wage earners in the city were tailoress, dressmaker, and seamstress, with cigar maker and silk-mill operative in a distant fourth and fifth place.[39] Those designated as

tailoresses worked in the men's clothing trade, while dressmakers worked in women's apparel, and seamstresses were typically pieceworkers (also called homeworkers) in both industries.[40] A wide range of other consumer goods recruited Italian women, including artificial flower, candy, and paper-box industries, since they too relied on low-wage labor.[41]

This concentration of Italian women within the city's manufacturing sector would have a profound impact on their consciousness, community formation, and political culture. To begin, it meant that the demographics of the Italian immigrant population in the New York metropolitan area differed from other parts of the country. While the ratio was only one woman to every two men in the rest of the United States, women comprised close to half the Italian immigrant population in New York City.[42] The city also attracted a much higher percentage of immigrants who had labored as artisans or petty merchants in Italy because of the kinds of jobs that were available.[43] The Dillingham Immigration Commission reported that over 90 percent of the Italian immigrant women working in New York City's garment trades by 1911 had worked in sewing, embroidering, or lace making in Italy before migration.[44] Those who had not learned to sew before were easily trained by female relatives and coworkers in the simple work of finishing garments, such as tacking, felling, or basting.[45] Migration to New York City thus offered the promise of acquiring the preferred status of artisan and abandoning the more dependent and stigmatized work of the peasant farmer. While some found work in high-end shops as custom tailors, the vast majority became factory operatives or home finishers, where the work was as menial as that which they had left behind, if not more so. Stories of newly acquired wealth from returning migrants enticed many to migrate, but the realities were far more complicated once they arrived. Maria De Luca, the dressmaker from Spinoza in Basilicata who left for New York because of the stories of wealth she had heard from returning migrants, expressed the sentiments of many when she noted that she would not have migrated had she known of the realities and hardships that awaited her. Like many, the life she found was one of dilapidated and crowded tenements and monotonous and poorly paid factory work.[46]

Former divisions between artisans and peasants gave way to new divisions as Italian women were twice as likely to work in manufacturing, and Italian men were four times more likely to work in the service sector.[47] This discrepancy reflected the preference that manufacturers and contractors had for hiring immigrant women and children, who they could pay far less than men.[48] For example, of the 29,439 workers in U.S. dress and waist shops in 1913, 24,128 were women and 4,711 were men.[49] The proportion of Italian women working in the city's manufacturing sector outpaced

other women as well. The 1900 Census reported that 78 percent of Italian immigrant women wage earners in New York City were employed in manufacturing, followed by 69 percent of Russian women, 40 percent of German women, 28 percent of Irish women, and 26 percent of native-born women.[50] By 1905, close to 80 percent of all Italian women working in the United States were employed in the fashion industries, which included garments, millinery, and artificial flowers.[51]

The numbers of women working in manufacturing corresponded to the timing of immigration because the industry relied on the steady displacement of old immigrant groups by the more recent arrivals. During the middle of the nineteenth century, Irish and German immigrant seamstresses and tailors worked in the city's first clothing shops. But at the turn of the century, Eastern European Jews and Italians entered the garment trades, just as clothing became the city's largest and most significant industry. For many decades, Eastern European Jews were the most numerous in the industry. But by the 1920s, Italians became the largest group, though they were still concentrated in the lowest-paid jobs, and their numbers continued to grow through the 1930s and 1940s.[52] By 1925, 64 percent of all Italian women in the United States (first and second generation) worked in the fashion industries; and by 1950, 77 percent of the immigrant generation and 44 percent of the American-born generation were factory operatives, the majority in the needle trades.[53] For Italian immigrant women and their American-born daughters, industrial factory work and home finishing were a defining experience.

A Sweatshop in Every Kitchen

The arrival of a large body of workers who were desperate for jobs and familiar with needlework combined with technological advances at the end of the nineteenth century to bring dramatic shifts in production, most notably from custom- to ready-made clothing.[54] As the demand for ready-made garments grew, the industry became highly decentralized since new production processes required very little machinery. What emerged was an elaborate system of subcontracting in which manufacturers contracted work out to ethnic entrepreneurs who were almost always male and often Jewish immigrants themselves. They in turn hired women to finish the garments within their own homes or small tenement workshops. The sexual division of labor reserved the best-paid, high-status jobs for men, and the lowest-paid, most "unskilled" jobs for women, even though few jobs required specialized knowledge, extensive training, or physical strength.[55] As a result, Italian women entered the garment industry at the bottom of the

ranks. By 1919, work in both artificial flowers and feathers—the very lowest-paid work in manufacturing—had become known as "the Italian women's trade."[56] The Dillingham Immigration Commission noted the same for the garment industry, documenting how a "large number of contractors sublet their work to small groups or families who have one room or more in a house or tenement. These groups do the finishing and buttonhole work. This class of work is done almost entirely by Italian women."[57] Embroidery and lace making also relied heavily on Italian immigrant women. For example, in 1920, the International Ladies' Garment Workers Union estimated that close to 80 percent of the 10,000 hand-embroiderers in the city were Italian immigrant women, the majority of whom labored within their homes, adding elaborate embroidery to high-end clothing and textiles.[58]

Since this was the work that was open to them, Italian women turned their kitchens into factories. Homework was a necessity given how few well-paying jobs were open to them and the men in their families. "We all must work if we want to earn anything," one woman told an investigator. She, her three- and four-year-old daughters, and her mother, all worked together in their tenement on MacDougal Street in Greenwich Village, assembling artificial violets, while her husband worked as a porter.[59] The story was the same for most of her generation. They collected bundles of partly constructed flowers, feathers, and clothes from subcontractors, at the agent's warehouse or local factory. Then, with the help of their children and other kin or neighbors, they finished the products at home—lining garments, sewing on buttons, trimming threads, pulling bastings by hand, pasting on petals, inserting pistils into stems, et cetera—tasks that did not require any particular training or skill.[60] As one 1902 study of the industry noted, "Three-fourths of the women go for the work themselves, and it is a common thing in these districts to meet Italian women on the street, balancing twenty pairs of pants on their heads."[61]

The experience of Maria Rosario was as typical as that of Tina and Lucia, which opened this essay. She migrated from Naples to Greenwich Village with her large family when she was five years old, in 1909. As a child, she and her eleven siblings helped their mother with piecework, sewing ribbons and buttons on ladies' corsets. For one dozen corsets they made six cents, and sometimes each child made two dozen corsets before heading to school in the morning. At night, they would pick up where they left off. As an adult, Maria continued to work in the industry, as an operator making slips, nightgowns, and corset covers.[62]

Given the limited range of choices, homework was a preferred option to Italian immigrant women for several reasons. It allowed women to care for young children while they worked and to set their own production pace.

The majority (two-thirds) did not speak English even after a full year in the United States, and unlike other jobs, such as domestic service, homework did not require proficiency in English.[63] Moreover, homework represented a "superficial approximation of an elevated social status" since it had been idealized work in southern Italy, where women tended to value artisan labor close to home over agricultural labor. It also "enabled these women to establish and maintain strong contacts with neighboring women who could in turn be a source of support for them in caring for children and securing other forms of aid."[64] It was highly exploitative, however. Women often had to work eighteen hours a day to earn a measly four or five cents an hour. They labored in cramped, poorly ventilated, dimly lit tenement apartments that were often only two small rooms, and home to an average of five people.[65] Since homework was seasonal, "families had to maximize their wages in the rush period," which often meant working around the clock.[66] This was of course in addition to all their unpaid domestic labor, not to mention the work they did keeping boarders, working as janitors, and the other work that occupied much of their day.[67]

Most parents were forced to pull their children out of school, since, as in Italy, their labor was necessary for the family to make ends meet. While many wished for a different life for their children, their meager wages necessitated child labor. American social workers and reformers often told of the many ways Italian families circumvented city officials and factory inspectors who attempted to shut down or regulate homework within their neighborhoods. As soon as an agent appeared on the block, word spread like wildfire through the tenements, and everyone hid their homework while the inspection was made.[68] Many of the legal measures and reform movements that developed to regulate homework did not have much appeal to Italian immigrant women since they often restricted their ability to earn wages without providing better options. Informed as they were by middle-class bias, reformists often sought not to resolve the problems as they were articulated by homeworkers, but to address the needs of all others: to protect more-established workers against homeworkers' underbidding and "cheapening" of work; to guard against the perceived immorality and ignorance of immigrant workers; to protect consumers from the contagious diseases many believed passed from immigrant workers through the clothing they produced; and to defend male breadwinning and the middle-class gender ideal of separate spheres. Rarely did social commentators express an understanding that homework was symptomatic of the gendered division of labor under industrial capitalism and a manifestation of women's subordinate position within the family, the labor market, and the nation-state.[69] Instead, this critique would come from the women workers themselves.[70]

The Lessons of Factory Labor

Factory work taught women workers a powerful set of lessons, and they would use these to expose the power arrangements and ideological justifications that gave rise to their marginalized position within industrial capitalism. Homework often led to factory work, and children typically graduated from one to the other as they grew older. Theresa Albino's story captures what was common. Born in New York City to immigrant parents, Theresa began helping her mother make artificial flowers in their home when she was five, alongside her brothers and sisters. After completing sixth grade, she entered factory work, since the combined wages from the homework and her father's earnings as a day laborer were insufficient. At the age of fourteen, she became an errand girl in a neighborhood candy factory and then a year later a factory worker in artificial flowers in the same shop that supplied her mother with homework. Theresa wished to attend evening school, but she noted, "It was this way, when it gets busy in the trade we have to take work home, and I knew I would have to stop then, so what was the use of starting?" She also felt strongly that work conditions would improve only with effective unionization. But her most impassioned plea concerned her mother. "My mother works all the time—all day, Sundays and holidays, except when she is cooking or washing. She never has time to go out or she would get behind in her work."[71]

For most women, factory work and homework were deeply connected and all-consuming. According to the federal government's Dillingham Report, young women entered factories on average at the age of sixteen, and many stayed in the industry, alternating between homework and factory work, and often combining the two, throughout their lives.[72] Whether they worked on sewing machines, looms, or by hand, women experienced the constant pressure to work as fast as possible, since employers often compelled them to increase the pace so they might reduce the number of workers and generate more profit. In addition, "the materials that Italian women used in the shops were dangerous to their health. In paper box factories glue fumes caused nausea; in the flower factories the aniline dyes irritated throats and skin; and in the feather factories swirling fluff caused bronchitis, asthma, and eye disease. Many of the work materials were highly flammable, yet fire escapes were rickety and inaccessible."[73] Exhaustion from standing, the routine bending over to complete tasks, eye strain from long hours of close work in poor lighting, long-term exposure to unhealthy work environments, and the routine sexual abuse and harassment of some bosses and male workers made factory work extremely dangerous and difficult.[74]

An Italian immigrant sewing-machine operator described her working conditions this way:

> [W]orkers spent long hours in the shops in those days. They worked from eight in the morning to six o'clock at night, all day Saturday, and sometimes even on Sundays. They had no breaks and were given three-quarters of an hour for lunch. If they went to the bathroom, the boss kept count of how long they took. If they took too long, he would go to the bathroom door and knock.... They were not allowed to talk or laugh.[75]

While the workday was legally set at sixty hours per week and ten hours per day, many worked much longer hours in these seasonal industries, due to the rush periods.[76]

Employers monitored women closely to maximize production and discourage collective action. Their efforts to prevent alliances among workers were notorious as well, leading labor economist John Commons to conclude, "The only device and symptom of originality displayed by American employers in disciplining their labor force has been that of playing one race against the other."[77] In addition to engineering ethnic conflict, manufacturers fined workers for being late, for talking, singing, and taking too much time in the bathroom, since workers often used such activities to build a sense of community and organize. When workers did attempt to unionize, employers found additional methods of surveillance, including sending spies to union meetings to spot the "trouble makers" whose lives they would make "so unbearable, that the worker was forced to leave voluntarily, if not actually dismissed."[78]

Italian women found many ways to contest capitalist labor discipline, or what they termed the "*rigorosa sorveglianza*" (rigorous surveillance) of employers, including unequal divisions of labor, dangerous work conditions, and the low quality of work they were forced to produce rapidly.[79] When they learned English, they critiqued the system with new words. "They were crooks," Carrie Golzio recalled of the men who ran the ribbon factory in Paterson, New Jersey, where she worked from age nine.[80]

To be sure, factory conditions varied considerably. Some worked in modern brick buildings with hundreds of other girls and women. Others worked in small, crowded tenement workrooms alongside boys and men. Most shops employed between fifteen and fifty workers, but the larger, more modern factories became common in the 1920s.[81] Before World War I, Italian women in the garment trades most often worked alongside Eastern European and Russian Jewish, Irish, and German immigrant women. In the 271 garment factories that Louise Odencrantz investigated, only hand-embroiderers

labored in a more ethnically homogenous setting, since Italian women comprised 94 percent of that workforce.[82]

Since most Italian women found jobs through family and friends and worked in factories located within or near their neighborhoods, factories were important centers of informal systems of female networking. Cramped working conditions encouraged women to develop relationships with coworkers, through which they learned transportation systems, how to communicate with employers and coworkers in other languages, and how to find child care while they worked.[83] Women also relied on these networks to learn the rudiments of the trade and to adjust to their new lives: Many recalled learning from their coworkers "so she did not feel as 'strange' as if she had been plunged into the midst of work," and "to make her clothes more presentable according to American standards, so she will look less like a new arrival."[84] In fact, some became quite skilled in the art of performance in order to secure work, including taking on new identities and passing for other immigrant groups. When Filomena Macari went for her job interview in a garment shop she was told by her employer "not to tell anyone she was Italian because everyone in the shop was Jewish and they didn't want other groups there. She worked as an examiner for a whole year before she gave herself away. By that time, she was already known to be a good worker, and it didn't matter to them."[85]

Overall, wage earning led women to develop new kinds of relationships, whether in factories or their own homes. As one reformer observed, it led "the woman from Naples to take her home work into the rooms of her Sicilian neighbor."[86] Many have richly documented the ways working women forged new kinds of relationships with one another: They learned one another's languages and cultures, celebrated birthdays, baby showers, and weddings together, and organized the labor movement side by side. They also struggled with prejudice and mistrust. Rose Gorgoni's older sister lamented the behavior that her sister Rose was learning from the other women at work: "She is always going into paper boxes or paper bags, and the girls use awful language in them places."[87] At the other end of the spectrum, workers in the higher-end custom shops encountered the woman of wealth who "saunters into a shop, puts up her lorgnette, and lisps, 'I'd like to see something in a satin afternoon dress.'"[88] The world of manufacturing work introduced Italian women to new experiences of intimacy, mutual aid, distancing, and oppression.

Tracing how women became labor migrants reveals their location within globalizing capitalism and the complex, often hidden, processes by which they decided to traverse oceans to enter factories halfway across the world. Such an investigation helps us to understand how women's low-wage labor

was foundational to global economic restructuring at the turn of the last century. It also reveals the profound contradictions at the heart of women's experiences: Labor migration provided women with a chance to earn much-needed wages, contribute to their family economies, and enter new social worlds. But the work into which they were channeled was also exhausting, debilitating, and demoralizing. It jeopardized their health and that of their families, subjected them to new, extreme forms of routinization, surveillance, and exploitation. All the while they were, for the most part, slandered in the popular media. In living these contradictions, they would pose a question that remains with us today: economic development at what cost?

The opening story within a story helps us to understand how this critical question has emerged. Women contended with exploitive conditions by developing alternative ethical systems to repudiate, in the words of historian Dana Frank, "capitalist power, employer manipulation, and a largely hostile state."[89] Within these worlds of intensive menial work, a conversation took place in which women developed a vision of themselves and the world around them that rejected the legitimizing narratives of their oppression. Such a vision developed through stories and discussions, and it resided within actions taken, as in the case of Philomena Cioffari, who flared up at her father when he suggested that she and her sister Flora did not belong in school because they were "stupid and could not learn anything." She exclaimed, "How could I when I had to work all the time?"[90] The radical subculture and revolutionary industrial-union movement that Italian women seamstresses formed alongside other workers in early twentieth-century New York, New Jersey, and other locales, drew such enthusiastic support because it provided a space for women to further educate themselves, become more conscious, and develop a collective critique of power in its many manifestations.

Notes

1. This essay is an abridged version of chapter 2 from *Living the Revolution: Italian Women's Resistance and Radicalism in New York City, 1880–1945*. Copyright © 2010 by Jennifer Guglielmo. Used by permission of the University of North Carolina Press, www.uncpress .unc.edu. Tina Gaeta, interview with Columba M. Furio, November 22, 1976, now included with eight other of Furio's oral histories in the Italian Immigrant Women in New York City's Garment Industry Oral Histories (MS 556) at the Sophia Smith Collection, Smith College, Northampton, Massachusetts (hereafter SSC); abridged transcript of Gaeta interview is reprinted in Furio, "Immigrant Women and Industry: A Case Study. The Italian Immigrant Women in the Garment Industry, 1880–1950" (Ph.D. diss., New York University, 1979), 449–50.

2. Frank Sheridan, "Italian, Slavic, and Hungarian Unskilled Immigrant Laborers," *Bulletin of the Bureau of Labor* 72 (September 1907): 420; U.S. Department of Commerce, Bureau of Census, *Twelfth Census of the United States,* Vol. 13, Occupations (Washington, DC: Government Printing Office, 1900), 634–41.

3. Donna Gabaccia, *Italy's Many Diasporas* (Seattle: University of Washington Press, 2000), 74.

4. Saskia Sassen, "Strategic Instantiations of Gendering in the Global Economy," in *Gender and U.S. Immigration: Contemporary Trends,* ed. Pierrette Hondagneu-Sotelo (Berkeley: University of California Press, 1999), 43.

5. Gaeta interview with Furio, November 22, 1976.

6. Donna Gabaccia, "In the Shadows of the Periphery: Italian Women in the Nineteenth Century," in *Connecting Spheres: European Women in a Globalizing World, 1500 to the Present,* ed. Marilyn J. Boxer et al. (New York: Oxford University Press, 2000), 167.

7. Wendy Gamber, *The Female Economy: The Millinery and Dressmaking Trades, 1860–1930* (Urbana: University of Illinois Press, 1997), 126.

8. Stefano Merli, *Proletariato di fabbrica e capitalismo industriale. Il caso Italiano, 1880–1900* (Florence, Italy: *La Nova Italia* Editrice, 1972), 90–97, 214, 239; Vittorio Ellena, "La Statistica di alcune industrie italiane," *Annali di statistica* 2, no. 13 (1880): 29; Ministero di agricoltura, industria e commercio, *Generale della Statistica, Censimento della Popolazione del Regno d'Italia al 10 febbraio 1901,* vol. V (1904): xci.

9. Anna Cento Bull, "The Lombard Silk-Spinners in the Nineteenth Century: An Industrial Workforce in a Rural Setting," in *Women and Italy: Essays on Gender, Culture and History,* ed. Zygmunt G. Baraski and Shirley W. Vinall (New York: St. Martin's Press, 1991), 26; Emiliana P. Noether, "The Silent Half: Le Contadine del Sud Before the First World War," in *The Italian Immigrant Woman in North America,* ed. Betty Boyd Caroli et al. (Toronto: The Multicultural History Society of Ontario, 1978), 7; Teresa Noce, *Gioventù senza sole* (Rome: Editori Riuniti, 1973); "Organizing a women's union, Italy, 1903," in *European Women: A Documentary History, 1789–1945,* ed. Eleanor S. Riemer and John C. Fout (Brighton: Harvester Press, 1983), 27; Elda Gentili Zappi, *If Eight Hours Seem Too Few: Mobilization of Women Workers in the Italian Rice Fields* (Albany: State University of New York Press, 1991).

10. Donna Gabaccia, *Militants and Migrants Rural Sicilians Become American Workers* (New Brunswick, NJ: Rutgers University Press, 1988), 42–43.

11. Jane C. Schneider, "Trousseau as Treasure: Some Contradictions in Late Nineteenth-Century Change in Sicily," in *Beyond the Myths of Culture: Essays in Cultural Materialism,* ed. Eric B. Ross (New York: Academic Press, 1980), 336.

12. Louise Odencrantz, *Italian Women in Industry: A Study of Conditions in New York City* (New York: Russell Sage Foundation, 1919), 39.

13. Odencrantz, *Italian Women in Industry,* 38–50; Amy Bernardy, "L'emigrazione delle donne e dei fanciulli italiane nella North Atlantic Division," *Bollettino dell'emigrazione* 1 (1909): 168–84; Joel Seidman, *The Needle Trades* (New York: Farrar & Rinehart, 1942), 35; Corinne Azen Krause, *Grandmothers, Mothers, and Daughters: Oral Histories of Three Generations of Ethnic American Women* (Boston: Twayne Publishers, 1991), 18; Furio, "Immigrant Women and Industry," 67 and reprinted interviews in Appendix D; Noether, "The Silent Half," 7; Judith E. Smith, "Italian Mothers, American Daughters: Changes in Work and

Family Roles," in *The Italian Immigrant Woman in North America*, ed. Betty Boyd Caroli et al. (Toronto: The Multicultural History Society of Ontario, 1978), 207; Elizabeth Ewen, *Immigrant Women in the Land of Dollars: Life and Culture on the Lower East Side, 1890-1925* (New York: Monthly Review Press, 1985), 244; Edwin Fenton, *Immigrants and Unions: A Case Study, Italians and American Labor, 1870-1920* (New York: Arno Press, 1975), 469; Phyllis H. Williams, *South Italian Folkways in Europe and America* (New Haven, CT: Yale University Press, 1938), 26–27.

14. "Mrs. L" interview with Columba M. Furio, November 2, 1976, in Furio, "Immigrant Women and Industry," 409–10. See also Renate Siebert, *'È femmina però è bella': Tre generazioni di donne al sud* (Turin, Italy: Rosenberg & Sellier, 1999), 198; Ewen, *Immigrant Women*, 52.

15. Gamber, *The Female Economy*, esp. chapter 7.

16. "Mrs. D," interview with Columba M. Furio, October 20, 1976, in Furio, "Immigrant Women and Industry," 397–98.

17. "Mrs. S," interview with Columba M. Furio, October 10, 1976, in Furio, "Immigrant Women and Industry," 415.

18. "Mrs. M" interview with Columba M. Furio, November 2, 1976, in Furio, "Immigrant Women and Industry," 402.

19. Schneider, "Trousseau as Treasure"; Sydel Silverman, *Three Bells of Civilization: The Life of an Italian Hill Town* (New York: Columbia University Press, 1975), 198–99; Andreina De Clementi, "Gender Relations and Migration Strategies in the Rural Italian South: Land, Inheritance, and the Marriage Market," in *Women, Gender, and Transnational Lives: Italian Workers of the World*, ed. Donna Gabaccia and Franca Iacovetta (Toronto: University of Toronto Press, 2002), 82–87; Jane C. Schneider and Peter T. Schneider, *Festival of the Poor: Fertility Decline and the Ideology of Class in Sicily, 1860-1980* (New York: Academic Press, 1976), 209–10.

20. Sandro Rogari, *Mezzogiorno ed emigrazione. L'inchiesta Faina sulle condizioni dei contadini nelle province meridionali e nella Sicilia, 1906-1911* (Florence: Centro Editoriale Toscano, 2002), lxv–lxvi; Linda Reeder, *Widows in White: Migration and the Transformation of Rural Italian Women, Sicily, 1880-1920* (Toronto: University of Toronto Press, 2003), 147–54; Giuseppe Bruccoleri, *La Sicilia di oggi: appunti economici* (Rome: Athanaeum, 1913), 91; Gaetano Conte, *Dieci anni in America* (Palermo: Tip. G. Spinnato, 1903), 11.

21. Gabaccia and Iacovetta, eds., *Women, Gender, and Transnational Lives*, 16.

22. Odencrantz, *Italian Women in Industry*; Elizabeth Mathias and Richard Raspa, *Italian Folktales in America: The Verbal Art of an Immigrant Woman* (Detroit, MI: Wayne State University Press, 1985), 272; Ewen, *Immigrant Women*, 52; Ruth Laub Coser et al., *Women of Courage: Jewish and Italian Immigrant Women in New York* (Westport, CT: Greenwood Press, 1999), 69–70, 73–75; Gabaccia, *Militants and Migrants*, ch. 3.

23. Odencrantz, *Italian Women in Industry*, 44, 304; Louise Odencrantz, "The Italian Seamstress," in *Out of the Sweatshop: The Struggle for Industrial Democracy, ed.* Leon Stein (New York: Quadrangle/New Times Book Company, 1977), 62–63; Leonard Covello, *The Heart Is the Teacher* (New York: McGraw-Hill, 1958), 4–5.

24. Commissariato Generale Dell'Emigrazione, *Annuario statistico della emigrazione italiana dal 1876 al 1925* (Rome: L'Universale Tipografia Poliglotta, 1926), Table V; Luigi Favero and Graziano Tassello, "Cent'anni di emigrazione italiana," in *Un secolo di emigrazione*

italiana, 1876–1976, ed. Gianfausto Rosoli (Rome: Centro Studi Emigrazione, 1978), 9–64; Joseph H. Senner, "Immigration from Italy," *North American Review* 162, no. 6 (June 1896): 652; Walter F. Willcox, *International Migrations* (New York: National Bureau of Economic Research, 1931); Gabaccia, *Italy's Many Diasporas,* 67.

25. Between 1876 and 1914 close to 5,400,000 people left southern Italy, with the largest numbers emigrating from the regions of Campania (1,476,000), Sicily (1,353,000), and Calabria (879,000). Percentage of women migrants: Abruzzo/Molise (19 percent), Campania (27 percent), Apulia (21 percent), Basilicata (30 percent), Calabria (19 percent), Sicily (29 percent), Sardinia (15 percent). Rosoli, ed., *Un secolo,* 19; Commissariato Generale dell'Emigrazione, *Annuario statistico,* 149.

26. Massimo Livi Bacci, *L'immigrazione e l'assimilazione degli italiani negli Stati Uniti secondo le statistiche demografiche americane* (Milan: Giuffrè, 1961), 26; Betty Boyd Caroli, *Italian Repatriation from the United States, 1900–1914* (New York: Center for Migration Studies, 1973); Antonio Stella, *Some Aspects of Italian Immigration to the United States* (New York: G. P. Putnam's Sons, 1924), 34; Gabaccia, *Italy's Many Diasporas,* 8; De Clementi, "Gender Relations and Migration Strategies," 79.

27. Athena Iris (Capraro) Warren, interview with author, December 5, 2005; "Notes to interview questions dictated by Angela Bambace to Marian, February, 1975"; Speech, November 15, 1980, Bambace Papers, Immigration History Research Center, University of Minnesota, Minneapolis (hereafter IHRC); Certificate of Death 2780, Josephine Bambace, April 9, 1941, City of New York, Department of Health, Bureau of Records, Anthony Capraro Papers, Box 1, IHRC; Jean A. (Vincenza) Scarpaci, "Angela Bambace and the International Ladies' Garment Workers' Union: The Search for an Elusive Activist," in *Pane e Lavoro: The Italian American Working Class,* ed. George E. Pozzetta (Staten Island, NY: American Italian Historical Association, 1978).

28. "Notes to interview questions dictated by Angela Bambace to Marian, February, 1975," Bambace Papers, IHRC.

29. The family lived at 158 East 103rd Street. Scapaci, "Angela Bambace," 101.

30. "Notes to interview questions dictated by Angela Bambace to Marian, February, 1975," Bambace Papers, IHRC.

31. Odencrantz, *Italian Women in Industry,* 18, 170.

32. These figures are derived from the 1905 and 1925 New York State Manuscript Census. See also Miriam Cohen, *From Workshop to Office: Two Generations of Italian Women in New York City, 1900–1950* (Ithaca, NY: Cornell University Press, 1992), 44.

33. Cohen, *From Workshop to Office,* 42–44; Dillingham, *Immigrants in Industries,* 228; Louise Bolard More, *Wage Earners' Budgets: A Study of Standards and Cost of Living in New York City* (New York: Henry Holt and Co., 1907); and "Immigrants from Italy," *New York Times,* October 6, 1895, 25.

34. Odencrantz, *Italian Women in Industry,* 18, 20, 189–90. See also Lillian Cicio, "Mama Vita," *American Immigrant Autobiographies,* Part I, Manuscript Autobiographies, Microfilm #4634, IHRC, 332; More, *Wage-Earners' Budgets*; Coser et al., *Women of Courage*; Ewen, *Immigrant Women,* 124, 248; Gabaccia, *Italy's Many Diasporas,* 101–3.

35. Commissariato Generale Dell'Emigrazione, *Annuario statistico*; Favero and Tassello, "Cent'anni," 16; Gabaccia and Iacovetta, eds., *Women, Gender, and Transnational Lives,* 5.

36. Commissariato Generale dell'Emigrazione, *Annuario statistico*, 74–75, 145, 149, 150–51; Rosoli, ed., *Un secolo*, 19.

37. Samuel L. Baily, "Italian Immigrants in Buenos Aires and New York City, 1870–1914: A Comparative Analysis of Adjustment," in *Mass Migration to Modern Latin America*, ed. Samuel L. Baily and Eduardo José Míguez (Wilmington, DE: Scholarly Resources, 2003); José Moya, "Italians in Buenos Aires's Anarchist Movement: Gender Ideology and Women's Participation, 1890–1910," in Gabaccia and Iacovetta, eds., *Women, Gender, and Transnational Lives*, 191, Table 6.1.

38. Daniel Soyer, ed., *A Coat of Many Colors: Immigration, Globalization, and Reform in New York City's Garment Industry* (New York: Fordham University Press, 2005), 3–7; Green, *Ready-to-Wear*, 46–54.

39. *Twelfth Census of the United States*, Volume XIII, Occupations (1900), 634–41.

40. William Dillingham, *Reports of the United States Immigration Commission: Immigrants in Industries* (Washington, DC: Government Printing Office, 1911), Part 6, 384.

41. Commissariate Generale dell'Emigrazione, *Annuario statistico*, 619; U.S. Department of Commerce, Bureau of the Census, *Women in Gainful Occupations, 1870–1920*, by Joseph A. Hill, Census Monographs 9 (Washington, DC: Government Printing Office, 1929), esp. chs. 5, 6; Donna Gabaccia and Franca Iacovetta, "Women, Work, and Protest in the Italian Diaspora: An International Research Agenda," *Labour/Le Travail* 42 (Fall 1998): 168; Cohen, *Workshop to Office*, 45.

42. Gabaccia, "Peopling 'Little Italy,'" in *The Italians of New York: Five Centuries of Struggle and Achievement*, ed. Philip V. Cannistraro (New York: Mondadori and the New-York State Historical Society, 1999), 47.

43. Donna Gabaccia, *From Sicily to Elizabeth Street: Housing and Social Change among Italian Immigrants, 1880–1930* (Albany: State University of New York Press, 1984), 63.

44. Dillingham, *Immigrants in Industries*, Part 6, 376; and Table 57, 546.

45. Mabel H. Willett, *The Employment of Women in the Clothing Trade* (New York: Columbia University Press, 1902; reprint, New York: AMS Press, 1968), 65; Odencrantz, *Italian Women and Industry*, 43; U.S. Department of Labor, *Regularity of Employment in the Women's Ready-to-Wear Garment Industry* (Washington, DC: Government Printing Office, 1916), 18–22; Joel Seidman, *The Needle Trades* (New York: Farrar & Rinehart, 1942), 36; Green, *Ready-to-Wear*, 175–83.

46. "Mrs. D," interview with Colomba Furio, October 20, 1976, reprinted in Furio, "Immigrant Women and Industry," 397–98.

47. *Twelfth Census of the United States*, Volume XIII, Occupations (1900), 634–41. See also Gabaccia, *Militants and Migrants*, 76–97, 127–36; Gabaccia, *From Sicily to Elizabeth Street*, 61–64; Dennis J. Starr, *The Italians of New Jersey: A Historical Perspective and Bibliography* (Newark: New Jersey Historical Society, 1985), 12–14.

48. Willett, *The Employment of Women*, 78–79, 90–92, 110–13; Mary Van Kleeck, *Artificial Flower Makers* (New York: Russell Sage Foundation, Survey Associates, 1913), 58–89; Nancy C. Carnevale, "Culture of Work: Italian Immigrant Women Homeworkers in the New York City Garment Industry, 1890–1914," in Soyer, ed., *A Coat of Many Colors*, 160–61.

49. U.S. Department of Labor, Bureau of Labor Statistics, *Wages and Regularity of Employment*, 8; Dillingham, *Immigrants in Industries*, Part 6, 370, 385; Bernardy,

"L'emigrazione delle donne," 9, 22–24, 38–61; Elizabeth C. Watson, "Homework in the Tenements," *Survey* 25 (February 4, 1911), 772–81.

50. *Twelfth Census of the United States,* Volume XIII, Occupations (1900), 638; Odencrantz, *Italian Women in Industry,* 32; Van Kleeck, *Artificial Flower Makers,* 31–34.

51. Dillingham, *Immigrants in Industries,* Part 6, 366–67.

52. U.S. Department of Labor, *Regularity of Employment in the Women's Ready-to-Wear,* 17. See also Dillingham, *Immigrants in Industries,* part 6, 369–73; Willett, *The Employment of Women,* 33–34, 38; Seidman, *The Needle Trades,* 31–36; Daniel Bender, *Sweated Work, Weak Bodies: Anti-Sweatshop Campaigns and Languages of Labor* (New Brunswick, NJ: Rutgers University Press, 2004), 31; Green, *Ready-to-Wear,* 20–21.

53. On men's clothing, see U.S. Congress, Senate, *Report on Condition of Woman and Child Wage Earners,* 2: *Men's Ready-Made Clothing,* 45. For the clothing industry as a whole, see U.S. Congress, Senate, *Report of the Immigration Commission, vol. 11: Immigrants in Industries,* Part 6, 372.

54. Willett, *The Employment of Women,* 31; Green, *Ready-to-Wear,* esp. chapter 1.

55. Dillingham, *Immigrants in Industries,* Part 6, 385; New York State Department of Labor, *Report of the Growth in Industry in New York* (Albany, NY: Argus Co. Printers, 1904), 88, 93; New York State Department of Labor, *Seventh Annual Report of the Factory Inspectors of the State of New York* (Albany, NY: State Printer, 1893), 112–211; Jesse Pope, *The Clothing Industry in New York* (Columbia, MO: E. W. Stephens Pub. Co., 1905), 28; Bender, *Sweated Work,* 23–35; Soyer, ed., *A Coat of Many Colors,* 4–5; Green, *Ready-to-Wear*; Cohen, *Workshop to Office,* 47; Susan Glenn, *Daughters of the Shtetl: Life and Labor in the Immigrant Generation* (Ithaca, NY: Cornell University Press, 1990), 106–22.

56. Odencrantz, *Italian Women in Industry,* 45, 52, 119–20, 178; Van Kleeck, *Artificial Flower Makers,* 38; Cohen, *Workshop to Office,* 65.

57. Dillingham, *Immigrants in Industries,* Part 6, 385–86.

58. Odencrantz, *Italian Women in Industry,* 45, 52, 119–20, 178; Cohen, *Workshop to Office,* 65; Green, *Ready-to-Wear,* 203, 351.

59. Van Kleeck, *Artificial Flower Makers,* 94–95; Willett, *The Employment of Women,* 118–33; U.S. Congress, Senate, *Report on Condition of Woman and Child Wage Earners,* vol 2: *Men's Ready-Made Clothing.* S. Doc 645, 61st Cong., 2d sess. (Washington, DC: Government Printing Office, 1911), 300.

60. Dillingham, *Immigrants in Industries,* Part 6, 385–86; Willett, *The Employment of Women,* 94–98, 109–10, 273–74; Van Kleeck, *Artificial Flower Makers,* 96; Seidman, *The Needle Trades,* 36; Bernardy, "L'emigrazione delle donne," 34–37; Watson, "Homework in the Tenements."

61. Willett, *The Employment of Women,* 106.

62. "Mrs. R" interview with Colomba Furio, October 6, 1976, in Furio, "Immigrant Women and Industry," 399–400.

63. Bernardy, "L'emigrazione delle donne," 9; Willett, *The Employment of Women,* 100; Odencrantz, *Italian Women in Industry,* 44; Carnevale, "Culture of Work," 149–50; Green, *Ready-to-Wear,* 184; Fenton, *Immigrants and Unions,* 467–69.

64. Carnevale, "Culture of Work," 151–52; Gabaccia, *From Sicily to Elizabeth Street,* 64.

65. Willett, *The Employment of Women,* 63, 103; Van Kleeck, *Artificial Flower Makers,* 99–117; Bernardy, "L'emigrazione delle donne," 38–47, 168–84; Odencrantz, *Italian Women in*

Industry, 106–7, 257; Cicio, "Mama Vita"; Antonio Stella, "From Italy's Fields to Manhattan's Sweatshops," *Survey* (May 7, 1905); Fenton, *Immigrants and Unions*, 468–69; Furio, "Immigrant Women and Industry"; Cohen, *Workshop to Office*, 47–51; Ewen, *Immigrant Women*, 248–49; Gabaccia, *From Sicily to Elizabeth Street*, 92.

66. Cohen, *Workshop to Office*, 48; Seidman, *The Needle Trades*, 62–63; Elizabeth Shipley Sergeant, "Toilers of the Tenements," *McClure's Magazine* 35 (July 1910), 239; Van Kleeck, *Artificial Flower Makers*, 40–57; Carnevale, "Culture of Work," 155; Eileen Boris, *Home to Work, Motherhood and the Politics of Industrial Homework in the United States* (New York: Cambridge University Press, 1994), 186.

67. Coser, *Women of Courage*, 97–98; Gabaccia, *From Sicily*, 59, 80–81, 93; Gabaccia, *Militants and Migrants*, 132; Odencrantz, *Italian Women in Industry*, 226; Bernardy, "L'emigrazione delle donne," 8, 16–17, 168–84.

68. Watson, "Homework in the Tenements"; "Characteristics of Italian Immigrants," *New York Times*, May 18, 1902, 12; "Saving the Lives of Babies," *New York Times*, July 3, 1910, 11.

69. Boris, *Home to Work*, 2.

70. Guglielmo, *Living the Revolution*, chs. 5 and 6.

71. Van Kleeck, *Artificial Flower Makers*, 228–35.

72. Dillingham, *Immigrants in Industries*, Part 6, Table 66.

73. Cohen, *Workshop to Office*, 67; Van Kleeck, *Artificial Flower Makers*, 118–43.

74. Odencrantz, *Italian Women in Industry*, 54–107; Grace Hutchins, *Labor and Silk* (New York: International Publishers, 1929), 114–27; Van Kleeck, *Artificial Flower Makers*, 23–39; Cohen, *Workshop to Office*, 66–67; Ewen, *Immigrant Women*, 246–55.

75. "Mrs. R.," interview with Colomba Furio, October 6, 1976.

76. Willett, *The Employment of Women*, 73–77.

77. Quoted in Matthew Frye Jacobson, *Barbarian Virtues: The United States Encounters Foreign Peoples at Home and Abroad* (New York: Hill and Wang, 2000), 69.

78. Concetta D., interview with Colomba Furio, September 22, 1976, in Furio, "Immigrant Women and Industry," 408.

79. "Fra I Tessitori, Lo Sciopero di Hackensack," *Il Bolletino della Sera*, December 17, 1909; Odencrantz, *Italian Women in Industry*, 41; Grace Billoti Spinelli Autobiography, *American Immigrant Autobiographies*, Part I, Manuscript Autobiographies, Microfilm #4634, IHRC, 34; Ewen, *Immigrant Women*, 244–47.

80. Carolina Golzio, interview with Steve Golin, June 13, 1983, now housed at the SSC.

81. Willett, *The Employment of Women*, 35–40, 65; Cohen, *Workshop to Office*, 63–64.

82. Cornelia Stratton Parker, *Working with the Working Woman* (New York: Harper & Brothers Publishers, 1922), 17, 28; Hutchins, *Labor and Silk*, 141; Odencrantz, *Italian Women in Industry*, 59–60; *Lotta di Classe*, December 18, 1914; reprinted interviews in Furio, "Immigrant Women and Industry"; Cohen, *Workshop to Office*, esp. chapter 2.

83. Cohen, *Workshop to Office*, 60–64; Scarpaci, "Angela Bambace," 101. See also Gaeta, Lazzaro, and "Mrs. D" interviews in Furio, "Immigrant Women and Industry," 453, 473, 397; Josephine Roche, "The Italian Girl," *West Side Studies* 2 (1913): 95–98; Odencrantz, *Italian Women in Industry*, 273.

84. Odencrantz, *Italian Women in Industry*, 13, 25, 43; Nan Enstad, *Ladies of Labor, Girls of Adventure: Working Women, Popular Culture, and Labor Politics at the Turn of the Twentieth Century* (New York: Columbia University Press, 1999), 61–62.

85. "Mrs. M" interview with Columba Furio, December 2, 1976.

86. Odencrantz, *Italian Women in Industry*, 13, 25, 43.

87. Ewen, *Immigrant Women*, 275.

88. Parker, *Working with the Working Woman*, 117.

89. Dana Frank, "White Working-Class Women and the Race Question," *International Labor and Working-Class History* 54 (Fall 1998): 83.

90. Parker, *Working with the Working Woman*, 258.

Domestic Textile Work among Italian Immigrant Women in Post–World War II Mar del Plata, Argentina

—Bettina Favero

The domestic textile work of Italian women who immigrated to the city of Mar del Plata, Argentina, in the post–World War II era was a family-based economic enterprise. It relied on nuclear and extended family members of several generations, including mothers, daughters, grandmothers, cousins, and mothers-in-law. Knitting techniques were transferred from Italy to Argentina, and in particular to Mar del Plata, a city whose social and economic vitality appealed to many Italian immigrants. The oral testimonies of these working women—interviews I conducted in the "Archivo de la palabra del Immigrante Europeo en Mar del Plata" (UNMDP)[1]—tell the story of the birth and development of Italian Argentinian domestic needlework.

The Italian Immigration to Mar del Plata

Mar del Plata is distinguished from other cities in southeast Buenos Aires Province by its seaside conditions, the presence of Buenos Aires city elites who spend their summers there, its seasonal population shifts, and the concentration of inhabitants in urban activities. Toward the end of the twentieth century, Mar del Plata began to develop a large and complex society and economy, becoming one of the most important cities in Buenos Aires Province. Two periods of population growth—1895–1914, which coincided with the massive influx of foreigners, and 1947–1960, which was the result of internal migration and the postwar immigration—are relevant to understanding the relationship between Italian immigration and the textile work produced by Italian women in Mar del Plata.[2]

District of General Pueyrredón Population Figures			
Year	Total population	Foreigners	Percentage of foreigners over the total population
1895	8.175	3.220	40%
1914	32.940	15.495	47%
1947	123.811	26.070	21%
1960	224.824	40.270	18%
Sources: National Census of 1895, 1914, 1947, and 1960.			

Between the end of the nineteenth century and the early twentieth century, when Mar del Plata was developing as a city, Italians emigrated mainly from the northern regions such as Lombardy, Piedmont, and Veneto. In the mid-twentieth century, most Italian immigrants came from southern and central Italy, especially the regions of Abruzzi (including Molise), Apulia, Calabria, Campania, Le Marche, and Sicily. Although the migratory flow of the postwar period was smaller than the earlier one, the arrival of Italians from 1947 onward altered the city significantly. The 1947 census indicates that 40 percent of the foreign population was Italian,[3] with a revealing Italian regional emphasis: Campania (16.2 percent); Sicily (13.5 percent); Calabria (11.2 percent); Molise (11 percent); Abruzzi (10 percent); and Veneto (6.2 percent).[4] Along with the steady growth in population the city experienced an increasing complexity in economic activities, specifically in heavy industries, commerce, and services. This economic diversity resulted in the expansion of the urban center and the creation of new neighborhoods.

After the war, a much higher proportion of immigrants were children, young people (a significant component of the city's population), and women; as a result, the city had a low number of men).[5] It was more and more common for entire families to immigrate, and there was a noticeably large group of young immigrants whose ages ranged from fourteen to thirty years old.[6]

The gender distribution of this immigrant population demonstrated a strong male predominance between 1947 and 1950 (as a result of the immigration of men alone) followed by a steady increase of women, resulting in a ratio of fifty-three men for each one hundred women in 1953.[7] The proliferation of women immigrants was interrupted from 1957 to 1959 with a slight increase of men; however, ultimately this increase was not enough to break the female predominance among Italian immigrants. The strong feminine component reinforces the dominant family type of migration, defined by the arrival of whole families or by the reunification of them.

Women's Presence in Postwar Migration and the Possibility of Family Reunion and Domestic Work

Many women worked at home as weavers, dressmakers, and laundresses or performed chores in family establishments without being considered actual employees. In some cases, a mother and her daughters were involved in weaving at home for the same textile factory, a common occurrence during the 1950s and 1960s. In time, a number of these women created their own establishments and worked as freelancers. This type of domestic labor also occurred during the first years of the twentieth century as part of the Great Wave of Italian immigration.[8] Alicia Bernasconi and Carina Frid observed that, in the urban areas of Rosario, La Plata, or Córdoba at the end of the nineteenth century, there was no drastic occupational change for women who were able to continue activities done in Italy; that is, "typical feminine chores" such as washing, cooking, ironing, and to a lesser degree those tasks related to shirt-making or dressmaking, which were done in the domestic domain.[9]

Nevertheless, after World War II some of the women immigrating had experience in Italy doing jobs outside the domestic sphere. In addition to factory workers, house maids, and seamstresses, eventually spinners and olive pickers and rice pickers (*le mondine*) can be added to the categories of workers who, at the beginning of the twentieth century, traveled long distances to secure economic revenue for their families. They could continue with this line of work in the receptive society of the city, even if they did less-skilled work and received less money than men doing the same activities, such as temporary service in the touristic industry during the summer or fish processing in small salting establishments during the anchovies season.[10]

The Textile Boom in Mar del Plata

The large numbers of European immigrants who came to Mar del Plata after World War II brought with them fishing and weaving skills and in some cases even production devices such as knitting machines.[11] One woman recalls the way she learned the activity in Italy:

> Yo en Italia tenía una vecina tejedora e íbamos siempre. . . . Entonces, allá las nenas no íbamos por la calle, ¿te das cuenta? Enseguida o te daban para tejer o te daban para coser . . . en fin, siempre te tenían ahí. Entonces ella cuando tenía que hacer tirillas de los cardigan, que era aburrido, entonces llamaba a las chicas que

The Serpillo family workshop.
From left to right: Lina, José,
Felicia, and Vittorina. 1965.
(Courtesy of Eutizia Serpillo.)

éramos vecinas. Le decía a mamá: "Elsa, ¿no me mandás a las chicas?" e íbamos y tic, tic, tic con la máquina. Así que ya conocía la máquina de tejer. (Enrica R.)[12]

In Italy I had a neighbor who was a weaver and we went there all the time. . . . Back then, us girls did not wander around in the streets, you know? They gave you something to do right away, to weave or to sew . . . anyway, they always have you there. So when she had to do sweater finishing, which was very boring, she called us, the neighbor's girls. She would tell my mom: "Elsa, can you send me the girls?" and we went there and tic, tic, tic with the machine. That's how I knew the knitting machine.

In Mar del Plata, Italian immigrant women started knitting sweaters for their husbands and sons in order to reduce expenditures, but they soon realized that they could generate an income selling the garments they manufactured or working for larger factories. In this way, many Italian families were organized around a nascent industrial economy that in time would become one of the most important in the city.

Tourism to Mar del Plata played a major role in the development of this growing industry. During the 1950s and 1960s the city became a destination site, a capital of summer tourism. The millions of tourists spurred the growth of businesses such as hotels, restaurants, and catering. Tourism also sparked the city's textile market. Factories were founded to produce for both locals and tourists. According to the Economic National Census of 1974, approximately 180 textile companies existed and were operating in the city at that time.[13] In turn these companies, which had their own local stores, were affiliated with a wider network of local laborers (domestic workers)

that accounted for 31 percent of the industrial employment in Mar del Plata.[14] Italian immigrant women were serving the larger factories with their craft production. They worked knitting *a façon*, that is, by the piece, in car garages or in the dining rooms of their homes. Finished pieces of cloth were delivered to the factory to be assembled there.

The small and medium textile companies were located in the city center; in time, they settled around Avenida Juan B. Justo, known today as "*la Avenida del pulóver*" (Sweater Avenue). Families like Pieroni, De Paoli, Del Prete, Fioriti, Manzo, Pagliardini, just to name a few, were some of the forerunners in this sector.[15] The Pieroni family was the first, arriving in 1950 and founding its knitting business, called Raquel, the following year. Some of the production was done in the factory and some by *a façon* weavers. The Raquel Company sold knitting machines directly to the weavers. By providing the workers with the right tools for the job, the Raquel Company guaranteed a high-quality product and allowed many weavers to go on to create their own factories and knitting brands.[16]

Nowadays, many of the aforementioned factories, conceived and administered by family groups, have grown and significantly increased their production. The family character continues to affect different aspects of the economic and productive performance of the firms. Three textile companies—Liberati, Buffagni, and Mauro Sergio—originated as outsourced knitting enterprises and today are some of the city's most important textile companies, doing business in the national and international markets. Vincenzo Liberati began during the 1950s when he established a knitting workshop;[17] Pierangela Buffagni started knitting sweaters with her machine at the end of the 1950s;[18] and Sergio Mauro Todisco's firm is currently the foremost company in the local textile area due to its spinning facility and large factory space.[19]

Several factors contributed to establishing these early domestic businesses. One was the basic economic need for immigrant women—who had worked in the domestic sphere in Italy—to contribute to the family's survival. Mar del Plata's economic situation allowed for the development of these family ventures, which in turn helped the economic growth of those sectors in the city. Likewise, at the national level, Argentina favored the development and production of industrial activities, especially those belonging to the secondary sector, such as textiles. Juan Domingo Perón's economic policy during and after the war rested on developing the industrialization of the country to address the lack of imported products. In the early 1940s in Argentina, there was a surplus of foreign exchange accompanied by a lack of goods, due to the income provided by Argentinean exports; imports, in turn, were fewer owing to the rationing on those nations at war. This situation made it possible for local industries to produce substitutes for

imports no longer entering the country. All in all, the industrial growth of the postwar period was backed by official promotion policies, the improvement of industrial goods relative to prices, the intensive use of already installed industrial establishments, and the reorientation of financial and labor resources to manufacturing activity.[20] The textile industry developed in the early 1930s and consolidated in the 1940s and 1950s, during which time it reached an annual growth rate of 11 percent. The sector's producers enjoyed exceptionally favorable conditions, such as the abundance of wool due to the collapse of exports during the Great Depression. Governmental policies and the increase of cotton production also helped this industry. Profiting from the presence of a cheap labor force, the textile sector became "the major patron of women."[21]

Textile Domestic Work and Italian Immigrant Women

The topic of immigrant employability in Argentina has not been analyzed as thoroughly as the relationship of ethnicity to residency and matrimony. Nevertheless, some research examines the work patterns of new inhabitants in different cities. Such research focuses mainly on the strength of the migratory networks in the marketplace and the newcomers' placement in various jobs.[22] Using a micro-historical analysis, these studies highlight the insertion of Italian immigrants into an urban labor market that offered vacancies not only to unqualified workers but also to artisans and merchants, and that in a rural market allowed peasants to work the land as tenants or settlers. Fernando Devoto adds a third possibility to these labor markets: The ethnic market allowed professionals, small-business owners, and employees to work in Italian businesses or for a largely Italian clientele.[23] The insertion of workers in any of these three types of labor markets was undoubtedly related to their different migratory traditions and the interpersonal relations that they developed.

Local textile companies had their origins in the family arena. In many cases, families of Italian origin devoted themselves to this activity immediately after arriving in the city. Once they had enlarged their output, many of them looked for Italian weavers to knit the sweaters and/or assemble the garment's different pieces as part of *a façon* work. These domestic workers were part of a network of affiliations based on relations of ethnic origin.

This network functioned in the following way: The immigrant factory owner looked for female weavers among his fellow countrymen, usually the wives and/or daughters of acquaintances or friends. Shortly afterward, he met them and taught them the required knitting techniques. Angelina

S. recalled this pattern: *"Fui a aprender a tejer y mi mamá empezó a coser pulóveres con mi prima, mi tía, todas cosían y y ... tejía en la fábrica que los dueños eran italianos."* ("I went to learn how to knit and my mom started sewing sweaters with my cousin, my aunt, all of them sewed while I ... knitted in the factory whose owners were Italian.")[24] In other cases, a family member learned how to knit and then taught the rest of the group: *"Nosotros hacíamos façón en casa. ... Una de mis hermanas nos enseñó y tejíamos todas en casa."* ("We did *façón* at home. ... One of my sisters taught us how and we all knitted at home" María C.).[25]

Sometimes the skills were learned directly in the factory and then brought home, as Enrica R. explains: *"A fines del '55 fui a aprender y fui a trabajar en tejidos 'Sarita.' Yo trabajé siempre con los Giacobone que fue una firma muy buena en Mar del Plata. Y aprendí con ellos."* ("At the end of 1955 I went to learn and to work at Sarita. I always worked for the Giacobone family. They were a very good firm in Mar del Plata. And I learned with them.")[26] Antonietta S. and Enrica R. remember the contact between fellow countrymen:

> *Mi hermana después empezó a ir a una fábrica a hacer las prendas de tejido de punto y de ahí mismo traían las prendas para terminar ... para hacer las terminaciones, coserlo a mano. Y después otro conocido ... traía y se hacían terminaciones de esas prendas.*

> My sister then started going to a factory to make the knitted garments and she brought the pieces to finish from there ... to do the finish work, to do it by hand. And then another acquaintance ... brought some other things and we did the terminations on those pieces. (Antonietta S.)[27]

> *Cuando fui acá de Ottavio Giacobone, bueno un poquito porque la máquina ya la conocía y un poquito, como eran todos italianos, y ellos eran de la Lombardía y yo piemontesa. Ellos son de Pavia y bueno ... me tomaron enseguida ... y a mí me enseñó Ottavio, el hijo del dueño.*

> When I went to Ottavio Giacobone's place, well ... they hired me immediately, partly because I already knew the machine and partly because they were all Italian ... and, well ... they were from Lombardy and I was from Piedmont. They are from Pavia and then the owner's son, Ottavio, taught me the job. (Enrica R.)[28]

Many of these immigrants bought knitting machines and started family businesses that supplied the medium and large textile industries that were expanding. They maintained piecework production but expanded

Vittorina Serpillo working in the family workshop. 1965. (Courtesy of Eutizia Serpillo.)

productivity. As the sisters Angelina S. and Antonietta S. confirm, the family business was structured to supply other factories, not to sell products of their own.

> *Después compramos máquinas nosotros y mis hermanas aprendieron y nos dedi-camos al tejido. Era una empresa familiar.*

> We then bought some machines ourselves and my sisters learned [how to use them] and we dedicated ourselves to the knitting business. It was a family business. (Angelina S.)[29]

> *Cuando hizo un poco más de piso compró una maquina de tejidos de punto y compró también para devanar y después se compraron otras máquinas, dos máquinas más y durante el día teníamos toda la familia acá, a trabajar.*

> When he was better-off he bought a knitting machine and bought another one to spin and then other machines and two more machines ... and during the day we had the whole family over to work, here at home. (Antonietta S.)[30]

The work performed in the homes was carried out with different kinds of machinery. Some were small- to medium-size machines such as "Knittax" or "Lady Tricot," known as "home machines" or "manual machines" because they were used only domestically and could be handled manually. There were also large industrial machines—which could be 55 to 59 inches in length, 8 inches in width, and 28 to 32 inches in height—that could be operated manually or automatically. The equipment was either owned by the knitters or provided by the textile companies to the knitters.

Antonietta S. remembers that the first machine in her home workshop was an Argentinian-made Fritex N° 10. It had manual positions and could be calibrated for the production of each part of the garment, such as sleeves,

body panels, and cuffs. Collars and patterns were made separately. It was used to make thin fabric. When they needed to expand production to meet an increased demand, the family business purchased Argentinian Caba N° 8 knitting machines, which had manual positions and were suitable for the production of medium-thickness fabrics, and the German Seyfert und Donner N° 5 knitting machine, which offered automatic positions and was suitable for the manufacture of thick knitted fabrics. Some years later, the business acquired an American Diamant N° 8, which had automatic positions and was used to produce medium-thickness fabrics. Furthermore, the family business also acquired an electric four-bobbin winder to speed up the work prior to the arrival of the new machine.

Initially, the textile companies provided family workshops with the yarn for producing the knitted fabrics. When the home workshops were in a position to expand, the families started to assemble the pieces they had knitted, first manually and later by machine. For this purpose, other machines were bought, for example, a Bicatenella lockstitch sewing machine, a "La Ducale" assembly machine (both Italian), and an industrial iron.

On average, it was possible to make seven unassembled garments in an eight-hour workday. Workers were paid for each item produced. Approximately ten people, including sisters, mothers, aunts, and other Italian women, worked in these family home-workshops year round. Production was carried out in series; that is, each group of workers produced a different part of the garment (body panels, collars, sleeves, patterns, and later assembly and embellishment). An advantage to this type of work was that women could stay at home and take care of the children. Enrica and Maria recall:

> *Ahí me quedé, me quedé de tejedora y después yo me compré la máquina y me quedé en mi casa. Trabajábamos para una firma grande.*

> I stayed there, I stayed as a weaver and then bought a machine and stayed at home. We worked for a big firm. (Enrica R.)[31]

> *Cuando me casé empecé a trabajar con las máquinas de tejer. Porque por no salir y no dejar a los chicos en casa. . . . Tejía a una fábrica de tejido . . . cómo se llamaba . . . pienso que todavía esta la fábrica de tejido . . . se llamaba "Lobito." Era una fábrica de tejidos muy grande.* (María C.)[32]

> When I got married I started working with the knitting machines. Because I did not want to leave the kids at home alone. . . . I knitted for a knitting factory . . . what was its name? . . . I think the factory still exists . . . it was called "Lobito." It was a very big factory.

The strictly women- and family-oriented work allowed workers not to be tied to one specific textile company. Weavers worked for different establishments because the demand was high.

Mamá era costurera y yo tejedora. Tejía mucho para los de "Marisé" que era ropa para bebé. Durante treinta años hice cosas, escarpines y todas cosas para bebés, en lo de "Marisé," primero en lo de "Stella Maris," después se enfermó y entonces seguí con "Marisé." Era de los Malesani. Era todo tejido.

My mother was a seamstress and I was a weaver. I knitted a lot for "Marise" that made baby clothes. For thirty years I did things, ankle socks and all kinds of things for babies in "Marise," first in "Stella Maris" but then she got sick so I continued with "Marise." It belonged to the Malesani family. It was all knitted stuff. (Elisabetta T.)[33]

Yo trabajé para Sara Giacobone, y para Tosca, que fue una firma de pulóveres grande. Esas dos firmas grandes.

I worked for Sara Giacobone, and for Tosca, that was a big sweater company. Those two big firms. (Enrica R.)[34]

Conclusion

Devoto makes this observation about the work patterns of post–World War II Italian immigrants:

Los migrantes, aunque en modo desigual, accedieron a posiciones laborales estables, manuales, sobre todo calificadas, y en muchos casos se incorporaron a ocupaciones no manuales. Vinieron a engrosar, en un sentido amplio, la clase media urbana . . . se convirtieron asimismo en propietarios de sus viviendas. . . . Ciertamente, el modelo de desarrollo económico llamado de sustitución de importaciones favoreció la plena ocupación y la estabilidad laboral.

Migrants, even if unevenly, got stable positions, manual jobs, particularly skilled ones, and in many cases they incorporated themselves to non-manual occupations. In a broad sense, they came to enlarge the urban middle class . . . they became home owners. . . . Certainly, the development of the import substitution economic policy favored full occupation and job security.[35]

In macro terms, migratory groups arrived in Argentina at a moment of economic expansion that favored their employment in different sectors of

the economy. The so-called process of "import substitution" allowed for the development of a secondary sector in which migrants could do well not only in qualified activities but also in unqualified ones. Mar del Plata's textile industry at the time was experiencing a significant expansion, which allowed for the hiring of many immigrants in the domestic system of *a façon*, as well as the establishment of small textile factories of a strictly family nature. The testimonies of the female Italian immigrant knitters suggest how workers used social networks to establish and expand their economic situations. Their words enlarge our knowledge of the history of the Italian immigration in Mar del Plata and its characteristics, providing opportunities for others to explore this local scene in a national Argentinian context and in the even larger context of the global diaspora of Italian working women.

Acknowledgments

I would like to thank Gabriela Manetta, Melina Piglia, and Karina Silvestro for the translations of the original text.

Notes

1. Henceforth referred to as "APIE."

2. María A. Irigoin, "La población, los habitantes y la trama social urbana, 1880–1940," in *Mar del Plata. Una historia urbana*, ed. Adriana Alvarez et al. (Buenos Aires, Argentina: Fundación Banco de Boston, 1991), 48.

3. See *IV Censo Nacional de Población* (Buenos Aires, Argentina: Dirección Nacional de Servicio Estadístico, 1947), 38 and 94–95; *Población censada en 1947, clasificada por sexo, grupos de edades y lugar de nacimiento* (Buenos Aires, Argentina: Dirección Nacional de Servicio Estadístico, 1947), chart 7, 441–43.

4. A significant percentage of Veneto natives chose Mar del Plata as a destination because it was already populated by a large number of Italians from their regions. I analyze the data about Italian immigration in my dissertation. See Bettina Favero, *La última immigración: Italianos en de Mar del Plata, 1945–1960* (Buenos Aires, Argentina: Imago Mundi, 2013).

5. I analyze the statistical data presented in this paragraph in *La última immigración.*

6. This latter group represented 17 percent to 37 percent of all Italian immigrants in this period. Italian immigrants whose ages ranged from infant to thirteen years old represented from 17 percent to 36 percent of all Italian immigrants in 1954, with a steady decline from that date onward. Moreover, the low numbers of people over fifty years old during this period point to family-based migration, with the arrival of whole groups of children, adolescents, and adults no older than forty who had left their parents in Italy and consequently maintained family ties with their country of origin.

7. According to national statistics the bulk of the postwar European migration were young men between the ages of twenty-two and forty (from 1947 to 1950); this situation

changed afterward with the arrival of a significant number of women, children, and adults younger than forty, which produced a fall in the male index and which favored a reunification process. See María I. Barbero and María C. Cacopardo, "La inmigración europea a la Argentina en la segunda posguerra: viejos mitos y nuevas condiciones," *Estudios Migratorios Latinoamericanos* 19 (1991), 305 and subsequent pages.

8. Domestic work was women's work by default, and in some cases it was an exclusively Italian venture: embroidery, clothing, and the manufacture of artificial flowers. For instance, in New York, 98.2 percent of Italian women were involved in domestic work. See Bruna Bianchi, "Lavoro ed emigrazione femminile," in *Storia dell'emigrazione italiana*, ed. Piero Bevilacqua et al. (Roma, Italia: Donzelli Editore, 2001), 257–74. Devoto reports that during the Argentinian centenary in 1910, immigrant women were present in *a façon* work (sewing, washing, pressing), in the small workshops (shirt, hat, and cigar factories), and in self-employment arenas, but they were also present in the few large food and textile factories. Fernando Devoto, *Historia de la inmigración en la Argentina* (Buenos Aires, Argentina: Sudamericana, 2003), 303.

9. Alicia Bernasconi and Carina Frid de Silberstein, "Le altre protagoniste: Italiane a Santa Fe," *Altreitalie* 9 (1993): 116–38.

10. Several scholars have studied immigrant employability in Argentina, such as María Inés Barbero, "Los obreros italianos de la Pirelli argentina (1920–1930)," in *Asociacionismo, trabajo e identidad étnica, Los italianos en América Latina en una perspectiva comparada*, ed. Fernando Devoto and Eduardo Miguez (Buenos Aires, Argentina: CEMLA-CSER-IEHS, 1992), 189–204; Mariela Ceva, "Las imágenes de las redes sociales de los inmigrantes desde los archivos de fábrica. Una comparación de dos casos: Flandria y Alpargatas," in *Inmigración y redes sociales en la Argentina Moderna*, ed. Hernan Otero y María Bjerg (Tandil, Argentina: CEMLA-IEHS, 1995), 203–20; Mirta Lobato, "Una visión del mundo del trabajo. Obreros inmigrantes en la industria frigorífica 1900–1930," in *Asociacionismo, trabajo e identidad étnica, Los italianos en América Latina en una perspectiva comparada*, ed. Fernando Devoto and Eduardo Miguez (Buenos Aires, Argentina: CEMLA-CSER-IEHS, 1992), 205–30. It is important to highlight research that focuses on the experiences of working women that, in many cases, mention immigrants who arrived in Argentina from the end of the nineteenth century to the middle of the 1950s. See Mirta Lobato's *Historia de las trabajadoras en la Argentina (1869–1960)* (Buenos Aires, Argentina: EDHASA, 2007), and *La vida en las fábricas, trabajo, protesta y política en una comunidad obrera. Berisso (1904–1970)* (Buenos Aires, Argentina: Prometeo, 2004).

11. See Bettina Favero and Gerardo Portela, *Más allá de la Avenida Cincuentenario: el barrio del Puerto (1920–1950)* (Mar del Plata, Argentina: Ed. Suarez, 2005), for a discussion of immigrant fishermen from southern Italy adapting their fishing techniques to the conditions of the Atlantic Ocean.

12. I use only the first name and the initial of the surname for all people interviewed on November 4 and 23, 2001.

13. See *Censo Nacional Económico, 1974. Industria. Resultados definitivos* (Buenos Aires, Argentina: INDEC, 1974).

14. According to the data provided by the Mar del Plata Textile Bureau, there are at present 140 companies, but only 80 affiliated with the bureau. This sector generates around 5,000

direct jobs and 20,000 indirect ones. See Verónica Presa and Mariela Favero, "Mar del Plata, en camino hacia un reposicionamiento de su industria textil" (paper presented at "II Congreso Internacional Lanero," Trelew, Argentina, February 2002).

15. Information provided by industrial-textile designer Mariela Favero (April 2010).

16. According to data for 1974, there were 252 businesses in Mar del Plata dedicated to knitting garments that had their own factories. *Gui Pla*, 5th ed. (General Management, Julio Carlesi: Mar del Plata, 1974).

17. Information from the firm's website "Tejidos Liberati," accessed April 14, 2010, http://www.tejidosliberati.com.ar.

18. Information from the firm's website "Tejidos Buffagni," accessed April 14, 2010, http://www.tejidosbuffagi.com.ar.

19. Information from the firm's website "Mauro Sergio Sweaters," accessed April 14, 2010, http://maurosergio.com.

20. Several essays discuss the development of industrial production during Perón's administration; nevertheless, I consider the following studies to be the most important ones: Juan José Llach, "El Plan Pinedo de 1940; su significado histórico y los orígenes de la economía política del peronismo," in *Desarrollo Económico* 92 (1984): 515–58; Jorge Schvarzer, *La industria que supimos conseguir. Una historia político social de la industria argentina* (Buenos Aires, Argentina: Planeta, 1996), 187–220; and Pablo Gerchunoff and Lucas Llach, *El ciclo de la ilusión y el desencanto. Un siglo de políticas económicas argentinas* (Buenos Aires, Argentina: Ariel, 1998), 155–242.

21. For the development of the textile industry, I have consulted David Rock's "Argentina, 1930–1946," in *Historia de la Argentina*, ed. John Lynch and Roberto Cortes Conde (Barcelona, España: Crítica, 2001), 188–89.

22. See Félix Weimberg and Adriana Eberle, "Los abruzzeses en Bahía Blanca. Estudio de cadenas migratorias," *Estudios Migratorios Latinoamericanos* 8 (1988): 27–50; Dedier Marquiegui, "Aproximación al estudio de la inmigración italo-albanesa en Luján," *Estudios Migratorios Latinoamericanos* 8 (1988): 51–81; and Beatriz Argiroffo and Claudia Etcharri, "Inmigración, redes sociales y movilidad ocupacional: italianos de Ginestra y Ripalimosani en Rosario (1947–1958)," *Estudios Migratorios Latinoamericanos* 21 (1992): 345–70. Likewise, there are specific studies dealing with the work environment and the influence of the networks on it. See Barbero, "Los obreros italianos de la Pirelli argentina," 189–204; Ceva, "Las imágenes de las redes sociales de los inmigrantes," 203–20; and Lobato, "Una visión del mundo del trabajo," 205–30.

23. Fernando Devoto, *Le migrazione italiane in Argentina* (Napoli, Italia: Istituto Italiano per gli Studi Filosofici, 1994), 78.

24. Interview conducted on September 17, 2001 (APIE).

25. Interview conducted on May 15, 2004 (APIE).

26. Interview conducted on November 4 and 23, 2001 (APIE).

27. Interview conducted on May 2, 2001 (APIE).

28. Interview conducted on November 4 and 23, 2001 (APIE).

29. Interview conducted on September 17, 2001 (APIE).

30. Interview conducted on May 2, 2004 (APIE).

31. Interview conducted on November 4 and 23, 2001 (APIE).

32. Interview conducted on May 15, 2004 (APIE).

33. Interview conducted on June 5, 2003 (APIE).

34. Interview conducted on November 4 and 23, 2001 (APIE).

35. Fernando Devoto, *Historia de la inmigración en la Argentina* (Buenos Aires, Argentina: Sudamericana, 2003), 422.

Factory Girls, Bangkok

—Phyllis Capello

In the morning country girls (on their way
to city jobs) ride the rickety bus
over the steep green hills.
All the way to the factory they chatter
like a treeful of birds.
Soon, their quick brown fingers,
their bright, sharp eyes,
will feed cheap fabric to furious needles;
dart by dart, seam by seam, piles of dresses
and sleeves will rise up beside
their clattering sewing machines; they'll work
as if bewitched, till dark.

Yesterday, the dawn, rising over
the far mountains, was mirrored
in the still lake; but today there is deep fog;
the bus, gears grinding, winds its way
down slick roads; the air is wet
and dense against the windshield.
Girls, at a nearer stop, huddle in the mist,
wave dim flashlights, board,
like a family of ghosts.

Each one carries a small packet of lunch,
a tube of lipstick, a plastic comb
to smooth down her sleek black hair.
A homely girl, voice rising happily,
reads aloud from a movie magazine.
Every now and then she stands and holds
the glossy photos high above her head.

This afternoon when the explosion
rises—an enormous roar
over the drone of machines,
and the windows splinter—millions
of needles sailing off into
the air like glass bullets,
when the raging fire obscures
every exit save one, hundreds of girls
will go running and screaming
through the terrible heat,
the stinging black smoke.
Tomorrow they'll find the youngest ones,
dead by the dozens: tiny wrists,
small clever fingertips crushed,
trampled by their rushing sisters,
till they have no breath to rise
and move—like the half-grown
flowers they are—toward the light.

Girl Talk

—Paola Corso

The Triangle girls say

to the Chinese girls, the Indonesian girls,
the Vietnamese, the Taiwanese
 girls girls,

take your 16-hour work day
and glue it to the sole of the shoe,

take your 20 cents an hour wage
and glue it to the heel of the shoe,

take the $180 he charges for the shoe
and glue it to the padding of the shoe

And the Triangle girls say

to the Chinese girls, the Indonesian girls,
the Vietnamese, the Taiwanese
 girls girls,

take the room with 6 bunkbeds
and no place to stand
and glue it to the arch of the shoe

take the glue glue toxic glue,
the burning eyes, ringing ears, bleeding nose
and glue it to the tongue of the shoe,

take the fans and vents you don't have,

the gloves, masks, and aprons you don't wear
and glue them to the threads of the shoe,

And the Triangle girls say

to the Chinese girls, the Indonesian girls,
the Vietnamese, the Taiwanese
 girls girls,

take the chopsticks you can't hold
at lunch because your fingers are too numb
and glue them to the Velcro of the shoe

take the vertigo, the headache, the vomiting,
the memory loss, shortness of breath, the cancer
and glue it to the glue of the shoe

take the glue glue toxic glue
and put it under his nose, a Nike nose,
an anything-goes nose and make him sniff.

ENVIRONMENTAL SITES

Siate Felici: Garden Imagery in a Messinese *Biancheria da Letto,* c. 1900

—Joseph J. Inguanti

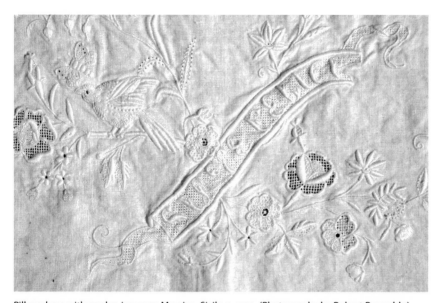

Pillow sham with garden imagery. Messina, Sicily, c. 1900. (Photography by Robert Reynolds.)

As roses bloom and other plants set fruit, a moth flutters through the perfumed night air and a nightingale alights on a branch and prepares to sing. A banderole floats across the paradisiacal scene bearing the message, *"Siate Felici."* "Be Happy," it announces to the newlywed couple that lies in this garden. Appropriate for an object that marks the beginning of marriage, the iconographic program of this pillow sham, part of a set of century-old Sicilian nuptial linens, abounds in references to springtime, the season of flowers, coupling, and growth.

The embroidered pillow sham is Italian American in the most literal sense; created in Italy, it traveled from Messina, Sicily, with its maker to a

new home in New York in 1903.[1] Like the countless other objects brought to America by Italian immigrants, this piece of *biancheria* embodies values that fostered the construction of an Italian American worldview, identity, and culture. The iconography of the pillow sham demonstrates how attitudes about the ideal landscape intersect with the social values, especially sexual mores, of Italians of the Great Migration. As such, the embroidered horticultural scene must be understood as a modern manifestation of an age-old tradition that associates gardens and romantic love. At the same time, however, the values expressed by the garden imagery of the *biancheria*—domesticity, fecundity, beauty, utility—correlate strongly with the attributes of the Virgin Mary, the exemplar of humility and chastity. Visual analysis and historical contextualization reveal the rich meanings encoded in the *biancheria* and point also to the prominent roles that landscapes and landscape imagery play in Italian American culture.

An Iconographic Reading

From an iconographic discussion grounded in biology to an art-historical assessment of the motifs, the symbolism of the pillow sham lends itself to a range of analytical approaches. These analyses yield multiple and at times contradictory interpretations. Nonetheless, they attest to the richness and complexity of the iconographic program, one that is elastic enough to allow ambiguities and shades of meaning.

Science

The embroidered scene teems with life. Leaves, stems, and flowers intertwine; a bird and a winged insect coexist harmoniously. A reading informed by botany, ornithology, and lepidoptery that takes into account the physical properties and life cycles of the plants and creatures allows for a reasonable assignation of species, season, and even time of day depicted in the scene. Easily identified by five prominent outer petals with wavy margins and by the cluster of stamens at their centers, roses (*Rosa* sp.) comprise the largest and most elaborately worked flowers in the piece. While the nineteenth century was a time of extensive hybridization and introduction of new varieties of roses, the simple roses depicted here appear to be species roses—naturally occurring roses—or roses genetically close to them. The embroiderer calls attention to the undulating edges of the petals with a padded satin stitch and captures their delicate, diaphanous texture by using a pulled-thread technique. The emphasis on the ethereal quality of the rose petals deftly evokes

scent and temporality: Petals, the source of attar, are the fragrant parts of the rose; in species roses the petals are short lived, lasting only a day in some varieties. Fragrance and a falling petal both waft through the air.

Additional botanical specimens in the embroidered garden scene emphasize fragrance and the passage of time. The plant whose flowers dangle on arched stems above the insect and the bird may represent lily of the valley (*Convallaria majalis*). The plant features pendulous, bell-shaped flowers, each borne on a fine pedicel. The source of the perfume known as *muguet*, lily of the valley, bears a delightful fragrance. Sweet-scented and unassuming lily of the valley has a short season of bloom in late spring. The swordlike leaf and the minute flower of this specimen allow for another interpretation, one that while contradictory in assignation of species does not hinder—in fact may amplify—the iconographic reading. It may represent flax (*Linum usitatissimum*). The terminal structures of the embroidered specimen bear a striking resemblance to the buds and fruit of that plant. These reproductive elements—different phases of the same structure—descend individually from thin pedicels along the main stem. A projection from this structure suggests the first hint of petals in a flax flower bud as well as the filament that dangles from the newly fertilized seed capsule. Although no fully open flax flower appears on this stem, it is significant for this attribution to note that all phases of sexual reproduction occur on real specimens. Flax flowers bloom, lose their petals, and set fruit in only one day. Therefore it is common for bud, flower, and fertilized ovary to appear on a single inflorescence. The delicacy of these short-lived flowers and the fine texture of the plant belie the strength of its fibers. As its specific epithet, *usitatissimum*, denotes, the flax plant yields the "extremely useful" fabric, linen. Thus, the embroidered image references the very material from which the pillow sham is made.

Floral motifs that feature four to seven petals also decorate the fabric. The scale and shape of their petals vary considerably, making it difficult to identify the flowers with certainty. Nonetheless, the embroidered blossoms suggest several possible readings. Citrus flowers have five uniform white petals, and the blossoms of one species, the orange (*Citrus aurantium*), are traditionally associated with marriage.[2] The carefully worked center of the flower above the "L" on the banderole suggests the prominent pistil and ring of stamens of an orange blossom. The three small flowers on the stem that dangles from the bird's perch and lies below the openwork rose resemble stephanotis (*Stephanotis floribunda*). Not a true jasmine, stephanotis, also a wedding flower, bears the common name Madagascar jasmine. Star jasmine (*Trachelospermum jasminoides*) or true jasmines such as poet's jasmine (*Jasminum officinale*) or royal jasmine (*Jasminum grandiflorum*) may be represented by the pair of tiny white flowers that grows from the stem below the

"A" in the word "*Siate*." Lastly, two small multipetaled blossoms extending from the lower end of the stalk below the banderole recall Arabian jasmine (*Jasminum sambac*). Orange blossoms, stephanotis flowers, and the various jasmines all possess delicious, sweet fragrances. As noted with the rose, the free-floating quality of the botanical motifs in the *biancheria*, suspended as they are in air, evokes the airborne nature of scent.

Like a jasmine that is fragrant at night, the winged insect suggests a nocturnal setting. One may be tempted to see a butterfly in this garden scene but close inspection of the insect reveals characteristics of moths in the silk moth family, *Saturniidae*. The embroidered moth has a particularly thick body; the six segments of the body recall the caterpillar from which the moth metamorphosed. Three circles of openwork at the margins of the forewings of the embroidered moth represent eyespots, another typical feature of *Saturniidae*.[3] Although the embroidered insect lacks the verisimilitude of a scientific illustration, it may represent *Saturnia pavonia* or *Saturnia pavoniella*, two silk moths native to Europe. The motif also calls to mind *Bombyx mori*, the domestic silk moth, a member of the *Bombycidae* family. That moth features white wings and an exceptionally thick body. A Chinese native domesticated for millennia, *Bombyx mori* no longer occurs in the wild. Moreover, as it lacks mouthparts it cannot feed. If not killed for the silken cocoon in which it pupates, its adult life centers on mating and producing eggs. Although the cocoons of each of the moths discussed here yield the raw material for silk production, those of *Bombyx mori* are the most widely used. Thus, the embroidered moth conflates features of various wild and domesticated genera and species of moths to arrive at an easily read emblem for "silk moth," one that advances the prevailing theme of domestication in the linen. The placement of the moth motif directly below the specimen I have identified as flax advances a commentary on the domestication and cultivation of fiber sources in this section of the cloth.

Below the silk moth a solitary bird perches on a branch from which a rose and three stephanotis flowers issue forth. The nearness of the bird to the moth (the left wing of the moth nearly grazes the bird's beak) suggests that the two creatures occupy the same nocturnal realm, indicating that the bird represents a nightingale (*Luscinia megarhynchos*). The bird's firm grasp on the branch and its outstretched wings imply that it has just flown in to perch in the garden. With its throat, back, and belly puffed up and the rigidity of its ample tail emphasized, the nightingale appears ready to burst forth with its beautiful song. Moreover, the fluttering of the bird's wings provides a visual analogue to the melodious warble of the nightingale. While a centuries-old history of nightingales appearing in gardens of love in Italian literature corroborates this attribution, the bird on the pillow sham also possesses

characteristics that allow for an alternate reading.[4] The embroiderer emphasizes the heavy bill of the bird, and with alternations of unadorned linen and minute knotted stitches she suggests the face and breast pattern of the male *Passer domesticus*, the house sparrow. As its scientific and common names attest, this bird makes its home in civilization. It commonly nests in residential landscapes and for that reason affords us a clear view of its own domesticity perhaps more than any other species of bird. Although it is a diurnal creature, its long days keep it active from daybreak to dusk. The natural history of these small perching birds, the nightingale and the sparrow, intertwines closely with European cultural history. These creatures, like the silk moth and the flax plant, direct us to the point of transition between the natural and the civilized worlds. And like the other motifs in the linen, they may be seen as metonyms and metaphors for the idea of "garden." A manmade art form fashioned in part from natural components, a garden demarcates a place where nature mingles with culture. The temporal transition from day to night evoked by the silk moth and nightingale/sparrow motifs complements the seasonal specificity of the floral motifs. Beautiful flowers—utilitarian or fragrant—bud and bloom at another pivotal time, the change of month from May to June, the traditional point of transition from virginity to marriage. For this, we must turn from a scientific reading to social historical and art-historical analyses.

Messina and Circumstances of Production

Part of a set of bed linens produced in a convent school and orphanage in Messina, the pillow sham must have been produced between 1886 and 1903, the period in which the embroiderer resided in the orphanage. While it was common for workshops run by convents to produce *biancheria* for sale to the laity, a set of napkins bearing the embroiderer's initials provides evidence that the young women in the care of the convent sisters also made items for themselves. If the present pillow sham was executed expressly as part of the embroiderer's personal property—as distinct from a "leftover" commissioned work—it seems likely that it would have been created when its maker had reached marriageable age. By the middle of the last decade of the nineteenth century the embroiderer was in her late teens; she left the convent orphanage in 1903 at the age of twenty-six in order to marry.

The custom of placing poor or orphaned girls in the care of nuns until they could be married off, the production of nuptial linens, and the iconography of those linens converge to offer a fascinating glimpse of the attitudes and values of immigration-era Messinese. Schooled in religious texts and

intricate needlework within the confines of a chaste Catholic setting, the abandoned child herself would be fashioned into a desirable commodity. An appropriate suitor would be assured a devout Catholic, a skilled needle-worker, and a virginal bride. These convent schools produced not only elaborately embroidered nuptial linens; perhaps more importantly they turned out marriageable young women. The *biancheria* references these social values and explores them through an iconography that stitches together themes of utility and productivity with those of pleasure and abundance.

Unfortunately, our informant, the daughter of the embroiderer, does not know the name of the orphanage, the religious order with which it was affiliated, or its location in Messina. Nonetheless, a plausible scenario may be advanced, fostered by a centuries-old tradition of devotion to the Virgin Mary. Guidebooks contemporary with the *biancheria* point to a plethora of convents in Messina, especially along the Via dei Monasteri.[5] The creation of the present object required scores of hours of manipulation and scrutiny of an elaborate repertory of Marian symbols. Undoubtedly this physical reconstruction and visual reminder of elements of the *hortus conclusus*, the enclosed garden of the Virgin Mary that I discuss more fully below, facilitated meditation on the attributes of the Virgin. Such practice would have been particularly comfortable in Messina, where the Franciscan Order of Saint Clare (Santa Chiara)—in that city since 1294—saw women's imitation of the qualities of the Virgin Mary as a fundamental tenet.[6]

At the time of the production of the pillow sham, Messina had been host to convents of Poor Clares, as the nuns of the Order of Saint Clare are called, for six centuries. The establishment of the Monasterio di Montevergine, a convent of Poor Clares, in 1464 by Messina's own Eustochia Calafato (canonized Saint Eustochia by Pope John Paul II in 1988) amplified the culture of female Franciscanism in Messina. The prominent Monasterio di Montevergine and other Franciscan convents would have helped to shape a moral code for girls in the city at large and certainly would have exhorted the orphaned girls in residence to emulate Saint Clare's own Marian attributes. The embroiderer's lifelong devotion to Sant'Antonio di Padova (Saint Anthony of Padua) further links her to a culture of Franciscanism. At the turn of the last century such convents provided the ideal settings in which to teach the Marian and Franciscan values of poverty, chastity, and obedience and to guarantee the virtue—the virginity—of the orphaned girls sheltered within their walls. How appropriate, then, that an iconography that recalls the *hortus conclusus*, the inviolable garden of the Virgin, be evoked by young women whose cloister ensured their own virginity.

According to legend, devotion to the Virgin Mary became a citywide affair after a delegation of Messinese led by Paul the Apostle returned

from the Holy Land in C.E. 42 bearing a letter written by the Virgin. This event established Mary as the *Madonna della Lettera, Protettrice della Città*, because in the letter the Virgin assured the Messinese of her perpetual protection. Annual festivities in honor of the Madonna of the Letter still take place in Messina on June 3, the date of the letter.[7] Moreover, the date adds a specifically Messinese dimension to my assertion that the *biancheria* imagery recalls Marian symbolism and the horticultural realities of May and June. Mary, whose virginal qualities prevail in the month of May, extends her influence in the Messinese context into early June as protectress and *mother*. The European custom of the "June bride" derives from the proscription against marriage in May, the month of Mary, or more accurately the month in which Mary's virginity cannot be sullied by the consummation of new marriages. This fact resonates with the complex iconography of an object that positions its maker and user at the interstices of distinct Marian attributes, virginity and maternity. As noted earlier, the botanical motifs corroborate this transition as their bloom times span the months of May and June. The embroiderer's own wedding took place on June 1. It is plausible that she was stitching the finishing touches on her nuptial linens at the very time of year they depict.

In the broader context of Italian history, the very practice of needlework is associated with female virtue. As early as the sixteenth century, Italian embroidery pattern books were marketed to *"virtuose donne"* (virtuous ladies).[8] The engraved illustrations in these books demonstrate that needlework had a sororal dimension. In the frontispiece illustration of Zoppino's *Convivio delle Belle Donne*, published in Venice in 1531, women embroider in the company of other women. Throughout the centuries pattern books present embroidery as an edifying labor for groups of women—a belief that clearly still prevailed in Messinese religious communities as recently as the turn of the last century. Although the pattern books are secular texts, the crucial issue of feminine virtue they promote would have been of value in Messinese convents of the period. In that context, virtue is perhaps best defined in contrast with its antonym, vice. Thus, the practice of needlework advanced a notion of virtue bound up with virginity and creation. Ultimately, the embroidered linen product of this labor alludes to the Marian paradox: The virtuous young woman in the convent school strove for both chastity *and* productivity.

Productivity

The social context in which the *biancheria* was made placed a high value on industriousness and productivity. Providing orphans, both boys and girls,

with gender-specific vocational skills was one of the fundamental goals of Messinese orphanages at the turn of the last century. This is especially true of the orphanages founded in Messina in the early 1880s by Father Annibale Maria Di Francia (canonized 2004). Upon marriage a young woman schooled in needlework would have the skills to manage the sewing needs of her family in her new role as wife and mother. Furthermore, a skilled needleworker might supplement the family income. The young woman's set of linens, her *biancheria*, offered tangible evidence of her socioeconomic eligibility for marriage. In his novel *The Fortunate Pilgrim*, Mario Puzo demonstrates the abject poverty of the protagonist, Lucia Santa, herself an immigrant of the Great Migration, by pointing to her *lack* of bridal linen.

> There had come a time when her father, with stern pity, told her, his favorite daughter, that she could not hope for bridal linen. The farm was too poor. There were debts. Life promised to be even harder. There it was. There could be found only a husband witless with love.
>
> In that moment she had lost all respect for her father, for her home, for her country. A bride without linen was shameful, shameful as a bride rising from an unbloodied nuptial bed; worse, for there could be no recourse to slyness, no timing of the bridal night near the period of flood. And even that men had forgiven. But what man would take a woman with the stigma of hopeless poverty?[9]

As part of a trousseau of linens, the embroidered pillow sham helped to provide an impoverished orphan with a respectable marriage.

The iconographic references to flax and silk and the theme of domestic labor in the *biancheria* bear strong associations with Italian female roles in the era of migration. Hasia R. Diner relates that in Italy "Young women left home for lengthy periods of time to work in silk mills and textile factories, or to labor as domestic servants for local elites."[10] Moreover, the embroidered citrus blossoms and moth emphasize the theme of productivity in a specifically Messinese economic context. Oranges and lemons ranked first and silk third among the main exports of Messina at the beginning of the last century.[11] Much of the silk produced in Messina, from the cocoons of the thick-bodied *Bombyx mori* silkworm, was destined—like the pillow sham and its maker—for American shores.[12] The *biancheria* participates in the construction of an economic and social value system that emphasizes the productivity of the bride-to-be in several forms—already-realized practical skill, the potential for more work, and the readiness for the production of children—on sheets that celebrate the move from virginity to married life. Salient embroidered motifs conflate references to municipal economic output, transnational movement, and the personal productivity of the maker in

an iconography of abundance. It is fitting that this emphasis on productivity finds its expression in a garden scene. Richard Gambino has noted the strong correlation between beauty and productivity in the landscape in Italian and Italian American culture.[13] Elsewhere I have demonstrated that the tendency to recognize productivity and order in residential and cemetery landscapes *as beauty* prevails to this day among Italian Americans in the New York City metropolitan area.[14] Motifs associated with cultivated, not wild, nature—orange blossoms, silk moth, flax plant, and the garden itself—advance the theme of Messinese productivity in the pillow sham.

Sources and the Transmission of Enduring Themes

Etymology provides a fruitful model for decoding the iconography of the pillow sham. Encounters between cultures, faint echoes of archaic usage, and nuances of meaning all persist in the lexemes, or the words, that comprise modern languages. Etymologist George Steiner observes, "When using a word we wake into resonance . . . its entire previous history."[15] An individual motif in the present piece of *biancheria* may be queried in a manner parallel to the etymologist's interrogation of a particular lexeme. Art-historical deployment of etymology posits the transmission of a motif/idea across the ages while acknowledging the likelihood of accretions to its original meaning. Although he does not invoke etymology in his classic work, *The Shape of Time*, art historian George Kubler advances an analogous method for the study of objects. Kubler simply but eloquently asserts that "everything made now is either a replica or variant of something made a little time ago and so on back without break to the first morning of human time."[16] Thus, a method that reveals the introduction of a motif and charts the endurance of—and modifications to—its original meaning throughout the centuries yields a rich reading of the pillow sham.

One item of material culture among innumerable others, the pillow sham participated in the transmission of beliefs about the landscape from one side of the Atlantic to the other. As a *representation* of a landscape, this piece of *biancheria* has its own particular value; it is portable, whereas a real landscape is not. Moreover, as an embodiment of an ideal landscape, it is well suited to serve as a source of inspiration rather than an immutable plan. The values and moods it advances—sensual beauty, abundance, contentment—are ultimately more potent shapers of the Italian American landscape than a recapitulation of specific horticultural elements depicted in the linen. A biological appraisal of the motifs and a consideration of the Messinese social and economic context in which young women and *biancheria* were a sort

of currency for the valuable state of virginity have shed light on the meaning of the pillow sham. Situating the iconography of the pillow sham in the historical context of real and imagined landscapes will further elucidate its meaning. As elements of the desirable landscape, the motifs in the *biancheria* are continuously redeployed in a variety of media—text, image, and real space—throughout Western history.

Garden History

The medieval *hortus conclusus* and the subsequent and related *giardino segreto* of the Renaissance provide the clearest historical precedents for the scene depicted on the pillow sham. Echoes of these garden types endure in the *biancheria*. In both models, love prevails amid beautiful plantings; both gardens are separate, enclosed components of a larger landscape. A distant descendant of these forms, the pillow sham implicates the discourses of life science, the economics and commoditization of maturing young women, and the validation of—or challenge to—Marian attributes. In the *biancheria* as in its precursors these themes intersect at the site of a beautiful, enclosed landscape. The *hortus conclusus,* the apocryphal garden of the Virgin Mary, offers a potent symbolic foundation for the imagery of the pillow sham. Although the *hortus conclusus* is a nonscriptural device, most scholars maintain that it derives from the biblical Song of Solomon 4:12: "A garden locked is my sister, my bride; a garden locked, a fountain sealed." This Old Testament passage came to be associated with the Virgin Mary. A medieval motif, the *hortus conclusus*, literally "enclosed garden," appears in European literature and painting. In it sits the calm, contemplative Virgin Mary. Other occupants might include the Christ Child, Saint Anne (the Virgin's mother), and even a unicorn. *Hortus conclusus* imagery emphasizes loving, familial bonds and a quiet, peaceful mood among the figures. An inviolable space, the *hortus conclusus* provides a metaphor for the impenetrable Virgin who rests within its walls.

Identifiable botanical specimens in *hortus conclusus* imagery provide a catalogue of Marian symbols.[17] The remarkable similarity between the floral motifs of the *biancheria* and those of the *hortus conclusus* tradition suggest the enduring currency of traditional Marian symbolism in linens made around 1900. If one chooses to see lily of the valley in the motif that I suggested might represent flax, the symbol nevertheless remains rich in Marian attributes. As the flower's Latin name makes clear, it blooms in the month of May, the Virgin Mary's month. The sweet scent and white blossom of lily of the valley traditionally suggest Mary's purity. The downward-facing blossom recalls the humility of the Virgin. Lily of the valley is also a symbol of

the Incarnation because it sprouts at the same time of year as the Annunciation. Jasmine also blooms in May and bears a fragrant, white flower, and it too suggests the purity of the Virgin. In some depictions of the apocryphal Betrothal of the Virgin, jasmine appears with roses on the staff of Saint Joseph. The rose, the most prominent of the traditional floral symbols of the Virgin Mary, plays a significant role in this piece of *biancheria* as the most elaborately embroidered flower. Orange blossoms, a symbol of marriage since antiquity, are also associated with the Virgin in her symbolic role as the Bride of Christ. In an early fourteenth-century text the Bolognese theologian Armando de Bellovisu considers the orange the most beautiful of all trees because it bears leaves, fruit, and flowers at the same time. Similarly, the Virgin simultaneously bore the flower of virginity and fruit of her womb.[18] Thus, Marian botanical symbolism in European, especially Italian, art and text reconciles the carnal with the virginal in the spirit of divine, Christian union. It is in this very old tradition that the embroidered garden, the work of virginal hands destined for the nuptial bed, must be seen.

The *hortus conclusus* also begs comparison with other Judeo-Christian gardens. A beautiful place, a place set apart, and a place touched by divinity, the *hortus conclusus* recalls the Garden of Eden. Yet the *hortus conclusus* differs from Eden perhaps most significantly with regard to sin. Mary's virginity and humility in the *hortus conclusus* counter Eve's temptation of Adam in the Garden of Eden. The Virgin, the "new Eve," reposes in a garden in which sin has no place. The other prominent biblical garden is, of course, Paradise or Heaven, the realm of righteous souls. As in prelapsarian Eden, beauty, remoteness, and exemption from quotidian cares prevail there. These potent models for the idea and iconography of the garden in the Christian West share numerous features with other antique landscapes in literature and real space. In his work on garden imagery in the Renaissance epic, A. Bartlett Giamatti notes that the Old Persian word *pairidaeza* refers to "the royal park, enclosure, or orchard of the Persian king." Hebrew and Greek variations of the word add a spiritual dimension; by the time of the New Testament Gospel of Luke, "paradise" denotes not only a royal park or garden but also the celestial and earthly paradises, Heaven and Eden. In the ancient Greek tradition Homer and Hesiod describe analogous earthly paradises of Elysium and the Golden Age, respectively.[19] With Sicily's ancient Greek and subsequent Early Christian history, the topos of an enclosed, blissful garden would have been an element of Messinese culture even prior to the manifestation of the *hortus conclusus* tradition.

Representations of secular medieval gardens bear a striking resemblance to images of the *hortus conclusus*. Although the denizens are no longer divine, three important attributes remain unchanged: the space is

enclosed, it abounds in beautiful plants, and love fills the air. Here profane love replaces the divine love of the *hortus conclusus* and the notion of pleasure moves from the tranquility of prayer to the joys of courtship or even physical intimacy. The medieval "garden of earthly delights" occurs at the carnal end of this continuum of love. Such enclosed lovers' gardens provide the model for the *giardino segreto*. Like its medieval precursors, the *giardino segreto*, or "secret garden," is an enclosed garden within the confines of a larger landscape. Gianni Venturi points to "a link between the purpose of a *giardino segreto* and its interpretation as a setting for erotic love, as it came to be regarded in its secular guise as a *hortus conclusus*."[20] A feature of Renaissance villa gardens, the *giardino segreto* retains the theme of love noted in earlier forms and enhances it by means of sensuous plantings.

However, the *giardino segreto* is informed not only by the *hortus conclusus* motif and by secular gardens of medieval Christians but also by Muslim ones. Sicily was an important point of contact between the landscape traditions of Christians and Muslims in the Middle Ages. William Emboden points out that the Arabs built Islamic pleasure gardens filled with exotic flowering plants in Sicily. He maintains that the Italian Pietro de Crescenzi, whose *Liber Ruralium Commodorum* (c. 1305) describes pleasure gardens, knew of the Muslim gardens of Sicily. One of the most complete accounts of late medieval horticulture, the *Liber Ruralium Commodorum* became a crucial landscape treatise in the Renaissance thereby transmitting medieval ideas—both Christian and Muslim—to the modern era. In Crescenzi's text one notes echoes of Muslim pleasure gardens that share much with the lovers' gardens depicted in contemporary Persian manuscripts. The ancient Persian *pairidaeza* tradition cited above is the primary source for the Arabic pleasure garden. Crescenzi discusses the practice of interlacing the boughs of trees to form walls and roofs of gardens. In the late fifteenth-century garden of the prominent Rucellai family at Quaracchi, near Florence, a barrel vault bearing intertwined damask rose (*Rosa damascena*) and jasmine covered the maze in the *giardino segreto*. The fragrance must have delighted those who were fortunate to linger there. Although he did not limit his discussion to the *giardino segreto*, Leonardo da Vinci noted the importance of fragrant flowers, especially citrus, and birdsong as components of a successful villa garden. Leonardo and other designers and critics of the Renaissance villa garden were indebted not only to Classical writers such as Vitruvius but also to medieval Christian precedents.[21] Thus, elements of the enclosed Christian garden of the Middle Ages and the Near Eastern pleasure garden inform subsequent European landscapes and the iconographic program of the pillow sham.

Botanicals that appeal to the eyes and the nose—damask roses, various jasmines, citrus—arrived and/or spread with the Arab conquest of Sicily.

Flowers of these plants figure prominently in *biancheria*. In 842, the Arabs took Messina and retained control of the city until the Norman conquest of 1061. Even under Norman rule horticulture and garden design, like other aspects of culture, retained Islamic attributes.[22] This is especially true under Roger II, who demonstrated a high level of tolerance for Sicily's multiethnic citizenry. The Norman kings built elegant royal residences outside Palermo probably on the site of preexisting Arab country retreats. La Zisa, built by William I in the middle of the twelfth century, advances the Muslim notion of the garden as an earthly paradise with its very name. An inscription at the garden reads, "Here is the earthly paradise . . . this is called *al-ʿaziz* (the Glorious.)"[23] In Messina the Arab-Norman style Church of the Annunziata dei Catalani testifies to the endurance of the Muslim artistic tradition. Second only to Palermo in importance, and capital of one of the three regions into which the Arabs divided Sicily, Messina would certainly have had a rich Islamic landscape tradition, although its history of conquests and natural disasters has erased the physical evidence.

In the medieval *hortus conclusus* and its secular analogues, Christian and Muslim gardens of pleasure, and in the Renaissance *giardino segreto*, beauty, tranquility, and love—whether sacred, profane, or a mixture of both—prevail in an enclosed precinct. Removed in space and in mood from ordinary life, these places of plenty and sensuality foster spiritual or bodily rapture. In mythical versions of such gardens even time itself takes on an extraordinary dimension; a garden might enjoy an eternal springtime or trees may leaf out, flower, and fruit simultaneously. This notion of time unfettered by conventional sequence or measurement rings true for both physical and divine union. Clearly it is thematically relevant for an object such as a pillow sham that touches a couple on their wedding night. Moreover, the *biancheria* exploits the long history of enclosed gardens and their association with love. Its floral program shares much with historic pleasure gardens of Muslim Sicily and with Marian *hortus conclusus* iconography. Set apart from ordinary space by a scalloped border this item of *biancheria* represents a liminal space where chastity and pleasure converge.

Folklore and Literature

The union of Muslim masculine ardor and Christian feminine virtue provides the theme for one of Messina's best-loved origin myths.[24] The legend probably dates from the sixteenth century, although the narrative is set in the Middle Ages. The invading Saracen general Hassan Ibn Hammar, besotted with Mata, the Christian maiden, asks for her hand in marriage. Refused by Mata's father because he is not a Christian, the Muslim general increases

the severity of his attack on Camaro, a village just outside Messina. Finally, Mata's father acquiesces to Hassan's demand, but Mata places a condition upon the marriage. The Moor must accept the Christian faith. Hassan agrees to Mata's requirement, changes his name to Grifo, and marries Mata. His nickname, Grifone, refers to the general's large stature. To this day, colossal statues of these legendary founders of Messina travel through the streets of the city as part of *ferragosto* (the Italian mid-August festival).

The religious component of *ferragosto*, the Feast of the Assumption, marks the unique transit of the Virgin from earth to Heaven in both soul and body. Like the Mata and Grifone legend, the Assumption story features a virgin, a transformative moment in the life cycle, and emphasis on corporeal transition. The comfortable contiguity of these tales provides an instance of the permeability between the religious and the secular in the Messinese value system. The statues of Mata and Grifone exhibit marked differences in skin color. Grifone's dark skin suggests the conflation of Muslim and African in the popular imagination as it does in the famous adaptation of a story from Giuliano Cinthio's *Hecatommithi* of 1565, Shakespeare's *Othello, the Moor of Venice*. Yet, Mata's fair complexion attests to the European contribution to the Messinese gene pool. From this mixture of races and creeds springs the Messinese people. The salient themes in the Mata and Grifone legend offer additional insights into the Messinese value system encoded in the *biancheria*. The Saracen general's transformation from Hassan Ibn Hammar to Grifone results from an accumulation of changes in his state of being. He moves from Muslim to Christian, bachelor to married man, destructive warrior to prolific father, Arab to Messinese. Grifone's metamorphosis clusters around themes invoked also by the *biancheria*. The characters in the tale and the motifs in the linen function as emblemata for the pursuit of pleasure and for the need to frame that pleasure within the confines of Christian moral code. Only *after* Grifone's conversion—in all senses of the word—may he enter Mata's heart and body. Despite the difference in gender emphasis, this legend, like the *biancheria*, describes a nuptial transformation. In the narrative the marauding Muslim becomes the forefather of an entire city. In the garden depicted in the *biancheria* a young woman begins the sanctioned transformation from virgin to mother safely within the institutions of marriage and home. Similarly, the Messinese origin myth emphasizes the domestication and moral compliance of Grifone and the subsequent abundance of his progeny with the homegrown Sicilian beauty, Mata. Metaphorically, Mata's body shares much with the idea of the garden and the Messinese notion of the city. The tale implies that urbanism and horticultural beauty arise from the civilizing impulse of domesticity. In the Messinese context, the germination of exotic seed in native soil catalyzes the process.

Male quest for entry into a fertile space also drives the narrative in a much earlier story, *Roman de la Rose* (*The Romance of the Rose*), written by Guillame de Lorris around 1230.[25] The quintessential *roman*, a late medieval French literary genre, the *Roman de la Rose* circulated widely in Western Europe. *Roman de la Rose* describes the movement of the male protagonist toward the enclosed garden where his beloved Rose reposes. Like the flower that shares her name, Rose possesses great beauty. The young man does not succeed in his pursuit of Rose. Her garden and her person remain impenetrable. The botanical metaphor continues in an alternate ending to the tale written about forty years later by Jean de Meung. This version culminates with the suitor's entry into Rose's walled garden and her ultimate "deflowering." The author of the second ending elevates the moral tone of his bawdy tale by identifying the "garden of procreation as the Christian pasture of the Good Shepherd."[26] *Roman de la Rose* provides yet another instance of how the meaning of the enclosed garden oscillates between the sacred and the carnal in European cultural history.

European folk and literary traditions dating from or set in the medieval era thus perpetuate similar character types and narrative sequences. The aforementioned tales feature an ostensibly inviolable woman who presents substantial challenges to the ardent man who seeks to penetrate her garden walls and/or her body. Despite the initial wish to remain in a virginal state, the female character ultimately yields to male desire. Love transforms the characters, and they live happily as a married couple. Love also modifies the connotation of the garden. As the setting for both intact virginity and coupling, the same garden metamorphoses from a Marian-style *hortus conclusus* to a lovers' *giardino segreto*. The linen discussed here similarly provides a garden scene for precisely this pivotal moment in life's narrative. The white-on-white embroidery and the inclusion of Marian botanical motifs evoke the impenetrable precinct of the *hortus conclusus* and the chastity of its primary denizen, the Virgin Mary. At the same time, the sensuous qualities of citrus and jasmine, fertilized seed capsules, and the coexistence of native and exotic species call to mind the *giardino segreto*, the site of erotic love. The horticultural ensemble of plants whose blossoms straddle May and June further underscores the theme of transition from virgin to wife.

The Nightingale Motif

The bird motif in the *biancheria* evokes a literary history rich in symbolism. In Greek myth the nightingale recalls a tale of violent sexual union. Tereus, a Greek king, rapes Philomela, the sister of his wife, Procne. Tereus cuts out Philomela's tongue so that she cannot tell Procne what he has done to her.

Philomela reveals the truth to Procne by means of weaving a cloth. Procne takes revenge by killing her son, Itys, and serving him to Tereus for dinner. When Tereus pursues Procne and Philomela with an axe, the gods intervene and transform them all into birds. In Ovid's retelling of the myth in *Metmorphoses*, Book VI, Philomela becomes a nightingale. The motif of the nightingale in Ovid's version has a far-reaching effect on subsequent European literature.[27] Significantly for the present study, the Greek myth and Ovid's adaptation situate in close narrative and thematic proximity the loss of virginity, the making of a textile, and the theme of metamorphosis. In the tale, weaving (embroidery in some versions) functions as the frame for the retelling of Philomela's unhappy story. As such, the cloth of her own making recounts Philomela's transformation, her loss of virginity. In an ironic twist, she who has no voice metamorphoses into a nightingale, a creature loved for the beauty of its song.

Although still associated with coupling, the female nightingale of Greco-Roman texts shifts sex to male in texts written in the European vernaculars. Paul Larivaille observes that in the Italian literary tradition the nightingale represents the male bard of nocturnal love poetry. He further asserts that in the works of Boccaccio and Aretino the word "nightingale" signifies the penis: *"le nom de l'oiseau est ironiquement employé comme substitut métaphorique du membre viril"* ("the bird's name is used ironically as a metaphorical substitute for the male member").[28] In the Fourth Story of the Fifth Day of *The Decameron* Ricciardo scales the garden gate and climbs up to the garden gallery where Catarina reposes at night. Catarina has been granted permission by her parents to sleep in the gallery on the pretense of hearing the nightingale's song. Catarina's father discovers her and Ricciardo asleep together after their "amorous pleasure." Boccaccio writes,

> Stepping out onto the terrace, he gently raised the curtain surrounding the bed and saw Ricciardo and Caterina, naked and uncovered, lying there asleep in one another's arms, in the posture just described.
>
> Having clearly recognized Ricciardo, he left them there and made his way to his wife's room, where he called her and said:
>
> "Be quick, woman, get up and come and see, for your daughter was so fascinated by the nightingale that she has succeeded in waylaying it, and is holding it in her hand."
>
> "What are you talking about?" said the lady.
>
> "You'll see, if you come quickly," said Messer Lizio.
>
> The lady got dressed in a hurry, and quietly followed in Messer Lizio's footsteps until both of them were beside the bed. The curtain was then raised, and

Madonna Giacomina saw for herself exactly how her daughter had taken and seized hold of the nightingale, whose song she had so much yearned to hear.[29]

Catarina and Ricciardo's predicament does not end in disgrace. Agreeing that the two are a suitable match, Catarina's parents connive to have them engaged upon waking them, and the lovers are later respectably married. Boccaccio successfully conflates the old tropes of the walled, virginal garden and the secret garden. Once breached, the metaphoric *hortus conclusus* of the story becomes the *giardino segreto* for the lovers. When the lovers' nightly dalliances are no longer their *segreto*, the institution of marriage redeems all from potential disgrace. The nightingale, the "*membre viril*" in Larivaille's reading of Italian literature, is thus metaphorically domesticated at the hand of the young woman.

Marriage, the expression of tradition, law, and morality, tames the character that represents intrusive male desire. Previously proscribed, penetration is now sanctioned. In this regard the nightingale motif echoes the qualities of Grifone the Moor. Moreover, the nightingale is yet another device by means of which the arts of East and West converge. A nightingale appears in *The Gulistan* (*The Rose Garden*), a major Persian text written in 1258 by Sa'di: "not only the nightingale and the rose-bush are chanting praises to God, but every thorn is a tongue to extol him."[30] The thorn also plays a role in medieval Christian legend; its pressure on the breast of the nightingale evokes the bird's song. By the late Middle Ages, the wild songbird of thickets and the victim of Tereus becomes in the Christian West the symbol of male domesticity and obedience to God's law.

Expanded View of the Bird Motif: The Linnet

Earlier I posited that the bird motif might alternately or even simultaneously signify a house sparrow. Another bird, the linnet (*Carduelis cannabina*), a small, widely distributed European finch, conflates some of the characteristics of the nightingale and the house sparrow and suggests others relevant to the theme of productivity. The bird appears as the harbinger of spring in William Wordsworth's poem "The Green Linnet" (1803). Wordsworth describes the linnet's joyous voice as it sings amid the fruit trees and from the cottage eaves. The poem reveals that the linnet shares several qualities with the nightingale: It is associated with spring; it visits places of human habitation and cultivation; its song moves the sensitive listener to reverie. Further evidence for the desirability of the linnet's voice—in contrast with its generally drab plumage—to the early twentieth-century ear comes from

an Edwardian-era song in which the linnet appears as a caged house pet. By the nineteenth century the linnet suggests the main themes traditionally evoked by the nightingale and the sparrow. Additionally, the linnet bears an association with the pan-European rise of manufacturing and ultimately with the theme of late nineteenth- and early twentieth-century productivity. The word "linnet" enters English in the early sixteenth century from *lin,* the French word for flax, and refers to the bird's taste for the nutritious, oil-rich seeds of that plant, the source of linen. The embroidered bird in the pillow sham has the sturdy bill of a seedeater and the bodily proportions of a finch. Since male linnets sport a red breast during the springtime mating season, the same color as the thorn-pierced breast of the singing nightingale in medieval legend, this species might be the ideal vehicle by which medieval ideas of love meet modern notions of productivity. The embroidered bird in the *biancheria* lies directly below the stem of flax; the wing of the bird extends between the two lowest leaves on the left side of the stem.

The moth, the only other creature depicted in this botanically rich linen, lies directly above the head of the bird. The top of the bird's beak almost touches the lower-left wing of the moth. Birds routinely prey on moths, but the scene does not suggest that the bird intends to devour the insect. Nonetheless, the moth heads away from the bird, which in turn, has just arrived on the scene, judging from its extended and rigid legs, grasping feet, and still-fluttering wings. Might the silk moth be traveling toward the light of the June moon, fleeing from male attention like the initially hesitant Mata in the Messinese origin myth? The pairing of the intruding bird, strongly associated with masculine attributes and characters, and the moth, the only other member of the animal kingdom in the scene, suggests a gender-specific narrative. In this regard, the moth, itself the result of a striking metamorphosis, functions as an appropriate symbol for female attributes and transformation. With the notable exception of the nightingale, night and its creatures generally exemplify the female principle in the Western tradition. Moths navigate by the moon, the celestial body of lovers and the satellite whose twenty-eight-day cycle recalls the rhythm of fertile women. Locked in a cocoon of its own creation, the caterpillar rests as a pupa until emerging as a sexually mature moth. As noted in the initial identification of the silk-moth motif, the adult lives *only* to mate. It does not even feed. The reality of an orphaned girl placed in a convent school at the turn of the last century provides a parallel to the moth's life cycle. Occupying herself with the fiber arts, the girl lives sealed away from the world of men in a convent, an institution that probably had its own cloister, a version of the Marian *hortus conclusus.* When sexually mature, she leaves the convent as a virginal bride ready for marriage and reproduction.

The iconographic weight of the bird-moth-flax passage in the *biancheria* must not be underestimated. Spatially and symbolically these motifs indicate the key themes of the linen. Here the bird and the moth, motifs associated with masculine and feminine attributes respectively, meet at a spot where flax grows. Moreover, the moth and the flax, sources of the raw materials of women's work, evoke the salient theme of production. Citrus blossoms amplify this economic reading and add, as does the jasmine, a reminder that the Messinese people arise from the comingling of the autochthonous and the foreign. This evocation of origins—of a people and of a family— plays out in a garden rich in historical associations. The ideal garden of the *biancheria* has deep historical roots. It recalls and derives from the mythical *hortus conclusus,* the real-life cloister garden, the Sicilian Arab-Norman pleasure garden, and the *giardino segreto.* Through a complex iconography of flowers and creatures, the linen's message of sexual transformation, productivity, and domesticity rings clear.

From Specimen to Motif: Botanical Illustration and Embroidery Patterns

The embroidered garden is heir to medieval traditions that persist until the early twentieth century; yet it is difficult to trace with certainty a direct line from the real and imagined gardens of the Middle Ages to the embroidered garden in a Sicilian textile of the early twentieth century. Rather, more than a millennium of artistic and literary production—religious and secular narratives, horticultural treatises, painting, manuscript illumination, and actual gardens—reinforces the symbolism depicted here. Botanical texts and embroidery-pattern books provide crucial iconographic links between the Renaissance and the time of this pillow sham.

Illuminated books of hours such as the fifteenth-century *Hours of Catherine of Cleves* or the early sixteenth-century *Grand Hours of Anne of Brittany* provide a place where the contemplation of religious text meets the close scrutiny of sumptuous, naturalistic renderings of flowers, insects, birds, and beasts. These northern European royal commissions point to a growing European fascination for what comes to be known as botanical illustration. Herbals, the illustrated compendia of useful plants, had existed since antiquity, but the books of hours differ from those earlier forms in that their illuminations present meticulously observed natural specimens. Moreover, in these two exceptional books of hours, the natural world depicted in the illuminations meets the spiritual world of the written word. Illuminated books of hours present gardens of images in which the female

patron, like the Virgin Mary, positions herself as she reads the sacred texts. In their book about the botanical arts commissioned by the Medici, Lucia Tongiorgi Tomasi and Gretchen Hirschauer argue that naturalistic illustration emerges as a "new artistic genre" in the sixteenth century. This new genre must be seen against the backdrop of nascent scientific inquiry as well as European exploration and colonization. Botanical illustrators catalogued specimens sent to Europe from far-flung lands by means of accurately and beautifully rendered illustrations. Artists also catalogued native European plants with the sharpened vision needed to render the "new" plants of the New World.[31]

The Veronese artist Jacopo Ligozzi, perhaps the most prominent Italian botanical illustrator of the late sixteenth and early seventeenth centuries, worked at the court of the Medici Grand Duke Francesco I. Ligozzi's work transcends mere scientific description of botanical specimens. His painstakingly executed paintings feature subtle handling of light and a masterful ability to render botanical color and texture. Works of art in their own right, Ligozzi's botanical illustrations delighted Francesco. The artist's gouaches of birds perched in tree branches demonstrate that Ligozzi was also an accomplished ornithological illustrator. Indeed, Ligozzi's naturalist friend Ulisse Aldrovandi included a woodcut based on Ligozzi's painting of birds on a fig branch in his book *Ornithologiae* of 1599. Botanical illustrations featuring birds and insects became a standard visual type in Europe during the seventeenth century. In Italy botanical iconography moved beyond the genre of naturalistic illustration and, due in part to Ligozzi's influence, had a profound impact on other art forms, including embroidery. Tomasi and Hirschauer write,

> Like their colleagues engaged in the other decorative arts, embroiderers adopted naturalistic themes as they came into vogue, particularly after Jacopo Ligozzi, who was born into a family of embroiderers, became director of the Galleria dei Lavori [at the Uffizi] and began to furnish designs for costumes and other applications.[32]

Despite Ligozzi's contributions to the widespread artistic use of naturalistic motifs, this phenomenon looms larger than the contributions of one man or the Uffizi artists he directed. Of course Dutch still-life painting of the era, the most renowned form for this subject matter, abounds in flowers, fruits, insects, and birds. In sum, the seventeenth century constructs a place for the aesthetic value of botanical and naturalistic imagery in painting and in the decorative arts.

Accompanying the novel practice of cultivating plants for the decorative value of their flowers rather than for medicinal or culinary purposes, a new type of book, the florilegium, came into being in the seventeenth century. Florilegia not only addressed the interest in collecting and cataloguing but also catered to the growing taste for floral motifs in the applied arts. The books feature cultivated plants only and like the embroidered image typically arrange the specimens by season of bloom. Moreover, many florilegia include illustrations of insects, much as the present textile does.[33] Florilegia ensured that botanical motifs retained their visual currency in seventeenth-, eighteenth-, and nineteenth-century European material culture. Furthermore, the relevance of floral imagery now extended beyond the religious or literary symbolism of earlier eras to include the discourses of scientific observation and aesthetics. Thus, Gill Saunders observes, some florilegia "fulfill [two] functions, being records of the contents of actual gardens, but with the illustration intended as a source of floral motifs for designers."[34] As with the work of Ligozzi, there exists a close affiliation between florilegia and embroidery patterns.

Embroidery Pattern Books

The historical development of embroidery pattern books parallels that of books of botanical illustration. Pattern books began to appear throughout Europe in the early sixteenth century; their manufacture flourished in the seventeenth and eighteenth centuries. Early pattern books often feature botanical metaphors in their titles and subtitles. As collections of various motifs, the pattern book titles reference flowers, garlands, and gardens; examples include Mattio Pagano's *Giardinetto novo di ponti tagliati* published in Venice in 1542 and Pietro Paolo Tozzi's *Ghirlanda di sei vaghi fiori scelti dai piu famosi Giardini d'Italia* published in Padua in 1604.[35] Other symbols such as the mirror, the gem, the crown, and the theater, all coalesce around the ideas of image, art, and beauty. Like the *hortus conclusus* tradition, the pattern books continued to identify the garden as a place of female habitation.

A secular form and a commercial product in its own right, the pattern book promulgated the theme of domestication and transformation of young virgins to productive wives as did earlier religious texts, legends, and images involving gardens. In this way, the *giardino* or *ghirlanda* of embroidery constructed a textual or imagined landscape in which to promote needlework as the socially and morally edifying activity of *virtuose donne*. One of the earliest examples, Giovanni Antonio Tagliente's *Essempio di recammi,* published in Venice in 1524 positions embroidery as a specifically female enterprise

and includes an engraving of women engaged communally in the task. This inviolable community of women clearly shares much with the spirit of the *hortus conclusus* tradition and the cloistered life of the convent school where the old sexual mores of the Virgin Mary's garden ensured a virginal bride. As early as the late sixteenth and early seventeenth centuries, pattern books use the idea of the garden and the flower to advance the moral imperative of virtue, the socialization of young women, and the arts of the needle.

The Conflation of the Two Traditions

A confluence of the florilegium and the embroidery pattern book, two genres of women's books that showcase floral imagery, occurs at least a century prior to the execution of the pillow sham. As we have seen, florilegia provided visual pleasure on their own but also served to inspire creativity in other art forms. Eighteenth- and nineteenth-century European textiles, embroidered or printed, reveal the remarkable impact of the florilegium tradition. An embroidered French sampler from 1798 features moths, robust birds with curved beaks, and floral motifs that couple a rose with a smaller flower. An Italian piece of printed cotton c. 1830–50 also demonstrates its indebtedness to florilegia. It depicts a bird with an insect in its beak perched on a stem of what appears to be morning-glory vine (*Convolvulus* sp.).[36] Throughout the nineteenth century, European textiles feature an abundance of botanical, entomological, and ornithological motifs based upon naturalistic illustration. Despite the "certain unity" described by Sheila Paine in Western European embroidery due to the wide distribution of pattern books throughout the continent, I maintain that the garden scene in the *biancheria* would not have been selected for use in the Messinese convent school had it not resonated with appropriate symbolic meaning grounded in the local religious, folkloric, and literary customs described above.[37] In this regard, the old religious symbolism of botanical motifs such as the rose, citrus, or jasmine is joined by the additional associations of modern ways of seeing. With an infusion of the taxonomic vision of science and the impulse for decorative application in the "minor arts," a naturalistic image—like an essential yet malleable word in a slowly shifting language—retains its relevance and prior significations *and* takes on novel nuances of meaning. Thus an embroidered jasmine flower, for example, recalls the grace of the Virgin Mary, the infusion of medieval Arab culture and blood, the sensuousness of the *giardino segreto,* and a visually pleasing taxonomic image worthy of redeployment in women's decorative arts. Were *all* these meanings present in the minds of *all* contemporary users? Probably not, but the powerful

echoes of meaning and the compelling physical attributes of the motif guarantee its continuing relevance.

Iconography in Social and Historical Context

As the *biancheria* marks the time and place of the consummation of marriage, its iconography recapitulates the temporal transitions of various plants and creatures. On a grander scale, it draws an analogy between the institution of marriage and the idea of garden. In both instances, beings in their natural state are made to conform to the strictures of civilization. Like a rose, a flax plant, or a silk moth, the new bride is "domesticated" when she moves in accordance with Messinese moral code from virginity to marriage. An iconography of beauty and sensuality that ostensibly appears at odds with conventional ideas about convent morality marks this physical and social ritual. However, the sources upon which the image is predicated, the *hortus conclusus* and the *giardino segreto*, overlap considerably in iconography and meaning. The sensuous garden imagery of the *biancheria* conflates the chaste and the fecund.

Shaping Italian American Attitudes toward the Landscape and Beyond

The imagery and symbolism of the medieval Christian *hortus conclusus* are compounded by Islamic landscaping traditions and probably even by textiles. *Ricamo*, the Italian word for embroidery, derives from the Arabic, *raqim*. Muslim material culture in Messina predates Marco Polo's travels to the East by centuries. Many different forms of cultural production, ranging from painting to literature and from botanical illustration to embroidery pattern books, reinforce these symbols throughout Messinese history. Their imagery points to domestication—the silk moth and the flax plant, the nightingale, sparrow, or linnet all leave nature to make a home in a cultivated place—and as such this imagery attests to the characteristically Italian view that the wild must be cultivated in order to be beautiful. The *biancheria* asserts that in order to be among the *virtuose donne* the young women of the convent school must follow a prescribed path toward domestication. A marriage should take place at a preordained time of year and, like the nuptials of Catarina and Ricciardo or Mata and Grifone, must be sanctioned by family, religion, and state. Moreover, with its references to mythological and historical garden traditions, the floral and zoological symbolism reminds

the young women that they must enter marriage as virgins but ultimately acknowledge fecundity and abundance as valuable and beautiful.

At home on both sides of the Atlantic, this transitional and transnational piece of *biancheria* brings to America an ideal for the landscape, an ideal just as potent as memories of real landscapes. In the Messinese context the iconography of the ideal garden is inseparable from social mores relating to women and marriage. Moreover, the *biancheria* validates challenging handiwork; it holds domesticity in the highest regard; it teaches the beholder that beauty is never far from divinity and that horticultural beauty results from the transformation of wild nature into a bounteous, floriferous garden. For emigrants leaving Sicily and the Italian mainland during the Great Migration, these values kept in memory and encoded in material culture such as the *biancheria* form the foundation for the shaping of real space in the New World. Perhaps the most potent kernel of landscape theory embedded in the *biancheria* is the intersection of virginity and fecundity, a concept repeated throughout the northeastern United States in Italian American landscapes featuring a statue of the Virgin and bursting with flowers, fruits, and vegetables. Although they differ in form and medium, the pillow sham and typical Marian landscapes of Italian Americans both attest to the continued relevance of beauty, domesticity, and cultivation. Thus, this piece of immigration-era *biancheria* advances social values and landscape theory that live on in twenty-first-century real space.

Notes

1. The embroiderer's daughter, who wishes to remain anonymous, owns the *biancheria* and has shared what she knows of its history with the author.

2. The association of the orange blossom with marriage has persisted since ancient Greece. Several authors describe the history and symbolism of this motif: Lucia Impelluso, *Nature and Its Symbols*, trans. Stephen Sartarelli (Los Angeles: J. P. Getty Museum, 2004), 141; Mirella Levi D'Ancona, *The Garden of the Renaissance: Botanical Symbolism in Italian Painting* (Florence: Leo S. Olschki Editore, 1977), 272–74; Gertrude Grace Sill, *A Handbook of Symbols in Christian Art* (New York: Collier Books, 1975), 55–56.

3. John Himmelman, *Discovering Moths: Nighttime Jewels in Your Own Backyard* (Camden, ME: Down East Books, 2002), 37.

4. For a concise and informative history of the nightingale in Italian literature, see Paul Larivaille, *Sur quelques rossignols de la literature italienne: propositions pour l'étude des bestiaries* (Nanterre: Centre de recherches de langue et literature italiennes, Université Paris-Nanterre, 1975).

5. Enrico Mauceri, *Messina: Sessantaquattro Illustrazioni* (Florence: Alinari, 1924), 26. Two decades after the creation of the biancheria, Mauceri relates that along the Via dei Monasteri "every second building was either a convent or a church."

6. Giuseppe Miligi, *Francescanesimo al Femminile: Chiara d'Assisi ed Eustochia da Messina* (Messina: EDAS, 1994), 12–13.

7. Guidebooks of the period describe this narrative and the celebration. See Augustus J. C. Hare, *Cities of Southern Italy and Sicily* (London: Smith, Elder, and Co., 1883), 388; John Murray, *Handbook for travellers in southern Italy and Sicily; comprising the description of Naples and its environs, Pompeii, Herculaneum, Vesuvius, Sorrento; the islands of Capri, and Ischia; Amalfi, Pastum, and Capua, the Abruzzi and Calabria; Palermo, Girgenti. Part II, Sicily* (London: John Murray, 1892 [1903]), 363.

8. Giovanni Ostaus, *La vera perfettione del disegno: di varie sorti de ricami, & di cucire . . .* (Venice: Francesco di Franceschi Senese all'insegna della Pace, 1591), n.p.

9. Mario Puzo, *The Fortunate Pilgrim* (New York: Atheneum, 1965), 9.

10. Hasia R. Diner, *Hungering for America: Italian, Irish, and Jewish Foodways in the Age of Migration* (Cambridge, MA: Harvard University Press, 2001), 35.

11. Karl Baedeker, *Southern Italy and Sicily* (Leipzig: Karl Baedeker, 1903), 335.

12. "Sicily's Silk Industry," *New York Times*, October 3, 1909.

13. Richard Gambino, *Blood of My Blood: The Dilemma of the Italian Americans* (Garden City, NY: Doubleday, 1974), 129.

14. Joseph J. Inguanti, "Domesticating the Grave: Italian American Memorial Practices at New York's Calvary Cemetery," *Markers: Annual Journal of the Association for Gravestone Studies* 17 (2000): 8–31; Joseph J. Inguanti, "Landscapes of Order, Landscapes of Memory: Italian-American Residential Landscapes of the New York Metropolitan Region," *Italian Folk: Vernacular Culture in Italian American Lives*, ed. Joseph Sciorra (New York: Fordham University Press, 2011), 83–106.

15. George Steiner, *After Babel: Aspects of Language and Translation*, 3rd ed. (Oxford: Oxford University Press, 1998), 24.

16. George Kubler, *The Shape of Time: Remarks on the History of Things* (New Haven, CT: Yale University Press, 1962), 2.

17. Impelluso's concisely written and beautifully illustrated work has guided the readings of natural elements in the present article. Lucia Impelluso, *Nature and Its Symbols*, trans. Stephen Sartarelli (Los Angeles: J. P. Getty Museum, 2004).

18. Mirella Levi D'Ancona, *The Garden of the Renaissance: Botanical Symbolism in Italian Painting* (Florence: Leo S. Olschki Editore, 1977), 273–74.

19. A. Bartlett Giamatti, *The Earthly Paradise and the Renaissance Epic* (Princeton, NJ: Princeton University Press, 1966), 11–17.

20. Gianni Venturi, "The *Giardino Segreto* of the Renaissance," *The Architecture of Western Gardens: A Design History from the Renaissance to the Present Day*, ed. Monique Mosser and Georges Teyssot (Cambridge, MA: MIT Press, 1991), 89.

21. William A. Emboden, *Leonardo da Vinci on Plants and Gardens* (Portland, OR: Dioscorides Press, 1987), 44–47.

22. D. Fairchild Ruggles, *Islamic Gardens and Landscapes* (Philadelphia: University of Pennsylvania Press, 2008), 35.

23. John Harvey, *Mediaeval Gardens* (Beaverton, OR: Timber Press, 1981), 48, 44. For a discussion of Norman Palermo as a garden city, see Franco Cardini and Massimo Miglio, *Nostalgia del paradiso: Il giardino medievale* (Rome: Editori Laterza, 2002), 45–56.

24. Several reputable websites recount versions of the tale. One should note that Calabria also lays claim to the setting of the Legend of Mata and Grifone. In Reggio Calabria and other towns of the Capo Vaticano region, dancers dressed as Mata and Grifone perform in the streets.

Website of the Comune di Messina, July 7, 2010, http://www.comune.messina.it/index .php?link=storia/giganti.inc&VARMENU=turismo.

Website of the Associazione Culturale Gruppo folklorico di danza e canti popolari, July 7, 2010,

http://www.mataegrifone.net/laleggenda.htm.

ItaliaPlease Website. July 8, 2010.

http://www.italiaplease.com/eng/megazine/giroditalia/messina/.

Holiday in Calabria Website. January 25 2011, www.holidayincalabria.com/schede .asp?ID=417.

25. Guillaume de Lorris and Jean de Meun, *The Romance of the Rose*, trans. Charles Dahlberg (Princeton, NJ: Princeton University Press, 1971).

26. Elizabeth Barlow Rogers, *Landscape Design: A Cultural and Architectural History* (New York: Harry N. Abrams, 2001), 102.

27. "Tereus," *Encyclopaedia Britannica*. 2009. Encyclopaedia Britannica Online, July 7, 2009, http://www.britannica.com/EBchecked/topic/587903/Tereus.

28. Paul Larivaille, *Sur quelques rossignols de la literature italienne: propositions pour l'étude des bestiaries* (Nanterre: Centre de recherches de langue et literature italiennes, Université Paris-Nanterre, 1975), 11.

29. Giovanni Boccaccio, *The Decameron*, 2nd ed., trans. G. H. McWilliam (London: Penguin Books, 1995), 396–97.

30. Sa'di, *The Gulistan (Rose Garden) By Sády of Sheeráz*, trans. Francis Gladwin (Lucknow: Newal Kishore, 1883), 78.

31. Lucia Tongiorgi Tomasi and Gretchen A. Hirschauer, *The Flowering of Florence: Botanical Art for the Medici* (Washington, DC: National Gallery of Art, 2002), 26.

32. Tomasi and Hirschauer, *The Flowering of Florence*, 70.

33. Gill Saunders, *Picturing Plants: An Analytical History of Botanical Illustration* (Berkeley: University of California Press, 1995), 41–58.

34. Saunders, *Picturing Plants*, 55.

35. These titles and many more appear in Arthur Lotz, *Bibliographie der Modelbücher; beschreibendes Verzeichnis der Stick- und Spitzenmusterbücher des 16 und 17 Jahrhunderts* (Stuttgart: Anton Hierseman, 1963).

36. Both textiles are in the Museum of Fine Arts, Boston. Their acquisition numbers are 38.1162 and 25.547, respectively. These works are reproduced on plates 28, 29, and 64 in Suzanne E. Chapman, *Historic Floral and Animal Designs for Embroiderers and Craftsmen* (New York: Dover, 1977).

37. Sheila Paine, *Embroidered Textiles: Traditional Patterns from Five Continents* (New York: Rizzoli, 1990), 60.

Rebozos/K'uanindik'uecha

2009, Mixed Media
Photograph by Marcia Parrino

—Karen Guancione

In January 2009, the Centro de Formación y Producción Gráfica del Antiguo Colegio Jesuita invited me to a create a series of lithographs in Pátzcuaro, Michoacán, Mexico, as part of a printmaking residency. The center, which was built on the remains of pre-Hispanic pyramids and is housed in a sixteenth-century colonial building, is today the cultural center of Pátzcuaro. It includes printmaking studios, a museum, exhibition space, and folk art collections. A variety of classes are offered under the auspices of the Department of Culture of the State of Michoacán.

Because of the work I had done incorporating printmaking with ex-votos and local handwoven textiles, including *rebozos* (the Mexican shawls used by women), the Centro Cultural Antiguo Colegio Jesuita invited me to create a project that began in the summer of 2009 and was presented to the community later that year. The exhibit remained on view in Pátzcuaro through 2010 and later traveled to Casa de la Cultura Uruapan, Uruapan, Michoacán, Mexico, for the celebration of Domingo de Ramos (Palm Sunday).

For *Rebozos/K'uanindik'uecha* (the title is in Spanish and Pure'pecha, the indigenous language of Michoacán), I worked with master printers, local artisans, and local women who weave and embroider. These women make a living selling handwoven *rebozos* and other needlework garments and decorative items. This project expands upon my ongoing work in communities in the United States and abroad in which I combine women's handwork, sculpture, printmaking, textiles, performance, video, and interdisciplinary art to represent the stories of women workers and immigrants.

Much of my work draws on a family tradition of fine tailoring. Many of my family members, both maternal and paternal, worked in the sewing trades. My large-scale installations often entail sewing nontraditional materials (paper, plastic, and found objects) on my grandmother's industrial

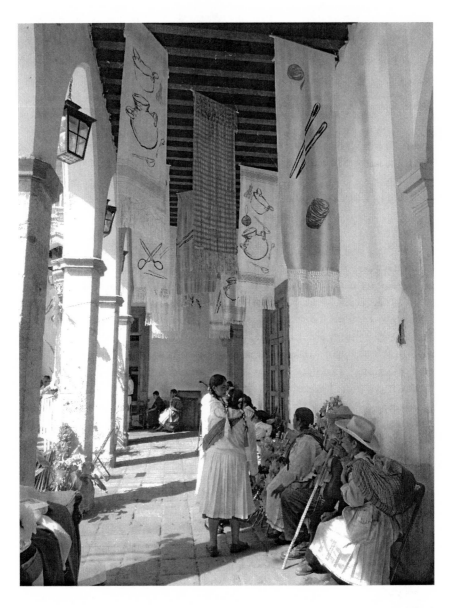

sewing machine from a Newark, New Jersey, coat factory where she worked in the 1940s. I have even worked on this machine in installations and public performances in museum settings.

Rebozos/K'uanindik'uecha is a large-scale, site-specific installation featuring images of domestic objects such as needles, scissors, thimbles, thread, brooms, combs, braids, bobby pins, pots, and cooking utensils silkscreened on flannel cloths, woven rags, and *rebozos*. I also created a video that was

first shown on the night of the opening and that documented the process leading to the installation and valorized the Mexican women and men who became an integral part of the project. Each worker was photographed and mentioned by name. They usually labor anonymously, and public acknowledgment of their work was vital to the spirit of the entire project.

Rebozos/K'uanindik'uecha fills the ground floor of Centro Cultural Antiguo Colegio Jesuita. A large number of silkscreened *rebozos* are suspended and exposed to the light winds that blow in the corridors surrounding a large courtyard. Numerous rows of flannel rags and woven cleaning cloths, also silkscreened with vernacular images of domesticity, hang alongside the *rebozos* like prayer flags or Mexican *papel picado*. While installing the exhibit, I paid careful attention to the environment—the colonial architecture, with its high ceilings, expanses of wooden beams, arches, columns, historic frescos, and large stairway. An antique working loom from the center's permanent collection and my drawings of household objects completed the exhibition.

In addition to the labor of hand-printing, I spent hundreds of hours ironing and heat-setting the images on fabric with the help of workers, students, and friends. The process of the installation involved a team of people who worked tirelessly together. Community involvement in labor-intensive art installations is reflected in all my work. Working with many people in different environments is an integral part of my art, perhaps even the most fulfilling part.

Many of my past installations and performances recognize the repetitive and hidden work often done by immigrants. To explore the questions surrounding women's work and the value placed on labor, I often employ traditional methods such as painstakingly cutting, tearing, sewing, assembling, and disassembling materials; arranging tens of thousands of singular pieces; and methodically reconstructing them. This repetitive process is like those found in piecework and domestic tasks, associations I am able to bring into an art environment. My interest in work that reveals the art of labor and the labor of art emerges out of my immigrant heritage and the old-world skills my forebears brought from Italy. This interest has expanded to reflect a larger concern for contemporary political issues such as immigration, labor, women's work, and ethnicity, as well as issues of identity and class and forms of resistance that challenge injustice and inequity.

Above the Forests of Second Avenue

—Maria Terrone

Her right hand flies up, then plunges down,
the needle between her bony fingers
like a beak that seeks nourishment,
but can't be filled and must rise to try again.

The needle alights on white cotton
as if to sip nectar or peck a seed,
but can't stay for more than a second.
Far across shining seas

of scrubbed linoleum, we sit—nephews,
nieces, cousins—eating the feast she cooked
before we rose. The needle rises
in a blur, veins on the back of her hand

pulsing like a small bird's heart.
We hardly notice when the flowers appear,
stem, leaf, then bud, and how they spread
across the field that ripples on her lap,

down her legs' spindly trellis, over the cracked plain
of a railroad flat five flights above the forests
of Second Avenue, strewn across an ocean,
back to the hills of Lercara Friddi.

Escape

in memory of Michela Marciano

—Paola Corso

1

She came to escape the fire

of Vesuvius, an eruption
that blew off the ring
of its crater, molten fingers
reaching for her village,
a fire that burned for ten days.
Roofs collapsing, lives collapsing
from the weight of ash.

2

She leapt to escape the fire

in a shirtwaist factory
with 288 sewing machines
but only 27 buckets of water
and no way out except
to jump off the window ledge.
An ember falling from the sky,
she left the way she came.

Needle and Thread

—Anne Marie Macari

There was something childlike about the clinging limbs
finding their places in the dark bed; or plantlike, vines
sewing themselves together, a needle and thread
made of skin and hair, sewing, made of breath.
How many lives could go on at once,
superimposed, as when he dreamed and she dreamed
and the green light of the clock kept changing or the stars
kept pulsing—the sex of stars—and she half
woke up and listened for him to see
if he were sleeping and then slipped back
into the stickiness of that other world she could never
wash off, her dreams making fun of her earnest life
and all the death she was trying to escape each night.
In the bed they moved close, then apart, then close again,
night a wall falling on them, one hated the dark,
one loved it, a wall pressing them together, a moist
mortar where skin met skin and penetrated each
in a different way so that he turned toward her
and she wondered if it was innocence
or foolishness that kept her always surprised, throwing
her head back and gasping.

Imagining Grandmother on the Paso Robles Ranch, Year My Father Was Born

—Denise Calvetti Michaels

—Agostina Gonella Bianco
Born: 1887, Montaldo Scarampi, Italy
Died: 1982, Redwood City, California

Looking back, women chat under oak shade,
crochet stars into blankets, blankets into stars.

Stiff as quills, cattails border the walk.
A crow hops away on one foot, tremble-light,
tawny glitter of buff weed birds.

Sun, a matchstick ember, streaks charcoal-gray sky
bronze, copper, dun—colors that glint the palette of arid places.

Hazel wrens sing in the boxwood, ranch hands smell of cow's milk.
Primipara, Agostina lingers, rapt, at the porch rail, settling in

to the good cinema in which she stars, the baby
asleep in the whir of dragonflies, temperature

one hundred degrees Fahrenheit and adobe disappears
like riverbed mirage, abandons crickets, the neutral hues of chameleon.

At twilight the infant's eyes focus and follow his fists
across the midline. Walls burn umber

and the house reappears from its distance with Agostina's reasons
to stay—biscuits-to-bake, oats-to-soak, polenta-to-simmer.

Winter winces by—a dairy, the place water boils,
sunrise a spell in the travail of lambing;
circles of crows, hawks and vultures, finding their zenith.

She warms a bleating newborn in gunny sack near the stove.
Calves arrive—rain roils.
Creeks torrent—chartreuse grasses grow.

When I ask if anything reminds her
of her life before America,
she turns both hands palm-side-up, reveals life-lines—

gullies, really—her gesture to explain
composing the body, a canyon-river, cumulous
crisscross to snag, to open, like reveries in oak shade.

Embroidery

—Phyllis Capello

This line is a red silk thread
and it is stitching a rose on this page
which is white linen.
This line is cornflower-blue and it is making
French knots in the flower patch.
This is yellow for a daisy, a satin stitch.
White for the petals,
one by one.
Wait: I'm not done.

Green for the stem stitches,
(Oriental in their graceful sway.)
My pen is the scissor that snips the threads,
my hand the box where I keep them;
my rhyme is the pattern I follow and work.
the ink is the needle that pierces the page—

Feel the fabric of my poem,
here and there a word sticks out
like a French knot in the middle of the stamen.

The Embroidery Hoop of Mourning

—Tiziana Rinaldi Castro

We had to listen carefully for she spoke softly. It wasn't dawn yet, and the night was the loom of the dead, as she would often say; words would need to be woven forth in a low tone of voice. Her hands were quick, though, and moved knowingly on the cloth, enriching the complex embroidery with each passing stitch.

"Are you sewing a word or a figure this time?" I asked.

The woman I called Mama, her voice vibrant and of a full depth, like the tuba, answered:

"A pattern. What's important is the intention. What goes into it the moment the needle enters the cloth, and again when it pulls the thread to the other side."

"That is where the prayer is formed," Jerome offered, looking at her fingers attentively.

Mama nodded.

"Son, crumble a little more cinnamon in the coffee pot," she told him, "the sick won't sleep much longer, and it's time to awaken this temple."

It was still dark outside; Harlem was asleep, and I regretted her zeal. Nothing was dearer to me than the nights we spent, Mama, Jerome, and I, around the shrines, learning the sacred ways of the *Orishas*, mending the wounded and healing the sick knocking at her door at all hours, and telling one another stories, especially Jerome. He was a born storyteller. Mama used to say that he would keep the dead awake well into the morning.

And praying for one, for two, for three, and a hundred more, all those names listed on her notebook on the table by her white chair, those names steadily turning into embroidered patterns in gold, silver, white, red, blue, green, yellow on cloth white as snow, to be given in the end to the altar, for the gods to read into it the desperate request, and breathe into it if They may, oh if They may, give their assent.

Maybe it was also because neither one of us cared much for sleeping anyway, and, what's worse, alone at home we would have missed each other and

wondered about the other's whereabouts, especially Jerome and I, and I would have phoned Mama, who never quite slept, to ask her how she was faring.

And she would have said:

"Wonderfully. The spirit is quite strong at keeping track of the past, you know, and has a marvelous way of threading stories. Even without Jerome."

Or:

"I have a clear vision of what tomorrow brings, and I am drawing it on my hoop, my little daughter."

Or:

"With a storm like the one we are blessed with tonight, one can only sing."

"Low voice?"

"No, *Dada*, the Spirit and the sick rejoice in strong voices. But what about you, little one?"

"I am thinking about home."

Or:

"I am wondering about Jerome."

And invariably she would answer:

"Tell me."

And I would bundle up my child, get in a taxi, and return to her. And we would start all over again. Mama would teach me her medicine while she embroidered, and I would listen and watch. And we would wait for Jerome and his stories.

I was mesmerized by the movement of her hands, the dance of her fingers on the cotton and how quickly the pattern would form. I felt the force behind it. It vibrated. And then she put it in my hands for me to place it on the altar for the gods to bless. I felt that, even without the benediction of the gods, it was charged with the force of healing. But Mama warned:

"No medicine works on its own; it is a false hope that healing comes from outside. You need to want to heal or you'll just get sick again in some other part of your body."

"But in that case, both your embroidery and the blessing of the gods are useless."

"We can hope that the sick person has reached this shrine with a conscious purpose. The gods take due note of that resolve and protect its intention."

I nodded. Still, what I liked the most was to practice with the herbs and make concoctions in her kitchen. Smell, choose, smash, chant on it, chew, pound, pray on it, then boil. Call the things with their secret names, make them come to you. *Witch it*. That is, bend it. Pull the curve of nature's will unto you.

"I came here to become a witch, Mama, and you put a needle and a thread in my hands?"

Like my grandmother Teresa. A smirk appeared on Mama's face.

"A needle and a thread could stitch the pattern of a spell too, Dada, if that's what you want."

I would nod, unconvinced.

"*Dada!*" she would gently reproach me. Dada, curly one, in Yorùbá language. My grandmother called me "*ricciolina.*" It means the same thing.

I was a lucky child. All the way from the south of Italy just a few months before, where, as a child, I had heard my grandmother speak to the dead while bent over her sewing machine, I was not on foreign ground. I had ventured out of a world of ties between the earth and the sky, through the dead and the saints, the angels and the Virgin Lady, into one in which the *Orishas* made their covenants with humans in a vibrating dialogue made of dance and divination, poetry and philosophy. And magic. My eighty-seven-year-old Bajan godmother and my twenty-nine-year-old Cuban *hermano* Jerome connected me with my severed umbilical cord.

The only thing my grandmother had managed to see me stitch onto anything had been the patches with the faces of Jimi Hendrix and Che Guevara on my jeans.

My grandmother was a seamstress by trade and could have taught me to sew. She no longer worked for customers when she raised us in my parents' house. My mother would have not allowed it. Still, every sheet, tablecloth, and towel were sewn by her. Even the kitchen rags. Cut from solid linen, they lasted throughout my youth and into my daughters'.

During World War II and throughout her children's youth, my grandmother had sewn to keep her family alive. She had lost her husband to consumption in 1942 and had to raise her children by herself. She had sent my mother to study law at the University of Rome. Stitch after stitch, she had made sure her daughter would become a lawyer at a time in which, in the south of Italy, women rarely studied, and when they did, it was mainly to become nurses or teachers.

My mother had chosen a more masculine road. She had chosen freedom, independence, and she had taught us, her children, to do the same. And yet despite, or because of, my mother's choice, here I was, across the ocean, in Harlem, contemplating the possibility of stitching salvation on white cotton, in a mysterious language, through ways my mother would consider arcane and backward, violations of that secularism she had so painstakingly taught us.

But Mama, as my mother and my grandmother before her, respected me and left me in her kitchen, concocting medicine and witchcraft with herbs and incantations.

"Listen to the vibration of the plants, listen to their intention. Make sure they meet with yours to sing the same song. Or nothing will come to be."

Then one night Jerome came into the temple gushing blood from a half-moon cut into his palm. Mama asked him to unload his gun before the altar and me to hand her the surgical thread and the semicircular needle for sutures.

My hands were trembling when I cleaned his wound and washed it with the yarrow root to stanch the blood. We sat by Mama's feet. Jerome opened his palm on a white towel over my legs. I looked up at Mama in disbelief. Was she going to give it to me? Mama was staring into my eyes, the needle between her fingers. I looked at Jerome and he was calm, waiting. My hands stopped trembling, I took the needle and I began. It didn't seem so different from when I had sewn a rip that had opened in the sleeve of a suede jacket my father had brought back from Barcelona. One night, when I was fifteen and still in Italy, I had stolen it from his closet to wear at a party.

I was afraid I would hurt him, but I didn't. Miraculously, or maybe because the touch of love is lighter.

Yet he had had one moment of insecurity. Looking at the needle moving closer to his palm, he stiffened and asked me if he could drink some whiskey.

"We ain't in a John Wayne movie, *chulo*! If you drink, you'll bleed even more," I had said, smiling at him, and then placed a bit of the analgesic paste into the side of his mouth. It was made with poppy straw. Mama prepared it every day for her patients.

Soon he fell asleep against her legs, the needle still in the flesh.

A freedom fighter in the Salvadorian revolution, which he foraged with weapons, Jerome had unwittingly been responsible for the murders of his wife and child four years before. It had been a warning to him: "Get out of this business or we will cut you down."

But those who killed Marta and little Geronimo didn't realize that they had already cut my *hermano* down. His life force drained from him, Jerome didn't have anything else to lose and nothing to live for. *I did what any man from whom they tore his life apart would do. I took justice in my own hands.* After hiding for eight months in Georgia to let things cool down, he returned to New York and became the most ferocious weapons dealer that New York had known at the end of the eighties. He also learned that he had a conscience, one on which he had not counted when sorrow and hate had demanded that he turn into a cold-blooded killer. Now it made just as urgent demands on him. He came to the temple then and, as other disciples would later tell me, looked Mama straight in the eyes and said in his husky voice:

"My life is ending soon. It can't be undone. I made sure of it. Teach me to die with awareness. It is all I ask."

And Mama, who was smoking her cigar, passed it to him and nodded.

When I met them, three years after this encounter, Jerome was still mourning, and though he didn't resist falling in love with me, he made it clear that we could never really be together. Crushed by his guilt and afraid for my life, he spent most of his energies protecting me from himself. To this day this is the only thing I can't forgive him. Notwithstanding his stubborn resolution, our intense, exhilarating relationship earned us the nickname of "*los inseparables.*" In the three years we spent together in Mama's temple we learned the things that I am most grateful I know: how to pray, how to thank, how to listen.

One day Mama died. She was ninety years old and went peacefully. We mourned her bitterly. She had devoted her life to her disciples and, without her, we felt uprooted. We had her testament, as simple and as demanding as any discipline: "Make your life a prayer." So, we set out to live it.

A year later Jerome was killed. Far away, in Lima, Peru. Shot in the face by the police. Unrecognizable if not for a scar on his right shoulder, a mole on his belly, and that half-moon that I had sewn on the palm of his left hand.

My world was not shattered. It wasn't destroyed. It didn't crumble.

But it all got quiet, dark, empty. No words could be spoken of him and his death. I could not make myself pronounce his name or shed a single tear.

I could not sleep.

I could not dream.

What I could do and did was clench my teeth and pray to the *Orishas*, thank the *Orishas,* and listen to *Them.* My mourning folded into the back of my heart. It was the fabric of my present, though I refused to stitch anything on that white cloth, I refused to draw any pattern.

To the world that did not know of Jerome I was a perfectly adjusted woman with a knack for storytelling. A little melancholic, maybe.

Someone came and opened his arms to me and I to him, and another daughter was born, and a month later my grandmother died and her death touched me, but I kept quiet. My mother said:

"It is harder than I thought." And I listened to her but I was unable to comfort her. It is deep and scandalous what light we can make of someone's hell when we haven't stepped into an equal one yet. I still had my mother.

I took my girls and followed my husband to Colorado.

We lived at the foot of two volcanoes. The people of the land, the Jicarilla Apaches, called it the Wahatoya, the Breasts of Mother Earth, a fiery and harsh bosom.

And it was within that landscape that I ended up sewing the most endearing coat for the winter of my soul. Its ferociousness felt like my pain.

Nothing of the sweetness and the generosity of my native land greeted me here in the morning. It seemed as if this forest was taking more than it gave: Every storm—wind, rain, snow—left destruction and emptiness in its wake. That, and the extreme vicinity of wildlife, resounded with my unspoken mourning. When its force would have the best of me, I would walk up the ridges on any side of my house and give in to it. I would push my pain uphill, one step into the next, needles into my heart, the silence into my throat finally composing into a moaning that would scatter the birds, scare the animals away. Digging into the ground with my feet, with my nails, with my mouth, I would walk and walk, and not a word would help me, all thoughts broken threads, unfinished stitches—a pattern of misery in the embroidering of pain. My life was undone on a tattering fabric, and I was tearing it with my own hands. I was a widow and yet I was married. I was brokenhearted and yet I loved my husband. I told a charming story of my life by the fire every night and yet I hid a wordless hell inside every day.

One afternoon I went down the hill to help my dear friends prepare a sweat lodge at their house.

They asked me to make tobacco ties as offerings for the fire. The lady of the house put yards of red cloth and a pair of scissors on my lap. It was easy: All I had to do was cut little squares of fabric to hold the tobacco in a bundle and narrow strips to secure the pouch. But when I had cut all the squares, I could not resist offering my prayers. I went into the house to ask her for a spool of red thread and a needle, and permission to sew the cloth into little bags.

"Tobacco pouches instead of ties, so that I can pray upon them," I explained.

"But they are hundreds!" she observed.

"I have hours before they are needed and I'm fast. Not good, but fast," I said. She smiled and frowned at once, as she did when she looked upon the mess our little children left on the kitchen table after finishing their artwork. She was always gracious with me, revealing with her kind ways her compassion for my estrangement. She knew I felt alone. She gave me her sewing kit.

And so, sitting on a large stone by the fire in the middle of the field, I began. Quickly moving the needle in and out of the cloth with an intention as clear and pure as Mama would have wanted me to have.

"I pray that your time be light as the time of dawn, a time of promise, of that certitude that is true of all beginnings, when the sun is coming for the loser as for the winner and for those who deal in hope.

"And I pray that your heart be open when you unfold in the direction of the world each day.

"And that when you go look for the Spirit, you don't go further than your soul, at the center of yourself. And I pray that you do realize that you won't find it on any road if you yourself don't become the road.

"And I pray for your future and that the path of your children might be as clear and sensible as the flight of the butterfly, and as giving as the cup of the flower that quenches the thirst of the bee knowing not of what gift is about to be the giver for the bee, herself the giver of the honey.

"And I pray for your love, that it might always keep your side, for you are never so fortunate as when you are left alone, only when you ask for it.

"And I pray that the spirit of illness convinces you to part from it, that you can do without it, that you have learned enough from it, and that the time has come that you can resume walking without its help. That strength is at the door instead, waiting to take its place.

"And I pray that the distance between you and me be reduced as the gap between the bottom of this pouch and its mouth while my needle closes its side one eighth of an inch at a time. So that we can be one when we need to be of one."

And so it was that stitch after stitch I prayed for one thing and another while the evening grew deep and the sky starry and vibrant.

And while the sweat lodge was being prepared, all gathered around the fire, which grew strong with our hopes and our prayers. And those who had a heavy heart came forth and sighed, and those who were worried came forth and prayed. And those who were confused came forth and asked questions. And those who were grateful came forth and thanked.

When the tobacco pouches were ready, I looked into the basket: I had sewn close to fifty bags. Each of them was different because I can't stitch straight. None were precisely rectangular or square. A few were almost triangular. I laughed. Just then I felt somebody over my shoulder and I heard a deep male voice exclaim:

"How pretty!"

The voice chuckled. An enormous hand plunged into the basket and disappeared beneath the bags only to reemerge with half a dozen of them gathered in the big palm.

"May the Great Spirit bless you, sister! These are medicine pouches! How many did you sew! I have seen you curved on that cloth for hours."

I looked up and saw a giant with a moon face of clay crowned by silver hair and smiling the gentlest smile.

"And did you pray for each one of them?"

"Certainly," I answered shyly, pointing to the one he was holding between his thumb and his middle finger, which had a bulky corner where the thread had jammed and I had pulled, creating a crease that I had not been able to flatten. I said: "That one is for opening the heart."

"Oh, then I know who needs it," and turning to the crowd, he summoned: "Angelica!"

A young woman with a moon clay face similar to the giant's came forward. She had shiny black hair like the shawl of the western sky. He gave her the bag.

"Fill it up and offer it to the fire. You know what to pray for."

He winked. And the girl's face opened up in a smile like she was seven. And I swear I thought I could see her then, when she had been a little girl, missing a couple of front teeth and her dad had given her candies or permission to go to the circus.

The giant was her uncle, I found out later, and he was wishing her good luck with the boy who had stolen her heart.

"And this one?" he asked again, fishing for one larger than the others. I nodded. I remembered well.

"On that one I prayed for one who might need more time on earth to finish difficult tasks."

He looked around, searching the crowd.

"Martinez," he called. A man leaning on a cane turned slowly in our direction and looked at the giant without smiling. But in that stern expression, in those deep furrows, I could see the traces of the joy that had once been there. The giant walked toward him and gave him the bag. Martinez nodded, lightly beat his heart with his palm, and accepted it.

Then the giant returned to me and pointed to another pouch.

"A mother whose child needs more than she can give," I said.

"Ahi, sister. I do hope you have a lot of those."

"I have, brother, I have," I said. He smiled.

"Then you will give those away yourself."

"Yes, I will."

"And this one?"

"For one who might have to walk a very dangerous road very soon."

He looked at me straight in the eyes, and put it in his pocket.

"And this one?" he asked, taking another.

"For one who is very ill and needs to fight death."

"How many do you have of these, sister?"

"Four."

"Very well. Give them to me." I went into the basket to look for them.

"Carlos!" he called and Carlos came, a young man with a long ponytail in the back of his head and hair cut very short on the sides of his face. I handed him the bags.

"Bring these to Mauricio, Andreas, Francisco, and Ana," the giant instructed. And Carlos nodded and left.

"And this one?" he asked, pulling another.

It was a half-moon. Truly pretty and an almost perfect shape, as if I had cut a semicircle in the fabric on purpose. Instead, as the others, it had started as a square. But as I was praying on it, I had moved the needle too deep inside and found myself having to decide whether to pull the thread on two sides and sew it again, or simply cut around the seam. I opted for the latter and it became a half-moon.

"To forget, to let go, to move on."

He took the basket from my hand and put it back on the stone on which I had been sitting.

"Then this one is for you, sister."

I trembled and looked away. My eyes met the ridge at the end of the valley where the moon was shining through the birch trees on the top. I was stunned as if ten bees had just stung me. And I could not breathe. I felt him as he opened my hand and put the pouch in my palm. He closed it into a fist and surrounded it with his.

"We are not alone, sister. The Spirit is with us," he said in a quiet voice. "I can go into danger protected, and you can let go of your pain without fear."

My body quivered. I felt about to fall but the giant hugged me and kept me on my feet. I looked up at the sky. I had never seen so many stars. My heart filled with sorrow. Didn't Jerome have any pity on my children who lived with a mother who never smiled? Didn't he see that I was living a quiet death? I begged him to come back to visit just for a little while, that very night, when we were all there and nobody would have noticed another person in the crowd. And if he did, I promised, I would let go.

All the others around the fire called us and we went.

I distributed the pouches to the mothers with difficult children and everyone else took one from the basket and stuffed it with tobacco. The prayer became deep. Some sobbed and some whispered, and some hummed, and some sang in a low voice into their cupped hands.

And then one by one they threw the pouches into the fire. And the giant and I did the same.

Then many went to the sweat lodge to pray, and I stayed by the fire to prepare the food with the women and trade stories and songs with the elders and the children. And when hours later they came back, they were sweaty and touched by the Spirit. And they were beautiful. And we thanked and we ate and then we played the drums and we sang and traded more stories. And we were happy and grateful.

The night slowly moved aside for dusk to sit with us by the fire. And we were tired from talking and singing and we grew quiet.

I looked up at the breasts of Our Mother, as immense as the chest of God, and then I looked at all the people circling the fire. The drums set to rest, the

children asleep on their mother's bosom, the older kids retired inside the trucks and into the tepees, and the new energy of the day slowly crackling in. The big pot of water brought on the old fire, revived for coffee. Nobody spoke full sentences, but the old ladies whispered a couple of orders to the young men and women already awake. Reluctantly they let go of their *serape* and went ahead with it.

It wasn't my land, I thought. I was so far away from home. All things are borrowed for a while, and this turtle island, as they called it there, had grown inside my heart. Now I didn't have another home.

I went for a walk, following the line of birch trees that curved at the summit of the ridge where the night had furled its mantle, covering the face of the moon a couple of hours before, and took all hope with it that I would ever see Jerome again. I knew that it was up to me to smile again for my children.

When I sat on the top of the ridge and looked down at the camp and all the people around the fire, I saw a circle of color. It looked just like an embroidery hoop. And that line on the left, of people lining up for breakfast with their *serape* still on their back, were but a thread into a needle waiting to be embroidered onto the cloth and into a prayer.

Years before, on the way back to New York from a trip to the West, where we had known each other more intimately, looking into the Atlantic Ocean, Jerome had said:

"Love is the rarest gift in life and needs to be guarded. To destroy it is a crime. It can be committed but once in a lifetime."

He had been referring to his wife and child. As always, I had felt powerless before his wound, a rock I could not climb, a rock that could never crumble. He read into my mind:

"No, *querida*. In the end, even an implacable mourning quiets down, no matter how fiercely you try to keep it alive. Your love is the bridgehead of my life, the reason to accept that at last I live again." And holding my hand tight, he said: "I MUST live again."

Somewhere in that crowd were my two little daughters and my husband. I loved them. And though I hadn't quite grasped then that I had to learn to "lower my head before his death with a humility that should be equal to the gratitude for his life," as a good friend would tell me twenty years after Jerome's passing, I did know that I had to make space inside myself for life. Jerome himself was asking me to. He had done it for me; I had to do it for them.

And I did it, the best I could. But some wounds cannot be stitched, no matter how strong the suture thread and the surgical needle. I ended up living the way most people who have lost the world do: with an open hole into the heart. I learned to laugh again, and in a precious and secret way that

I know Jerome would have understood, I lived for two, for him and for me, to continue in the tradition of *"los inseparables,"* living with joy and compassion and a natural salve spread onto the wound. No poppy straws there, though, no hope to put it to sleep. I didn't want to either.

Last year, the day after my mother's funeral in Italy, I noticed my twenty-five-year-old daughter drying the dishes with one of those kitchen rags my grandmother had sewn. I sat down, bewildered. Out of the blue depths of memory my grandmother had reemerged one summer day of forty years before, wetting stiff, candid, spotless yards of white-and-red ticking fabric she had just brought from the market, in a tin tub in the garden of my parents' house. I was five then.

My daughter asked me if I was OK and, of course, I wasn't. My mother had just died; I was grappling with winds ravenous and unyielding. But mourning and I were as acquainted as a sailor with its boat. What I had to do now was to unfurl the sails and steer into the eye of the storm. They would not shred or break. I had sewn them myself for the past twenty years with all that I knew. My grandmother had taught me how, with her dedication, and my mother with her determination, Mama with her spirituality, Jerome with his selflessness, my daughters with their love, my husband with his trust, and Mother Nature at the foot of the Wahatoya, in Colorado, with her ravishing storms, her unforgiving winters, her gentle beauty come spring, when as late as May, the snow melts into a rolling stream by the south side of my house, after uncovering patches of green fields all around, which fills with the prettiest, minute purple flowers. And then the ice would break on the surface of the deep silver pond, where the wild geese would land again to drink and bathe.

"This is going to be a hard one," I told my daughter. She nodded. She was grieving, too. She dried the last dishes. When it was time to put the old rag away, she looked at it intently. I was afraid she was going to tell me that it was time to retire it. I was never going to allow it, unless we should fold it, pray on it, and offer it to a fire that we would light for that very purpose. I asked for it back. She gave it to me, puzzled.

"It's dirty," I explained, "it goes in the washer." And I took it in the laundry room. I put it in a little basin and washed it by hand, using the Marseilles soap bar for delicate items. Then I brought it into the garden and lay it out to dry in the sun.

LOST,
DISCARDED,
RECLAIMED

Bachelor, Lace, Butch, Trousseau

—Annie Rachele Lanzillotto

"Stai zeet? Stai zeet? Perchè no maritt?" is a line of questioning that greeted me in my grandmother's town, Acquaviva delle Fonti, upon every visit in my twenties and thirties. Getting assailed in this way by Zia Filumena was my least favorite part of being there and the reason I had to leave, every time.

"*Are you engaged? Are you engaged? Why aren't you married?*" my Sicilian editor Edvige Giunta e-mails me the translation.

"No," I protest. "*Are you married? Are you married? Why no husband?*" I know what my Zia Filumena was telling me, and what she was implying— *why are you traveling around the world without a man by your side. Why no husband—a woman alone is no good."*

"It doesn't say all that," Giunta writes back, "the word *zita* is interesting. It means engaged, while *zitella* means spinster. Also *maritarsi* has its root in *marito*: husband."

"Barese is twisted," I write Giunta. And of course, the hands fill in where the words leave off. The meaning is made in between words and hands. I can still see Zia Filumena's fingers kneading the air while she poked me about the reason behind my marital status. Now I had two arguments in my head, one with my Barese aunt about my relationship to men, and one with my Sicilian editor about dialect and meaning, and what really transpired between my aunt and me, Acquaviva and me.

I had one other unmarried female cousin in the town, not just unmarried, but somehow beyond being with a man. Giusy was my age and lived with her parents in a three-story marble building built by her father and grand-father. Her brother lived upstairs with his wife and kids. I thought she might be a lesbian, but I couldn't decipher her sexuality or the tragedy, perceived by her family, that she was clearly on her way to becoming one of the barren old spinsters in Acquaviva, still a role the town despised.

My first trip to Acquaviva was in 1986: I had a *Silence = Death* Act-Up T-shirt, black with a large pink triangle, but I wouldn't wear it in Acquaviva, not for meeting my aunts and uncles and cousins whom my family had been

separated from by the Atlantic Ocean since 1919. I wasn't going to march into town with my gay flag raised. I didn't feel my life mattered. I aimed on reuniting our family. Over the years I traveled with various lesbian lovers to Acquaviva; but I was never *out* in Acquaviva. That was an ocean I wasn't ready to cross.

Giusy had a deep laugh barbed with a manic darkness that kept me at a distance. Her laugh had spikes in it. It reminded me of my insane relatives this side of the Atlantic. For the last decade of his life, my father had been in a mental home in Babylon, New York, with PTSD and paranoid schizophrenia. His sister was a paranoid schizophrenic who practically lived at the Port Authority Bus Terminal; that's where I would go to visit her: my aunt Apollonia, the Donut Visionary. At the end of my father's life, he said to me, "Look what kind of woman you've become, you're just like your aunt Bella." Bella is what they called Apollonia. What I know of her denouement into mental illness is a scant list of plot points. Apollonia was the family beauty. She carried her cup of coffee in the street when everyone else stayed home to drink their coffee. According to my mother, carrying your coffee in the street was a radical act for a Bronx Italian woman in the post–World War II years. "I carry my coffee, baby, I carry my coffee. In the street where it's sweet," is the lyric that swims in my head when I sing of Apollonia. She didn't say those words. I sing them.

Apollonia had a vision: She opened Johnny's Donuts, named after her adopted son, in the Morris Park train station at 180th Street. Johnny's Donuts preceded Dunkin' Donuts. My mother reports that everyone in the family said this would never catch on, that people had their morning coffee *a casa*, but Aunt Apollonia insisted that New Yorkers would learn to grab a coffee and donut on their way to work. She believed it would catch on. "Unheard of back then," my mother reports. Her husband, Uncle Tony, a war hero who had seen hard combat in World War II and suffered from PTSD, hung himself by a strap from a pipe in the kitchen of the donut shop.

Every time I drink a coffee in a Dunkin' Donuts I think—this could have been Johnny's Donuts—Aunt Apollonia's ambitious groundbreaking vision, and my stomach tightens with all the lost potential of my aunt's American dream. I think of Cat Stevens's lyric, "for you may still be here tomorrow but your dreams may not," and I hammer away at my artistic visions and manifest as many as possible, for me, and for the collective lost dreams of my *paesane*.

Apollonia reinvented herself, getting a job as a crossing guard with the 42nd Police Precinct in the Bronx. She became obsessed with taking photos of cops, patrolling and reporting their activities.

Nights, my cousin Giusy would don high heels, tight dark pants, and dark shirts with iridescent patterns for the evening *passeggiata*. She invited me on these walks in the town square, where the local kids our age would lean against a stone wall, smoke cigarettes, laugh, and flirt. On these walks, I met the youth my cousins, except for Giusy, had intimate interests in. My other cousins, younger and older, met their mates this way, on the local streets. Years later, when various cousins mailed me wedding photos, I was glad that I'd met, when we were young, the cute ponytailed boy Fabrizio who pulled up on a Vespa, or the shy girl with the black-cherry eyes, Lucia, whom my cousin pursued outside the church on the *murge*. They would become my cousins-in-law, and their children's names are now the names I pass on to my nieces and nephews on Facebook.

Me, I didn't procreate.

Procreation was something I grew up thinking God would take care of, almost without me knowing about it, and I left it in his, yes, *his* hands. One day in my late forties I realized I was going through menopause and realized this part of life was now, all of a sudden, on its hinges, slamming shut and sealed behind me. In menopause I looked back over the lifespan of my eggs and my early idea of who I would grow to become: When I was eighteen, my ovaries had been "laterally transposed"—stapled off to the side, out of the field of external beam radiation, to protect them during my first cancer. From the time I was three or four, I had been very aware of older bachelors, men who would visit our house alone, sit at our table, eat with our family, talk of their travels and their nieces and nephews. They clearly floated from house to house, *paesan* to *paesan*, visiting and staying for dinner, bringing gifts and entertaining stories of adventure. They did philanthropic volunteer work. I felt a kinship with their freedom and unattachedness. I knew in my gut by the time I was twelve that I would become one of these bachelor troubadours, sitting at the tables of extended family, regaling everyone with stories and songs of international adventures, doing favors to help people, and never having a table of my own filled with my children to come home to. I would have lovers. I would have protégés. Would have dogs. I would never give my dogs people's names.

Acquaviva delle Fonti, Bari Province, 1986

On my first venture to Acquaviva, I felt a compulsion to buy a lace table-cloth for every member of my family back in the States. At the time, lace was made by hand by the women in the town who crocheted endless circles

and webbing with tiny metal hooks and connected the circles into large patterns that dazzled me. The message was clear: Life itself had some grand design. I knew I'd never have the patience or presence of mind or dexterity of fingers to create what they did. The place in my brain to hook white cotton had deteriorated—I was sure of it. I am American and lucky to get up off the couch. A *paesana* of mine, Gina, has lain on her couch for three years straight; an aide comes twice a day to lift her to the bath. Another brilliant *paesana*, Amelia, who first introduced me to the writings of Flannery O'Connor, spent the better part of her last twenty years on a day-bed sofa. "If I only had a *balcone*, like in Italy," she used to say. I am determined to resist the gravity and isolation of my body to the couch, though with the passing years I realize the sickbed and the couch have claimed my body for far too many hours. I am determined to wake up every day, take my blue pill, and create my visions. Damn all else. This particular blue pill is Thyroxin. Without a thyroid gland, taken after my second bout with cancer, if I don't take the blue pill, I will slowly come to a complete halt, like a wind-up toy. The blue pill is my morning wind-up.

Lace called to me. I stood at the outdoor market, squeezing my brain to picture the dinner table of my sister, and my mother, back in New York. My mother's maple table was a large oval; my sister had a rectangular table. I closed my eyes and counted how many people could fit around each with the leaves inserted to approximate the sizes of lace I needed. The vendor opened many lace tablecloths for me under the Saturday morning sun and my Zia Filumena quickly separated the handmade from machine-made lace and sternly haggled the prices. She quickly threw some aside with a rejecting swipe of the hand. I couldn't tell the difference between the handmade and machine-made lace. Zia Filumena brought it closer to my eye, turned it upside down, and showed me the difference. I still couldn't see it, but I knew inside that if she knew I was a lesbian, I too would be swept to the side like a piece of machine-made lace.

Zia Filumena was a quick talker. I couldn't keep up with her commentary. She wanted me to make up my mind and not buy too much. When I reached into my Caucasian-colored money belt for my greenback dollars, she told me to put them away. She wanted to pay in lire, and get a better price. For myself, I found a round lace. I had no table, but found comfort in round. One day I would have a table, and the lace from my grandmother's town would hold us—whoever us would be. My dogs would sit on chairs at the table, if need be. The lace from grandma's town would weave all our tables into one big web. The pattern I chose for myself began with one central rosette and built out concentrically, eight petals surrounding the rosette, then twenty-one rosettes forming a perimeter of the circle, and variations

on and on, with thousands of interstitial stitches. I could see that this work could have been built in an infinite radial pattern outward, if there were only enough hands to collaborate. But this tablecloth stayed in a human proportion. It is finished in a scalloped edge to fall over the thighs around the table.

On my way back to New York, I stopped in Firenze, where I bought a giant lace, nine yards, with heart shapes. "*Auguri,*" the man at the market shouted in a congratulatory tone. As I walked away, I realized the lace vendor had concluded that I was getting married. Why else buy all this heart-patterned lace? His intonation was surprising. It was the exact opposite of the biting, "*Stai zeet! Stai zeet! Perchè no maritt!*" I didn't know what I would do with the giant lace, or if I would ever have the heart to cut it to make into something functional, but I was sure of one thing: No one had ever been so happy for me in all my life as the lace vendor who thought I was engaged to be married.

Brooklyn, New York, 1996

Trash nights were Fridays in my Park Slope neighborhood. One Friday night on a dog walk with my mutts, Scaramooch and Cherub, I found a discarded heavy wood round tabletop on 6th Avenue off 1st Street. The trash gods were good to us. I lived with my lover, Audrey Kindred. We were proud to have furnished our three-room railroad apartment with great throwaways: butcher-block cabinets on wheels, a wooden bureau of Madonna-robe blue with gold stars like a painting of The Annunciation. The treasures of the streets in the Friday-night flow of trash were endless. I made bookshelves out of two hardwood staircases I paid guys to drag up the three flights of steps into our apartment. These I turned upside-down and finished with one-inch moldings serving as railings to hold my books on the perfect slant so that I could read the titles on the spines. Down 6th Avenue and up the Carroll Street hill I rolled the round tabletop home like a giant wheel, wearing my black motorcycle gloves that I used on trash-hunting expeditions. The edge of the table had grooves, like a quarter. It rolled through dog feces on the sidewalk. I kept walking. That's what life was about—walking through the shit, then purifying yourself when you got home. I scrubbed the tabletop with bleach, then gave the entire slab three coats of white paint, making it clean and sterile. As I whitewashed the table, I thought back to a job I had when I was twenty-two and traveling in Greece. I was at the port, trying to get a boat back to Bari to see my cousins, when a lady grabbed me at the port. "Are you American? I hear there's an American here. I need workers. Greeks are lazy. You're not getting off this island. You're working for me."

And that's how I became a cook in Greece, on the island of Mykonos. One of the things I learned was the weekly ritual of whitewashing the streets. Every Friday, before sundown, the entire town whitewashed the streets around the paving stones. Everyone had their own bucket of thick white paint and a brush and would paint outside their home or shop. Painting the streets white was such a counterpoint to how I grew up in the asphalt-laden Bronx, where more black tar was poured and leveled for every street problem. The elders on Mykonos told me that whitewashing began ages ago as a sanitation practice against plagues. By the time I got there, the white streets highlighted the leatherwork of the tourists' sandals. No matter what this round wooden tabletop had gone through, painting it white made me feel safe. All would be clean. I screwed a wooden base to the underside and *ecco qua*—here, *finalmente*, was my round table to hold the lace from Acquaviva. Now I was Lancelot at my own Round Table. Lanzillotto, *Lancillotto*.

I put a protective layer of plastic over the lace, copying my mother's ways: A plastic shower curtain with the loops cut off is the cheapest way to go. This was the table of my dreams. The Statue of Liberty, every night illuminated outside our window, seemed to be a small green candle on the edge of my *tavola*. I was always connected with Acquaviva, through the lace, through the Lady of Liberty. I slept on a pillowcase made from a flour sack from which my grandmother had, decades before, bleached the lettering off.

Audrey and I took the giant heart-patterned lace onto the stage. We got ten people to help us hold it, and we shook it and sang. At Ellis Island, as part of artist B. Amore's exhibition "Life line," we organized a performance tableau with the women of the "CIAW: Collective of Italian American Women." We had passers-by hold it, shake it, and sing of their grandmothers, riffing off a line I made up: "My grandmother's heart is as big as the ocean." The heart lace was holding all our stories.

Providence, Rhode Island, 1981

I had arrived at Brown University with a red-white-and-blue basketball tucked under my arm and, unbeknown to me, a basketball-size tumor in my ribcage. All I knew was that I couldn't run down the court or get the ball into the hoop as I used to. These were my biggest symptoms. By Christmas, I was bifurcated surgically from sternum to pubis with a laparotomy and, by the next Halloween, opened laterally with a thoracotomy from angel wing to breast around the underside of the left sixth rib. "Nerves don't run on the underside of the ribs," Dr. Martini explained. That year, in between those surgeries, I went through sixteen different chemotherapeutic agents and 4,000

external beam rads. I remember telephoning my mother on late rainy Providence nights from a phone booth on Thayer Street with, intermittently, either of two proclamations. The gist of the first set of phone calls was that I was ready to commit suicide. In the second set of calls I announced that I was ready to become a nun. To the latter, she replied, "I always knew." In response to the former, she would call and awaken my therapist who ran the support group "Teenagers with Terminal Illness" at Rhode Island Hospital and insist on talking with one of my housemates who pledged to see me through the night and call her in the morning. By junior year, when I allowed myself to fully be a lesbian, both of these types of midnight calls to my mother stopped.

The first woman I kissed was a senior athlete, aptly named Gale, matching the maelstrom I felt inside me at the time. Gale had a waterbed down in Fox Point. Sleeping at her house and buying Portuguese sweet bread in the morning became my greatest pleasures in Providence. There's a photo of Gale visiting me at Sloan-Kettering with her feet up on the chair and sporty stripes down the sides of her sweatpants. Six months out of Sloan-Kettering I found myself in her heated waterbed. Making out in a waterbed for the first time posed enough challenges. Tasting a woman for the first time and feeling how female bodies move differently from men, without one protruding focus, together with the sucking motion of the water, was too much for me all at once. The lapping, churning water approximated what was going on inside my gut. I dove in. The water shaped around us like a third lover. We drank vodka. Gale got on top of me and I punched her. That's how I expressed love, with a punch. In my life as a virgin, punches, shoves, choke holds, and wrestling were the only acceptable ways I could touch girls, and on my softball teams, that's what we did: We rough-housed. Finally, when a woman was on top of me, in a sex act, my first natural reflex was to punch. One punch, turned to wrestling, turned to hugging and making out full body, on top of a giant hot water bottle.

Throughout my life, my father continually pulled magnets out of his pockets and showed me the powers of reverse magnetism. When you flip one polarity, two magnets that at first held each other at a distance, now lurch together; flip again and the force field stops you—you push and push, but the magnets will resist at that invisible thick wall and one will flip. This is what I felt, for the first time in my life, with a woman on top of me: The magnet had flipped and that barrier I was accustomed to feeling with guys was gone. My Catholic fear of sex turned into a fear of Saint Paul, who wrote about homosexuals, "the earth will spit you up." But this fear was not nearly as strong as the immense pull of my body to another female body.

Gale's sheets pulled off the waterbed, and my legs felt the rubber of the warm water bladder against my skin. The bed with her in it was a charged

magnetic field I was sucked into; the world was a giant vagina sucking in the galaxy and me along with it. Suddenly, I had an insight into the Bermuda Triangle, though I cannot for the life of me put words to the thought: It had to do with suction and not protrusion being the life force of the universe.

Teaneck, New Jersey, 2003

Edvige Giunta took me up to her bedroom to show me a great oak box with the linens that was her dowry, her trousseau, and when she opened the box, a tidal force of emotion hit me, the force of a lineage of generations of women who made things by hand to prepare the tables and beds of the next generation, women who would create the next generation of souls.

In 1995 I did a performance project at the Arthur Avenue Retail Market, where, for the first time, I worked with Italian Americans. But even for this project, none of my collaborators were Italian. I was not interested. And no Italian ever asked me to collaborate with them either. Not that I remember. I had a Russian pianist and an Argentinean set designer and a WASP choreographer, and an African American lyric soprano to sing the arias, even when I was creating the most Italian American project of my life. It was during this project that I met Joseph Sciorra. Shortly thereafter I heard Edvige Giunta perform at a poetry reading. Both of these people, coeditors of this volume, had not yet met, and both would become great organizers for the Italian and Italian American community of writers, scholars, and artists. I remember sitting at a meeting of the Collective of Italian American Women organized by Edvige and psychologist Elizabeth Messina, sometime in the late 1990s, in New York City, and writing Joseph Sciorra's name and number on a scrap of paper and passing it to Edvige. We were all just beginning to know one another and create work together. There was some part of me that Edvige touched that I'd been ignoring for a decade. As I got to know her, I learned she took an interest in Italian American women writers, and soon she had a community of us swirling around her. She became the hub of the wheel, around which a community of writers grew. Before her, I had never been able to sustain any great interest in other Italian American poets I'd met. I had heard a few over the years but never pursued these relationships in friendships or artistic collaborations. And I don't remember being pursued by them. Edvige's scholarly interest in us watered the seeds of our interest in one another, and over the next decade many of us would grow to be a literary, activist, and social family.

On that day, up in her bedroom, when Edvige carefully took the folded items out of her trousseau, wrapped in ribbon and tissue paper, what I

remember most is the list in the box, a handwritten list of the contents. This list, and not the contents, gripped me. In the careful and deliberate handwriting, I pictured her great-grandmother, grandmother, and mother carefully cataloguing the contents to be passed on and ultimately shipped from Gela, Sicily, to the United States. I couldn't decipher the list, not knowing a sheet from a towel in Italian, but the words of Edvige's trousseau list rhymed inside me as I read them. Having been exposed to Italian rap from Joe, I was inspired to create a rap song from Edvige's trousseau list. I dropped the end-syllables at will and added vowels where I wanted, stressed whatever syllables struck me. Through working in song with these words, I was weaving my own literary trousseau for myself, reaching back to things I'd never have, and things I'd never pass on to anyone. The sounds of these words were, for me, a world away. This trousseau, this investment in my table and bed and linen closet, was missing. My palpable connection to my female ancestors and to the unborn was not manifest in white-on-white cotton. Just through these words might I have anything to pass on, and to whom? I'd never know. Readers are strangers, not *descendants*. Or are they? My readers are my true descendants.

Coperta e lenzuolo di lino con margherite
tovaglia in batista di lino
coppia lenzuola bianche con pizzo Sangallo
2 lenzuola bianche senza ricamo
2 strofinacci da cucina + grembiule + federa
asciugamani di lino 2+2 con ricami rosa e celeste
copriletto pizzo bianco con copricuscini
servizio tavola verde
trapunta e servizio tavola ricamato . . .

Edvige's trousseau seemed to me to be everything a woman would need to begin to make a happy family. A well-made bed and a table where the stitches of the ancestors could touch you a hundred years later, when their fingers could not. Napkins, pillowcases, tablecloths, bedspreads, to bless the table and the bed, to make love, to make food, to make life. Be a lover with good linens; fit the sheets and fold the napkins with the ceremony of an altar.

Acquaviva delle Fonti, Province di Bari, 1996

I was sitting with my Zio Salvatore for a late-night homemade fettuccine. He was the last of the great *contadini* in my family. His hands were so muscular the fingers stayed open like a starfish. I turned his hands over in mine; they

were tools, not hands, thick hard tools. They were paws. They were claws. They were vice grips. As we ate, drinking his homemade wine, potent as blood, mixed with Fanta, he began to cry, salting his pasta with his own tears, like the Commedia dell' Arte lazzo I call "Mangia Piangia," and what is referred to in Commedia literature as "Pasta alle lacrime," when Pulcinello (in my mind it is always Pulcinello) takes to the makeshift stage with a plate of spaghetti and, as he eats, weeps profusely.

I asked my uncle, "*Perchè piange, Zio?*"

His eyes were so open, as if he wanted to tell me all his troubles, which, his eyes told me, were heartbreaking and life-ruining. The handmade cavateel, made by his wife, my loving and strong aunt Preziosa, and the sacred wine and oil that he made, opened his soul up to cry at the table.

"Giusy," he said, referring to his daughter Giuseppina, and then in a whirl of crying and hand gestures, and eating and drinking, and long pauses with deep eye contact, and repetitions of words, he told me, what I understood from his dialect, was the story of my unmarried cousin, just a few years older than I. This is the story I discerned: Giusy had "lost" an engagement and had been a ruination since then, sitting in her room, buying shoes she didn't need. She was surrounded by towers of shoes. After her fiancé had left her, she had dyed her hair blonde and cut it too short, and had suffered a deep depression and always laughed—"*sempre ride.*" On her fortieth birthday, out of mockery and in an act of giving up on her marrying, Zio Salvatore gave her the trousseau they were saving for her marriage. In an act of anger and despair, Giusy dragged the trousseau out onto the quiet street and down the block to where stray cats piss on the dumpsters. According to my uncle, she tore each lace, each linen, each embroidery, every piece of *biancheria*, passed down to her from her grandmothers. The shreds lay in the dumpster of cat piss.

My cousin had thrown away what I'd longed for. I think I understood her impulse. I remember shaving my head in an act of rebellion and desire to break any continuity with my family. I remember racing downtown to the Gay and Lesbian Center, and holding on to the very brick building as a life raft. Growing up, I'd watched nineteen female cousins walk down the aisle one by one, and I remember feeling at every single wedding that I would never be a bride, never wear the flow of lace. Queer or not, Giusy had to rupture the lineage by ripping the fabric itself of her grandmothers, heavy with generations.

On stage, I ripped lace, in homage to her story. It is a difficult thing to do. Handmade or machine-made, I could feel the hours in the white cotton, feel the urge to purify with white, clean, cotton, lace. I could feel the generations woven together. Tearing lace felt like I was tearing the flesh of

grandmothers. I still have the inner urge to set the table, make the bed, let the curtains blow into the rooms filled with wind.

New York, June 24th, 2011

I was sitting alone in New York. It was 10:39 p.m. Gay marriage had just, at that minute, passed in the New York State Assembly by a vote of 33–29. My lace tablecloth from Acquaviva and my giant heart-shaped lace from Firenze were folded in a plastic container on the bed. Just that day I had taken them out of the closet. I thought back to loves with whom I'd exchanged rings and whispered vows. An ache in my gut told me that those whispered vows could now be echoed in City Hall by the voice of the magistrate. Maybe one day I'll get the heart-shaped lace fitted into a tux. On that night, I am sure of it. In 1986, I had a *Silence = Death* T-shirt. In 2011, I could make an = T-shirt. All I have in 2011 is = . Equal. Equal. Equal. The silence and the death were for an earlier time. I vow to wear this = shirt on my next trip to Acquaviva. This day will come.

Sloan-Kettering, 2011

It is my mother this time, not me, who is in the hospital. I stay with her overnight, I don't leave her room. The amenities have gotten world-class at Sloan-Kettering over the decades. Mom calls the arts-and-crafts room and asks for a size-eleven knitting needle so she can finish a poncho she started for her great-granddaughter. She also asks for sewing projects. The arts coordinator comes with fabric and thread and needles to make an apron and two potholders. That night I thread the needle. As a kid, I used to thread the needles for my grandmother. Now it's hard for me. I push the thread. It goes behind the needle. In front of the needle. Hits the needle. I lick and twist it to a point. After numerous attempts, the head of the thread goes through the eye of the needle, and I carefully pull the thread through. I sew the potholders first. My stitches are crooked and different sizes, but each stitch feels like a word or lyric. I am proud of each stitch. I don't want to edit or redo any of them. The stitches record my time. I sew for four hours. I finish the potholders. I finish the apron. My mother is proud of me. I think this is how one begins a trousseau, with hours of stitches. I think of my nieces and nephews and wonder which one I will pass it on to. I decide to give it to my goddaughter Melissa and her new husband, Rob. Melissa's been asking my mom for her gravy recipe. There is no recipe, just know-how. I think

back to Edvige's trousseau. Giusy's trousseau. All the stitches, the expression of the ancestors.

I begin a list. I think, "Whoever I give these to will want to look at my stitches, and think of my hours, and my life."

grembiule con girasole

presina, due, giallo

Ink Still Wet

in memory of Delia

—Paul Zarzyski

Oh, what ballet, what sway and sinew
of musical movement, as I hang my wash
on five woven-wire lines, on the horizontal
staff, like notes, like words,
like a wardrobe of sound—bath towels,
nouns, dish towels, vowels, jeans,
verbs, gerunds, shirts, modifiers, socks,
consonants, tablecloth, and my unmentionables
soaking the September sun into twill,
thread, fiber, stitch, thanks
to cotton pouches bulging
with the most intricate invention of all
evolved pre- and post-iPad time,
the clothespin, the *iPin*!
 Yes, thank you,
dear patron saint of whittlers,
for these deep-notched pinchers
slipping so snuggly over
overlapped corners of even
the thinnest linens gripped
against stiff wind. Or, more dramatic
than wind, Comanches prodding us
cowpuncher kids to run the gauntlet, wet
towels plastered to our faces
and stretching the lines that snapped
us, grass-stained, to our Levi'd fannies
before those wooden clothespins of yore
would ever turn loose.
 How simple

it is still, at 61, to rekindle the 1950s
TV mimickings, while pirouetting
a red, western bandana, a wildrag,
from Mom's wicker basket to the line—
this pinning of words
into their rhythmic syntax. Yes,
because the 1960s Maytag dryer belt
finally spit the bit. But also because
an Indian summer sun bid me
to go for its magical spin
on these time-machine lines that beam
me back to my mother
singing in Italian, so alive
while folding her Monday loads—
as I'll fold mine, once the ink dries.

The Woman and the Tiger

2000
Dyed cotton queen-size bedsheet, 90" x 102"
Photograph by Angela Valeria

—Angela Valeria

"The Woman and the Tiger" is part of a series inspired by childhood memories of my Nonna Francesca's dazzling *biancheria* hanging on the backyard line to dry, flapping in the breeze like doves or ghosts, and later, of the shock of seeing blood on a white bedsheet, and every so often, the random stain of spilled wine on a damask tablecloth. On washdays, Nonna would hang out her *biancheria* across the paved part of my grandfather's garden, a jungle of fig trees, roses, and zinnias, and a fascinating variety of detritus of mirrors and dolls' heads.

We lived in Brighton Beach, Brooklyn, where the fresh air, the clear light, and the horizon line of the Atlantic Ocean were ever present. Ours was one of three Italian families in this urban seaside neighborhood, in those days consisting almost exclusively of Eastern European Jewish refugees who had survived the Holocaust. From early spring to late fall evenings, grandpa's bocce court was the center of everyone's excitement and entertainment.

On those bright mornings when Nonna would carry out the white, wet bedclothes, tablecloths, aprons, shirts, and undergarments, my younger brother Roland and I (at the time about four and seven, respectively) would run outside to "help" and observe the military precision with which she would arrange the laundry, back and forth in layers across the yard. After she finished and returned to the kitchen, we would begin our shadow play amid the white, clean-smelling laundry, the sun behind us, dancing, posing, casting our changing shadows on the undulating cloth. Years later, Roland became an actor and I became an artist. We pursued and shared our dreams until the terrible day my dear brother suddenly died of a massive heart attack, at the age of fifty.

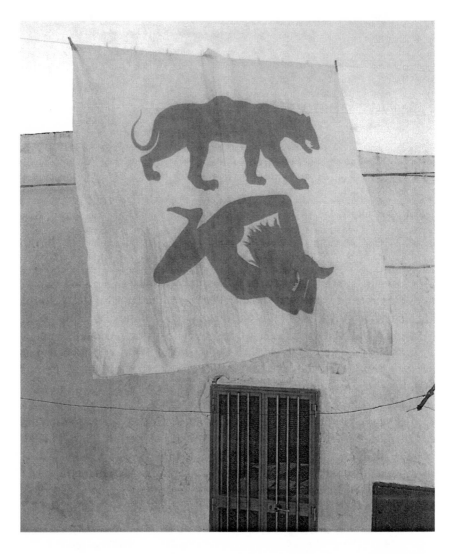

Later that year I was invited to create an installation in an eighteenth-century garden in Bagno a Ripoli, overlooking the city of Florence. Initially I turned down the invitation. It was a struggle to maintain my creative process after such a devastating loss, much less fill a garden with art. My thoughts kept returning to the experiences Roland and I had shared, especially the joyous moments we had spent playing together as children. The lingering images of our shadow projections prompted me to work with dyes instead of paint so that the stain would penetrate the cloth and could hang outdoors, exposed to changing weather conditions. Since I had been drawing and researching extinct and endangered animals—reptiles, fish, and

birds—I decided to dye their silhouettes using the color of blood into my own collection of *biancheria* gleaned from flea markets and thrift shops in New York City, Rome, India, and Mexico. I hung the cloth like my grandmother's laundry in that beautiful sprawling garden, on lines between trees, on bushes, fences, and balconies, animating and haunting the space in a tribute to my brother Roland.

Following that installation, I was invited to create others in Monopoli, Ostuni, San Vito dei Normanni, and finally my father's hometown of Giovinazzo, all in the region of Apulia. "The Woman and the Tiger" was one of two dyed sheets that hung in the streets of Ostuni, along with the works of a coterie of international artists on June 16, St. John's feast day, in celebration of *il solstizio delle streghe* (the witches' solstice), that once again conjured Nonna Francesca's Brighton Beach clothesline. The public art show that year was dedicated to strong women, like Penelope, the loyal wife of Ulysses, who put off her many suitors with the excuse that she would consider their proposals only after she finished weaving a funeral shroud for her aging father-in-law, while she secretly kept unraveling it each night.

"The Woman and the Tiger" symbolized the power, skill, and cleverness of a woman in the face of impending danger: a whirling yogini (female yoga master) immune to the stalking tiger. A few youngsters tried to imitate her difficult *asana* yoga position. That evening in Ostuni, the festivities continued well into the morning, with everyone—old and young—discovering art that was displayed on stairwells, balconies, archways, rooftops, street corners, walls, and clotheslines throughout the town.

Back in New York, I became more interested in painting and printing again, and the images began to morph from animal shadows into composite creatures with human as well as animal features, symbolizing our reciprocal evolution and interconnectedness. We are not separate but inexorably linked to the rest of the natural world, something we all too often forget at our own peril.

Identified

—Paola Corso

Sophie Salemi
by the stitched knee of her stocking mama darned the day before

Ignatzia Bellotta
the heel of her shoe the cobbler repaired with a metal plate

Mary Levanthal
the gold cap Dr. Zaharia set on her wisdom tooth last week

Gussie Bierman
by the pendant watch she wrapped around her neck twice

Julia Rosen
the hair braids her daughter Esther fixed for her that morning

Rosie Grosso
the savings she wrapped in cheese cloth and hid in her left stocking

Kate Leone
by a blue skirt she wore to Randall's Island hospital to visit her son

Jennie Levin
the baby's sock found tucked in the heel of her shoe

Anna Cohen, Box No. 31

Celia Eisenberg, Box No. 56

Julia Aberstein, Box. No. 32

On the lid of one coffin written with white chalk:

Becky Kessler, call for tomorrow

My Lost Needle

—Anne Marie Macari

Never had I desire to mend
 hems or dangling buttons,

but tonight, though I can no longer
 easy aim the frayed end

into the eye, though we squint,
 needle and I, at each other,

and my hand trembles, yet feels true
 the needle between my fingers,

the tether of thread as I pull it
 through red linen, just the right

turn in my wrist, not too fast, thread
 rubbing the blouse, repeating

mend, mend, my dearest, hold fast, let me
 patch you, no one will know,

you limp in my hand, draped on my lap,
 my other body. I with

my warm, fine instrument, you undone,
 never whole without me.

I would sew till the world around wore
 patches bright and uneven,

sew my childhood back into my bones,
 I would bind, I would bind

what falls apart. My hand is happy
 piercing, rising, circling back

taking me thou needle, thou red thread,
 stitch to stitch, my way back,

taking there, and I go, what more
 wanting, what more?

Embroidery as Inscription in the Life of a Calabrian Immigrant Woman

—Joan L. Saverino

> There are, indeed, things that cannot be put into words.
> They make themselves manifest. They are what is mystical.
> —Ludwig Wittgenstein

Anna Guarascio was a reluctant immigrant. Sent for by her husband, Domenico Peluso, to join him in the north-central West Virginia coal fields, she left Calabria, Italy, at the age of twenty-four in 1915 with her two small children. Recognized in her hometown of San Giovanni in Fiore as a *maestrina* (teacher) of embroidery, she lost that identification upon emigration. Anna, the sole member of her family to emigrate, spent the rest of her life in various coal camps. She returned to her hometown only once, after a sixty-year absence. It was a life-changing experience that facilitated a rediscovery of an artistic method and inspired her to create one last life legacy in thread.

This essay is a close reading of one Italian woman's lived experience and self-representation through her artistic repertoire. It is the exploration of the intersections of genre, gender, creativity, narrative, and memory in one immigrant's extraordinary life in two out-of-the-way places—Calabria and Appalachia.[1]

Given that I am Anna's great-granddaughter as well as the one who turned an ethnographic eye on her life, I incorporate my own voice here. As ethnographers, we must simultaneously negotiate the stance of outside observer while immersing ourselves in the worldview of those with whom we work. This is never an easy task, but the triple stance of outsider, insider, and family member is one that few take on and is even considered inadvisable by some. The only way I can see to unwind the professional from what is so intensely personal is to make as transparent as I can my own thoughts, observations, and feelings.[2]

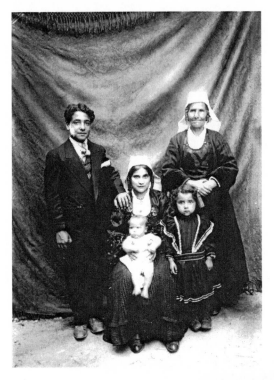

Seated: Anna Guarascio Peluso in traditional *pacchiana* dress of San Giovanni in Fiore. Son Tommaso on her lap with daughter Caterina standing. *At left,* her brother Vincenzo; *standing at right,* Anna Guarascio (sister of Anna Guarascio Peluso's father, Salvatore). Calabria, c. 1912. (Courtesy of *Archivio Fotografico Saverio Marra, Museo Demologico dell'economia, del lavoro e della storia sociale silana.*)

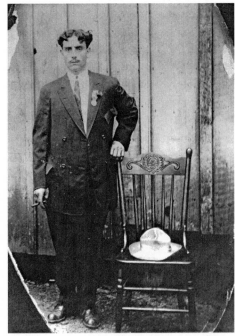

Domenico Peluso. West Virginia, c. 1913. (Courtesy of Joan L. Saverino. Photographer unknown.)

Situating Myself: Granddaughter and Ethnographer

Anna was the family matriarch. Diminutive—well under five feet—she was known for her outgoing and independent personality, her excellent memory, her wisdom, and her generosity. These appealing personal qualities kept her home a revolving door of family and friends of all ages and were crucial to her survival over a difficult lifetime. Growing up only one-half mile from her house, I, like many of my cousins, visited her often and loved spending time with her. She was a warm and indulgent great-grandmother whose simple home and yard could be explored unfettered by parents' scrutiny.

Akin to other immigrants, Anna was a hybridized adaptation of Italian beliefs and behaviors and American ones. This mix was endlessly interesting to me, a third-generation child. She prepared foods from her Calabrian heritage such as the annual fall production of one hundred pounds of pork made into sausage and green tomatoes and peppers *sott'olio*. At Christmas, she baked *pitta 'mpigliata*, the San Giovannese Christmas pastry filled with nuts, raisins, and orange peel whose dough is a simple combination of flour, olive oil, wine, and water. At Easter, there was *muccellatu*, the braided egg bread, which, in order to be authentically San Giovannese, must include wild anise seed collected from the fields. Anna's relatives sent her a packet of the seeds annually so that she could recreate the pastry. She doled out the precious seeds to her two daughters so that they too could bake the bread for their own families. Yet she also made apple butter, an Appalachian autumn specialty, using a neighbor's recipe that included cinnamon drops.

Werewolves, ghosts, and the evil eye were an integral part of her belief system. She believed that her uncle in Calabria had been a werewolf. I relished the story of how, once when staying overnight with her cousin, the girl instructed Anna to open the door if there was a knock, but if there should be scratching, they shouldn't unlock the door. Dreams could foretell events, and she kept several dream dictionaries for handy reference. She was a healer whose family sought her out for a rub of olive oil to soothe tight muscles. She believed in luck. She played the weekly lottery and always had money ready when the numbers runner came to the door. She also frequented the illegal gambling enterprise above the bus station. Once, one of Anna's friends laughingly recounted seeing her there, purse swinging from her arm, barely able to reach the lever of the slot machine. Anna watched her favorite television shows religiously—soap operas and particularly wrestling. During these episodes, she would carry on an animated conversation with and loudly root for the reigning "good guy." As my cousins and I got older we tried to explain that these were not real, but staged matches. She would have none of it.

When I was an undergraduate anthropology student in the mid-1970s at West Virginia University, a "life history" assignment added a professional dimension to my close relationship with Anna. I began to interview her to learn more about her past. I moved to Washington, D.C., to pursue a master's degree in anthropology with a specialization in museology. My specialty was African studies almost by default because of my professors' specialty in the field. Although it was satisfying, I wanted to pursue studying my own heritage. In 1981, I was awarded a grant that allowed me to spend an intensive six months with Anna to learn needlework (*ricamo*) she had once taught to others in Calabria. It was a fulfilling time for Anna and me, not only because of our close relationship, but also because I was the first person to want to learn embroidery from her since she had immigrated. I continued to interview her sporadically, almost until her death in July 1988, a few days short of her ninety-eighth birthday. Her death was especially traumatic for me since I had already lost both my parents, and my maternal grandmother—Anna's oldest daughter, who had been like a mother to me—had severe dementia.

The fall after Anna's death, I entered a doctoral program with the intention of focusing my dissertation research on the embroidery. In 1991, I was ecstatic when I received a fellowship that allowed me to expand my previous work by conducting research in San Giovanni for three months. My goal was to interview my great-grandmother's contemporaries to analyze women's changing socioeconomic roles during the emigration period. I hoped that research would close many gaps in my work, but it also held the promise of finally reconnecting with my past in a way I had not been able to accomplish previously.[3]

I had passed up the opportunity to accompany my great-grandmother on her only return trip there in 1975. My first trip to San Giovanni in 1983 had been traumatic. I couldn't speak Italian, but a friend who did traveled with my husband and me. My great-grandmother's friend Teresa Biafora was still living on the same street where Anna had lived as a young married woman before emigrating. Teresa, aware we were coming, opened the door, cried upon seeing me, and invited us in. She wore the traditional dress and spoke only Calabrian, not standard Italian. She wanted to share so many stories. My husband's friend could barely understand her. I was devastated. We stayed only a few hours before we moved on to our next destination. My inability to converse with Teresa and the aborted stay put the chasm of a lost family past in relief. I cried for three days. In 1985 and 1987, I returned to San Giovanni for brief visits accompanied by my relatives who were originally from there but were now living in Cosenza.

When I arrived in 1991, the women who were Anna's contemporaries and who wore the traditional dress of the town were literally dying out. I worked

furiously to absorb as much as I could. I explored the ancient streets and rediscovered the house where Anna had lived as a child and the fountain of Santa Lucia where she had hauled water. I interviewed women and men who were essentially contemporaries of my great-grandmother in terms of the socioeconomic status of the town. I discussed my great-grandmother and her family's early life with several of her nephews and a niece.

I met eighty-six-year-old Rosina Iaconis, a *pacchiana*, as the women who still wore the traditional dress were known. She became a key informant and a friend. Rosina lived alone in the old town center in an ancient stone house on Via Archi, a stone's throw from San Giovanni in Fiore's twelfth-century center, the Abbazia Gioacchino. Although she often had visitors, she was delighted to have someone who wanted to listen to her life story. At Rosina's, I often sat beside her, both of us warming our feet in front of her open hearth, the only source of heat in her three-room house.

Rosina, like my great-grandmother, had been an expert *ricamatrice*, and she, too, practiced the curious mix of folk religion and Catholicism that Anna had. Her belief system, however, had not been interrupted by emigration. She could no longer embroider because of failing eyesight caused by diabetes, but she could still discuss it. One incident marked a turning point for me in understanding. On one visit, Rosina sent me to the small wooden armoire in her bedroom. When I opened its doors, it was as if her life history as a *ricamatrice* came spilling out. There lay a traditional dress, carefully wrapped, newly sewn, unworn, waiting for her funeral and burial. There were pieces of a lifetime of clothing—some too old, some too small now, but none discarded. In the bottom of the closet, stacked, rolled, encased in plastic, were exquisite examples of the 'ncullerata, the two pieces of embroidered linen that form a sort of collar at the neck of the traditional costume, that Rosina had salvaged.

As I carried them to Rosina, she lovingly held each small piece, reciting the old Calabrian names for the designs. This trove was Rosina's gold, her hopes, dreams, and memories written in thread, her personal identity and legacy. Opening that armoire, I felt time tumbling out. It held the history of the commonplace—the minutiae of Sangiovannesi women's daily domestic lives, thoughts, and feelings—never fully knowable. These textile objects held a collective cultural memory and represented the "life of feeling" of the embroiderers who produced them.[4] In that moment, the yards of fabric before me, I could understand the depth of meaning of *ricamo* for the embroiderer. It was through Rosina's stories that I came to understand the contours of my great-grandmother's early life in her town and how the embroidery linked a woman's identity and life purpose. It was the deep inexplicable emotional connection I experienced in San Giovanni with places

and people (particularly Rosina) that paved the way for me to see the circumstances on the other side of the Atlantic in a new light.

San Giovanni in Fiore and Needlework

To understand Anna and the role that embroidery played at life's end, it is essential to understand its role in her youth and to locate both her and it in their temporal and cultural context. Anna's early life illustrates the conditions of a struggling nonlandholding Calabrian family at the turn of the century. A closer look at its dimensions will shed light on the interplay of individual agency and the constraints of social structure in Anna's life.[5]

San Giovanni in Fiore, 1,100 meters above sea level, is perched between the larger cities of Cosenza and Catanzaro, in the mountainous Sila Grande region of Calabria. It is the oldest and has remained the most populous commercial center of the area since Blessed Gioacchino built an abbey there in the twelfth century.[6] Francesco Meligrana described the economy of the town as based on agriculture, sheep rearing, weaving, and goldsmithing until well into the post–World War II era.[7] While not inaccurate, this statement does not reveal the constellation of factors that contributed to privation during much of the nineteenth and twentieth centuries in southern Italy. In spite of the town's reputation as an economic center, throughout its recent history, it has suffered from overcrowded conditions and scarce economic opportunities. Around the beginning of the twentieth century, the population of the town hovered around 15,000.[8] It was common that large families with seven or eight children lived in one room, perhaps with an additional attic space. The average San Giovannese was preoccupied with three things: getting enough food to eat, storing it for winter, and finding enough wood to burn for heat for the winter.[9] The diet was mostly vegetarian, consisting of tomatoes, beans, potatoes, zucchini, winter vegetables, mushrooms, and chestnuts. People were lucky if they owned a pig or two that they would kill for the winter meat supply. Animals were kept in the basement, which is also where the food and wood supply was stored. Often animals slept in the same room with the people.[10]

The details of Anna's family history are typical of the micro- and macroeconomic and social forces that buffet human lives. From at least the time of Anna's father's youth, the family was caught in the migratory pattern that prevailed in southern Italy during this period of moving in search of work. It was a survival strategy to cope with poverty and the worsening economic crises.[11]

Anna's father, Salvatore, a stonemason, had met his future wife, Fulvia, while visiting her native village of Caccuri in the province of Crotone, a

two-hour walk from San Giovanni in Fiore. According to Anna, Fulvia was fourteen years old when her mother, Anna Giampà, died. Anna Giampà had married Domenico Talarico, but she became dissatisfied with him when he continued to take her money and spend it on drinking and gambling at card games. Giampà moved in with a local priest, Vincenzo Abruzzino, who cared for her and her children. According to my great-grandmother, the townspeople accepted the arrangement. When Fulvia married Salvatore, Abruzzino wanted to bequeath her land, which would have been an expected part of a daughter's dowry. Salvatore rejected the offer, apparently due to his feelings about Giampà's scandalous living arrangement. While it may have been a decision born of pride, it doomed the family to remain landless peasants.

Anna said that Fulvia visited Caccuri only occasionally and that her mother cried all the time out of loneliness.[12] Salvatore brought Fulvia to San Giovanni where their first child, Pasquale, was born in 1885. In order to take a job building a bridge, he then moved the family to the small village of Magisano in the province of Catanzaro, where Anna was born in 1890. Then, once again, he moved the family back to his hometown of San Giovanni in Fiore, seeking work. When Anna was about ten years old, Salvatore, still unable to find adequate employment, emigrated to the United States, settling in Utica, New York. He wrote and sent money sporadically.

Like many women left behind, Anna's mother, Fulvia, was left to support herself and the five children she had by that time.[13] She tried to accomplish this task by using her accomplished textile production skills. Fulvia was a weaver and owned a loom that dominated her rented one-room space. Before the introduction of commercially produced cloth, all women, in order to marry, had to know how to weave. In 1913, Elisa Ricci noted that weaving was the primary work among Italian peasants: "The heavy rolls of cloth, made of hemp and flax, sown, cultivated and harvested by their labor, spun and woven by their hands, are the product and pride of the peasant women."[14]

In addition to weaving for her family's needs, Fulvia provided goods to the local elite as a way to supplement the family's income. Anna recalled her mother's association with them. The Barracco family owned the largest agricultural estate (*latifondo*) in Calabria that encompassed San Giovanni. One of their palaces was in Caccuri, and this may have been how Fulvia first came into contact with them. Because of the size of the estate, Barracco needed craftsmen on a continual basis. Although the relationship could be a hereditary one dictated by the artisan tradition rather than a paternal baronial relationship, artisans were independent workers and could even be itinerant. Tailors, seamstresses, and linen embroiderers were often hired at random. Almost all the master craftsmen came from towns with artisanal

foci, one being San Giovanni. Payment was in kind, often in the form of foodstuffs, and many owed debt to the *latifondo*.[15]

In this era, everyone in San Giovanni was dependent on handmade goods, since few manufactured goods reached the region characterized by its mountainous terrain, severe winter weather, and poor roads. Because of its relative isolation, cultural, social, and economic changes that were occurring elsewhere in Italy at a faster pace came more slowly to the Sila.[16] Accessibility to major transportation networks was nonexistent until the first railroad line linking Cosenza (located in the valley) and San Giovanni was completed at the late date of 1950. Passage during the winter months, when ice and snow blocked roads, a frequent occurrence even today, was impossible. The first telephone was installed in 1955, five years after the railroad line.[17]

In contrast to her mother, Anna never had her hand at the loom. She learned to crochet and knit at an early age from her mother and two other women. Anna estimated she completed school up to the end of the fourth grade when her mother insisted she quit. A teacher and the principal intervened, and her mother relented, with the stipulation that she had to knit one-half of one stocking before she left every morning for school. At this point, Anna was already assisting her mother to meet the demands of Fulvia's commission work. Anna continued to attend school for four or five more months under this arrangement. A seminal story that Anna repeated often was about the day she left her knitting and a book outside on a chair. When she returned, she found that her book had been stolen. The book had been a gift from her teacher. Out of shame and because she could not afford to buy another book, she never returned to school. She always suspected that her mother had taken the book to prevent her from continuing her education.[18]

When she was about fourteen, Anna began taking lessons in a class with other girls to learn the particular embroidery patterns used on the '*ncullerata*.[19] The embroidery, both drawnwork (*punto tirato*) and cutwork (*punto tagliato*), was done with undyed thread on natural or bleached linen spun and woven by San Giovannesi. Anna learned quickly and began helping other girls in the class. When her mother discovered this, she refused to continue to pay for lessons. Two of Anna's girlfriends who had been ashamed to ask the teacher for help requested that Anna continue to teach them. They came to her home every day to learn free of charge under Anna's tutelage.[20] Anna's skill was soon so expert that her mother engaged her to embroider for other girls' trousseaux.

Because of Anna's talent, the eldest daughter, Costanza, was given most of the housework. Anna could now keep her hands clean for the time-consuming task of embroidering white-on-white linen. She was sometimes

charged with two chores, which she remembered fondly because they were performed in social groups. She helped her mother with the bimonthly bread baking. The dough was mixed and then taken to a local bake oven owned and run by a woman to whom a small fee was paid for the service. Women visited with one another while their bread was baking. Anna also did laundry, a two-day process performed weekly or bimonthly. In winter months, the clothes and linens were taken to a hot spring. Usually, though, the washing was done in a local streambed lined with large rocks (probably the nearby Neto River). Anna estimated that it was a one-mile walk. First, the clothes were rinsed in the stream and then brought home. In order to whiten the fabric, a mixture of lye and ashes was put in between the layers of material over which hot water was then poured. The next day the clothes were hauled back to the stream, rinsed, and hung on bushes to dry. The girls sang together as they worked, and they shared a picnic dinner while they waited for the clothes to dry. Anna remembered the surroundings—the beauty of the flowers blooming in the woods and the sweet smell of the clothes drying in the open air.[21] Her most sensual descriptions always centered on forays into the woods to gather flowers, berries, or chestnuts with her friends. Perhaps these memories were strongest because they combined the social camaraderie of her peer group with the escape from the confines of the town itself. For travel writer Norman Douglas, the women of San Giovanni were the near singular positive attraction. He described them as "attractive and mirthful." As for the town itself, he ascribed to it such negative adjectives as *filthy* and *unhealthy*, a place with no public hygiene and one where black pigs wallowed in the doorsteps.[22]

Anna's training in embroidery, as opposed to her mother's in weaving, is indicative of the growing importance of *biancheria*, hand-embroidered whitewear, in a girl's trousseau. By the end of the nineteenth century, according to Jane Schneider, *biancheria*, or *letti* (beds), as the sets of *biancheria* were called, had become the primary component of trousseaux. *Biancheria* was a key symbol of social position, linked with the concept of female honor, and the preferred form of stored wealth in southern Italy.[23] Although girls in wealthy families learned to embroider (embroidery exemplified purity and social status), the huge trousseau that was bestowed upon them required an outsourcing of the work to the likes of Anna and her cohorts. Thus, these girls from less-fortunate families filled a particular economic niche. Their families tried to emulate the fashions and desires of the elite by training their daughters in the art of embroidery, competing in the village rivalry for social status. Their skills were not learned primarily to mark leisure status, however, as was the situation for girls in better-off families.[24] While these girls embroidered their own small trousseaux, they were also

pressed into service to produce *biancheria* for the elite to aid their own families' economic survival. In short, the conflation of female production with reproduction is complicated further when production is done at the hands of unmarried girls essentially in the servitude of others.

In the trousseau of a Sangiovannese woman, both the traditional peasant costume and bed linens were expensive and symbolic. A long discussion of the social role of regional peasant dress and its change over time is not within the scope of this article. Suffice it to say that regional dress differed from town to town, serving as a visual identifier of place (town), and situated the wearer as to his or her social identity in terms of gender, age, social status, occupation, and ritual occasion. Peasant dress in general served to de-individualize the wearer.[25] In San Giovanni, as late as the end of World War II, the peasant dress was donned upon marriage and worn daily by women of the working classes, wives of laborers, artisans, or small businessmen. Women of the upper classes had already adopted fashionable dress.[26]

Although girls began to wear a simplified version of the costume after first menstruation, indicating their willingness to marry, the *rituartu*, the head covering of white linen adorning a distinctive hairstyle, was worn only after marriage. The *pacchiane*—as the women in traditional dress are known in San Giovanni—say that without the *rituartu*, one is without womanhood. In 1991, I interviewed Annamaria Lopez in San Giovanni when she was eighty-seven years old. She still wore the costume and willingly posed for me while naming each piece. When I asked her if I could photograph her hair without the *rituartu* or *copricapo*, she declined to remove it.[27] The costumed human form is an embodiment not merely of the gendered self, but of its relationship to the idea of the honorable woman. The color white—the white head covering, white-on-white embroidered bed linens—encoded the concept of female purity, an important Mediterranean behavioral code.[28] The marriage bed itself, bedecked with trousseau linens, also embodied the symbolism of female purity, for the bride must be a virgin. In dictating virginal marriage as the proper path for a woman, such cultural codes enabled her to fulfill her designated role as a virtuous good woman and mother. The white-on-white embroidery symbolically reinforced these values.

Especially for young girls, embroidery played a primary role in social life. Female lives were circumscribed, their activities restricted by strict moral codes. To break the monotony of long hours spent doing handwork, girls embroidered in groups, a way for them to gather and socialize. Anna often spoke of the laughter and gossip she enjoyed when spending time in the company of other girls. In this way the social component became an impetus for the work at the same time that the embroideries were inscribed with the memories of a social life once shared with others.

In southern Italy, female labor was primarily unpaid and linked to domestic activities. The production of whitewear was a respectable avenue for the Guarascio women to supplement the family income. It was also essential. With the emigration of men, women were forced to work even harder to subsist. In general, women had to produce cloth and clothing for themselves, care for garden plots, do laundry, and prepare food. The money that immigrant men sent back to their families was used to repay debt or buy property, not for daily use.[29] Fulvia did not have enough food to feed her family. Anna remembered that her mother locked the bread in a wooden cupboard on the wall. Sometimes Anna visited her aunt, who would feed her. Anna described several times when her mother hit her. One description, in particular, illustrates her mother's frustration with her desperate situation.

[She] hit me, she pulled my hair, she bit my arm . . . she bit a big bite in my arm. I cry, you know, and [the] next day I go to my aunt's, my father's sister. She wanted to give me something to eat and I started to cry, I [didn't] want to eat. She say, "what [is the] matter [with] you?" I show[ed] [her] my arm, I say, "my mother, you see what she did to me?" . . . And when I came back home, my aunt had come too and she told my mother. She said, "how come you hurt that girl for nothing? . . . You don't need to hit her, [be]cause she [is] too good . . . " She hollered at my mother. She said "your man doesn't write"—see my father was in this country—"when your man doesn't write, you take a spell on this girl, you do one more time like this, if I find [out], I['m] going to take [her] in my own [house]." This was one time.[30]

As Fulvia's case demonstrates, women whose husbands had left experienced multiple anxieties from both economic and social pressures. With men no longer around to protect the family honor, wives were looked at suspiciously by other villagers because they no longer fit defined social roles. In the popular imagination and supported by medical writings of the time, women without men to control their sexuality would become voracious and were therefore suspect.[31] Fulvia not only had to worry about her own reputation, she also had to worry about those of her unmarried daughters. Getting her daughters married was a clear way to mitigate economic pressures and simultaneously solve the issue of protecting purity.

Women wielded power in the private sphere of family life. They played a central role in raising their children, educating them, and in arranging marriages that affected their social and economic standing.[32] Potential spouses were usually considered by parents among neighbors and acquaintances. Moral codes forbade a man to approach a girl. A son who had a preference could enlist the aid of his mother to make an overture to the girl's parents.[33]

Anna's story of her betrothal fits this scenario. Domenico Peluso had returned to San Giovanni from West Virginia where he had been working in the mines. Domenico's father had died when he was two years old and so, at age fifteen, he had joined his older brother, Andy, in West Virginia. Their mother lived across the street from Anna's family, and Anna reported, "He see me and he just [was] crazy for me."[34] It was not a marriage Anna sought, but one arranged by her mother. Returning immigrants from America were considered good matches because they held the promise of economic stability. Fulvia may have had one less mouth to feed with Anna's marriage, but there was little other apparent advantage to the match. Domenico's family was poor; therefore, in terms of class status Anna was not bettering herself in the village social hierarchy. Behaviors and practices that may have achieved a desired outcome in the past were unreliable during this period of social and economic upheaval.

On February 2, 1908, Anna's adult life and the path toward her own eventual emigration began when she married Domenico. They first went to the courthouse for a civil ceremony and then to the church, Santa Maria delle Grazie. Because of the couple's relative poverty, only a few people were invited to Anna's house for dinner afterward.

For more elaborate weddings, rituals in San Giovanni included a presentation of the dowry three days before the wedding. Maria Teresa Ventura, who was fifteen when she married in 1937, described her own dowry presentation to me in 1991. A horse with red bows on either side of its head was escorted to her home whereupon the *corredo* (trousseau) was piled on the horse and led to the groom's parents' home. The wedding bed was made up with dowry linens by the bride's girlfriends at the home of her future in-laws where, according to Calabrian custom, the couple would reside after marriage. Afterward, everyone went to Maria Teresa's family home where a meal was served. Guests danced the tarantella, and Maria Teresa danced with her betrothed. Traditionally, the bride did not see the wedding bed until the wedding day. On the day of the wedding, the bride's friends helped her to get dressed. Since Maria Teresa had not yet menstruated, she did not wear the traditional costume until her wedding day. After the wedding ceremony at the church, dinner was served at the groom's home.[35]

According to Anna, when her father found out that Fulvia had arranged Anna in marriage, he finally broke off contact altogether, using the excuse that he did not approve of the marriage because Anna was too young. In fact, she was eighteen, the age regarded as ideal.[36] At some point, the family discovered that Salvatore had married and started a second family in Utica, New York, giving rise to the family's belief that this was the real reason he had severed relations. After Anna immigrated, she tried to contact her

father, but he never responded.[37] When Anna talked about her father it was in idealized terms. His avoidance of her was a fact that she never reconciled with her image of him.[38]

Upon Anna's marriage, the couple moved to Domenico's family's house. Anna's relationship with her mother-in-law was an uneasy coexistence. "She was mean, she was no[t] like me. She was [an] honest woman, she never do nothing bad, but she was mean. She [would] get mad for nothing. She just do everything."[39] Anna also complained that she could not bring embroidery students into her mother-in-law's house. Charlotte Chapman notes that the relationship between a mother-in-law and a daughter-in-law was a proverbially antagonistic, tension-filled one, based in feelings that tie the family together. A son, after all, experiences divided loyalties. A southern Italian proverb stated "Strange flesh is always a source of pain." In reality, the relationship tended to be one in which the daughter-in-law was expected to perform much like a servant.[40]

Perhaps it was an intolerable situation that prompted the move, but after five or six months, the couple found their own living space. In November 1908, just nine months after her wedding, Anna gave birth to her first child, Caterina. After nine months, Domenico was drafted into the Italian army where he served for one year. Anna related that no compensation was paid to a draftee. She tried to support herself by teaching two or three girls "stitches." Apparently this was impossible, and she soon moved back into her mother's house. Domenico returned home for a year, and a second girl, Giovanna, was born on June 24, the feast day of St. John. Soon afterward, Domenico was called back into the army and was sent to Turkey to fight in the Italo-Turkish war (1911–1912). Anna reported that her economic situation improved since she had numerous girls to teach and the government now paid her a small sum monthly for herself and her two children. After three months in Turkey, Domenico returned home for two months, and Anna became pregnant with Tommaso. To avoid the draft again, Domenico decided to return to West Virginia. Domenico's decision to go back to America was not uncommon. Returnees often came back to Italy with the intention of staying, but their experiences once they returned to the home villages rarely lived up to expectations.[41] After Domenico left, two-year-old Giovanna died of rubella. Anna would later have many miscarriages and stillbirths, but she never forgot the loss of Giovanna.

With her husband gone, a situation reminiscent of her mother's, Anna continued to try to support her family with her needlework skills. She took on commissioned work for trousseaux and tutored as many as ten or fifteen girls at a time to read and to learn the art of *ricamo*. Embroidery done on the *'ncullerata* was sewn in two separate pieces of linen, and then each piece was

sewn onto the *cammisa* (the full-length white slip worn under the *cammisoda*, a sort of velvet vest, tucked into the skirt). The *'ncullerata* strip was thirty-five centimeters long and four centimeters wide.[42] Anna remembers that she charged one *lira* for each half of the *'ncullarata*. If material that was harder to work was used, then the cost would be increased by 50 percent per strip.

In addition to emphasizing her contribution to supporting her family, Anna's narratives about the embroidery served to reinforce her cleverness as well as her formidable reputation as an expert at her craft. Anna related that during Domenico's absence, an envoy for King Vittorio Emmanuele arrived in San Giovanni to collect needlework samples, and she was referred to him as the best *ricamatrice* in town. When he requested that Anna supply two cutwork samples in one week, an impossible task, she employed another woman to make one of the samples. Anna said that the envoy paid her ten *lire* for each piece.[43]

After two and a half years, Domenico sent Anna the fare to join him. Anna and her children—Caterina (whom Anna always called the diminutive Catinella), age six; and Tommaso, nine months—would embark at Naples, which required a long, arduous two-day descent from the mountains in a wagon to the Cosentino valley. According to Anna, three male villagers, also headed for the same destination in West Virginia, were fellow travelers, and it is likely that they all took a train bound for Naples at Cosenza. The act of women traveling alone or with men who were not family members was in itself a breach of traditional social codes and is one indicator of how the transoceanic migration affected traditional life. Upon arrival in Naples, Anna boarded the *Dante Alighieri*, which could hold 1,825 people in third, or steerage, class. Anna was sick for almost the entire fifteen-day trip and was aided somewhat with the children by the men from San Giovanni who were onboard.[44] My grandmother, Caterina, often shared her most vivid memory; it was a fearful one in which she accidentally locked herself in the one-stall dark bathroom and screamed frantically to be let out.

Anna brought only one small bag of personal belongings with her. Domenico had instructed her that everything she would need could be purchased in America. Before leaving, she gave her wedding jewelry, her traditional costume, and her *biancheria* to her family.[45] Trousseau was the primary component of a woman's dowry, and these items were often the most valuable possessions she owned. A woman's dowry was her property, and if it was to be sold it was she who sold it. It is unknown whether Anna's family sold her trousseau after she left in order to raise needed income.[46] Anna's abandonment of the traditional costume and dispersal of her *corredo* could only have been a traumatic event. When Anna left a culture of mutually understood norms, one in which her role and status as a woman

were unquestioned, her disrobing was powerfully symbolic of a rupture of personhood as a result of cultural and temporal displacement.

Life in West Virginia Coal Camps

Anna and her children arrived at Ellis Island on May 1. Her final destination was Coon's Run, a small rural coal-mining camp, in Marion County, in north-central West Virginia, where Domenico was working. Anna had to send a telegram to her husband so he would meet her at the train station when she arrived in the town of Fairmont, the county seat. Because Coon's Run was so remote, the telegram had to be sent to Fairmont. Luckily, Anna remembered the name of an immigrant from San Giovanni living in Fairmont, and she sent the communication to him so that he could notify Domenico. Once the family was reunited in Fairmont, they boarded a streetcar to Everson, where the track ended. From there, they walked to Coon's Run, a distance of about one mile. The family lived with Domenico's brother Andy and his wife, Sally, in their four-room camp house. In her thick accent, Anna said, "I left my mother, I left my brothers, everything. Andy was mean, Sally was mean. I never liked [it] very much."[47] After several months Andy and his wife moved to Fairmont, leaving the house to Domenico and Anna. Her emotional losses and the culture shock she experienced threw her into the depths of depression for months. Anna said that for a long time she yearned to return to Italy.

She had entered an American Appalachian culture in which she was a stranger, socially and culturally isolated. West Virginia had harsh winter weather and a mountainous landscape to which Anna was accustomed, but it was characterized by a rural isolation and an industrial rhythm that was unfamiliar. In San Giovanni, she had many women friends, and the numerous Catholic churches offered them sanctioned social opportunities. The closest Catholic Church to Coon's Run was in Monongah, a distance of about six miles. A wealthy friend in San Giovanni had offered to pay Anna's fare to return to Italy if she was still unhappy after five years. She said she could not manage, however, because she had the children and her husband preferred the United States.

Anna's unhappiness eased as she got to know the one other Italian family living in Coon's Run. Anna became lifelong friends with Mary and her daughter Pasqualina. She also said, "[T]he American people were pretty nice. Everybody liked me after I could talk a little bit. After I could talk, I had lots of friends."[48] Anna was blessed with a positive nature, which aided her adjustment to the United States and the brutal life in the coal camps.

Anna was one of many thousands of immigrants who arrived in West Virginia during this period. From 1900 to 1920, the coal boom was the greatest it has ever been. Mine operators began actively recruiting southern blacks and immigrants to fill the void of workers. Of the bituminous coal fields, West Virginia attracted the largest proportion of foreign-born workers.[49] Coal was the dominant industry that drew Italians to Marion County, and by 1923 it had over 1,153 Italian coal miners, one of the largest in the state. From 1908 to 1935, the largest percentage (43 percent or 429) of the 1,251 Italians who applied for citizenship in Marion County were from Calabria, and one-third of those were from only two towns in Calabria, one of them being San Giovanni in Fiore.[50]

While these figures might imply a settlement pattern similar to the urban enclaves of the cities where infrastructure networks existed by the early twentieth century, this was not the case. The mining towns where Italians resided were spread throughout the rural county, and therefore Italians were not able to form mutual aid associations that existed in urban areas where large concentrations of Italians lived together. Italians and immigrants in general were still a minority in the American-born population and were regarded with suspicion and often discriminated against.

Known in West Virginia as coal camps, these were company towns. The mine owners dictated the camp names, the architecture, and the layout of the camps themselves and segregated them along class and ethnic lines. Housing and work assignments were hierarchical, too, with the best going to American-born whites, then immigrants, and African Americans getting the worst treatment.[51]

Miners were forced to rent the spare housing, which was built and maintained by the coal companies. The typical camp house in Marion County was one of two types, and both often occurred in the same camp. A double house was two rooms over two rooms with a center adjoining wall with each family living in one-half of the construction; the other option was a four-room, one-story single. Heat was provided by a pot-belly stove and a cookstove, both of which were fueled by coal. Water was hauled from a communal well, and outhouses were the norm. Indoor plumbing did not arrive in these camps until after World War II. The companies provided a few items to begin housekeeping such as a kitchen table, chairs, and basic kitchen equipment.[52]

Every family's existence was circumscribed by the daily rhythms that centered on coal production. Work in the mining camps was segregated according to gender. Other industrial regions had work opportunities for women, but the mining regions of West Virginia had nothing to offer. Women did not mine coal underground; nonetheless, their labor was central. They

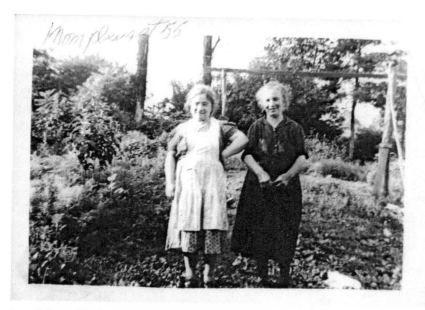

Anna (*left*), age fifty-five, with Caterina Roman, in Anna's backyard. Watson, West Virginia, c. 1945. (Courtesy of Joan L. Saverino. Photographer unknown.)

performed the arduous tasks of cooking, sewing, gardening, hauling water, washing laundry, cleaning the houses in which everything was covered with coal soot, and scavenging and bartering, all of which extended the family income. They took in boarders and laundry.[53] Because of social mores, Italian women did not generate income by other means such as cleaning homes.

During all these years, Anna, much like other miners' wives, assumed the role of housewife. She had numerous pregnancies, many of which resulted in miscarriages and stillbirths. She bore three more children (two girls and a boy) who lived to adulthood. Life with five children on a miner's wages required resourcefulness. Like other Italians, the Pelusos extended the family income by planting a large garden, collecting wild greens, berries, and mushrooms, and by hunting. Anna pickled fruits and vegetables in crocks according to Calabrian recipes; she also learned to can foods the American way. Italian families built bake ovens so that women could bake their own large round loaves of bread. Anna baked fifty pounds of flour into bread every two weeks in the brick bake ovens that Domenico built behind two different camp houses. She also learned to bake an American-style yellow cake in that bake oven.

Work in the mines was sporadic, forcing families to move often in search of steady work. Anna recounted moving to the towns of Viropa, Kilarm, and then to Watson. The Watson mine was located along the Monongahela

River, which divided the Watson coal camp from the city of Fairmont. The family's final move was to Freeland Street, located on a hill directly across the Monongahela overlooking Watson. The street was lined with identical double semi-detached houses, which had been built by the operators of the Watson coal mine where Domenico worked. The Pelusos continued to live in the house after the Watson mine closed in the late 1930s, at which point Domenico was forced to find a job at another mine. Domenico died of an apparent brain aneurism while working in that mine during World War II. Sometime shortly after the war, Anna had the opportunity to purchase both sides of the double. Once families owned the homes, they often significantly altered and updated them. After Domenico died, Anna was supported by her son Tommaso (Tom), a miner himself, who never married and continued to live with her and another unmarried daughter Jennila (Jenny).[54]

Anna's marriage could not be described as happy. She once told me that Domenico never gave her enough money to buy even so much as a cucumber. When I returned to San Giovanni to do research in 1991, Franceschina, the daughter of Serafina Scarcelli, one of Anna's friends who had remained there, recounted how Anna had written letters to her mother saying that Domenico wasn't treating her well. Anna felt someone had put the *malocchio* (evil eye) on her because Domenico brought strange women into the house whom he said were his "friends."[55] Whatever actually occurred, this story illustrates Anna's distress at the effects of separation on family stability as well as the disruption of traditional moral codes that emigration could cause. Domenico had begun working in the mines as a young single man prior to World War I when life in the early camps was compared with the wildness of that on the western frontier. Camp life in these early decades was characterized by boardinghouses comprised of unmarried or solitary foreign miners who had a reputation, particularly around payday, of drinking, gambling, and fighting.

Needlework in Marion County and Beyond

In San Giovanni, embroidered linens were integral to people's social and economic lives, but in this West Virginian Anglo community, the embroidery and its cultural symbolism were not relevant. In one sense, Anna became an isolated culture bearer. Although she was no longer a part of a tightly knit social group of embroiderers, all types of needlework were done by women in the United States and so her skills, if not the traditional patterns, were recognized.[56] Needle laces, such as crochet, were popular. Patterns for undergarments and household items such as doilies were promoted

Edge of trousseau sheet with embroidery, made by Anna for her youngest daughter, Mary. 1936. (Photograph by Joan L. Saverino.)

in women's magazines for those who could not afford to purchase them or who chose to express their own individuality. Crocheted corset covers were an American vogue. Anna became adept at making them for others. She was also commissioned to make crocheted lace that was sewn onto sheets and pillowcases. Around 1930, a Sangiovannese friend who had emigrated after Anna showed her the *passulilli* pattern. Freed from past cultural conventions, Anna put this design to a new use by incorporating it into curtains that neighbors requested. These examples reveal how Anna, always the opportunist, adapted her versatile expertise to the tastes and styles of early twentieth-century America and was able to earn a few dollars for herself.[57] Around 1936, as a gift to her youngest daughter, Mary, for her trousseau, Anna embroidered one wedding sheet with the *turnise* pattern. Although Anna continued to crochet and knit, she did not teach the traditional embroidery to her three daughters.

For most of Anna's busy middle years, except for short interludes, the *ricamo* lay dormant because she had neither the time nor the use for it. The conventions and constraints of time, place, economy, and fashion all affected the usefulness of the traditional embroidery that she had made in San Giovanni. One incident Anna recalled indicates her feelings about the

loss of the work that had brought her respect in Italy. When she lived in the Watson coal camp, a woman named Fiorina Biafora asked for her by referring to her as "*maestrina*" [young teacher]. Her neighbor (whose surname was Alvaro) said she didn't know a *maestrina*, but when Fiorina said her name, Mrs. Alvaro knew who she was looking for. When Anna met Fiorina, she told her, "In this country they don't call me a *maestrina*."[58] Anna's comment alluded to the level of respect that an artisan commanded in Italian culture at that time and also revealed her acknowledgment of its loss. It took another pivotal event to prompt the art's reemergence in her life.

In 1974, at age eighty-four, Anna made her only trip back to Calabria after an absence of sixty years. Her relatives were now living in the city of Cosenza, and she stayed with them during her month-long visit. She was reunited with Maria Rosa (Iaquinta), a former pupil, who had moved from San Giovanni to Cosenza. Maria Rosa was now teaching *ricamo* to her own granddaughter. Dependent on her relatives in Cosenza for transportation, Anna made one trip back to San Giovanni and stayed for only a few hours. When Anna returned, she expressed sadness that she had not thought to arrange to stay in San Giovanni for a few days.[59] Still, it was a momentous reunion with places and people from her past. Her nephew Salvatore recalled that it was as if the president of the United States had arrived. All the old women came to greet her, for here was one of their own returning.

In San Giovanni, she was reunited with Teresa Biafora, the former pupil I met in 1983 on my first trip there.[60] In Anna's recollections of that visit, she was always the protagonist. She was the *maestrina*, returning to the adulation of former students. The actual facts matter little. What is revealing here is how this trip was incorporated into Anna's future accounts; the very nature of the stories, the recollections themselves, point to the transformative nature of the experience. Such reminiscence—a reviewing of memories—is, as mentioned earlier, critical to achieving a coherent sense of self.[61] For many elderly people, only memory serves this integrative process. But Anna, if only for a few hours, was able to achieve something more—she physically reconnected with her past, with what had become a mythic landscape in her imagination. By revisiting her hometown, experiencing the environment, and interacting with people who had lived up to then only in memory, Anna felt an intensified need for "self-integration" because the trip cast into relief her sense of discontinuity with her past.[62]

Upon her return home, Anna set about resolving this disconnection by recreating and reviving the embroidery. Adaptability, resourcefulness, and reinvention had characterized Anna's long life, and she relied on those personal traits once again. Seeing the work still vibrant in San Giovanni, valued by many women who were still doing it, and seeing it preserved in

trousseaux, Anna was inspired to begin the work anew. Someone in San Giovanni had given her a hand-loomed piece of old linen. Using it as a model, she practiced recreating the stitches she had once taught to others. Much like poet Vincenzo Ancona, whose nostalgia for his hometown in Sicily and his returning visits there spurred him to new creative heights, Anna's romanticized San Giovanni, and her trip there inspired an avenue of creativity she had forgotten.[63]

At the end of Anna's life, narrative and embroidery merged to produce one last project. Returning to the *ricamo* that she had learned as a young girl but had abandoned during the middle years of her life, she wove stitches as well as stories.[64] For the elderly immigrant, reminiscence is an essential aspect of the process that Barbara Kirshenblatt-Gimblett calls "self-integration."[65] Barbara Meyerhoff notes that the construction of a

coherent experience of "I," a sense of continuity with one's past selves . . . is not inevitable. . . . It must be actively sought and maintained by examining, selecting, interpreting, and connecting elements from one's inner and outer history. . . . Reminiscence . . . should be regarded as a major developmental task for the elderly, resulting in the integration that will allow them to age well and die well.[66]

For the elderly artist, it is the acquisition of the traditional art form during childhood that facilitates the process of integrating a long varied life into a coherent one.[67] The role objects play in the "expressive life of the elderly," Kirshenblatt-Gimblett notes, has often been overlooked. In Anna's case, a narrated life review—or reminiscence—and the art of needlework became an inextricably linked method for Anna to accomplish coherence.[68]

For Anna, reminiscence itself was a life-sustaining activity. As Kirshenblatt-Gimblett points out, for the elderly immigrant, emigration was a life-rupturing activity that severed the continuity of life, and so reminiscence became an activity "essential to personal as well as cultural survival."[69] For the elderly artist, it is the acquisition of the traditional art form during childhood that facilitates the process of integrating a long and varied life into a coherent one.[70]

In *Number Our Days*, Meyerhoff writes about Jacob, a Jewish man who had come from a culture that valued literacy and had written two book-length autobiographies to complete the process of life-integration.[71] In Anna's cultural past, skill with a needle, not a pen, had been the province of women. Up until now, Anna had been weaving her autobiography through tellings and retellings of personal narratives. But these were not tangible records. With a renewed knowledge of the embroidery, Anna recontextualized a material

Anna doing *il ricamo* at her home on Freeland Street. Fairmont, West Virginia, 1981. (Photograph by Rick Lee. Courtesy of *Goldenseal* magazine.)

past for her present circumstances, instilling it with new meaning. Like Myerhoff's Jacob, Anna's approach to aging was "complex and dynamic."[72] In old age, she continued to bake bread, cook, and garden, domestic activities that gave her pleasure. She transformed them into gift-giving rituals, effectively cultivating a huge and extended intergenerational social network.

In 1979, at age eighty-nine, another event affected Anna's life profoundly. She decided to undergo surgery to remove her gall bladder because she was in severe pain. Her youngest daughter, Mary, pleaded with her not to do it, fearing that her mother would die. But Anna, true to her tenacious personality, said that she didn't care if she died, she was going ahead with it.[73] It saved her life. Afterward, however, because of the operation and her advancing age, she was unable to walk unaided. She was forced to spend her days sitting on the living-room couch. For Anna, always undaunted and ever resourceful, the needlework became the sole replacement for activities that required more mobility. Until that time, her creative outlets had centered primarily on food production that she ritually shared—produce from her garden, dozens of loaves of bread she baked every week, and huge Sunday dinners at which a rotating group of family members gathered to share stories. She also crocheted and knitted sweaters and pairs of socks (according to the patterns from San Giovanni), which she made for each of her great-grandchildren who lived nearby.

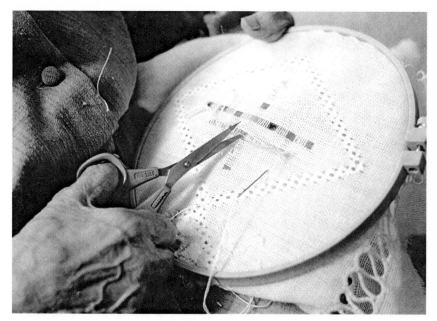

Close-up of Anna cutting threads. Fairmont, West Virginia, 1981. (Photograph by Rick Lee. Courtesy of *Goldenseal* magazine.)

To quote Meyerhoff in her reference to Jacob's strategies for aging well, Anna set new "standards and desires [for herself] . . . as the old ones became unattainable, generating from within appropriate measures of accomplishment and worth, in a continual process of discarding and creating."[74] Confined to the living-room couch for the long day, her body more feeble but her mind still keen, she practiced *ricamo* with a renewed sense of urgency. She set a personal goal to complete one fabric square decorated with needlework per week. The work of life integration was about her past, yet the immediacy of the task at hand kept her in the present and focused on the future. Little could distract her from her work. If something happened to prevent her from finishing by her self-imposed deadline, she pronounced herself behind and worked faster to catch up.

Unlike representational "memory objects" that document scenes from an elderly person's life, embroidery's geometric patterns cannot be easily "read." They provide no iconographic clues to Anna's past. Their significance must be deciphered by relying on factors of format, medium, and context.[75] In Anna's revival, she took great freedom with traditional conventions. Always innovative, she once again applied the designs for contemporary use. She conceived of making fabric squares that could be used as centerpieces on a table. Each square, approximately 60-by-60 centimeters, was decorated

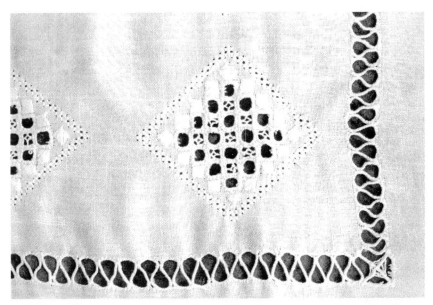

One side of cutwork square with Anna's invented diamond pattern (adapted from a traditional pattern) and *scencatiellu* pattern used around edge. 1981. (Photograph by Rick Lee. Courtesy of *Goldenseal* magazine.)

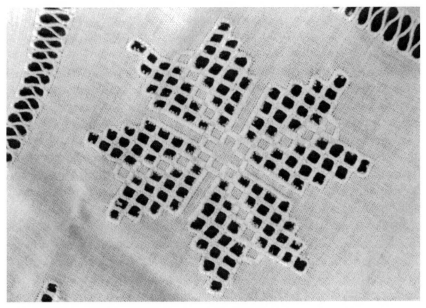

Passulilli or *Piessulilli* pattern that Anna had first adapted circa 1930 for use on curtains. This example is from a square Anna made in 1980. (Photograph by Joan L. Saverino.)

with embroidery patterns and edged with crocheted lace.[76] Anna's standards for judging her work were determined according to how quickly she finished a piece rather than solely on its quality. She worked with a large weave synthetic fabric and a fairly thick cotton thread because these were readily available, modestly priced, and easy to handle. When I found fine linen for Anna, she said she preferred the synthetic fabric that allowed her to quickly pull and cut threads, one of the first steps required, before thread is added to fill in the resulting spaces to create designs.[77] The materials Anna chose would have been rejected in San Giovanni, where the fineness of the linen and linen thread and small, expertly executed patterns were valued.

Anna also worked in a larger format than would have been traditional in San Giovanni. For instance, the *scencatiellu* pattern was ideally one centimeter in width, while Anna's was about two and one-half centimeters.[78] By enlarging each individual design, it took fewer stitches to fill up the empty space, lessening considerably the time it would take her to complete a square. This innovation helped her to accomplish her goal, but she still achieved an aesthetically pleasing overall pattern. The repetition of the same few geometric designs that she remembered and the speed of production set to a self-imposed deadline proved viable creative adaptations. Production and reproduction of narrative and artifact interacted, set to the rhythm of the meta-work Anna was accomplishing, the work of life review. Perhaps this very repetition—both of the needle threading in and out of the fabric and that of the designs themselves—functioned as a mnemonic device for memory retrieval, facilitating and accelerating the task of life integration.[79]

For Anna, *ricamo* was no longer the stored wealth of the trousseau. Instead, this was wealth to be shared; in fact, she distributed all her work as gifts—first to family members, then to friends, neighbors, and anyone who visited her and admired her handiwork. Anna combined both verbal and visual artistry to construct a coherent sense of self, a continuity with her past. Luisa Passerini says that memory insists on "creating a history of itself."[80] While self-integration was one task for recalling the past, the act of sharing is another, and that required someone to listen and watch.[81] I was the most willing witness to Anna's urgent need to pass along her memories and her art.

In July 1981, I began a six-month apprenticeship to study *ricamo* with Anna and tape-record her narratives.[82] Anna took great pride in teaching me the art that she had never transmitted to her own children or grandchildren. Why she had not done so she never clearly articulated. From the course of her life, I surmise that during the early years after emigration, as I mentioned earlier, the work had lost its original context. Therefore, there would have been no reason or time for her to teach her daughters. Also, her

three daughters were Americanized children. In the case of Caterina, Anna's eldest daughter and my grandmother, she learned the popular handwork of the 1920s and 1930s, which was crocheted doilies, embroidered runners and pillowcases, and American quilting. My apprenticeship assured the inter-generational exchange of a cultural legacy that was threatened with a loss of continuity. I wrote in my field notes that "Grandma told me that she was worried that she might get sick and even die before she could teach me. She says now she's not worried anymore, because I've learned."[83]

In the fall of 1981, Anna demonstrated her needlework at the West Virginia Italian Festival in Clarksburg, West Virginia, as part of a small exhibition I organized to focus on her life and needlework. The festival made a point of recognizing the surviving members of the immigrant generation. Anticipating the event, Anna's memory was further stimulated, and she remembered patterns she had long ago forgotten. In my field notes I wrote that "Grandma says she remembers another pattern." The next day I recorded, "Grandma tried out a new pattern she remembered." A few days later, "Grandma made another *aiegneletto* (a new pattern) for [the] exhibit." In a later entry, I recorded, "Grandma remembered a new pattern, the chain."[84] She became the center of attention for a short time at the festival, and she, along with her children who attended, basked in the limelight. Local newspaper articles featured her. Soon she began teaching another grandchild as well as a woman who had contacted her because of an article in the newspaper. Later that year, an article I had written about her for the state cultural magazine resulted in phone calls and letters. Finally, when a curator from the Smithsonian's National Museum of American History visited her the following spring to collect several pieces of her embroidery for the collection, she felt famous.[85]

Through creative adaptation, Anna transformed embroidered lace—a significant local means of production integral to women's identity in Italy—into objects of popular desire in post-immigration America. In her extreme old age, her final embroidery experiment creatively bridged the dislocation in space, time, and culture that the immigrant experiences.[86] The acknowledgment Anna received from her loved ones, the local community, and then a national museum delighted her. This recognition functioned on a deep level. When the work drew the attention of those analogous, in her estimation, to Vittorio Emmanuele's envoy, it validated her sense of identity as a *ricamatrice* and a *maestrina* in the American context. Today Anna would be pleased to know that family members still grace their dining-room tables with the squares she produced. Her embroideries remain front and center in their homes as tactile and visual reminders of Anna and her cultural legacy. With the geometric inscriptions of *ricamo*, Anna materialized memory, building a tangible tie between her past, her transplanted self, and future generations.[87]

Acknowledgments

I presented earlier versions of this essay in 2002 at the conference "*Biancheria*: Critical and Creative Perspectives on Italian American Women's Domestic Needlework," John D. Calandra Italian American Institute, Queens College, The City University of New York; at the 2002 American Folklore Society Annual meeting in Columbus, Ohio; at the International Oral History Association Meeting, Rome, Italy, in June 2004; and for the 2011 Alfred F. Mannella and Rose T. Lauria-Mannella Distinguished Speakers Series, Villanova University. My research was funded in part by a 1991 Giovanni Agnelli Foundation pre-dissertation fellowship and by a 1981 National Endowment for the Arts Apprenticeship with a Master Artist grant. Thanks to Joseph Sciorra for inviting me to present at the Calandra Conference and for reading an earlier version of this essay. I am also grateful to Suzanne MacAulay, Luisa Del Giudice, Nancy Watterson, Fariha Khan, and Amy Hillier for their sensitive readings and thoughtful suggestions. Any errors are my own. This paper is dedicated to the women in my life who gave me the love and emotional support I needed to pursue my dreams: my great-grandmother, Anna; my maternal grandmother, Caterina; my mother, Angeline; and my great-aunt Mary Beafore.

Notes

Epigraph. Ludwig Wittgenstein, *Tractatus Logico-Philosophicus*, 6.522, accessed July 7, 2011, www.btinternet.com/~glynhughes/squashed/wittgenstein.htm.

1. Barbara Kirshenblatt-Gimblett, "Authoring Lives," *Journal of Folklore Research* 26, no. 2 (1989): 142, emphasizes how "distinctions among types of objects, their relations to the past, and the ensembles they form can illuminate the interaction among objects, memory, and the life review process."

2. Reflexive and autoethnographical approaches have become respected techniques in ethnography that bring the author as subject to the fore. See Kirin Narayan, "How Native Is a 'Native' Anthropologist?" *American Anthropologist* 95 (1993): 671–86; Heewon Chang, *Autoethnography as Method* (Walnut Creek, CA: Left Coast Press, 2008); Carolyn Ellis, *The Ethnographic I: A Methodological Novel about Autoethnography.* (Walnut Creek, CA: AltaMira Press, 2004).

3. In 1975, I was an undergraduate sociology/anthropology major at West Virginia University where I completed the unpublished paper "Life History of Anna Peluso" for a fieldwork course with H. Russell Bernard. In 1981, I continued my research when I was awarded a National Endowment for the Arts grant with a master artist (the precursor to the Master Artist awards). This funding allowed me to take a leave of absence from my job to spend an intensive six months with Anna to learn and document the needlework and to conduct

more interviews with her. In 1991, as a doctoral candidate at the University of Pennsylvania, a pre-dissertation fellowship from the *Fondazione Giovanni Agnelli* enabled me to conduct research for three months in San Giovanni in Fiore. In addition to conducting archival research, I interviewed other needleworkers, women who were still wearing the traditional dress, and two men. Transcription excerpts are verbatim except for minor grammatical or syntactical alterations to improve readability or to clarify meaning. Anna Guarascio Peluso did not speak English fluently. The transcription key is as follows: . . . indicates deletion; [brackets] indicate insertion by author; AG indicates initials of person speaking.

4. Robert Plant Armstrong, *The Affecting Presence, An Essay in Humanistic Anthropology* (Urbana: University of Illinois, 1971), xviii.

5. Personal Narratives Group, ed., *Interpreting Women's Lives: Feminist Theory and Personal Narratives* (Bloomington: Indiana University Press, 1989), 5.

6. The Sila, occupying part of the provinces of Crotone, Cosenza, and Catanzaro, is divided north to south into Sila Greca, Sila Grande (with the Sila's highest peak *Botte Donato* at 1,928 meters), and Sila Piccola.

7. Francesco Saverio Meligrana, "*Donne, oro e monili in un universo contadino*," taken from *Donne E Società. Atti del IV Congresso Internazionale di Studi Antropologici Siciliani*, Palermo, Sicily, November 25–27, 1982, 396.

8. Luigi Ceraudo, "Appendice Statistica," in *San Giovanni in Fiore: Storia, Cultura, Economia*, ed. Fulvio Mazza (Soveria Mannelli: Rubbettino, 1998), 323.

9. Agostino Iaconis, personal communication, Fieldnotes, November 7, 1991, 32.

10. Joan Saverino, Fieldnotes, November 7, 1991, 32. Seasonal or permanent emigration was a dominant response to the depressed economy. In contemporary times, a lack of work persists so that emigration to the north of Italy or other countries remains an endemic part of the lives of the people of San Giovanni in Fiore.

11. Martin Clark, *Modern Italy, 1871–1982* (London: Longman, 1984), 1–2; Eric Wolf, *Europe and the People Without History* (Berkeley: University of California Press, 1982), 371.

12. Joan Saverino, Notes on Guarascio family history and genealogy diagram, Folder "My Family History."

13. See chapter 2 (55–102), "'Gone to America': Migrating Men and Abandoned Women," in Linda Reeder, *Widows in White: Migration and the Transformation of Rural Italian Women, 1880–1920* (Toronto: University of Toronto Press, 2001), for an examination of the ways in which women's lives and roles were transformed in Italy when men migrated and also the ways in which they played an active role in the migration process itself.

14. Elisa Ricci, "Women's Crafts," in *Peasant Art in Italy*, ed. Charles Holmes (New York: The Studio, Ltd., 1913), 18.

15. Marta Petrusewicz, *Latifundium: Moral Economy and Material Life in a European Periphery* (Ann Arbor: University of Michigan Press, 1996), 180–82.

16. Both Giuseppe Cocchiara, *Il Folklore Siciliano*, v. 1: *La Vita del Popolo Siciliano* (Palermo: S. F. Flaccovio, 1957), and Jane Schneider, "Trousseau as Treasure: Some Contradictions of Late Nineteenth-Century Change in Sicily," in *Beyond the Myths of Culture*, ed. Eric Ross (New York: Academic Press, 1980), discuss the fact that weaving survived longer in the mountainous areas of Sicily, Calabria, and Sardinia.

17. Eric Hobsbawm, *Nations and Nationalism Since 1780: Programme, Myth, Reality* (Cambridge: Cambridge University Press, 1990), 189.

18. Joan Saverino, "Anna Guarascio Peluso: Preserving an Italian Art in West Virginia," *Goldenseal: West Virginia Traditional Life* 7 (Winter 1981): 41.

19. Anna Guarascio Peluso, interview by author, tape 01, 1975.

20. Saverino, "Anna Guarascio Peluso: Preserving an Italian Art in West Virginia," 41–42.

21. Joan Saverino, "Life History of Anna Peluso," unpublished manuscript, 1975, 7–8.

22. Norman Douglas, *Old Calabria* (London: Century, 1915), 205–7.

23. Schneider, "Trousseau as Treasure," 87.

24. Schneider, "Trousseau as Treasure," 99.

25. I have used the term *traditional dress* or *traditional costume* throughout this article to indicate the dress of the *pacchiana(e)*, the term used by the people of San Giovanni to refer to a woman wearing the traditional dress unique to the town. For more discussion on terminology, see Jennifer Michael, "(Ad)Dressing Shibboleths: Costume and Community in the South of France," *Journal of American Folklore* 111, no. 440 (Spring 1998): 166; In *Modern Dress: Costuming the European Social Body, 17th–20th Centuries*; M. E. Roach-Higgins and Joanne B. Eicher, "Dress and Identity," *Clothing and Textiles Research Journal* 10, no. 4 (1992): 1–8; and Don Yoder, "Folk Costume," in *Folklore and Folklife: An Introduction*, ed. Richard M. Dorson (Chicago: University of Chicago Press, 1972), 304.

26. For specifics on the costume of San Giovanni in Fiore, see Ottavio Cavalcanti, "Il costume popolare silano e I suoi ornamenti," in *Atti del Convengno di Studi Storici e Antropologici*, San Giovanni in Fiore, Italy, September 6–8, 1995, by the *Museo Demologico* (San Giovanni in Fiore: *Museo Demologico*), 1995.

27. Joan Saverino, Fieldnotes, November 22, 1991, 47.

28. Schneider, "Trousseau as Treasure," 82.

29. Maddalena Tirabassi, "Bourgeois Men, Peasant Women: Rethinking Domestic Work and Morality in Italy," in *Women, Gender, and Transnational Lives: Italian Workers of the World*, ed. Donna Gabaccia and Franca Iacovetta (Toronto: University of Toronto Press, 2002), 113, 117.

30. Anna Guarascio Peluso, interview by author, tape 05, September 16, 1981, 1.

31. Reeder, *Widows*, 66.

32. Reeder, *Widows*, 92.

33. Charlotte Gower Chapman, *Milocca: A Sicilian Village* (London: George Allen & Unwin, 1973), 99.

34. Saverino, "Life History of Anna Peluso," 9.

35. Saverino, Fieldnotes, November 27, 1991, 52.

36. Chapman, *Milocca*, 96, 98.

37. In fact there are many Guarascios listed in the Utica, New York, telephone book.

38. Even Anna's youngest daughter, Mary, said wistfully to me a few years before she herself died that she would like to contact her grandfather's family in Utica.

39. Saverino, "Life History of Anna Peluso," 9.

40. Chapman, *Milocca*, 111.

41. Reeder, *Widows*, 99.

42. Saverio Basile, "*Il Costume Femminile di San Giovanni in Fiore*," unpublished manuscript, 1982, 1.

43. Saverino, "Anna Guarascio Peluso: Preserving an Italian Art in West Virginia," 42.

44. Saverino, "Life History of Anna Peluso," 10. In fact, the ship manifest, lists Salvatore Spina (age 22), Saverio Oliverio (age 45), Giuseppe Guido (age 50), and Francesco Iuliano (age 29), place of residence as San Giovanni in Fiore, as being on the same ship with Anna and her children, electronic access, October 23, 2005.

45. Saverino, "Anna Guarascio Peluso: Preserving an Italian Art in West Virginia," 42.

46. Chapman, *Milocca*, 97; Schneider, "Trousseau as Treasure," 84.

47. Saverino, "Life History," 11.

48. Saverino, "Life History," 12.

49. Crandall A. Shifflett, *Coal Towns: Life, Work, and Culture in Company Towns of Southern Appalachia, 1880–1960* (Knoxville: University of Tennessee Press, 1991), 67–68.

50. William B. Klaus, "Uneven Americanization: Italian Immigration to Marion County 1900–1925," in *Transnational West Virginia: Ethnic Communities and Economic Change, 1840–1940*, ed. Ken Fones-Wolf and Ronald L. Lewis (Morgantown: West Virginia University Press, 2002), 196.

51. Shifflett, *Coal Towns*, 61, 63; Janet W. Greene, "Strategies for Survival: Women's Work in the Southern West Virginia Coal Camps," *West Virginia History* 49 (1990): 42. Greene's article incorporates oral history excerpts from interviews with women who lived in the camps. See also Deborah R. Weiner, *Coalfield Jews* (Urbana: University of Illinois, 2006), 121.

52. Shifflett, *Coal Towns*, 51–52.

53. Greene, "Strategies for Survival, 37–38; See also Shifflett, *Coal Towns*, 82, 83.

54. For a description of coal company housing, see Karen Bescherer Metheny, *From the Miners' Doublehouse: Archaeology and Landscape in a Pennsylvania Coal Company Town* (Knoxville: University of Tennessee Press, 2007).

55. Saverino, Fieldnotes, 18–19.

56. For a history of embroidery and its association with the feminine changes in that association over time, see Rosika Parker, *The Subversive Stitch: Embroidery and the Making of the Feminine* (New York: Routledge, 1984).

57. Saverino, "Anna Guarascio Peluso," 43–44.

58. Anna Guarascio Peluso, interview by author, tape 04, August 1981, 1.

59. Anna Guarascio Peluso, interview by author, tape 04, August 1981, 1.

60. I later befriended and interviewed Rosina Iaconis during my research trip to San Giovanni in 1991.

61. For a discussion of life integration in relationship to the elderly's production of art, also see Mary Hufford, Marjorie Hunt, and Steven Zeitlin, *The Grand Generation: Memory, Mastery, Legacy* (Washington, DC: Smithsonian Institution Traveling Exhibition, 1987), 38.

62. Kirshenblatt-Gimblett, "Authoring Lives," 139.

63. Joseph Sciorra, "Locating Memory: Longing, Place, and Autobiography in Vincenzo Ancona's Sicilian Poetry," in *Italian Folk: Vernacular Culture in Italian-American Lives*, ed. Joseph Sciorra (New York: Fordham University Press, 2011), 125.

64. Transcription excerpts from Anna Guarascio Peluso are verbatim except for minor grammatical or syntactical alterations to improve readability or to clarify meaning. Anna

did not speak English fluently. The transcription key is as follows: . . . indicates deletion; [brackets] indicate insertion by author; AG indicates initials of person speaking.

65. Barbara Kirshenblatt-Gimblett, "Studying Immigrant and Ethnic Folklore," in *Handbook of American Folklore*, ed. Richard M. Dorson (Bloomington: Indiana University Press, 1983), 41.

66. Barbara Meyerhoff, *Number Our Days: Culture and Community among Elderly Jews in an American Ghetto* (New York: Meridian, 1979), 222.

67. Hufford et al., *The Grand Generation*, 27.

68. Kirshenblatt-Gimblett, "Authoring Lives," 141.

69. Kirshenblatt-Gimblett, "Studying Immigrant and Ethnic Folklore," 41.

70. Hufford et al., *The Grand Generation*, 27.

71. Barbara Meyerhoff, *Number Our Days*, 220.

72. Meyerhoff, *Number Our Days*, 219.

73. Giovanna Beafore Clayton, personal communication via Facebook, April 26, 2011.

74. Meyerhoff, *Number Our Days*, 219.

75. Barbara Kirshenblatt-Gimblett, "Objects of Memory: Material Culture as Life Review," in *Folk Groups and Folklore Genres: A Reader*, ed. Elliott Oring (Logan: Utah State University Press, 1989), 333.

76. The size of the squares vary somewhat. The squares I own range from fifty-eight to sixty-six centimeters in width.

77. The typical embroidery in San Giovanni consists of pulling the warp and weft, cutting some threads, and then filling in the resulting spaces with linen threads (*ricamo sfilato e poi riempito*).

78. Personal communication, Lina Iaquinta, fall 1991.

79. Mary Carruthers discusses mnemonic devices for memory retrieval in *The Book of Memory: A Study of Memory in Medieval Culture* (New York: Cambridge University Press, 1990).

80. Luisa Passerini, *Autobiography of a Generation: Italy, 1968,* trans. Lisa Erdberg (Hanover, NH: Wesleyan University Press, 1996), xii.

81. Hufford et al., *The Grand Generation*, 64.

82. In 1981, I was awarded a United States National Endowment for the Arts (NEA) Apprenticeship with a Master Artist grant to study embroidery with Anna. This particular program was discontinued after one year. Beginning in 1982, NEA instituted the National Heritage Fellowships program for master folk and traditional artists to be recognized for excellence and to honor their contribution to our national heritage. Although under the 1981 program, Anna was acknowledged as a master artist, because the award was technically a different program, she is not listed as a National Heritage Fellow.

83. Joan Saverino, Fieldnotes, Book 1, June 1981 to December 1981.

84. Joan Saverino, Fieldnotes, Book 1, June 1981 to December 1981. *Aiegneletto* was Anna's spelling. Rosina named the patterns in 1991 for me and spelled the same pattern *aietola*. The chain is *cattanila* in Rosina's spelling; *catiniglia* in Anna's spelling; the star pattern is *pessillilo* in Anna's spelling; *passulilli* in Rosina's spelling. Both Anna and Rosina were literate but with limited education. My summation is that they were spelling the words according to ear and had never seen the names of the patterns written. Another explanation is that for

Anna there was a lapse of decades when she was not embroidering and so, being a lone culture bearer, she might have forgotten the exact pattern names. Lina Romano, my landlady, who was also a *ricamatrice* but was about twenty-five years younger than Rosina, said that the elderly women remembered older names for the patterns. Fieldnotes, Book 1, 1981, and Fieldnotes (red book), 1991.

85. Saverino, "Anna Guarascio Peluso"; Richard Ahlborn was a curator at the Smithsonian Institution's National Museum of American History and collected two pieces of Anna's work for the museum's permanent collection.

86. Hufford et al., *The Grand Generation*, 56.

87. Ann Rosalind Jones and Peter Stallybrass, *Renaissance Clothing and the Materials of Memory* (New York: Cambridge University Press, 2000), 3, observe that cloth materializes memory.

Il corredo: Loss and Continuity in an Italian American Family

—Jo Ann Cavallo

"Your grandmother had a *corredo* for you, linens and things," my father mentioned over dinner a few months after my grandmother's death in 1976. "It's somewhere in the old house, but who knows where?" Although I would have liked to know more, I didn't press my father to search for it because I realized he was reluctant to return to the vacant house. During my childhood the Cavallo family used to gather at my grandparents' home in Vaux Hall, New Jersey, by noon every Sunday for "dinner" and spend the rest of the afternoon together. Unfailingly seated around the table were my father's siblings, Ange and Fred, who lived with their parents, along with their brother Frank and his wife, Minnie, who, like my parents, had moved to a nearby town. Although we continued the tradition after my aunt Ange and my grandfather died earlier in the decade, with my grandmother's passing the family fabric became unwoven. The house remained empty as my uncle Fred moved into the apartment of his lady-friend. My parents moved down the shore, and soon the relation among the three brothers was reduced to Christmas cards and occasional phone calls.

Besides, from what I had gathered, a *corredo* seemed no more than an antiquated custom requiring brides to supply such mundane items as bedsheets and dish towels. Coming of age in the 1970s, my high-school friends and I had pushed for the ratification of the Equal Rights Amendment, cheered for tennis champion Billie Jean King, and subscribed to *Ms.* magazine. The idea of a trousseau or a hope chest evoked a past in which women were confined to domestic spaces and lacked equal rights and opportunities in the outside world. Like Virgil's warrior maiden Camilla, we were not trained to handle Minerva's distaff and wool basket, but to stand up to arms in battle and to race against the wind.

While growing up, I had no inkling of the fundamental role that *biancheria* had traditionally played in the lives of women since ancient times. Nor

could I have imagined that, decades later, while teaching Columbia University's Literature Humanities course, I would come across so many examples of exceptional female characters from classical Greek and Roman literature skilled in the art of needlework. Turning to the *Iliad*, the *Odyssey*, and the *Aeneid*, I find Helen weaving a robe depicting the momentous struggles between Trojans and Achaeans, Penelope at the loom creating and unraveling Laius's funeral shroud in order to impede her remarriage, and Andromache giving Aeneas's son Ascanius robes she had woven herself as both a testament to her love for Hector and the only surviving material gifts from their fallen city. Even the most revered Olympian goddesses stake claim to the art, whether it be Aphrodite appearing to Helen in the guise of a woolmaker (*Iliad* 3) or Minerva herself, goddess not only of wisdom and warfare but also of weaving, descending to earth for her famed contest against the defiant and inimitable Arachne (*Metamorphoses* 6). Herodotus, in fact, considered women and needlework so closely connected in his ancient Greek culture that, when depicting Egypt as a land in which all gender customs were reversed, he remarked that there it was the man who stayed at home and did the weaving (*Histories*, Book 2). These associations did not mean, however, that the gentler sex was unfit for other tasks. Indeed, in Aristophanes's *Lysistrata*, the plucky female heroine explains how the world would be better off if run by women who would govern the state in the same fashion that they treated wool. But as a teenager I knew nothing of such models.

A few years passed before my father mentioned the subject of my *corredo* again. He was compelled to visit the old house after he was notified that it had been burglarized, and he mentioned that he would use the occasion to pick up some of his belongings and look for those linens my grandmother had wanted me to have. By then I was majoring in Italian in college, and I understood that a *corredo* consisted of needlework pieces handcrafted with patience and precision by young women who intended to use them later in life as they fulfilled their roles as wives and mothers. Although I had forgotten about my father's previous mention of a *corredo*, I was suddenly anxious to see my grandmother's handiwork. I viewed it as a gift that represented my family's heritage and that I could in turn pass on to the next generation when the time came.

As my father left to meet his older brothers at the empty family home, it occurred to me that, although I could vaguely envision a canister with skeins of yarn somewhere in the house, I did not remember ever seeing my grandmother doing needlework. Nor had I ever seen her at work on her old-fashioned Singer sewing machine, even though I knew she made dresses for herself and Aunt Ange. Perhaps that was because we mostly visited her on Sundays, when she and my aunt were busy in the kitchen. We

Dresser scarves with crocheted sides and Grandmother's Singer sewing machine. (Courtesy of Jo Ann Cavallo.)

sometimes arrived in time to see them rolling dough or cutting gnocchi on a wide wooden pasta board. Around Easter time she would make a dish we called "beets-a-gain," which, as I was later told, corresponded to "pizza *piena*," because it was in fact a "meat pie," full of meat, egg, and cheese. In the afternoon we would gather in the parlor or on the front porch if the weather permitted. When friends or relatives came to visit, my grandmother would sometimes comment on their news by saying: "The bed you make is the bed you lie in." When she said phrases in Italian, or perhaps in dialect, I would jot them down in my little blue notebook. The first words in the list were "Doze belle," my improvised spelling for the Italian phrase "*tu sei bella*," meaning "you are beautiful," as indeed all grandchildren are in their *nonna's* eyes. In my family's case, I was the only grandchild. Of my father's three siblings, neither Ange nor Fred had married, and Frank's marriage did not bring me any cousins.

The hope chest was nowhere to be found, my father reported upon returning, undoubtedly gone the way of the antique figurines, cameos, coins, and other missing valuables. This news triggered in me not only a sense of loss, but also a desire to know more about the needlework that comprised the *corredo*. My father could only recall that my grandmother liked to crochet

whereas my aunt had preferred embroidery. It then occurred to me that the *corredo* must have been originally intended for my aunt if she ever were to marry. I remembered sitting on her lap as she sang old American tunes like "How Much Is That Doggie in the Window?" and "All I Want for Christmas Is My Two Front Teeth." Aunt Ange, really Angelina, had lived at home and worked in a factory in nearby Maplewood until her retirement, duly commemorated with a Helvetia ladies watch. It is not clear to me whether this customary retirement gift is meant to demonstrate a company's appreciation for the time spent in its service or to inaugurate the free time available after years of labor, but in my aunt's case it marked time's inexorability, since she suffered a stroke and died shortly thereafter. I was given Aunt Ange's watch, along with her diamond ring, as a keepsake, but I never wore either for fear of losing them. Now, however, it seemed that I had lost her *corredo* even before coming into possession of it. Why had I never thought to seek it out before it was too late?

My sadness over the missing trousseau laid bare a deeper regret of not knowing more about my Italian family. I should have asked my grandmother to tell me what she remembered—the experiences of her youth, the life story of her own parents, her recipe for the *zeppoli* she made on St. Joseph's Day, her incantations against headaches that proved uncannily effective. I had filled in only a few pages of my ambitiously titled "Italian-English dictionary," but I would have been able to cover the notebook with her sayings and proverbs. Like Perceval at the palace of the Fisher King, I had lost access to the Grail by having failed to pose the vital questions. Any subsequent bits of knowledge to be gained would necessarily have to take the form of a quest.

During junior year abroad in Italy the following year, I traveled to my grandparents' birthplace of Montefalcione, a beautiful hill town of a few thousand inhabitants near Avellino, in the Campania region. My grandparents themselves had returned there only once, for a week, to sell a plot of land my grandfather had inherited from his parents, but after that my grandmother had continued to correspond with three elderly unmarried sisters from the town. When I wrote them that I would be stopping to see Montefalcione while traveling during Easter break, they invited me to stay with them for the holiday. My gracious hosts, whether out of concern for my safety or their reputation, did not let me leave the house to explore the town unless in their company or in that of the trusted Gennarino, a cousin many-times-removed. Luckily, Gennarino was happy to take on the role of tour guide to his American cousin, showing me not only Montefalcione and its surroundings, but driving as far as Caserta for a picnic on Pasquetta, the holiday celebrated the day after Easter that young people generally spend with their friends. Gennarino also introduced me to a distant uncle and

aunt named Carmenuccio and Pasqualina, although I didn't quite understand how they were related to me.

While in Montefalcione I also found that the town's patron saint was Saint Anthony of Padua, which helped to explain why this figure was so important to my grandparents. In fact, each year on the last Sunday of August the community of Montefalcionese immigrants would celebrate his feast day. Our family used to walk to the nearby church where we waited in line to pin dollars on his statue and then received bread blessed by the priest. Although the Vaux Hall feast was not famous like the one in Boston's North End, it was the big event of the year in the neighborhood and always ended with a display of fireworks. In Montefalcione, my hosts took me to the Sanctuary of Saint Anthony, which we reached by passing through a twelfth-century gate marking the entrance to the medieval part of town. Perhaps because it was Holy Week, every day they brought me to mass, which was attended almost exclusively by women.

When Montefalcione was one of the towns hit by a massive earthquake on November 23, 1980, Gennarino came to stay for a time with relatives of his on a nearby street in Vaux Hall. He joked that when *zio* Carmenuccio and *zia* Pasqualina learned of his trip, they wanted to give him a big cheese to take as a wedding present because they thought he was coming to propose to me. My grandparents' birthplace no longer seemed so far away. Nevertheless, no one from the town had been able to provide me with any further information about our family.

Thanks to a genealogy search, I found out that my grandmother Mary, really Armida, came to New York in 1897 at the age of four with her parents and siblings, while my grandfather James, really Vincenzo, was born in 1890 and set out for America on his own at the age of sixteen. From a visit to my uncle Frank, born in 1917, I learned that my grandfather had lived in Boston before moving to New Jersey and that he would never eat polenta because it had been served so relentlessly during his long journey across the Atlantic. My uncle also related other pieces of family history, such as the existence of an older sister who died of diphtheria as a child. His living room was graced by his woodworking and by doilies that my late aunt Minnie had crocheted.

It was only when my teaching and research as a university professor led me back to Italy in the late 1990s that I began to glimpse the astounding range of traditional handiwork created by women in every region of the country. While tracking down *l'opera dei pupi* (puppet theater) across Sicily, I saw many examples of *punto antico*, intricate drawn thread work. A woman selling curtains embellished with this style of counted-thread embroidery in Palma di Montechiaro, near Agrigento, explained that each piece required several weeks to complete. While directing Columbia's summer program in

Scandiano, in the province of Reggio Emilia, I learned about Ars Canusina, a stylized embroidery that the psychiatrist Maria del Rio developed in the early 1900s as a healing therapy, using designs inspired by ornamental motifs from the time of the countess Matilde di Canossa (1046–1115). Accompanying students to an opera at the Arena in Verona, I was drawn to *il pizzo di Verona*, exquisite Veronese crocheted lace, displayed in storefront windows. It seemed that every place I visited had a specialized form of needlepoint. Regretting the disappearance of my *corredo*, I would have purchased some handcrafted *centrini* (centerpieces) if they hadn't been so costly.

During a visit to Palazzo Schifanoia in Ferrara I purchased instead a poster that featured women weaving. It is a detail taken from the upper-level fresco representing the month of March in the palace's Sala dei Mesi. Excluded from the reproduction is the central scene depicting an armed Minerva riding a chariot as well as the group of philosophers standing to her right in various poses of reading and discussing, presumably the liberal arts that are under her protection. The print captures instead the group of females to Minerva's left, comprised of the three Fates handling thread in the foreground and about thirty young textile workers gathered around a large loom. The sense of continuity between the symbolic space of the goddesses determining human destiny and the labor of the industrious women creating textiles is striking. If it were not for the title of "Le Parche" under the print, one could mistake the Parcae for the mortal weavers above them, dressed as they are in the same clothing, their delicate faces conveying the same expression of quiet concentration. Wasn't weaving, after all, a metaphor for life itself? But could threads ever be reconnected once they were broken?

My uncle Fred eventually returned to the family home where he spent his final years. After he passed away in 2002, my father and my uncle Frank finally decided to put the house up for sale. They were selling it "as is" and leaving the task of clearing it out to the new owner, perhaps to avoid digging up painful memories. When I told my father that I wanted to visit the house one last time, he gave me the key and told me to check whether there was anything that I would like to have.

As I drove up to the house, I saw that the brick steps leading to the front porch were cracked and sagging, the yellow window shades were pulled down, and the porch that once welcomed visitors with its trellis of climbing roses and green wicker chairs was now empty, except for a stray cat on the worn-out doormat. Across the street there was a plot of land large enough to build another house, but my grandfather had reserved it for growing vegetables that supplied the family's needs—tomatoes, peppers, eggplant, zucchini, beans, and the like—as well as tobacco that he both rolled into cigars

Doilies with purple and yellow flower edges crocheted by Grandmother Mary Cavallo, Italian decorative ceramic bowl with floral lid, and the family portrait from Frank and Minnie Cavallo's 1951 wedding. (Courtesy of Jo Ann Cavallo.)

and smoked in his pipe. When I was very young, he would pick basil and crumble it in his hand, releasing its fragrance for me to savor. As could be expected, the once-vigorous garden had given way to a field of overgrown weeds with some trash haphazardly strewn about. Nor was there any sign of the immense fig tree whose fruit we used to pick from my aunt's upstairs bedroom window or the grape arbor that my grandfather had constructed behind the house. It was hard to believe that the backyard had once been bustling with rabbits, chickens, pigeons, and even a pig.

The changes wrought by time outside the house stood in stark contrast to the extreme state of preservation within. Entering through the front door was like stepping back into my childhood. Although almost three decades had passed since my grandmother's death, everything appeared as pristine as she had left it, from the Persian rugs to the crystal chandeliers. Uncle Frank and Aunt Minnie's 1951 wedding photo stood on the fireplace mantle in the parlor along with my father's 1953 high-school senior portrait and my 1959 baby picture. In the dining room were the china closet, buffet, credenza, and table we had never sat at and that still looked new even though a sticker underneath the table had the date of 1928. There were complete

sets of dishes, including one they had accumulated piece by piece through the promotional offer of a local cinema, and fancy glassware of all sizes. The kitchen, with its Formica-top table and shiny vinyl chairs popular in the 1950s, looked as though it had never been used.

It was in the downstairs basement kitchen, after all, that we had eaten all that macaroni. I recognized the porcelain-top farm table and the mixed dishware in the pantry that bore the nicks and chips of decades ago. The player piano, already out of tune when I was growing up, stood silently along the wall. The rest of the downstairs was dedicated to my grandfather's workshop, which was lined with every kind of tool imaginable. A master craftsman, he had made most of what he needed by hand, from copper funnels he used in wine-making and massive wooden spoons for the pasta pot to an outdoor swing and sandbox for his granddaughter. On the wall above his workbench hung a framed group photo of about forty-five men of all ages, some holding *bocce* balls. There my grandfather stood smiling next to a large banner that read *Fratellanza S. Antonio, fondata 1914*. Small print identified the occasion as the Brotherhood of Saint Anthony's twenty-fifth anniversary outing, July 1939.

Before heading back upstairs, I peeked into the wine cellar. Mason jars filled with homemade tomato sauce and peppers formed neat rows across the cabinet shelves. The wine press stood in the back corner along with the barrels, and gallon jugs of red wine lined the floor. My grandfather used to send me into that little room to fetch a bottle of wine before sitting down to Sunday dinner, and he would inevitably reward my efforts by pouring a bit of it into my glass of lemon soda.

When I ventured into the attic, I was surprised to find a baby carriage, crib, tricycle, rocking horse, games, and dolls galore—a reminder that I had lived with my parents in the house until I was almost three. I wound up the handle of a painted metal jack-in-the-box from before the era of plastic, and the notes still rang out the familiar tune of "Pop! Goes the Weasel." A huge cardboard box contained an assortment of stuffed animals, including a giraffe that was taller than me when I'd won it at the Seaside Heights boardwalk. Another box contained beautiful 1950s-style dresses that only my slender-waisted mother, Jacqueline, could have fit into. I set these aside to show my ten-year-old daughter Cristina. Army clothes that belonged to my father, Joseph, in the next box would be of interest to my eight-year-old son Alberto, who was obsessed with G. I. Joe action figures and comic books at the time.

With some hesitation, I ventured beyond our section of the attic and opened a trunk that contained Uncle Fred's army clothes from World War II and brightly colored *copriletti*, bedcovers, that he had brought back from

Italy upon his return. From various papers tucked away to the side I learned that he had been inducted into the army in February 1942 and that by 1945 he had reenlisted and served as a staff sergeant in Livorno, Tuscany. The tags on his trunk and travel bag showed that he had returned home on the steamship *Vulcania* at the end of 1947. Along with a stack of postcards and letters he had sent to my grandmother from Italy were two letters from a certain Francesca mailed from Florence to his Vaux Hall address in December 1947 and January 1948. The first letter, in Italian, was the response to a postcard he had sent from Naples just before his departure, while the second one, in English, began by expressing joy at having already received two letters of his from New Jersey. She continued: "If it is true, an immense distance separates us, but it is equally true that when two persons love each other as tenderly as we do there exists no obstacles. [...] In your second letter you ask me if there is any way to come to the States. I shall ask in the apposite places and then let you know all about it." Had I come close to having an Italian aunt? I would never know. My father said that his brother had never spoken about his years in Italy. The window into my uncle's past closed back shut at the end of that letter.

Taken aback by the unexpected revelation, I wondered whether it was right to unlock memories of a past that did not belong to me. Perhaps it was out of a sense of respect that my father and Uncle Frank had decided to leave the house untouched. Could I continue to search for my identity through family history without invading their privacy? Or did I risk replaying the part of Pandora, who out of curiosity unleashed a host of plagues and sorrows upon the world? Uncertain whether to go on, I watched particles of dust linger in the air before settling back down on worn, broken chairs and other household objects once deemed too precious to discard and now abandoned to their fate. It was getting late in the afternoon. As the sunlight began to fade, pieces of furniture and racks of clothes cast long shadows into recesses that the bare light bulb suspended above me was hardly equipped to illuminate.

I felt compelled to continue for a little longer while some light still entered from the windows. The next set of boxes belonged to my aunt Ange. There was mostly clothing, pocketbooks, hats, and shoes. One fancy black dress with pastel flowers had the price tag on it from Macy's in Newark, indicating that she had never worn it. Was it that the right occasion had never arisen or that she suffered the stroke prior to the event for which she'd bought it? She had never worn a wedding dress, either, I thought, remembering a conversation that occurred a few months after she died. It was a Sunday, and friends of my grandmother had paid her a visit while we were sitting in the parlor. The television had been shut off indefinitely as a sign of mourning,

so perhaps I was more attentive to their dialogue than I would have been otherwise. They told her about the death of a fellow named Anthony whose last name I didn't recognize. My grandmother clearly knew him, though, and she began to talk with her friends about how young he was, like Ange, about how strange fate is, and that if Ange had agreed to marry him, they would have died at the same age. I didn't have the heart to inquire about the broken romance with either my grandmother or my father, who was twenty-four years younger than Angelina and had considered her more of a second mother than a sister.

I decided not to open any more boxes. In any case, by this time there were very few left and the sun had already begun to set. Before turning to make my way out from the labyrinth in the impending darkness, though, my eyes fell upon a large trunk pushed against the wall. Kneeling under the sloping roof, I pulled the trunk toward me a little and lifted the lid. The next moment I found myself looking upon a stack of crocheted doilies, potholders, placemats, and tablecloths, along with embroidered bath towels, dish towels, handkerchiefs, nightgowns, bedsheets, and pillowcases. There was a drawn thread tablecloth, napkins, and doilies in a matching style. Underneath all of the handcrafted *biancheria* were Millford sheets and pillowcases, plus yards and yards of folded muslin fabric. As I stared blurry-eyed at what I knew to be *il corredo*, I wondered why I hadn't been looking for it all along. Or perhaps I had been doing just that without consciously acknowledging it. Whichever it was on my part, I thanked the Fates for bringing my grandmother and aunt close to me again, not only as the female relatives who had nurtured me during my childhood, but as part of a group of Italian American women who had carried their traditional skills and life-enriching crafts with them from the old land of their mothers to the new land of their daughters.

That day I drove home with my *corredo*. The next week, with the consent of my father and uncle, I hired a moving company and returned to Vaux Hall for as many pieces of furniture as could reasonably fit in my smaller house. My own previous furniture was brought to the curbside so that passers-by could help themselves to it. My children and I then brought life to the many family possessions that we welcomed into our home, eating daily on the porcelain-top farm table and making fresh orange juice with the old-fashioned manual juicer. We placed the crocheted tablecloth over my grandparents' dining-room table and doilies on the rest of the furniture. In my upstairs bedroom, I began using the heavy *copriletto* in winter and the crocheted bedspread in the spring. The art may have been lost in our family, I thought, but at least I was blessed to have the artifacts.

It would not be totally accurate, though, to say that needlework was no longer a pastime of the women in our family. A couple years later, when my

Tablecloth crocheted by Grandmother Mary Cavallo; grandparents' china set, candelabra, and dining-room table and chairs from 1928. (Courtesy of Jo Ann Cavallo.)

daughter was in seventh grade, she spontaneously expressed a desire to take up crocheting. Despite my skepticism that it would be too difficult to learn on her own, she insisted on taking out instructional manuals from the local library and received further assistance in mastering the basic stitches from my mother, whose specialty is Afghan blankets. What I had assumed was a passing whim became one of my daughter's preferred pastimes, resulting in an array of blankets, scarves, hats, and sweaters for family members, friends, and favorite teachers. To be more precise, then, what was missing from our modern family was knowledge of the intricate stitches used by Italian American immigrant women like my grandmother.

Yet the Fates don't only spin, measure, and cut single threads; they weave them together in unforeseen patterns. During the summers my children and I spent in Scandiano, our lives had become entwined with that of our neighbor, Franca Iotti. When I brought my teenage daughter and son back with me to the town while on a research leave in the fall of 2006, Franca spent many evenings sharing her traditions and pastimes with us. After dinner we sometimes played the card game *briscola* or sang folk songs like "*Quel mazzolin di fiori*" ("That Little Bunch of Flowers"). Thanks to Franca's impromptu cooking lessons, Alberto became the designated expert in

gnocco fritto, rectangles of rolled dough deep-fried in lard, and Cristina perfected the technique of making fresh pasta with a meter-long rolling pin. As Christmastime approached, we gathered around Franca's kitchen table along with her mother, Erminia, and other neighborhood women to form *cappelletti* (Emilian-style tortellini). As it turned out, Franca and her mother were also adept in the art of crochet, or *l'uncinetto* in Italian, and their homes were decorated with examples of their work.

Franca was always willing to answer our many questions about her experience as a young girl growing up in a farming family, and she happily obliged us when we asked about the assembling of a *corredo*. This custom, she explained, allowed young women to put their talent on display in works that would subsequently personalize their living space. It was especially vital to those brides who moved in with their husband's families under a patriarchal system, since it would have allowed them to surround themselves with things they truly owned. Franca herself had learned to crochet from her grandmother and mother when she was nine or ten years old and then practiced various techniques of needlework and sewing in intermediate school where three years of domestic economy courses were compulsory. In the evening the women of the family, sometimes in the company of their neighbors, would crochet or embroider together. "We could never have our hands idle," she recalled, "so when we finished one project we started another." By the time Franca married in 1972, she had a sizable *corredo* that she had accumulated over the years with the contribution of her grandmother and her aunts. She had especially enjoyed embroidering designs and flowers, such as colorful daisies and violets, on dish towels, bath towels, aprons, and linen napkins. In the years immediately following her marriage, however, Franca noticed that the young women around her no longer put together a *corredo*. Needlework fell into disuse, except for a few specialists who have retained the art. Like many other rich cultural traditions that had once characterized Italian and Italian American life, this one had fallen by the wayside, a victim not only of a shifting attitude toward gender roles but also of an increasingly media-driven, fast-paced consumer society on both sides of the Atlantic.

The evolution in bedsheets, however, suggested that at least some of the changes were determined by sheer practical aspects. When Franca's mother was young, sheets were made by first weaving flax on a loom and then sewing together the squares of linen. For Franca's bedsheets, however, her mother had purchased the linen and her aunt had embellished the borders. Both kinds were customarily washed in the open air twice a year, spring and fall, with a huge pail of boiling water and ashes, and their robust quality allowed them to repeatedly withstand this rigorous manner of manual washing. Around the 1970s, Franca told us, people started buying colored bedsheets that came

ready-made in stores. Her nephew and his wife, for example, would never use a white-linen bedsheet and she wouldn't even think of giving them one as a gift. In fact, Franca herself had definitively put away the sheets from her *corredo* and used only the store-bought variety because they were lighter, softer, and easy to wash weekly in the washing machine. In this case it would be hard to deny that innovations brought by modernity had increased comfort and lessened the burden of domestic chores.

I was touched when Franca responded to my daughter's fascination with the art by giving her several doilies. Mamma Erminia generously added some of her crocheted potholders as well. It didn't occur to me that Cristina could actually learn those intricate patterns, however, until she surprised us at Christmas with a crocheted *centrino* that resembled some of the needle-work in my *corredo*. As she later explained, one afternoon as she was scrutinizing a crocheted piece trying to unravel the mystery of its stitch, Franca volunteered to teach her the pattern. In this way, the chain that Nonna Armida had woven in America so long ago was picked up and continued through the stitching of her great-granddaughter while back on Italian soil.

Domestic needlework, as I am reminded whenever I teach the Literature Humanities syllabus, is not only an Italian and Italian American tradition, but an ancient art used by women of the Mediterranean and beyond throughout the centuries to express themselves creatively, lending meaning to their daily lives. Whenever I read about Virginia Woolf's Mrs. Ramsey knitting socks for the boy staying at the lighthouse or using her green shawl to cover a boar's skull on the wall that frightened her daughter at bedtime (*To the Lighthouse*), I can connect this archetypical female character to the lived experience of the women in my own family. Looking around my home, I have to acknowledge that the Fates truly are women with thread in their hands. While some strands are cut away and forever lost, others can be pulled back into the fabric and combined with new ones that are being constantly woven into the tapestry of our lives.

Bitter Trade: A Castle for a Trousseau

—Giovanna Miceli Jeffries

"The best years of my life were spent in the embroidering rooms and court-yard of the *istituto* (nuns' convent)," my mother would tell me. I saw sadness and fleeting dreaming on her face. Her mouth relaxed into a soft smile as she took a brief pause from her ironing or mending. It was evening, and we were in the kitchen of our second-floor duplex in a new Italian neighbor-hood on the north side of Montreal. After a long day at the garment factory where she and I had worked standing on our feet for seven and a half hours, cutting threads from finished skirts and pants, my mother would start pre-paring dinner without asking my sister and me to help her. After dinner, and once she had finished cleaning the kitchen, she would sit down for ironing or mending. It was close to relaxation to her, or it seemed to be.

"We were so hopeful, full of dreams; we would joke, play tricks on each other and sometimes on the nuns, talk and talk about prospective *fidanzati* (fiancés) while not missing a single stitch, *punto erba, punto ombra, punto occhiello* (grass stitch, shadow stitch, little eye stitch); the stitches were as lovely and sweet as our songs and prayers." My mother would reminisce about the years she had spent in the early 1940s embroidering her trousseau at the Sisters of Sant'Anna's day-convent in our Sicilian hometown, Ribera, in the province of Agrigento, the ancient Akragas the Greeks founded in the fifth century BCE and filled with magnificent temples. I sat at the kitchen table, next to her, reading a book or an Italian magazine, interrupting my reading once in a while to turn the inside out of shirts and underwear, which she would then iron. Her voice went into a parabolic inflection as she set the iron aside and looked far away, past the small, dark window of the new Canadian kitchen she kept spotless. The cabinets, the linoleum floor, the new appliances attracted and demanded her innate sense of cleanness, and she enjoyed looking at that modern, ordered kitchen, so different from the one she had left in Italy. Because we were renting, she felt an additional obligation to keep it as neat as possible. The hardwood floor that covered the rest of the apartment intimidated her. She was almost afraid to walk and make noise.

Educandato di Sant'Anna, Ribera (Agrigento province, Sicily), 1943. (Courtesy of Giovanna Miceli Jeffries.)

She finished ironing a white pillowcase with a modest embroidery of green stems and a few red poppies, for she would not dare put to regular use her truly "good ones," still untouched, neatly arranged inside the drawers of her new Canadian dresser. "I remember when I embroidered this pillowcase," she said, shaking her head. "It was one of my first work at the *istituto*. I was still learning." Then she folded it, caressing it with one last warm pat of the steaming iron. "*Vita amara!*" (bitter life), she said and sighed, slowly shaking her head, resisting a wind of atavistic rebellion to destiny, resigning herself to her impotence to harness some invisible yet deeply felt force that had changed her life.

The photo, taken in 1943, depicts thirty-four young women dressed in white frocks: In the first two rows they sit on chairs with their needlework on their laps, the right hand pulling the needle, the other resting on the white *pelle d'uovo* (eggshell texture) white cloth. Two nuns of the order of Sant'Anna, in black tunics and black floppy wimples, stand guard on each side of the rows. As I write (almost seven decades after that picture was taken), in the study of my Midwest house, I look at the irregular-sized, rectangular, black-and-white photo sitting on my old oak desk and cannot help but see two guardian angels' stern faces protecting and limiting all the dark-haired young women within the convent's courtyard. The rows are ordered by age, with the youngest of the group, girls of about fourteen, in the front. My mother, legs crossed, flanked by two smiling girls, sits in the middle of the first row, almost expressionless. Her mouth is a straight line. Her black, wavy hair cascades on her white shrouded shoulders. In the back row, the girls are standing, and with the exception of one seemingly distracted with fixing the collar of her smock, all seem to radiate self-confidence, their smiles wide and even worldly. I recognize a number of these older girls.

They belonged to prominent, wealthy families. This advantage, plus the two or three years of age difference, distanced them considerably from the rather somber, almost scared girls in the first row.

In my hometown, the most reputable place to learn the art of *ricamo* (embroidery) was the *Educandato di Sant'Anna*. The convent, called *istituto* (institute) by the girls, was housed in a building that had ironically been converted and restructured by an earnest priest around 1928 from its previous use as a "house of tolerance."[1] The girls would spend two to four years, between the ages of thirteen and seventeen, taking daily embroidery lessons at the convent and working on the linen pieces of their *biancheria*—sets of tablecloths, top bedsheets, and pillowcases, bedspreads, all in even numbers. The convent was located at the very end of Corso Umberto, the town's main street, which we also called the "piazza." Corso Umberto finished at the railroad station, the limits of town, and the convent was less than a block away. For the girls who, like my mother, lived on the opposite side, in the northern part of town, it was a twenty-five-minute walk, downhill in the morning, uphill in the evening. But the young women would not hurry back home after eight hours of embroidering. Slowing their stride, perhaps they lingered for ten or twenty minutes (longer than that would have been noticed and would have elicited harsh reprimands at home). The very few who could afford it would stop by Ciliberto's stationary and bookstore to buy *La donna*, a monthly magazine for women featuring also serialized novels and short stories. Most, however, just allowed themselves to chat, gossip, dream a little, share secrets in the early evening hours. At home, the chores of the evening were awaiting them. The echo of the songs and hymns in praise of the Virgin Mary that soothed their long day at the *telaio* (embroidery frame) at the convent would miserably crash down against the hurried, resentful notes of their tired and tried mothers, syncopated by the crescendo of the shouts of the men of the house—fathers and brothers—who, exhausted after a day of work in the fields, were either shivering in the cold of badly heated homes or sweating in the heat of the Sicilian summer. The young, dreamy women would not even notice or reflect on how this not-too-infrequent ritual might represent a preview of their future lives, when, after the thrill of the formal engagement time and the joyous wedding preparations, life's circumstances—raising a family, tending children, suffering bad harvests, worrying over debts, and coping with strict mothers-in-law—would eventually spoon out predictable lives, often not too different from those of their own mothers.

During those years, in addition to teaching the girls to embroider for a monthly fee paid by the families, the mission of the nuns was to "protect" the young women from the world, reinforce chastity, devotion, and sacrifice.

The girls started their day at 8:00 a.m. and spent the first part of the morning working on their projects, which was followed by a short interval of prayers and songs. On particular days, such as the first Friday of the month, they would attend a thirty-minute mass in the small chapel. At noon they would gather in the courtyard in the summer, or in the dining room in the winter, to eat their lunch. After lunch, they would stroll around the courtyard's perimeter to loosen up their stiffened limbs and then return to their work for three more hours, interrupted only by another interval for afternoon prayers and songs. By the end of the second or third year, a young woman would have had a head start on most of her trousseau or at least would have learned the most intricate, time-consuming stitches and embroidering techniques. She was thus able to work at home, with her mother's guidance, to complete all the pieces of her trousseau before getting married. It was understood that, once she became engaged, she would no longer be allowed to go to the institute. The newly engaged woman would spend half of the morning helping her mother do house chores, and then she would start embroidering, often with her mother's help. In the evening, when the *fidanzato* came to call, she would continue to embroider, using a round embroidery frame balanced against her chest, stopping a few times to chat with him and her parents, who were always present in the room. Only when guests and the future in-laws paid a visit would her *telaio* rest away from her: Her hands would then be crossed on her lap, her eyes moving around the room, exchanging glances, looking for cues from her mother when to pass around the refreshments: First a large bowl of roasted chickpeas, then a tray of almond biscotti, to finish with the *rosoliera*, a silver-plated tray with little glasses sitting on a rack and filled with *rosolio* liqueur.

My father's humorous recollections of his "so-called engagement period" were about his frequent arguments with my grandmother as he unsuccessfully petitioned her to permit my mother to quit working at her *telaio* in the evenings. He was convinced, he would tell us and her, that behind my mother's evening embroidering was my grandmother's scheme to prevent her daughter from sitting very close to him—in the immediate postwar years, it was not yet generally accepted for the engaged couple to sit next to each other. But my grandmother had a solid argument in her favor: My mother was behind with completing her trousseau.

When I became engaged to an American man in the early seventies, my mother realized with chagrin that I did not have any *biancheria*. I did have two pretty tea towel sets that I had received as a going-away present when my family and I had left for Canada in 1965. These tea towels were decorative pieces, with little functional value. They were customary gifts presented to young women, like a bottle of cologne or a silk scarf. So, although

nobody I knew served tea in the afternoon and thus never needed those nice towels, most young Sicilian women would have had at least six such sets in their hope chests.

My mother's concern about my *biancheria* during the first months of my engagement began to seep into me. I was still vulnerable to the sense of pride associated with the solidity of "things," with owning land, property, even *biancheria*. Without *biancheria*, I felt as if I were engaging in a sort of "cheap" matrimony, as if I were eloping. I was twenty-six, and my family and I had moved from Montreal to New Jersey two years earlier. After seven years of working in a garment factory in Montreal and after that in an office, I was now in graduate school, pursuing a master's degree in Italian to become a teacher and fulfill the vocation I had envisioned some years before, as an eighteen-year-old still living in Sicily.

I talked about my trousseau to my fiancé, and occasionally to a few of our friends, with a mix of embarrassment and dignity. It was as if my trousseau were a banner announcing a birthright for a female of my background that planted me firmly in an ancestral time, long before the *Mayflower* and my recent, shaky immigrant condition.

I grew up in a culture in which one's personal value and pride did not arise from one's inner self or one's personhood (even if one were beautiful and gifted). You were defined by your family's stature in the community, its history—especially if you were a woman: "The daughter of so and so." And if you or your own parents had some blemish in their personality or deeds, you could find solace in being identified as the "granddaughter of that honored woman or man." Therefore, when my parents insisted that I would not be allowed to marry, even in the United States and to an American man, "naked," that is, without *biancheria*, I felt a surge of pride—the ancient blood rushing through my veins and refueling my supply of cultural adrenaline.

However, I still made some timid attempts to relativize the circumstances: In New Jersey expectations regarding my *biancheria* did not exist, according to my American female acquaintances. Some of them were Italian American women, I told my parents, and they assured me that there was no need to follow old-fashioned customs in the United States. Indeed, it was a waste of money because another local, more modern and efficient custom, the bridal shower, would provide the essential *biancheria* and other household needs—at no cost to us. My mother, not knowing what a bridal shower was, in her visceral pride and ancestral mistrust, shut down my arguments with one of her adages: "They are simply jealous because they will never have a true *biancheria*. They don't even know what it is; that is why they tell you that. Watch their faces when they see your trousseau!"

Fueled by my mother's insistence, my parents traveled to Italy, for the first time since they had left eight years earlier, to search for and gather my *biancheria*. My father did not feel the same drive as my mother. His commitment and enthusiasm about my dowry were dampened by the fact that I was marrying an American. "Who are his parents? When are they coming to meet you and us?" My father was puzzled. "What kind of parents are those who do not care about meeting the future wife of their son?" These "parents" were not only divorced, but they also lived on equidistant, opposite shores of the United States. Since I did not have the courage to ask my fiancé to give explanations to my father's questions (which I privately found legitimate), I invented a series of justifications and excuses, but they never placated him.

Once in Sicily, my mother mobilized her mother and her sister for the selection and choices of the pieces for my trousseau. Some were handmade by local *ricamatrici* (professional embroiderers); others were bought in specialized *corredi* (fine linen) stores; others they ordered through traveling representatives of major Italian *biancheria* makers. My grandmother had already prepared two bed-linen sets bordered with delicate appliqués she had crocheted with her own hands. Even my mother's sister, who had three school-age daughters and had already started to embroider for her daughters' trousseaux, donated a lovely pale pink linen set she had embroidered for one of her girls. My trousseau was assembled in the two months my parents spent in our hometown, and was costly—more than my parents had anticipated. Since they did not have enough cash, my father decided to sell the last piece of land he owned. This property, located on the hilly countryside of the "Castello," included the remains of the fourteenth-century Misilcassim castle, also called *Poggio Diana*. Its standing cylindrical tower, still in good condition, has been, since I remember, the coat of arms of my hometown. The castle had reached its grandeur as the residential estate of the Moncada and de Luna families in the sixteenth century but had progressively decayed after an earthquake in 1603.

My father sold the property for a million lire ($700 at that time's exchange rate) to one of his first cousins who had plans to use it for a commercial chicken farm. I was appalled but not surprised when I heard of this transaction. So many times my father had said that it was not worth keeping the property: To him it was a pile of rocks. In his youth he had dug through the rubble, searching for buried treasures. He often complained of his bad luck for having inherited that piece of land from his grandparents: "The least cultivable of all the other lots." We were not there anymore, my father reasoned, so we could no longer harvest the valuable almond crop or collect the yearly thirty kilograms of fresh cheese the sheep herders gave in exchange for the use of the land in pasture.

I grew up listening to legends about how the castle had become rubble. The story was pretty much the same, no matter the source, with few minor variants and embellishments. During feudal times, Count Luna, the lord of the castle, had inadvertently offended King Pirollo, who reigned over the nearby town of Sciacca, and to whom Count Luna was also related by blood. It was a misunderstanding over which part of a fish should be served to a guest. The king waged war against the count, and after months of fighting all that remained of Count Luna's castle was the tower and crumbling walls.

I had not wanted my parents to sell the castle. I remembered that, when I was about eight years old, my mother would send me to the edge of town, on my little green bicycle, to collect the cheese from the shepherds as the bartered rent. I would come back home with a wheel of fresh, salted pecorino, studded with black peppers. Each September, my grandparents, aunts, and cousins would gather at our house to join us in the slow, manual work of removing the outer hull of the harvested almonds. It was hard to recognize *li mennuli duci e li mennuli amari* (the sweet and bitter almonds), which we were supposed to differentiate, shell, and place in different containers. But the knowledgeable, practiced eyes of my grandparents would adroitly guide my siblings and me. I was aware of the value of the crop because everyone around me kept talking about it and because I knew and ate the delicacies made with almonds: the *cubbata*, the *frutti di Martorana*, the soft *dolci di mandorla*.[2]

When my parents came back to New Jersey, in mid-September of 1973, after two months in Sicily, with two extra suitcases filled with *biancheria*, I rejoiced in the beauty of the linens and in the elegant patterns of the embroidery. My mother displayed each piece on her large bed; some she spread on her dresser and chairs, temporarily converting her bedroom into an altar. When my fiancé came to the house, she motioned him to the bedroom, and there, jubilant, she proceeded to describe each piece—what it was for, its high-quality linen and intricate embroidery—all the while making sure that I faithfully translated every detail in English. He looked with interest and wonder as he understood that he was going to partake of those beautiful linens and said that he remembered some of his maternal grandmother's fine pieces, that she would have enjoyed looking at mine.

But as much as I liked to have a trousseau that gave me a sense of continuity in a tradition, I could not ignore its price. I joked a few times with my father about the land and the castle, his last piece of property that still made him a landowner. But he would make his usual hand gesture, raising his open right hand halfway and pushing some imaginary air behind his left shoulder. This dismissive, conclusive gesture was enough to provoke my mother's everlasting resentment, always ready as she was to remind him of

his history of poor management of the family's assets. But this time, there was not much to cry about. That piece of land, she said, was the least valuable, especially if compared to the other properties, those with vineyards and fruit trees that he had sold in the past.

Through the year of my engagement that led to my June 1974 wedding, I felt a sense of loss and unsettlement anytime we talked about the *biancheria*: It prevented me from fully enjoying the refinement and beauty of the embroidered linens. I avoided talking about the subject with my father as a way of distancing myself from any responsibility for his decision and transaction. Even though I had to accept that he had sold the property to pay for my *biancheria*, I did not approve of it. Had I been consulted, I would have said no. The only consolation I felt was the pride of having a trousseau, albeit more modest than that of my girlfriends in my hometown: It was tangible proof of my roots. One day my own daughters would become the inheritors of my trousseau, I thought. My mother was eager to stress this point each time we looked at or talked about the *biancheria*. Although we lived in a place in which nobody cared about a trousseau, she was adamant we should keep the tradition of the trousseau. "I would never marry off my daughter in a *sottana* (slip)," she said, with the hyperbolic Sicilian scorn for those unfortunate mothers who did not or could not provide even a modest set of *biancheria* for their daughters. She was certain that my fiancé's family would take note of this difference. And when I remarked a few times that his family, being American, would not have cared, she bristled at that nonsense and felt humiliated by the possible lack of appreciation for her "sacrifices."

When the in-laws finally came, a few days before my wedding day, there was too much frenzy around our house, with large dinners for all of them and last-minute preparations that overwhelmed my mother and my sister. My mother had envisioned a "showing" of the *biancheria* for the "American" visitors, a small-scale replica of the joyous viewing of the *biancheria* that she and I knew well and had admired back in Sicily. It was customary in Sicily that the family of the soon-to-be bride, a week or so before the wedding, would host a kind of open house to show the entire trousseau, artfully displayed in one or more rooms of the house. The walls were wall-papered with linens, tablecloths, bed covers, nightgowns, all hanging from ropes, while long tables were covered with rows of undergarments, bath towels, dish towels, down to the elastic bands to hold in place the bride's nylon stockings. Family and friends would come to congratulate the future bride (and her family) for the quality and quantity of her *biancheria* and express their good wishes while enjoying almond biscotti dipped in marsala wine or rosolio liqueur.

There was no "showing" of the *biancheria* at my house. My future in-laws were staying in a hotel in Manhattan, spooling back and forth by taxi

and taking time to buy wedding presents. And strangely enough, I barely thought of it myself until after the honeymoon, when my mother reminded me to take the *biancheria* to my apartment. But where would I put it? Where would I store it? It was my American husband who searched for and found an antique trunk in a little place off George Street, in New Brunswick. He spent many hours cleaning and restoring it and lined it with white adhesive plastic sheets.

The day we went to my parents' home to retrieve my *biancheria*, we found my mother going through and counting white packages placed on her bed. She had carefully folded and placed two or three items of the *biancheria* inside some of her white linen sheets and folded them around into packages. She asked me to write the content of each on white pieces of paper and pin them to the top so that I knew where to find what without unwrapping the other packages. She reminded me that once a year I should take out the linens from the trunk, uncover, and let them "air" for a while or they would turn yellowish. Then she handed each package to me and my husband, piling them delicately on our extended arms as in a ceremonial offering. My husband and I carried them to his two-seater MG parked in front of my parents' apartment, and we placed them on the bench seat under the vigilant eyes of my mother, who stood on the balcony, her arms resting on the iron railing. We drove, not too fast, to our small apartment in New Brunswick through the busy New Jersey Turnpike, glancing at each other with conspiratorial amusement when other cars passed us, wondering if their drivers could have imagined or guessed at the content of the white cargo that draped the rear window of our car.

When we arrived and parked, we carried all the light white packages up to our attic on the third floor of a stately old home overlooking the Raritan River. I had left the oak trunk opened to air out its woody scent. Without waiting, my husband and I, each of us holding one end, started to place the packages inside the antique trunk with solemnity. When we finished, the trunk was more than two-thirds filled. Together we lowered the top and gently closed it while we exchanged smiles of humorous satisfaction. We did not yet have the queen-sized mattress we had ordered a month before, and our furniture consisted of a cheap sofa and a rocking chair. But the oak trunk triumphed in the middle of the living room, solid and yet almost waiting to go somewhere, a somber reminder that its contents were in transit, from elsewhere, going elsewhere—like my parents, like the lucky bride and owner.

Several years later, I was the mother of three girls and living in a midsized city in the Midwest. On a cold winter night, on my way to bed, I took with me an issue of a new monthly published in my hometown, *Paesi* (Towns). The editor in chief was a good friend. As I nestled under the covers, I

removed the plastic shipping envelope and looked at the front page. There was a photo of the Castello of Count Luna and above it the headline: "The Castello will be bought by the city from its current owner for 30 million lire to be restored and turned into an archeological park." The article inside documented the last two transactions: The current owner of the castle was indeed my cousin to whom my father had sold it in 1973. I felt blood rush to my head and heat spreading all over my body. I glanced at the clock. It was 10:30 p.m. I felt I had to call my father even though it was 11:30 in New Jersey. I woke him up and read him the headlines. His voice was a murmur: "I don't believe this story. They are not buying it for 30 million. It is just rubble, a heap of rocks. Go to bed!"

In Greek mythology the almond tree is represented by the beautiful Thracian princess Phyllis (leaf), who is in love with and promised to be married to Demophon, son of Theseus. When Demophon does not return on the agreed day from his trip to visit his family in Athens, Phyllis hangs herself on a tree at the very spot where they were supposed to meet. The place is called *Ennea Odoi* (Nine Roads) since Phyllis returned there nine times that day to see if Demophon had arrived. When Demophon does eventually return (he had only been delayed in Athens), he clings to the tree in desperation, only to see that the tree is suddenly covered in leaves and bursts into bloom. In one of those sympathetic and compassionate metamorphoses, the gods transform Phyllis into an almond tree, a symbol of hope.

Many times, as a schoolgirl, I had found myself with my friends pointing in the direction of the castle, from an overlook at the edge of my hometown. In those moments, I would swallow my urge to announce, "Look, all of you, that is MY castle! We harvest its almond trees every year." But I did not want to be ridiculed. I thought my family merely owned the land, while all the rest still belonged to the defeated Count Luna. He kept the castle. I kept my *biancheria*: a bitter bargain—my inglorious, deciduous metamorphosis.

Notes

1. A euphemism for brothel.
2. In order: a type of hard bar made with toasted almonds glued together with honey and sugar; marzipan in the shapes of fruits; soft, almond macaroons.

Biancheria and My Mother

—Maria Mazziotti Gillan

As a girl, my mother embroidered linen towels
with her initials, tablecloths and linen slips
and nightgowns, placed them neatly in a trunk.
When she married my father, she brought the trunk

to America in the hold of the ship where she traveled
in steerage. She was six months pregnant and sick
most of the way over, but on the day the ship arrived
in New York, she tells me she was so excited she got

dressed in her best dress, blue with a white collar,
and a blue hat and waved and waved to my father
who waited on the dock for her. Before she left Italy,
my father's mother gave her appliquéd tablecloths

she'd made of fine linen, the stitches so delicate
and perfect they were a work of art. My mother, like
the other Italian immigrant women, knew how to sew
so she got a job sewing the sleeves in coats by hand.

The factory would drop the coats off first thing
in the morning and pick up the ones she had sewn
the day before. It was called piecework. Later, when we,
her children, were old enough to be in school, she worked

at Ferraro's Coat Factory, doing the same work, but paid
a penny more for each piece that she sewed. The whole time
we were growing up, my mother bought sheets and towels
for my sister and myself, bought a metal trunk

for each of us, and began to save the *biancheria*.
She taught us how to embroider so that we would
have dresser scarves and towels that we had embroidered
with our initials or with pre-printed flowers. For my mother

that *biancheria* was our dowry, something she felt she had
to give us. When I married I had this huge trunk that I carted
wherever I went, the sheets my mother bought for me
with the pennies she earned sewing in that factory were 100%

cotton and needed to be ironed. I was 100% lazy
and not domestic and bought permanent-press sheets
for myself, her sheets packed in the trunk like an accusation.
I still have the embroidered towels and dresser scarves

and tablecloths, but a few years ago, I emptied the trunk
of all those sheets I knew I'd never use and let my daughter
sell them at a garage sale, and as I lifted them out, I thought
of my mother, sewing those coats for years, piles of basting

thread covering her feet, and of what we can pass on,
and what we can't and the *biancheria* I have saved
for my daughter and how much else we give
when we try to pass it on.

Medicine of Language

—Peter Covino

Shred the language, *dovrei scrivere,*
filter the commerce: *le strisce blu*
della copertina, concertina,
concentrate, this arduous excuse
to excuse all, why the past
is a mirror, in it an anorexic sister
hair falling, *capelli che cascano,*
cascare, cascade, a waterfall
hold up the building, a Mannerist
mantelpiece *pezzo di—pezzente*
peasant nothingness what you belong to
the dust of country, not even a country
a hill town in some vague Neopolis
metropolis, *non sono,* am not;
while he turns so quickly—
we all want to see a Ford Explorer
in the mirror, *nello specchio,* specter
the divided part, spectator
spectacolo, spectacular medicine

Lace

—Maria Terrone

In small Mediterranean towns
women stooped and girls
with rag-soft bodies
are making lace intricate as brain circuitry.

See how the light spins through,
imprinting the wall—
not with a maze, but a map
to trace your way home

to women yet unborn who'll find
the lace at the bottom of a cedar chest,
and marvel.

When the world is like a skein
unraveling, look again to the lace: see
how absence forms its pattern,
and purpose fills even the smallest space.

Love how much do we know & when do we know it

—Rosette Capotorto

thread through history thread through memory
thread through the eye of the needle
needle me i'll
needle you

(from) those who could not say the word
 l o v e

how do we come down softly
unlike maxwell's silver hammer

a cloud
pink
sea froth
open your mouth
I will place a kiss
a kiss so newborn
it can bring only peace
tender token for the long dirty haul

White Shadows (2)

2009
Cloth, thread, acrylic paint, 9" x 7" x 1"
Photograph by Cathy Carver
Courtesy of the artist and Elizabeth Harris Gallery, New York City
Collection of Victor and Dena Hammel

—Elisa D'Arrigo

For the past twenty-five years I have produced work in various media, such as cloth, thread, clay, handmade paper, wax, wire, acrylic paint, and bronze. Although largely abstract, this work contains a range of allusions to the body, nature, and personal memory. A specific memory underlies each piece and partially determines its particular character and color. These are memories of things that I have observed and then held in my mind's eye, sometimes for decades: They are the subtext of the work.

The impetus for *White Shadows (2)* was the sun-drenched, dense stonework of Chaco Canyon, a pre-Colombian site in New Mexico. The experience of seeing (and also touching) the irregular, hand-hewn grids of those immense and undulating walls left a powerful visual, emotional, and even visceral impression.

Attempting to conjure a physical object from a mental image is an elusive process due to the fugitive, constantly shifting nature of memory. Memories are only points of departure. It is the physical process of making the work that takes over; it assumes a life of its own. A work in progress could evolve for months (even years)—expanding, contracting, even recombining with cast-off parts of itself.

My objective is to stay in the moment, mindful of accident and chance, responding to what unfolds. The actual working with materials, and how that results in particulars of form and configuration, is what ultimately determines each piece.

While I have used sewing intermittently over the years, since the mid-1990s most of my work has been constructed by hand sewing together

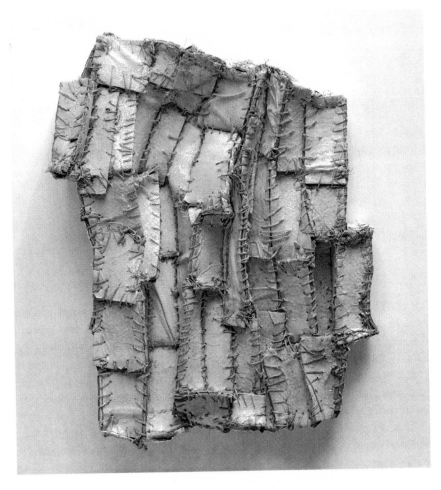

many (sometimes hundreds of them) either flat rectangular units or hollow vessel-like elements to create larger configurations. These components are formed from layers of cloth (or cloth and paper) that have been laminated and stiffened with acrylic paints and mediums. The tension and puckering created by sewing the individual components result in structures that billow as if animated from within. These undulations are a chance product of the sewing process. My responses to such unplanned effects plot the trajectory of each piece. There is no understructure. These pieces are held together with thread alone. Seams define contours, and stitches create lines, marks, and surface.

Much is layered in this work. Early on I worked intensively in ceramics, a medium where form, color, and surface are inseparable. As a child, I was exposed to elaborate embroideries made by various female relatives,

including my maternal grandmother, Vicenza, who emigrated from Savoca, a hill town in Sicily (Messina province). Seeing these textiles prompted a desire to draw with thread, thereby creating form and line by amassing stitches. I was captivated by the nature of needlework and its possibilities—how a single gesture (a stitch), when repeated, can become something complex, elusive, and rich with expressive nuance. This led me to a lifelong interest in all things created by accretion, from Byzantine mosaics to votive accumulations to multicellular organisms. This interest has been a companion that has affected my work and sensibility over the years.

AFTERWORD

Needling Scholars, Needling Scholarship

—Donna R. Gabaccia

I am the woman scholar you see knitting through conferences, lectures, scholarly panels, and public events. In the past I have also embroidered or crocheted obsessively while listening. But few people know that also I weave and sew because weaving and sewing are, for me, home arts. At most I have finished a hem or two and once or twice emptied a mending basket while attending to departmental squabbles or committee decisions. Paradoxically, the types of textile work that entered the public sphere with the biggest and most significant flourish—in the form of an industrial revolution, mechanical looms, and mechanized garment-making shops—are not ones that any handloom weaver or seamstress can now easily carry into her busy, professional life. My sewing machine is heavy and needs a firm table. Even my small handloom sits uncomfortably on my lap, while my pale blond full-size loom has four harnesses and weighs hundreds of pounds. Alongside a colorful stash of yarn displayed in dozens of woven baskets and on several wooden shelves and needlework projects draped (attractively, I think) over furniture and walls, the loom dominates my Minneapolis bedroom. Far larger quantities of my weaving stash have been knitted into socks and sweaters and scarves than woven into cloth. As long as meetings and teaching dominate my professional life, weaving and sewing must be, and are, relegated to the occasional pleasurable margins of leisure, domestic time.

I'm fully aware of crossing gendered boundaries between public and the private whenever I knit at a meeting or crochet while listening to a lecture. How could I not be aware? Over the years I've heard my share of complaints about my behavior and seen my share of annoyed expressions. The handwork that calms *me*, allowing *me* to focus my nervous energies and to listen effectively, apparently distracts or affronts those colleagues who view it as an insensitive and selfish assault on their own concentration and sense of control over their immediate environment. "Maybe I'll bring my cat next time," a male colleague proclaimed to me once, early in my career. Another time, a nun gently approached me after a conference panel to tell me my

work—I believe I was knitting a white, raised-leaf bedspread in small sections—was lovely, but she then also reproached me for my inappropriate behavior. I know she meant to mentor me. Nevertheless, for a time in the 1980s, I assumed I could not be taken seriously as a scholar if I held needles in my publicly viewable hands. I began knitting again in meetings and conferences only after I received tenure in 1992. Since then, I have taken great pleasure in knitting in public. This is me, I feel myself announcing; this is who I am—whether in private or in public. Luckily enough, I now find myself at a university where full professors and even directors of programs and centers—so far, none of them men, I admit—also knit "openly." Even the untenured knit in Minnesota! Comments about our handcraft are generally limited to supportive queries about "What will that be when it's finished?" or "Where did you find the pattern?" Statements of solidarity and support outnumber sardonic or critical commentary. Yarn bombing makes me smile. So do knit-ins. I'm happy to see the boundaries breached.

Despite my commitments to needle and textile arts and my scholarly penchant for themes that resonate autobiographically, I've never written about the handcrafts I obviously know and love. Perhaps there are some skills one simply possesses or practices without mobilizing as research topics? I can think of other examples, including my avoidance of German history even though I speak and read German better than any language other than English. In fact, this essay represents a first attempt to write about something that I more often merely do. As I began to write it, I easily remembered how much and how often I once thought about needlework as a scholarly object of research. Why did I never pursue it through publication?

In their introduction, Edvige Giunta and Joseph Sciorra declared their goal for this volume to be an "interdisciplinary collection of creative work—memoir, poetry, and visual art—by authors of Italian origin and academic essays by scholars from the social sciences and the humanities." As editors they were obviously interested in the problem and challenge of disciplinarity, obviously committed to working across methodological boundaries, obviously fascinated with storytelling genres, and obviously convinced that authors of Italian origin have something special to say about needlework. In this short afterword I want to take their goal seriously by combining some of the methods and genres they name, confronting the origins of my own needling skills, and reflecting on why I as a historian have never before written about needlework.

That women's handwork could be the intense focus of scholarly research and critical analysis was never a strange idea to me as a scholar. On the contrary, needlework and *biancheria* were something I thought about almost continuously as I began my dissertation research. When I met Jane Schneider

in the library of Palermo's Museo Pitrè in 1977 (was it, as I recall, really on International Women's Day?), I probably carried with me a tiny ball of lace I was crocheting to trim a tablecloth packed away in storage in Toledo, Ohio. Jane and I were, I think, excited to meet each other because of our shared interest in domestic life and women's domestic worlds. As an anthropologist, she immediately grasped the significance of my dissertation topic: I wanted to write as a historian about how people lived in their homes and about how their "house lives" changed (or not) as they migrated from the agrotowns of Sicily to the tenements of New York City. When we met, Jane had just published her first book on Sicily[1] and she was—as I soon learned—pursuing research that would inform her foundational article on needlework and *biancheria*, "Trousseau as Treasure."[2] (I also discovered that Jane's earlier article on honor and shame and the role of needlework in defining femininity pushed her in that direction.[3]) Soon after we met in Palermo, she and her family (her coauthor and husband, Peter Schneider, and their two children, Ben and Julie Schneider) were introducing me to the streets, people, and archives of "Villamaura"—their pseudonym for Sambuca di Sicilia, a town of over 7,000 in the rural, southern province of Agrigento. (Even on this small point, one sees the power of discipline: Historians always fully reveal their research sites; anthropologists more often conceal them.)

During my first visit to Sambuca in 1977, Jane and I talked a great deal about women's crafts and their meaning. And as we talked, I often crocheted. (As I recall, I also later either knitted or crocheted a sweater and a scarf for Julie Schneider's favorite teddy bear.) I carried my work with me as Jane and I visited older women to talk with them about their mothers' and grandmothers' houses, housework, dowries, lives, and work with textiles. Together with the Schneider family, I visited a convent—as much to purchase the sweets made there as to admire the nuns' needle arts—and I was also inspired to undertake, somewhat later, a solo trip into Sciacca to visit the district's *archivio notarile*, hoping to find information about the contents of dowries. (Alas, the archive's organization proved too unwieldy to be of use for a researcher on a tight schedule, and despite good intentions I never returned there in later years.)

Jane Schneider helped me to see that hook and thread were ethnographic tools. She pointed out how they rendered me accessible, knowable, and likable in a way I might not otherwise have appeared to elderly Sicilians unused to conversing with a young North American woman. Since I (unlike Jane) had no children at that time, my growing ball of crocheted lace helped establish a satisfying, and satisfyingly material, common ground for initiating conversations and encouraging empathy. Although I later concluded that I much preferred archival to ethnographic methods—I found

that managing a multilingual life (I lived in Germany at the time) and navigating always-complex relationships with informants to be exhausting—Jane's identification of crochet hooks and knitting needles as tools of research remained with me as a key insight. (I rediscovered it years later while training students to do oral history—"Ask your informant to bring along a material object that reminds her of the past.") Not surprisingly, my research notes from that first visit to Sicily, along with my notes on published works by travelers and folklorists from the late nineteenth century, were full of references to and images of looms, bedspreads, spindles, *la sarta*, dowries, *biancheria*, and bedframes wound about with elaborately embroidered "skirts." Some of these images and themes would reappear as I worked through tenement-house photo collections, the documentary photography of Riis and Hines, and descriptions of Italian immigrant "homework" in New York repositories.

By the time I met Jane Schneider in Sicily in 1977 I had a long history of needlework behind me but I was a scholarly novice, in awe of Jane's knowledge. This collection of essays pushed me to consider for the first time what it was that I—the scholar-in-training—brought to those long walks and conversations in Sambuca with Jane. I had learned to knit quite early— whether from my mother or grandmother, I do not recall—then forgot the skill for several years, only to begin knitting, crocheting, and embroidering in earnest and expanding my repertoire of skills as a teenager. Despite the fact that Jane and I met in Italy, shared a passion for understanding Sicily's peasants and artisans, and talked about the needlework and textile arts of Sicilian women, my own needle skills—unlike my name—had no obvious Italian roots.

My paternal grandfather hailed from Lombardore, a tiny village outside Turin, and my paternal grandmother was born in Bollengo, a tiny fraction of the larger textile-producing town of Biella. But both were dead long before I picked up my first needle. Because of family feuds, furthermore, I had grown up isolated from the Italian great-aunts, aunts, and girl cousins who formed the circles of needleworkers (or rebels) described in this collection. Only in the past decade did I learn from my father's oldest living (and female) cousin that my Italian grandmother had been "good with her hands" and that she, despite her mental illness, had left a warm memory with this cousin by teaching the then-young girl, recently arrived from Italy, how to "make little things," presumably with a hook or needle and thread. Predictably, however—as the essays in this collection document—my training as a needleworker did tell a story of "threads of women." My path to needleworking, too, was a tale of "the intergenerational connections and disconnections" in which "mothers, aunts, grandmothers, great-grandmothers"

figured prominently. But in my case, those needle skills emerged from the German American, maternal side of my family.

I grew up surrounded by my mother's family. These too were all people who—like many Italian Americans—were "good with their hands"; the extended family included many, many boy cousin, uncle, and grandfather leather workers, carpenters, machinists, plumbers, electricians, builders, and operators of the kind of big equipment that constructed docks, ski lifts, and high-rise dwellings. Although theirs was decidedly not an Italian American family (and my father often felt like an interloper and outsider), my maternal grandmother and my mother both treasured the cedar chests they had purchased prior to their marriages and in which they both stored cloth, embroidered handkerchiefs, and linens. (I have yet to uncover the origins of this custom, which seemed common among neighboring families at the time.) Both women kept huge kitchen gardens. Both canned. Both were heroic workers, who relished hard, physical labor. Both were proud of their urban roots and connections (in Brooklyn). My mother was also a particularly fine and, I believe, self-trained seamstress who made all the clothes worn by my two sisters and me. The gray-green case of her Elna sewing machine was one of my earliest toys; in it I created houses for tiny dolls wearing dresses my mother had crocheted for them from fine white thread. My mother knitted; she made bedspreads, doilies, and curtains. She painted, carved, and hammered. Her creativity was more often ferocious than careful (*ben fatto?* she didn't know it!), but from an early age I admired what I saw as her strength, her mastery, her energy, and her artistry. What she made was beautiful. Or it tasted good. Or it was fun to wear and to look at. (Admittedly, she didn't like to finish garments neatly; that soon became my task.) Both my mother and grandmother possessed practical skills that I was determined to make my own. And by the time I graduated from college I felt I had succeeded, at least in part: I had made a quilt of hand-dyed cloth and wallpapered a room with hand-drawn paper; I had made, embroidered, and even sold clothes; I had knitted sweaters and hats; I had made bead jewelry and crocheted a bathing suit; I had preserved foods and cooked meals.

I carried needles wherever I went.

Ultimately, however, it was not me—the skilled, passionate needleworker and all-around artisan—who made the textile arts her longtime object of scholarly inquiry but rather Jane Schneider, whom I, at least, recall as uninterested in *doing* needlework of any type. Jane not only wrote "Trousseau as Treasure"—a brilliant work, frequently cited in this collection—but also "Peacocks and Penguins: The Political Economy of European Cloth and Colors,"[4] an important review essay ("The Anthropology of Cloth"),[5] and an edited volume, *Cloth and Human Experience*.[6] And I? Although I

subsequently wrote two books about Sambuca and its migrants,[7] needle-work appeared—and then only fleetingly as an element of everyday life and household decoration—in just one of them.

As I ponder that paradox today, I know I must address the long-term impact of disciplinarity on my intellectual evolution. Jane Schneider was a University of Michigan Ph.D. in Political Theory who had, under the influence of Eric Wolf, transformed herself into an anthropologist just as that discipline became interested in history and political economy. I was an undergraduate sociologist (also with a special emphasis on social theory), who—not wanting to submit to the quantitative methods and empiricism of American sociology—had switched to history before entering a Ph.D. program at Michigan almost a decade after Jane's graduation. I remember the study of history as alive with interdisciplinary ferment in the 1970s. To my own surprise, I had gravitated toward anthropology rather than back to sociology in choosing my "outside field" even before I traveled to Sicily. Anthropologists were writing about peasants long before historians, like me, became interested in them. After returning temporarily to Michigan, I participated in occasional anthropology seminars in Ann Arbor and New York and asked an anthropologist, William Lockwood, to serve on my Ph.D. committee. My dissertation was the product of a methodologically eclectic mix of demography, fieldwork, analysis of housing and vernacular architecture as forms of material culture, behavioral social science, and close readings of Pitrè's proverbs and folklore collections. The Social Science History Association soon became my preferred professional home.

But then a first teaching position in American Studies returned me to Germany and moved me away from anthropology and folklore in both my research and my teaching. At some point in the mid-1980s, I had the humbling experience of hearing my conference paper on housing, dowries, and the Sicilian marriage market during the period of the mass migration dismissed by commentators from both history and sociology. Worse, I seemed unable to interest feminist journals in the paper. It eventually went into a file of rejects, and it never emerged. Looking back now I sense I was being "disciplined"—that is to say, I was encountering the disciplinary limits of what topics seemed worthy of study and which methods seemed worthy of respect.

Reading the many essays in this volume gave me the opportunity to question for the first time where research on needlework has found a disciplinary home, as it did not in my own scholarly development. My attempts to answer this question were scarcely exhaustive. Rather simplistically, I merely treated the digital resource JSTOR as an archive of disciplinary knowledge production in scholarly journals.[8] I did not choose my keywords in

	Anthropology	Arts and Art History	Folklore	History	Language/ Literature	Feminist/ Women's Studies
Needlework	1.8	14.1	4.7	5.0	3.7	10.5
Embroidery	9.2	30.9	13.8	7.1	11.1	14.6
Knitting	3.4	4.6	5.5	7.3	7.9	9.7
Crochet	2.7	2.3	1.3	1.3	.4	.6
Lace-making	1.1	1.1	4.4	.7	.4	.6
Dressmaking	.5	1.6	1.0	3.0	2.7	5.1
Weaving	57.6	40.4	48.8	61.0	63.6	51.6

sophisticated fashion but merely searched for "needlework or needlework-ers," "embroidery or embroidering," "knitting or knittery," "crochet or cro-cheting," "lacemaking or lacemaker," "dressmaking or ladies tailor," and—to satisfy my personal curiosity as a weaver, since this book focuses not on cloth production but on the needle arts—for "weaving or weaver." I sur-veyed six disciplines, using JSTOR's standard categorization of journals; for example, anthropology, arts and art history, folklore, history, feminist and women's studies, and language and literature. I did not attempt to analyze change over time, but I did create a measure that took into account the fact that some disciplines were represented by more journals (290 in history, 254 in language and literature, 184 in arts and art history) than others (86 in anthropology and only 29 in feminist studies and 24 in folklore).

The simple table below gives the results: It measures the total number of articles in which each set of terms appears, divided by the number of journals for each discipline. For example, 1.8 in the first cell means that ref-erences to needlework or needleworkers appeared an average of 1.8 in times per journal title. In interpreting these figures, it is helpful to remember that scholarly journals in anthropology, arts and art history, folklore, history, and language and literature have been publishing (and are recorded in JSTOR) since the nineteenth century while almost all journals in feminist and wom-en's studies have appeared only since the 1960s. This means that—if all dis-ciplines were equally interested in any given term—the average numbers of references to that keyword in feminist studies ought to be considerably lower than in the many longer-term journals of older disciplines.

One story visible in this table reaches across all disciplines. Apparently the movement of cloth production from private to public sphere has made

weaving of considerably greater interest to all disciplines than the hand-needle arts—performed at home and by women, usually in their roles as wives, mothers, and daughters—which are explored in this collection. A second story in this table is a more disciplinary one. As I became more and more deeply disciplined into history in the 1980s, I entered a field that has been interested almost exclusively in textile production and that has limited interest in any type of needlework as handcraft. At first, I was surprised not to find in the table more evidence of historians' attention to ladies' tailors and dressmaking. Certainly historians of immigrant women have long and routinely focused on workers in textile *and* garment factories, along with domestic servants. But I suspect that had I searched for "garment-making or garment-makers," my results would have been very different. Certainly in this collection of essays, historians contributed mainly to the study of garment workers in the industrializing new world. Third, and finally, the table makes clear how important the development of feminist and women's studies as a discipline has been in making almost all forms of needlework more respectable and significant: Despite their relatively short histories of publication, the journals in feminist and women's studies contain well-above-average numbers of articles with references to needlework of all varieties.

By far the most interesting contrast between the results displayed in the table above and in the essays collected in this volume can be found in the relative merit of studying various types of needlework. I assume, for example that embroidery, rather than knitting or crocheting, falls into the second-most important category of research, after weaving, in almost all disciplines covered by the table because embroidery is generally understood to possess greater artistic merit, or at least artistic potential, than the more humble and widespread arts of knitting and crocheting. When we imagine ladies of the European aristocracy doing needlework, we do not imagine them with knitting needles or crochet hooks in their hands. (This probably also explains the relatively high attention to needlework and embroidery in journals in the arts and art history—although, to be fair, that potential for artistic achievement applies equally to lace making, which attracts far less attention, perhaps because it too came to be mass produced, for example, in Italy as early as the late middle ages.)

Notable in the essays collected in this volume, by contrast, is an almost universal insistence on the artistic value of *all* types of needlework. The essays collected here suggest that what makes a trousseau a "treasure" (in Jane Schneider's terminology) is not just the possibility that a desperate woman might at some point exchange her embroidered or finely woven linens for cash—although that strategy did exist and was exercised. Instead, by providing intimate, and often highly personal memories of needleworkers,

the essays here understand treasure in a different way. Women's needlework is treasured, and the focus of memory, because of its beauty and because it records women's artistic creativity, artisanal skills, and accomplishments.

This insistence on the creativity of the female needleworker does not, I believe, intend to make all needleworkers equal in their skills and their accomplishments. It does, however, explain the pleasure my mother and I take when looking at the little treasures we have created. It does match her— and my—desire to store up these treasures, to display them, and to gift them to people we love. A respect for the artisanal skill and artistry represented in the physical objects that women create, along with respect for the pleasure women take in their creations, should be one of the most lasting and important contributions of *Embroidered Stories* as a work of scholarship and of culture. We look at our creations, and when we finally rest from our labors we find them good. We treasure them.

Notes

1. Jane Schneider and Peter Schneider, *Culture and Political Economy in Western Sicily* (New York: Academic Press, 1976).

2. Jane Schneider, "Trousseau as Treasure: Some Contradictions of Late Nineteenth-Century Change in Sicily," *Beyond the Myths of Culture: Essays in Cultural Materialism*, ed. Eric B. Ross (New York: Academic Press, 1980).

3. Jane Schneider, "Of Vigilance and Virgins: Honor, Shame and Access to Resources in Mediterranean Societies," *Ethnology* 10, no. 1 (January 1971): 1–24.

4. *American Ethnologist* 5, no. 3 (August 1978): 413–47.

5. *Annual Review of Anthropology* 16 (October 1987): 409–48.

6. Annette B. Weiner and Jane Schneider, eds., *Cloth and Human Experience* (Washington, DC: Smithsonian Institution Press, 1991).

7. Donna R. Gabaccia, *From Sicily to Elizabeth Street: Housing and Social Change among Italian Immigrants, 1880–1930* (Albany: State University of New York Press, 1984); *Militants and Migrants: Rural Sicilians become American Workers* (New Brunswick, NJ: Rutgers University Press, 1988).

8. Roger C. Schonfeld, *JSTOR: A History* (Princeton, NJ: Princeton University Press, 2012).

CONTRIBUTORS AND EDITORS

B. Amore is an artist, educator, and writer who has spent her life between Italy and America. She studied at Boston University, the University of Rome, and the Accademia di Belle Arti di Carrara. She is a Fulbright scholar and founder of the international Carving Studio & Sculpture Center. Amore has won numerous public-art commissions in both the United States and Japan. "Life line—*filo della vita*," her Ellis Island exhibit, was published as a book in 2007 by the Center for Migration Studies. Her most recent project and monograph, *Invisible Odysseys*, has been the result of working with Mexican migrant farmworkers in Vermont.

Mary Jo Bona is professor of Italian American Studies and chair of Women's and Gender Studies at Stony Brook University. Bona is the author of *By the Breath of Their Mouths: Narratives of Resistance in Italian America* (2010) and *Claiming a Tradition: Italian American Women Writers* (1999); editor of the reprinted *The Voices We Carry: Recent Italian American Women's Fiction* (2006); and coeditor of *Multiethnic Literature and Canon Debates* (2006). She is past president of the American Italian Historical Association and has edited two of its conference volumes. Her current project examines popular novels vis-à-vis issues of canonicity.

Phyllis Capello, writer/musician/performer, has had her work published in many anthologies and literary magazines: *The Dream Book*, *From the Margin*, *The Voices We Carry*, *Don't Tell Mama*, *The Milk of Almonds*, *Creative Nonfiction*, *Our Roots Are Deep with Passion*, *Reading, Writing and Reacting*, the *New York Quarterly*, *The Wind in Our Sails*, *The Little Magazine*, *Leggendaria*, *Mothering*, the *Paterson Literary Review*, *Literary Mama*, and *Journey Into Motherhood*. She is a New York Foundation for the Arts fellow in Fiction. *On the Breath*, her stories and songs about the Triangle Shirtwaist Factory fire, was presented at the International Oral History Conference.

Rosette Capotorto was born and raised in the Bronx, New York. A printer by trade, she is the author of a chapbook of poetry, *Bronx Italian* (2002). Her work has been published in literary journals such as *Long Shot* and *Barrow Street* and in the anthologies *Are Italians White? How Race Is Made in America*; *The Milk of Almonds*; and *All American Women*. As a teaching artist, Ms. Capotorto developed *Poetry Live!*© a series of "cool" writing workshops. She also runs "No More Secrets," a writing workshop for adults.

Jo Ann Cavallo is professor of Italian at Columbia University. She is the author of *Boiardo's* Orlando Innamorato: *An Ethics of Desire* (1993); *The Romance Epics of Boiardo, Ariosto, and*

Tasso: From Public Duty to Private Pleasure (2004); and coeditor of *Fortune and Romance: Boiardo in America* (1998). She has published articles on early Christian and gnostic literature, on Italian authors from the medieval to the modern period, and on folk traditions that dramatize epic narratives.

Hwei-Fen Cheah lectures in textile history and Asian art at the Australian National University. Her book *Phoenix Rising: Narratives in Nyonya Beadwork in the Straits Settlements*, published in 2010, examines the cross-cultural appropriations and transformations in the beadwork of the immigrant Peranakan Chinese in Malaysia and Singapore. Her interest in diaspora, needlework, and cultural memory stems in part from her own position as a member of a "double diaspora," a migrant from her ancestors' adopted home in Southeast Asia to Australia.

Paola Corso was born in the Pittsburgh area, where her southern Italian immigrant family found work in the steel mill. She is the author of *Catina's Haircut: A Novel in Stories* (on *Library Journal's* notable list of first novels in fall 2010) and *Giovanna's 86 Circles and Other Stories* (2007), a John Gardner Fiction Book Award finalist. A New York Foundation for the Arts Poetry Fellow, she is the author of *Death by Renaissance* and two collections published in 2012, *Once I Was Told the Air Was Not for Breathing* and *The Laundress Catches Her Breath*. She lives in Pittsburgh.

Poet, translator, and editor **Peter Covino** is author of *The Right Place to Jump* (2012) and *Cut Off the Ears of Winter*, winner of the 2007 PEN America/Osterweil Award and finalist for the Paterson Poetry Prize and the Thom Gunn Award. Recent poems have appeared in *America Poetry Review, Colorado Review, LIT, Paris Review, Yale Review*, and other publications. His coedited volume *Essays on Italian American Literature and Culture* was published in 2011. He is associate professor of English and Creative Writing at the University of Rhode Island.

Barbara Crooker is the author of three books of poems: *Radiance*, winner of the 2005 Word Press First Book Award and finalist for the 2006 Paterson Poetry Prize; *Line Dance* (2008), winner of the 2009 Paterson Award for Excellence in Literature; and *More* (2010). Her poems appear in a variety of literary journals and anthologies, including *Good Poems for Hard Times* and *Good Poems American Places* and the *Bedford Introduction to Literature*. She received three Pennsylvania Council on the Arts Fellowships in Literature. Her grandmother, Annunciata Poti, was an accomplished knitter who did alterations for Bonwit Teller.

Elisa D'Arrigo has had solo exhibitions at the High Museum of Art, the Lehman College Art Gallery, Elizabeth Harris Gallery, Luise Ross Gallery, and PanAmerican Art Projects. Her work is in the collections of the High Museum of Art, the Mead Art Museum, the Weatherspoon Art Museum, the Mint Museum of Craft and Design, the Samuel Dorsky Museum of Art, and the New School for Social Research. Reviews and articles about her work have appeared in *Art in America, ArtNews*, the *New York Observer, Sculpture Magazine*, the *New York Times*, and the *Partisan Review*.

Louise DeSalvo is the Jenny Hunter Endowed Scholar for Creative Writing and Literature and a recipient of the President's Award from Hunter College, the Douglass Society Medal

for Distinguished Achievement, and the Gay Talese Award for her memoir, *Vertigo* (1996), also a finalist for Italy's Primo Acerbi prize for literature. DeSalvo has published sixteen books, including Virginia Woolf's *Melymbrosia* (2002), the coedited *The Letters of Vita Sackville-West and Virginia Woolf* (2001), and the coedited *The Milk of Almonds: Italian American Women Writers on Food and Culture* (2002). *Virginia Woolf: The Impact of Childhood Sexual Abuse on Her Life and Work* (1989) was named one of the most important books of the twentieth century by the *Women's Review of Books*. DeSalvo has also published the memoirs *Vertigo*; *Breathless* (1997); *Adultery* (1999); and *Crazy in the Kitchen: Food, Feuds, and Forgiveness in an Italian American Family* (2004).

Bettina Favero was born in Mar del Plata, Argentina. She studied history at the Universidad Nacional de Mar del Plata and Universidad Nacional del Centro de la Provincia de Buenos Aires. Her research focuses on Italian immigration to Mar del Plata after World War II. She is an investigative assistant for CONICET and a teacher at the Faculty of Humanities (Universidad Nacional de Mar del Plata).

Marisa Frasca is a fashion designer who recently turned her grading chalk into pen and returned to school to complete an MFA in poetry at Drew University. Her poems have appeared, or are forthcoming, in *5AM, Adanna Journal, VIA, Philadelphia Poets, Sweet Lemons*, and other literary journals. Currently at work on translating a contemporary anthology from her native Italian into English, Frasca is also putting the final touches on her first bilingual poetry manuscript, *Via Incanto: Poems from the Darkroom*.

Donna R. Gabaccia is professor of history and former director of the Immigration History Research Center at the University of Minnesota. She is the author of many books and articles about U.S. immigration and Italian migration around the world. Her latest book, *Foreign Affairs: Global Perspectives on U.S. Immigration*, was published in 2012 by Princeton University Press.

Sandra M. Gilbert, Distinguished Professor of English emerita at the University of California, Davis, is the author of seven collections of poetry, including *Kissing the Bread: New and Selected Poems 1969–1999; The Italian Collection* (2003); and *Belongings* (2004). She has also published *Death's Door: Modern Dying and the Ways We Grieve* (2006); the memoir *Wrongful Death* (1995); the anthology *Inventions of Farewell* (2001); and *Acts of Attention: The Poems of D. H. Lawrence* (1973). With Susan Gubar, she has authored *The Madwoman in the Attic: The Woman Writer and the 19th-Century Literary Imagination* (1979), and *No Man's Land: The Place of the Woman Writer in the 20th Century*, volumes 1, 2, and 3 (*The War of the Words* [1989], *Sexchanges* [1989], and *Letters from the Front* [1994]). They have also coedited *Shakespeare's Sisters: Feminist Essays on Women Poets* (1979) and *The Norton Anthology of Literature by Women: The Traditions in English* (1985).

Maria Mazziotti Gillan is a recipient of the 2011 Barnes & Noble Writers for Writers Award from *Poets & Writers*, and the 2008 American Book Award for her book *All That Lies Between Us*. She is the founder/executive director of the Poetry Center at Passaic County Community College in Paterson, New Jersey, and editor of the *Paterson Literary Review*.

She is also director of the Creative Writing Program and professor of Poetry at Bingham-ton University-SUNY. She has published twelve books of poetry, including *The Weather of Old Seasons* (1989); *Where I Come From* (1995); *Things My Mother Told Me* (1999); *Italian Women in Black Dresses* (2003); and *What We Pass On: Collected Poems 1980–2009*. She is coeditor of four anthologies: *Unsettling America* (1994); *Identity Lessons* (1999); *Growing Up Ethnic in America* (1999); and *Italian-American Writers on New Jersey* (2003).

Edvige Giunta is professor of English at New Jersey City University, where she teaches memoir and other writing and literature courses. Her research focuses on Italian Ameri-can women and the pedagogy of memoir. She is the former editor of *Transformations: The Journal of Inclusive Scholarship and Pedagogy*. She has published *Writing with an Accent: Contemporary Italian American Women Authors* (2002); *Dire l'indicibile: Il memoir delle autrici italo americane* (2002); and the coedited anthologies *The Milk of Almonds: Italian American Women Writers on Food and Culture* (2002); *Italian American Writers on New Jer-sey* (2003); and *Teaching Italian American Literature, Film, and Popular Culture* (2010). Her articles, reviews, translations, memoir, and poetry have been published in many journals and anthologies.

Lucia Grillo is an actress, filmmaker, producer, editor, and also a correspondent for the Calandra Institute/CUNY-TV's monthly program, *Italics*. As an actress, she has worked with directors Spike Lee and Tony Gilroy and with actors Mira Sorvino, John Leguizamo, and Vincent Schiavelli. She founded Calabrisella Films to produce the award-winning *A pena do pana* (*The Cost of Bread*); *Ad Ipponion* (*Ode to Hipponion*), Official Selection of the Cannes Film Festival Short Film Corner; and a feature-length documentary, *Terra sogna terra* (*Earth Dream Earth*). She is developing her first feature-length narrative film, *A Tigered Calm*.

Maria Grillo was born in Calabria, Italy. She obtained her certificate in tailoring at the age of thirteen. She was married at age fifteen and emigrated to the United States, where she raised a beautiful family, all of whom went to college. She is proud of this but does not cease to educate herself further. She has worked at Montessori schools and at Gymtime and still continues to work with children. Her beloved Italy will always remain in her heart, but she is very happy to be in America.

Karen Guancione's interdisciplinary art includes large-scale installations, performance, sculpture, printmaking, papermaking, book arts, and video. Her work has been exhibited worldwide and is in numerous public and private collections. She is the first recipient of the Erena Rae Award for Art and Social Justice. She has been awarded a Mid Atlantic Arts Foundation Artists & Communities Grant, three New Jersey State Council on the Arts Fel-lowships, a Ford Foundation Grant, and a Puffin Foundation Grant. She has curated many exhibitions. She is an adjunct professor at Montclair State University and SUNY Purchase.

Jennifer Guglielmo is associate professor of history at Smith College. She is author of *Liv-ing the Revolution: Italian Women's Resistance and Radicalism in New York City, 1880–1945* (2010), which received the Theodore Saloutos Memorial Book Award for best book in U.S.

immigration history and an Honorable Mention from the Berkshire Conference of Women Historians' First Book Prize. She is also coeditor (with Salvatore Salerno) of *Are Italians White? How Race Is Made in America* (2003).

Joanna Clapps Herman's latest publication is *The Anarchist Bastard: Growing Up Italian in America* (2011). She coedited two anthologies: *Wild Dreams* (2008) and *Our Roots Are Deep With Passion* (2006). Her essays appear in *The Milk of Almonds; Don't Tell Mama; Oral History, Oral Culture, and Italian Americans;* and *Lavandaria.* She has published extensively in fiction, poems, and creative nonfiction. She received the Bruno Arcudi Prize and the Henry Paoloucci Prize. The *Litchfield Review* awarded her their medal for Literary Excellence. She teaches at the City College (CUNY) Center for Worker Education and is on the graduate writing faculty of Manhattanville College.

Joseph J. Inguanti holds a Ph.D. in History of Art from Yale University. He teaches art history at Southern Connecticut State University. Professor Inguanti has written about cemetery landscapes ("Domesticating the Grave: Italian American Memorial Practice York at Calvary Cemetery," *Markers XVII: Annual Journal of the Society for Gravestone Studies,* 2000) and residential landscapes ("Landscapes of Order, Landscapes of Memory: Italian American Residential Landscapes of the New York Metropolitan Region," *Italian Folk: Vernacular Culture in Italian American Lives,* edited by Joseph Sciorra, 2011).

Annie Rachele Lanzillotto is a Bronx-born poet, author, director, and performance artist. Her memoir, *L is for Lion: An Italian Bronx Butch Freedom Memoir,* was published in 2013 by SUNY Albany Press. Recent works include her independent CD release *Eleven Recitations,* and her band's album *Blue Pill.* Her poem "Triple Bypass" won the Paolucci Award in Poetry of the Italian American Writers Association and was published in *The Milk of Almonds: Italian American Women Writers on Food and Culture,* edited by Edvige Giunta and Louise DeSalvo. Her solo shows include *Confessions of a Bronx Tomboy; Pocketing Garlic; How to Wake Up a Marine in a Foxhole;* and *a'Schapett,* at the Arthur Avenue Retail Market in the Bronx. Lanzillotto has received performance commissions from Dancing in the Streets, Dixon Place, Franklin Furnace, and the Rockefeller Foundation.

Anne Marie Macari's most recent book, *She Heads Into the Wilderness,* was published by Autumn House Press in 2008. Her book *Ivory Cradle* won the 2000 APR/Honickman first book prize, followed by *Gloryland.* Her poems have appeared in numerous magazines such as the *Iowa Review, Field,* and *TriQuarterly.* Macari directs the Drew University MFA Program in Poetry & Poetry in Translation.

Born and raised in Rome, **Giuliana Mammucari** has lived her adult life between Westchester County and Manhattan. She studied Italian Literature at Columbia University and has taught Italian in various universities and colleges in the New York area and at Parliamo Italiano Institute, Manhattan. In addition to two volumes of poetry in bilingual text, she has published articles on Giambattista Vico's philosophy and on her observations of both cultures in Italian and U.S. literary journals. She now lives in Rome.

Denise Calvetti Michaels has published poetry and memoirs in *City Works Press*, the *Paterson Literary Review, Clamor*, and other publications, with new work forthcoming in *Broken Circles*, Cave Moon Press. Her work has also appeared in *Against Forgetting* (2009), *In Praise of Farmland* (2003), and *The Milk of Almonds: Italian American Women Writers on Food and Culture* (2002). She was awarded the 2008 Crosscurrents Prize for Poetry from the Washington Community College Humanities Association. She teaches psychology at Cascadia Community College in Bothell, Washington.

Giovanna Miceli Jeffries teaches Italian at the University of Wisconsin. She is one of the founders of WisItalia (a Wisconsin-based organization devoted to the promotion of Italian in K–12 schools). Since 1994 she has been the coordinator and director of the Italian Language and Culture program at the Italian Workmen's Club, in Madison, Wisconsin. She is the author of *Lo Scrittore, il lavoro e la letteratura* (1988) and editor of *Feminine Feminists; Cultural Practices in Italy* (1994). She is cotranslator in English of the Italian novel *Casalinghitudine*, published by SUNY Press with the title of *Keeping House, a Novel in Recipes* (2005).

Lia Ottaviano holds an MFA in Creative Writing from Hunter College and works as a senior assistant at John Wiley and Sons Publishing. She lives in Bushwick, Brooklyn, by way of Coventry, Rhode Island, and is currently at work on her first memoir, tentatively titled *Consuming*.

Gianna Patriarca is the award-winning author of eight books of poetry and one children's book. *Italian Women and Other Tragedies* was runner-up for the Milton Acorn People's Poetry Award and was translated into Italian in 2009. *My Etruscan Face* was short-listed for the Bressani Award in 2010. Her work is extensively anthologized in Canada and internationally and has been adapted for Canada Stage Theater and for CBC radio drama.

Tiziana Rinaldi Castro was born in Italy in 1965 and came to New York in 1984. She teaches Ancient Greek Literature at Montclair State University. In Italy she has published a book of poetry titled *Dai Morti* (1992) and two novels: *Il Lungo Ritorno* (2001) and *Due cose amare e una dolce* (2007). Her second novel is to be published in France by Cap Editions, Paris. Her third novel, *As of the Rose*, will be published in Italy in 2012.

Joan L. Saverino is an adjunct professor in the Department of Sociology, Anthropology, and Criminal Justice at Arcadia University. She is the former director of Education and Outreach at the Historical Society of Pennsylvania, where she was the creator and founding director of PhilaPlace (www.philaplace.org), an interactive website and outreach project. Saverino has a doctorate in Folklore and Folklife from the University of Pennsylvania. Her work has most recently appeared in the edited books, *Italian Folk: Vernacular Culture in Italian-American Lives* and *Global Philadelphia*.

Joseph Sciorra is the director for Academic and Cultural Programs at the John D. Calandra Italian American Institute, Queens College (City University of New York). As a folklorist, he has published on religious practices, cultural landscapes, and material culture, among other

topics. He is editor of the journal *Italian American Review, Italian Folk: Vernacular Culture in Italian-American Lives* (2011), and *Sacred Emblems, Community Signs: Historic Flags and Religious Banners from Italian Williamsburg, Brooklyn* (2003), coeditor of *Graces Received: Painted and Metal Ex-votos from Italy* (2012), *Mediated Ethnicity: New Italian-American Cinema* (2010), and poet Vincenzo Ancona's *Malidittu la lingua / Damned Language* (1990; 2010), and author of *R.I.P.: Memorial Wall Art* (1994; 2002).

Maria Terrone is the author of two poetry collections: *A Secret Room in Fall* (2006), winner of the McGovern Prize, and *The Bodies We Were Loaned* (2002), as well as a chapbook, *American Gothic, Take 2* (2009). Among her magazine credits are *Poetry*, the *Hudson Review, Poetry International, VIA*, and *Italian Americana* and more than a dozen anthologies, including *The Milk of Almonds: Italian American Women Writers on Food and Culture* and *Killer Verse: Poems About Mayhem and Murder*. She is the AVP for Communications at Queens College, CUNY. Visit her at mariaterrone.com.

Angela Valeria grew up in Brighton Beach. In the sixties she studied art at Hunter College and the Academy of Fine Arts in Florence and Bologna. She has exhibited extensively in New York and Europe, especially Italy, and in Mexico, India, and Japan. She has taught art to a wide and varied audience, most recently at the Parsons School of Art and Design.

Ilaria Vanni studied art history is Siena, Italy, before moving to Sydney to pursue graduate work on the early exhibitions of indigenous Australian objects. She is senior lecturer in International Studies and head of the Cultural Studies Group at the University of Technology, Sydney. Her research interests include multimedia practices and activism; the Italian diaspora in Sydney; objects, theories, and histories; digital media, multiculturalism, and cultural citizenship.

Lisa Venditelli lives and works in San Diego, California. Originally from Boston, she attended Rhode Island School of Design for her BFA and Mills College in Oakland for her MFA. She has shown her work at galleries across the country, including the Museum of Contemporary Art San Diego Café, La Jolla Athenaeum Music and Arts Library, the Museo Italo Americano in San Francisco, and the Crocker Art Museum. Lisa has won several awards for her work. She was represented by David Zapf until his retirement. She is an adjunct professor at Southwestern College. Her work is in many private collections and part of the La Jolla Athenaeum Collection and the Museo ItaloAmericano.

Paul Zarzyski's poetry is imbued with the spirited people and stories of his Polish Italian heritage set in his birthplace—Hurley, Wisconsin—where his mother, Delia (Paternoster-Pedri), conceived in Trentino-Alto Adige, was born after immigrating in utero to the United States in 1920. He received his MFA degree from the University of Montana, where he later taught after the passing of his mentor, Richard Hugo. He is the recipient of the 2005 Montana Governor's Arts Award for Literature. Zarzyski—a rodeo bronc rider for fifteen years—often recites his work on the "cowboy poetry" stages of the West. His recent Bangtail Press collection is *51: 30 Poems, 20 Lyrics, 1 Self-Interview* (2011).

Christine F. Zinni, Ph.D., is an ethnographer and filmmaker. She teaches indigenous and cultural studies in the Department of Anthropology at the State University of New York at Brockport. Gravitating toward video as a medium for storytelling and activism, she has produced over ten "shoestring" documentaries. Her experiences are published in "*Cantastorie*: Ethnography as Storysinging" (in *Oral History, Oral Culture and Italian Americans*, ed. Luisa Del Giudice, 2009) and "The Medium and the Message: Oral History, New Media and The Grassroots Histories of Working Women" (*Journal of Educational Technology Systems*).

CREDITS

Phyllis Capello, "Factory Girls, Bangkok," previously published in *Paterson Literary Review* (1998). Used by permission of the author.

Phyllis Capello, "Embroidery," previously published in *The Wind in Our Sails* (Midnight Sun Press, 1982). Used by permission of the author.

Rosette Capotorto, "The lady in the hat," previously published in *Bronx Italian* (Pronto Press, 2002). Used by permission of the author.

Paola Corso, "Girl Talk," originally published in *Feminist Studies* 31, no. 3 (Fall 2005): 616–17. Used by permission of the publisher, Feminist Studies, Inc.

Paola Corso, "Identified," originally published in *Feminist Studies* 31, no. 3 (Fall 2005): 615. Used by permission of the publisher, Feminist Studies, Inc.

Peter Covino, "Medicine of Language," from *Cut Off the Ears of Winter* by Peter Covino. New Issues Poetry & Prose (Western Michigan University, 2005). Used by permission of New Issues Poetry & Prose.

Barbara Crooker, "Junior High: Home Economics," *West Branch* (1999), and *Radiance* (Word Press, 2005).

Barbara Crooker, "Knitting," previously published in *Connections* (Issue 7, Fall 1981). Used by permission of the author.

"Daguerrotype: Lace Maker" and "The Dressmaker's Dummy," from *Emily's Bread* by Sandra M. Gilbert. Copyright © by Sandra M. Gilbert. Used by permission of W. W. Norton & Company, Inc.

Maria Mazziotti Gillan, "Donna Laura," originally published in *What We Pass On: Collected Poems 1980–2009*, Guernica Editions (2010). Used by permission of the author and the publisher.

Maria Mazziotti Gillan, "Biancheria and My Mother," originally published in *Ancestors' Song*, Bordighera Press (2013). Used by permission of the author.

INDEX

embroidery (technique), 8, 329; counted thread, 65, 317; cutwork (*punto tagliato*), 14, 65, 74, 76, 89, 233, 288, 294, 303–5, 323, 325; drawnwork (*punto antico, punto tirato*), 14, 158, 214, 288, 317, 322; filet, 104; openwork, 144–45, 155–61, 215, 216. *See also* stitch

Emilia-Romagna, 155; Ferrara, 318; migration from, 155; Modena (province), 155; Reggio Emilia (province), 317–18; Scandiano, 317–18

Ennea Odoi, 335

Ente Nazionale Artigianato e Piccole Industrie, 10–11

ethnic identity, 3, 4, 15, 16, 19, 43, 46, 50, 53, 57, 84, 124–25, 128, 130–32, 144, 156, 214, 241, 283, 284, 314, 321

ethnographer, 10, 281, 283–86

ethnopoetics, 79, 84

Eucharist, 76, 83, 85, 88; First Communion, 13, 14, 37, 86, 108

Europe, 10, 11, 46, 141, 145, 168, 177, 216, 217, 219, 222, 223, 224, 226, 227, 228, 229, 230, 231, 232, 233, 234, 354; Medieval, 83; northern, 11, 145, 177

exhibition of needlework, 12, 17, 49, 277, 306; "Belongings," 121, 126; "Lace, the Spaces Between," 15; "Life line—*filo della vita*," 6, 266; "*Rebozos/K'uanindik'uecha*," 239–41; "Sempre con te," 49–50, 58; "Stitches—*fare il punto*," 15, 121–22, 123, 131

fabric. *See* cloth

factory, 3, 8, 11, 16, 17, 18–19, 44, 76, 90, 104, 145–46, 152, 167–68, 169–92, 193–206, 207–8, 209–10, 220, 239–40, 243, 316, 326, 330, 336, 337, 354; child labor, 150, 168, 178, 180–81; working conditions, 44, 71, 167, 168, 182–85. *See also* garment industry; industrialization; sweatshop

Fair Isle (knitting), 141

family, 3, 6, 7–8, 9, 10, 11–12, 14, 16, 17, 18, 19, 29, 33, 36, 37, 42, 43, 48, 49–55, 64, 66, 72,

74, 75, 80, 83, 85, 88, 103, 106–18, 123, 126–27, 128, 131, 141, 145, 146–48, 150, 152–58, 160–61, 168, 169–70, 172, 173–77, 180–81, 184–85, 220, 222, 231, 232, 235, 239–40, 250, 261–62, 263, 269, 270, 281, 283–87, 289–90, 291, 292–95, 297–98, 302, 305, 306, 313–25, 328, 330, 332–33, 350–51; economy, 146, 150, 152, 168, 172, 174–77, 185, 193–206, 220, 287, 291; memory, 18, 131–32, 317, 321; network, 55, 82, 93; values, 57; woman-woman relationship, 3–4, 18, 19, 29–30, 31–36, 37–38, 39–40, 45, 48, 50–57, 62, 70–71, 73, 78, 81–82, 106, 109, 112, 113, 118, 121, 127, 131–32, 145–46, 152–55, 158, 160, 169, 173, 179, 193, 195, 199, 201, 250–52, 258, 261, 263, 266, 270–71, 281, 283, 284, 288, 291, 293, 316, 322–23, 325, 326, 328, 336–37, 349–51 (*see also* intergenerational transmission)

farm, 75, 107, 109, 110, 111, 117, 147, 169, 178, 220, 324, 331. *See also* peasant

Fascism, Italian, 4–5, 10, 13, 123, 148, 149; Anti-Fascism, 150

fashion, 289, 290, 299. *See also* garment; factory, garment industry

Favero, Bettina, 18

feast, religious, 10, 14, 33, 75, 76, 77–78, 226, 277, 293, 317

femininity, 8, 18, 122, 132, 219, 225, 231, 349. *See also* womanhood

feminism, 17, 122, 148, 167, 352–54

Ferraro's Coat Factory, 336

filet lace, 14, 54, 104

Fishman's Fabric Store, 116

flax, 117, 215, 216, 217, 220, 221, 222, 230, 231, 235, 287, 324

flea market, 5, 277

flora, 35–36, 38, 50, 68, 69, 74–75, 77, 80, 91, 132, 153, 213, 215, 224–25, 233, 234, 242, 254, 258, 289, 323; artificial flower, 178, 179, 180, 182; daisy, 123, 132, 247, 324; imagery of, 8, 25, 34, 37, 45, 46, 48, 64–66, 70, 79–81, 109, 132, 139, 208, 214–17, 222, 223, 225, 227, 230–33, 234–36, 247,

264–65, 319, 321, 324, 337, 347–48; jasmine, 215–16, 223, 224, 227, 231, 234; lily of the valley, 32, 215, 222–23; rose, 8, 14, 32, 48, 49, 65, 67, 213, 214–16, 223, 224, 227, 229, 234, 235, 247, 275, 318; violet, 180, 324; zinnia, 275. *See also* citrus; garden; horticulture

florilegia, 233, 234

folktale, 148–49, 151, 225–29, 230, 233, 352

Frank, Dana, 185

Frieri Ruberto, Leonide, 10

furniture, 9, 49, 90, 125, 128, 321, 322, 334, 347

Gabaccia, Donna, 19, 146, 156

Gaeta, Lucia, 169–71, 180

Gaeta, Tina, 169, 170–71, 180

Gallo, Eleonora, 10

garden, 45, 75, 79, 81, 82, 91, 111, 114, 153, 214, 224–25, 231, 234, 258, 275, 276, 277, 291, 296–97, 302, 319, 351; imagery of, 213–17, 218, 221, 222–25, 226, 227, 228–29, 231–32, 233, 234, 235–36

Garden of Eden, 223

garment industry, 8, 10–11, 17, 18–19, 44, 63–64, 104, 150–51, 154, 155, 167–68, 169–92, 193–206, 220, 239, 318, 326, 330, 347, 350, 354; women's wages, 11, 71, 104, 145, 169–92, 209. *See also* factory; sweatshop

Gattuso, Maria, 175

Gay and Lesbian Center, 270

gender, 8, 16, 50, 71, 122, 145, 146, 148–49, 150, 152, 172, 175, 181, 194, 219–20, 226, 230, 281, 290, 296, 314, 324, 347

Genoa, 172

German American, 75, 179, 183, 351

Giampà, Anna, 297

Gilbert, Sandra M., 17, 144

Girl Scouts, 37

Giunta, Edvige, 4, 6, 16, 261, 268–69, 271–72, 348

globalization, 145, 170, 171–72, 184–85

glory box, 14, 50, 53, 121, 123, 130. *See also* hope chest; trunk

Golzio, Carrie, 183

Gonella Bianco, Agostina, 245

Gorgoni, Rose, 184

Greece, 265–66; Athens, 335; Mykonos, 266

Grifone, 226, 229, 235

Grillo, Lucia, 63–66

Grillo, Maria, 18, 63–66

Grillo, Vincenzo, 63

groom, 9, 32, 55, 66, 292; as Catholic symbolism, 82. *See also* bride; courtship; marriage; wedding

grosgrain, 116

Grosso, Rosie, 278

Guancione, Karen, 17, 19

Guarascio, Anna, 281–312

Guarascio, Costanza, 288–89

Guarascio, Pasquale, 287

Guarascio, Salvatore, 282, 286–87, 292

Guglielmo, Jennifer, 11, 18, 148

Gullo, Lucia, 76, 89, 91

Gullo, Thomas, 79, 89–90

hair net, 47, 48

handkerchief, 8, 17, 38, 41, 55, 62, 81, 107, 114, 322, 351

Haudenosaunee (Iroquois), 74–75

Heaven, 223, 226

heirloom, 5, 15, 36, 50, 52, 53, 121, 127

hem, 10, 37, 113, 114, 115, 116, 118, 139, 279, 347

hemp, 287

Henderson's, Melbourne, Victoria, 45

Herodotus, 314

herringbone (cloth), 116

Histories, 314

hole, 65–66, 111, 159

home, 12, 14, 18, 41–42, 44–45, 49–50, 51, 53, 54, 56–58, 64, 69, 72–73, 78, 79–82, 85, 91, 107, 117, 123–28, 130, 133, 146, 152, 154, 159, 174, 220, 226, 236, 263, 283, 288, 292, 306, 314, 322, 324, 325, 328, 329, 334, 339, 349, 353–54

homework, 18–19, 44, 104, 150–51, 168–70, 174, 176–82, 184, 195, 197, 198–203, 241, 336, 350. See also *a façon*

honor and shame, 9, 85, 147, 153, 159, 174, 220, 288, 289, 290, 291, 330, 349

hook and eye, 112, 139

hope chest, 3, 4, 107, 117, 121, 151, 313, 315, 330, 339, 351. *See also* glory box; trunk

horticulture, 19, 213–38. *See also* flora; garden

hortus conclusus, 218, 222–25, 227, 229, 230, 231, 233–34, 235

house, 9, 29–30, 33, 126, 128–29, 136, 156, 245, 285, 295, 296–97, 298, 313–14, 318–21, 333

house work. *See* domestic work

Hwei-Fen, Cheah, 18, 47, 48, 52, 54, 55

Hyland, Barbara, 115

Iaconis, Rosina, 285–86

Iaquinta, Maria Rosa, 300

Ilacqua Ianni, Anna, 123

Iliad, 314

Illinois, 155–56; Chicago, 155–56, 157; Highland Park, 155–56; Highwood, 155–56, 157; Lake Forest, 155–56

imagination, 4, 5, 7, 19, 41, 55, 74, 116, 126, 127–28, 158, 159, 161, 222, 226, 231, 233, 291, 300

immigrant experience, 4, 5, 6, 12, 15, 17, 44–46, 57–58, 71, 121, 123–24, 126, 127–30, 133, 156–59, 160, 167–68, 180–81, 184, 294–98, 300–301, 306; discrimination, 131, 296

Immigration Museum, 49

industrialization, 18, 169, 171, 172, 175, 196, 197–98, 247, 354

Inguanti, Joseph, 17, 18, 19, 213

intergenerational transmission, 3–4, 8, 11, 14, 18, 44–45, 109, 112–13, 115, 123, 127, 130–31, 145, 170, 178, 250, 289, 305–6, 336–37, 350–51. *See also* heirloom

International Ladies' Garment Workers' Union (ILGWU), 180

intimate apparel, 7, 9, 34, 173, 174, 180, 275, 293–94, 298–99, 326, 333, 336

Iotti, Franca, 323–25

Irish American, 14, 75, 179, 183

ironing, 3, 51, 53, 58, 89, 104, 111, 115, 136, 195, 201, 241, 326–27, 333, 337

Islam, 224–26, 235

Isole Eolie Association, 43

Italian American studies, 6

Jews, 17, 90, 179, 183, 184, 275, 301

John D. Calandra Italian American Institute, 6, 16, 307

Juvenile Protection Asylum, 153

Kader Industrial Toy Factory Fire, 17, 207–8

Kessler, Becky, 278

Kessler-Harris, Alice, 146

Kindred, Audrey, 265, 266

Kirshenblatt-Gimblett, Barbara, 301

knitting, 4, 5, 31, 32, 33, 34, 35, 36, 45, 56, 80, 107, 109, 126, 132, 136, 141–42, 147, 151, 196, 197, 198, 199–202, 203, 271, 288, 299, 302, 325, 347–48, 349, 350, 351, 353, 354; machine, 195–96, 197, 199–201; needles, 31, 33, 34, 35, 141, 348, 350, 351, 354

knotting, 25, 62, 99, 104, 106, 217, 247

lace, 3, 7, 8, 9, 10–11, 14, 15, 17, 25, 30, 34, 37, 41, 50, 52, 76, 77–78, 79, 80–81, 83, 84, 85, 87, 88, 89, 107, 115, 125, 130, 132, 133, 168, 173, 174, 178, 180, 263–66, 270–71, 298, 299, 304–5, 306, 318, 339, 349, 353, 354

La donna (magazine), 238

Landrum, Patricia, 119

language, 126, 156, 221, 338, 353; of immigrants, 74, 155, 168, 184, 348; Italian, 43–44, 129, 131, 261, 270, 315

Lanzillotto, Annie, 18, 19, 266

latifondo, 287–88

laundry, 3, 12–13, 32–33, 38, 52–53, 89, 111, 120, 141, 170–71, 182, 195, 258, 273, 275, 277, 289, 291, 276–77, 324–25

lavoro ben fatto (work done well), 4

lawn (cloth), 116

layette, 112

lenzuolo. See bed sheet

Leone, Kate, 278

lesbian, 261–62, 264, 267–68

Levanthal, Mary, 278

Levin, Jennie, 278

Liberati, Vincenzo, 197

life integration, 86, 301–5

linen, 33, 51–52, 53, 62, 63–66, 80, 89, 90, 117, 121, 156–57, 158, 161, 215, 216, 217, 219, 221, 226, 227, 230, 231, 247, 250, 279, 285, 287, 288, 290, 293–94, 301, 305, 324–25, 328, 331, 332, 334, 336, 354

Lizza, Carmela, 173

Lomax, Alan, 8

Lombardo, Pina, 44

Lombardy, 128, 199; migration from, 128, 194; Milan, 172; Pavia, 199; Sondrio (province), 128

loom, 84, 93, 126, 130, 144, 148, 162, 168, 182, 241, 248, 287, 288, 301, 314, 318, 324, 347, 350

loop, 62, 68, 109, 112

Lopez, Annamaria, 290

love, 8, 35, 51–53, 57, 65, 72, 124, 141–42, 149, 152, 214, 216–17, 220, 222, 223–24, 225, 227, 230, 251–52, 257, 267, 269, 307, 314, 321, 335

Luperino, Lena, 76

luxury, 5–6, 7, 71, 116

Lysistrata, 314

Macari, Anne Marie, 17

Macari, Filomena, 184

Madonna, 10, 77, 91, 151, 214, 218–19, 222–23, 225, 226, 227, 230, 231–32, 234, 236, 250

Madonna della Lettera (Madonna of the Letter), 218–19; Our Lady of Mount Carmel, 14

madras, 116

Mammuccari, Giuliana, 17

Mani di Fata (magazine), 46–47, 132

mappine (dish towel), 114

Marche, 194; migration from, 194

Marciano, Michela, 243

marriage, 4, 7, 8, 9, 41, 45, 49, 51, 53, 57, 63, 64, 71, 103, 140, 146–48, 149, 150, 153, 154, 159,

169, 173, 174, 175, 198, 201, 213, 215, 217–18, 219, 220, 223, 225–26, 227, 229, 230, 235–36, 253, 261, 265, 270, 284, 287, 290–93, 298, 314, 315, 316, 322, 324, 329, 330, 331, 333, 335, 336, 337, 351, 352; arranged, 292; gay, 271; gifts, 50, 62, 121, 317. *See also* bride; courtship; groom; wedding

Martini, Dr., 266

Massachusetts, 71; Boston, 14, 317; North End, 104, 317

Mata, 225–26, 230, 235

material culture, 16–17, 42, 58, 124, 221, 233, 235, 236, 352

Matilde di Canossa, 318

Mazziotti Gillan, Maria, 17, 19

McCall's, 116, 139

Mele, Francesca, 275–77

Meligrana, Francesco, 286

Melino, Rosa, 49

memoir, 6, 17, 18, 19, 31–36, 68–73, 86, 106–18, 121, 147, 148, 248–58, 261–72, 313–25, 326–35, 348. *See also* autobiography

memory, 5, 7, 15, 17, 18, 19, 41, 42, 49–57, 65, 76–77, 84–86, 88, 92, 93, 109, 121, 124, 125, 129–33, 143, 157, 158, 210, 236, 258, 275, 281, 283, 285, 289, 290, 294, 300–306, 318, 321, 340, 341, 350, 354–55; work, 4, 16, 19

mending, 34, 111, 145, 157, 159, 248, 279, 326, 347

Messina, Elizabeth, 268

Messina, Maria, 9

Mexico, 239–41, 277; needlework of, 17, 239–41; Pátzcuaro, 239; State of Michoacán, 239; Uruapan, 239

Meyerhoff, Barbara, 301, 303

Miceli Jeffries, Giovanna, 18, 327

Middle Ages, 83–85, 222–31, 234–35, 317, 354

migration, Italian, 4, 5–6, 7, 9, 10, 11–12, 14, 16, 18, 19, 29, 37–38, 41–61, 75, 76, 121–35, 144–48, 150, 155–56, 160, 170–80, 184–85, 193–95, 214, 220, 236, 281, 286, 291, 295–96, 298, 349, 352

minuta, 9

modernization, 14, 18, 49, 57, 104, 122, 169, 183, 325, 330

Molise, 76; migration from, 76, 79, 194

Moliterno, Caterina, 56–57, 58

Monongahela River, 297–98

morality, 8, 9, 147, 152, 153, 154, 161, 181, 218, 226, 227, 229, 233–34, 235, 290–91, 298

moth, 36, 213, 214, 216–17, 220–21, 230–31, 234, 235

Mruczek, Carol Lombardo, 86–87

Museo Pitrè, 348–49

muslin, 110, 116, 322

National Museum of American History, 306

Native American, 17

needle, 3, 5, 17, 31, 33, 34, 35, 38, 66, 71, 81, 82, 84, 90–91, 99, 106–7, 108, 109, 111, 112–13, 114, 116, 139, 141, 144, 152, 154, 155, 160–61, 174, 207, 208, 240, 242, 244, 247, 248, 249–50, 251, 253, 254, 256, 257, 271, 279–80, 301, 305, 327, 340, 348, 350, 351, 354. *See also* spool; thread

needlework (domestic), 3, 6, 7–11, 15–19, 42, 45, 46, 51, 63–66, 84, 122, 124–25, 126–27, 130, 131, 132, 133, 158, 193–206, 220, 234, 240, 307, 325, 350–51, 353–54; comfort associated with, 35, 38, 50, 51, 52, 57, 264, 325, 347; display of, 8, 9, 14, 19, 35, 57, 64, 66, 78, 85, 92, 125, 158, 240, 241, 277, 289, 324, 332, 333–34, 347, 348, 355 (*see also* exhibition of needlework; private/public spheres; *stima*); drudgery of, 8, 18, 20, 170; economic value of, 3, 7, 8–9, 14–15, 41, 289–90, 305; as hobby, 44–45, 48, 71; pawned, 3, 9, 161, 174; pleasure in, 108, 111, 116, 218, 224, 225, 226, 234, 302, 348, 355; pride in, 51, 64, 107, 124, 133, 137–38, 168, 287, 305, 330, 333; for religious statues, 10, 77–78; ritualized, 3, 9–10, 12, 124, 292; sentimental value of, 41, 42, 50, 56, 127, 130; socializing aspects of, 14, 56, 288–89, 290, 298; sold, 3, 14, 174, 294; symbolism of, 4, 5, 8, 9, 14–15, 16, 41–42,

46, 51, 84, 88, 131, 147, 156–57, 161–62, 289–90, 294–95, 298; technique of, 4, 7, 8, 14, 15–16, 18, 104, 125, 132, 173, 193, 198–99, 214, 324, 329; use value, 14–15, 130, 158, 162, 214, 218. *See also* pattern

Nero, Maria, 50

New Jersey, 4, 32, 168, 183, 185, 239–40, 268, 313, 317, 321, 330, 332, 335; Hoboken, 32; Maplewood, 316; Newark, 239–40, 321; New Brunswick, 334; Paterson, 183; Ridgefield, 32; Seaside Heights, 320; Teaneck, 268; Vaux Hall, 313, 317, 321, 322

New Mexico, 157; Chaco Canyon, 341

New South Wales Migration Heritage Centre, 121, 126

New York, 74, 91, 162, 168, 213–14, 350; Babylon, 262; Batavia, 18, 74–98; Bensonhurst, 12; Brighton Beach, 275, 277; Bronx, 262, 266; Brooklyn, 5, 13, 73, 174, 265–66, 275, 351; Corning, 3, 14, 15; Genesee region, 74, 77; Greenwich Village, 173, 180; Harlem, 14, 152, 153, 176, 248, 250; Lewiston, 91; Lower East Side, 150, 151; Manhattan, 11–12, 176, 333–34; Morris Park, 262; New Rochelle, 64; New York City, 4–5, 11, 12, 72, 85, 161, 169–70, 173, 176–85, 221, 251, 257, 262, 264, 265, 268, 271, 277, 317, 336, 349, 352; Park Slope, 265; Saratoga, 107; Utica, 287, 292

New-York Historical Society, 12

Niagara Falls, 75, 91

Nocciolino, Ciana "Spina," 76–77

nostalgia, 49, 56, 64, 127, 301

nun, 8, 9, 10, 56, 79, 82–85, 123, 125, 132, 217–18, 267, 326–27, 328–29, 347–48, 349; *monaca di casa* (house nun), 10. *See also* convent

Odencrantz, Louise, 183–94

Odyssey, 314

Ognibene, Josephine, 76, 86, 88

Ognibene, Kay Martino, 86

oral history, 155–56, 169, 350

Ottaviano, Lia, 17

77–78, 92. *See also* Catholicism; feast: religious

Salemi, Sophie, 278

Sardinia, 50; Burgos, 50

Sarta. See seamstress

Sartina. See seamstress

Saverino, Joan, 9, 19, 86, 282, 297, 299, 304

Scarcelli, Franceschina, 298

Scarcelli, Serafina, 298

Schneider, Jane, 7, 9, 161, 289, 348–50, 351–52, 354

Schneider, Peter, 349

school, 10, 45–46, 48, 123, 173. *See also* convent

Sciorra, Filomena, 5

Sciorra, Joseph, 4–5, 6, 13, 15, 16, 85, 268, 307, 348

scissor, 65, 116, 137, 169, 240, 247, 253

Scuola d'Industrie Italiane, 12

seam, 4, 34, 108, 110, 114, 115, 139–40, 170, 207, 256, 342

seamstress, 3, 4, 16, 34, 63–64, 144, 147, 152, 153–54, 156–57, 158, 161–62, 169, 173–79, 185, 195, 202, 250, 287, 347, 351; symbolism of, 155, 159–60

Seneca, 74

settlement house, 12

sewing, 4, 5, 10, 11, 12, 17–18, 29, 37–38, 40, 41, 44, 45, 56, 62, 63–64, 86, 90, 103, 104, 106, 107–8, 110, 111, 113–17, 121, 130, 132, 137, 139, 144–45, 148, 149, 150–52, 154, 155, 156, 158–62, 167–68, 169, 170, 172, 173–74, 176, 178, 180, 196, 199, 220, 239–40, 241, 244, 248, 250–51, 252, 253, 254, 256, 258, 271, 279, 285, 293–94, 296–97, 299, 324, 336–37, 341–42, 347; pattern, 107, 108, 115, 116, 137, 139; stay, 139; top-stitching, 139

sewing machine, 107, 108, 114, 128, 130, 136–37, 154, 182, 183, 201, 207, 239–40, 243, 250, 314, 315, 347, 351

sexuality, women's, 174, 231, 261, 267, 291. *See also* lesbian

shawl, 25, 32, 33, 34, 36, 54, 107, 239, 325, 355

shirt, 45, 76, 90, 107, 113, 114, 148, 195, 273, 275, 326

shirtwaist, 173, 176, 243

shrouds, 9, 86, 277, 314

Sicily, 8, 9, 123, 127, 148–50, 223, 224–26, 231, 301, 317, 328, 330, 352; Agrigento, 149, 317; Agrigento (province), 326, 327, 349; Catania (province), 44, 172; Enna (province), 175; Gela, 269; Leonforte, 175; Lercara Friddi, 242; Lingua, 127; Lipari, 123; Messina, 127, 172, 223; Messina (province), 343; migration from, 4, 11–12, 37–38, 44, 49, 75, 76, 79, 123, 127, 146, 150, 175, 176, 184, 194, 236, 349, 352; needlework of, 7, 8, 17, 76, 99, 123, 172, 173, 213–38, 317, 330, 331, 332, 333, 342–43, 350; Palermo, 128, 172, 173, 225, 348, 349; Palma di Montechiaro, 317; Poggioreale, 49; Ribera, 326; Salina, 127; Sambuca di Sicilia, 349; Savoca, 343; Sciacca, 332, 349; Scordia, 44; Trapani (province), 49; Trapani, 172; Vallelunga, 76

Signor, Angela, 45

silk, 14, 116, 136, 139, 168, 172, 177, 216, 217, 220, 221, 230, 235, 247, 329

skill, 3–4, 7, 10–12, 14, 17, 18, 19–20, 41, 44, 46, 63, 69, 82, 84, 104, 107–8, 112–13, 118, 124, 125, 126, 130–31, 145, 152–54, 156, 168, 169, 170, 172–73, 176, 179–80, 195–96, 199, 202, 218–20, 241, 277, 287, 288, 289, 293, 298, 301, 314, 322, 348, 350–51, 355. *See also* craft

Sloan-Kettering Hospital, 267, 271–72

smarlatura, 65, 66

snaps, 112, 116, 139

Società Cooperativa delle Industrie Femminili, 10

spindle, 117, 350

spinning, 8, 30, 107, 117, 149, 173, 195, 197, 200, 323, 339

spool, 17, 109–10, 114, 116, 118, 137, 139, 167–68, 253. *See also* thread

Statue of Liberty, 266

stima, 9, 12

9/15

CPSIA information can be obtained at
Printed in the USA
BVOW02s2341290615

406727BV00001B/1/P

9 781496 804594